D1000387

Suzanne Valadon

Also by June Rose

The Drawings of John Leech
(English Masters of Black and White)
Changing Focus: The Development of Blind Welfare in Britain
The Perfect Gentleman: A Biography of Dr James Miranda Barry
Elizabeth Fry
For the Sake of the Children: A History of Barnado's
Modigliani: The Pure Bohemian
Marie Stopes and the Sexual Revolution

Suzanne Valadon

The Mistress of Montmartre

June Rose

St. Martin's Press ❧ New York

Library of Congress Cataloging-in-Publication Data

Rose, June, 1926-
 [Mistress of Montmartre]
 Suzanne Valadon: the mistress of Montmartre / June Rose.
 p. cm.
 Previously published under the title: Mistress of Montmartre. London:
Richard Cohen Books, 1998
 Includes bibliographical references and index.
 ISBN 0-312-19921-X
 1. Valadon, Suzanne, 1865-1938. 2. Painters—France—Biography.
I. Valadon, Suzanne, 1865-1938. II. Title.
ND553.V3R66 1999
759.4—dc21 98-47609
 CIP

First published in Great Britain by Richard Cohen Books

First U.S. Edition: February 1999

10 9 8 7 6 5 4 3 2 1

To Malka and Albert

Contents

List of Illustrations

The author and publishers would like to thank the estate of Suzanne Valadon for permission to publish her works, Jeannette Anderfuhren of the Pétridès Gallery for permission to reproduce from Valadon's Catalogue Raisonné, Léonard Gianadda of the Fondation Pierre Gianadda for permission to reproduce photographs from the catalogue of the Suzanne Valadon exhibition of 1996 in Martigny, Switzerland and the following sources:

1 Miguel Utrillo y Morlius,
 Portrait of Suzanne Valadon,
 1891–2
 Red chalk and coloured pencils
 on paper
 Collection Museo del Cau
 Ferrat, Sitgès, Spain

2 Henri de Toulouse-Lautrec,
 Young Woman at a Table, 1887
 Oil on canvas, 56 x 46 cm
 Amsterdam, Van Gogh Museum
 (Vincent van Gogh
 Foundation)

3 Pierre Auguste Renoir,
 The Bathers, 1887
 198 x 114 cm
 Philadelphia Museum of Art,
 Pennsylvania (Photograph
 Bridgeman Art Library,
 London)

4 *The Future Unveiled*, 1912
 Oil on canvas, 63 x 130 cm
 Musée du Petit Palais, Geneva

5 *Portrait of the Family*, 1913
 Oil on canvas, 97 x 73 cm
 Musée National d'Art Moderne,
 Paris (Photograph Philippe
 Migeat)

6 *The Blue Room*, 1923
 Oil on canvas, 90 x 116 cm
 Musée National d'Art Moderne,
 Paris

7 *Madame Coquiot*, 1915
 Oil on canvas, 93 x 73 cm
 Palais Carnoles, Menton
 (Photograph Musée National
 d'Art Moderne, Paris)

8 *The Casting of the Net*, 1914
 Oil on canvas, 201 x 301 cm

Illustrations on text pages

List of Illustrations

List of Illustrations

Suzanne Valadon

Acknowledgements

My thanks are due to all those who have helped in the writing of this book. In France I owe a special debt of gratitude to Jeannette Anderfuhren of the Pétridès Gallery for generously sharing so much of her knowledge. I am most grateful to Daniel Marchesseau of the Musée d'Art Moderne de la Ville de Paris for all his advice and encouragement. I must express my thanks to Geneviève Barrez for her ready assistance; to Christian Parisot for his information and introductions; to André Roussel, who kindly gave me a transparency of a Valadon drawing, and to Jeanine Warnod, an art critic whose parents had been friends of Valadon. My particular thanks to Léonard Gianadda of the Pierre Giannada Foundation for his generosity and encouragement. Sincere thanks too to Gérard Druet of Anse, who took great pains in showing me round Valadon's former château in Saint-Bernard and in producing documents and anecdotes about the trio. The couple from the Irish shop in Limoges were kind enough to drive me to Valadon's birthplace in Bessines-sur-Gartempe and guide me round the small town. Raymond Latarjet assisted me most kindly with his memories of Valadon. I should also like to acknowledge the help of Michel Lummaux, the cultural attaché to the French Embassy in London.

I owe a special debt of gratitude to the authors and publishers of all the quoted texts and I have endeavoured to trace them all. I would mention particularly Jean Fabris and the Utrillo Association. Monsieur Fabris kindly gave me a copy of a letter from Valadon. My thanks also to John Storm and Longmans; Ornella Volta and Marion Boyars; and Sarah-Jane Coxon of Brassey's (UK), who kindly made the text of *Brassey's Book of Camouflage* available before publication.

In London my warm thanks to Gill Perry for allowing me to consult the unpublished diary of Berthe Weill, lent to her by the Bouche family. Judith Downie very kindly spent half a day demonstrating the process of soft-ground etching on her own press. I was delighted to meet Angela Snell, Suzanne Valadon's great-great-niece, to hear her memories of the family, and through her to speak to Yves Deneberger, her cousin.

I am also greatly indebted to institutions on both sides of the Channel for their help. In London my thanks go to the efficient and courteous staff of the Tate Library; to the staff of the British Library, of the London Library, of the Courtauld Institute and of the National Art Library at the Victoria and Albert Museum; and to Ann Dumas, art historian.

In Paris I should like to thank the archivists Nathalie Schoeller and Nicole Bregegère at the Musée Nationale d'Art Moderne and the staff of the Bibliothèque Nationale for their assistance. A special note of thanks to the archivist at the library of Villefranche-sur-Saône and to Madame Druey at the Musée des Beaux-Arts de Lyon.

Personal friends were immensely kind and helpful. Dominique Darnault in Paris researched on my behalf in L'École du Louvre and Véronique Bolhuis-Castro scanned through the back files of newspapers in the Bibliothèque Nationale. Mona Gordon in Stockholm read and photocopied the catalogue essay on Suzanne Valadon in the Franska Institutet. In London Susi Donat of Camden Libraries recommended a number of useful books and Marion Bieber helped me with introductions. Gabrielle Morrison typed the original manuscript with great care and, as usual, made a number of helpful suggestions. Renate Koenigsberger spent endless hours with me, offering valuable advice and help.

Warm thanks to my publisher, Richard Cohen, and his managing editor Pat Chetwyn for her unfailing enthusiasm and support. Finally I should like to thank my editor, Linden Stafford, for her creative suggestions, her meticulous editing, her patience and her encouragement.

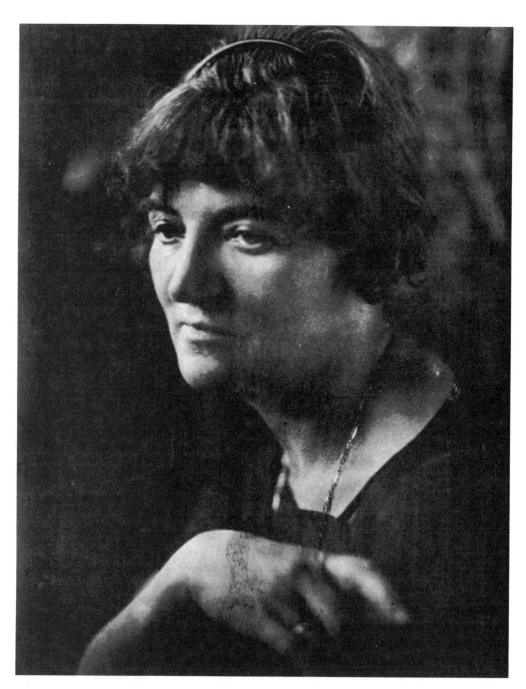

Suzanne Valadon in 1925, her sixtieth year.

In Search of Suzanne Valadon

*My work . . . is finished and the only satisfaction I gain from it
is that I have never surrendered. I have never betrayed anything
that I believed in.*

<div align="right">Suzanne Valadon to Francis Carco, 1937</div>

Suzanne Valadon made her début in the world of art as a model,
painted as a luscious nude by Renoir and as a slattern by Toulouse-
Lautrec. Long after she became an artist herself, these images of
her, beautiful and dissolute, lingered in the minds of critics, and her own
conduct as a woman cast a shadow over her achievement as an artist. 'No
one has ever washed her dirty linen in public so spectacularly,' wrote
Philippe Jullian twenty years ago in his book *Montmartre*. That tone of
disparagement of Valadon the slut has, curiously, clouded judgement of
her from the 1920s to the 1990s. As recently as 1996, an art expert in Paris
remarked in conversation that Suzanne Valadon was 'an excellent
instinctive artist and a bit of a prostitute'.

Valadon's own behaviour had helped to create the wilder stories. For
more than seventy years she had scandalised French society: by taking
lovers and discarding them; bearing an illegitimate son who grew into a
roaring drunk; and overriding the barriers of age – an old man's darling
in her youth, a young man's dream in her maturity. She was seen both as
whore and as heroine. Her promiscuity was equated to a cold heart, her
bohemian way of living considered unseemly for a woman. Yet her
admirers saw her as supreme. A Valadon myth came to eclipse the extra-
ordinary gifts of Valadon the artist. Along the way, Valadon the human
being was jettisoned.

The life she led and the times in which she lived lent themselves to
legend. Over a hundred years ago, Valadon flitted through the Paris of

the Impressionists, illegitimate, beautiful and impossible to control. Even among the artists she caused a stir as a girl, by sliding down the banisters of a famous dance-hall, wearing only a mask to cover her face. She enjoyed the lark and charmed as well as shocked her public. In later life she held to her code and saw no need to apologise for her nude body. At the age of sixty-six she painted herself with bare breasts.

As a girl of fifteen, in the carefree atmosphere of the Montmartre studios, she began to pose as a model. Her employers assumed the right to make love to their girls and at eighteen Valadon gave birth to an illegitimate son. 'Father unknown,' the birth certificate stated. Valadon retained the secret of her son's identity and continued her career.

To his credit, it was her neighbour, the aristocratic art student Toulouse-Lautrec, who first discovered Valadon's talent. One day he found a sketch of hers, chalked on a scrappy piece of paper. He was astounded by the power and vitality in the drawing and, as soon as she admitted it was hers, pinned up three of her works on his wall and mischievously invited guests to name their author. The enthusiasm of Lautrec and his friends brought Valadon an introduction to the one artist venerated by the avant-garde: Edgar Degas. The elderly bachelor, said to be a misogynist, became Valadon's first buyer. He encouraged her, taught her to etch on his own press and corresponded with her for years. Since no one dared to pretend that the two were lovers, that close friendship rates little attention in the more highly coloured accounts of the Valadon drama.

Through her marriage to a wealthy stockbroker Suzanne Valadon became a member of the bourgeoisie, a respectable married woman for thirteen years. Then she fell wildly in love with a man half her age, abandoned her husband and went back to Montmartre to live among the artists.

In her art, as well as in her life, Valadon ignored the rules. Her strong and sinuous drawings and paintings of nudes – her most powerful work – aroused the antagonism of critics by breaking with centuries of tradition. Instead of painting idealised or erotic images of naked women, Valadon depicted ordinary working women without their clothes, awkward, scrawny adolescents or fleshy girls. Reflecting her own experience as a model, she portrayed the tensions and imperfections of the flesh so explicitly that there is no trace of titillation in her work.

Meanwhile her son, Maurice Utrillo, had begun to paint under Valadon's tuition. Unexpectedly he showed flair and after the First World War the prices of Utrillo's landscapes soared, prompting a crop of stories about the wicked family trio – Suzanne Valadon, her drunken genius of a son and André Utter, the young lover who became her second husband. Before the mid-1920s the only book about her, published in 1922, was a scholarly and appreciative monograph with one brief paragraph on her life. Valadon herself found all personal publicity distasteful: she even discouraged art critics from visiting her home, believing that the private life of the artist was of no concern to the public.

'My dear Maurice,' she wrote to her son in an undated postcard which came to light in 1996, 'my little darling. Just to hug you and tell you that I find [the critic] Vauxcelles's article very good . . . if he had not spoken of me and your closeness to me . . . in my opinion your intimate life is not part of art criticism and does not concern art lovers and is nothing to do with your painting.

How wrong she was. In Paris in the twenties the art market was buoyant, and the more tragic or sensational the painter's life the more prices rose. Stories about Valadon and Utrillo fed into the public hunger to deify the artists and at the same time to drag them through the mud.

Journalists, critics and contemporaries were eager to contribute to the lurid tales of Utrillo's drunken exploits and to point out his mother's role in his downfall. The Montmartre artist Edmond Heuzé, Utrillo's friend, spread the word that Valadon's neglect of her son had caused him to turn to drink. Philippe Jullian claimed that the shock of discovering that his mother had bedded a young friend of his had sent Utrillo reeling. 'Utrillo's martyrdom began when his mother set up house with her favourite model, André Utter,' wrote Jullian. 'Suzanne Valadon found that the easiest thing to do was to shut her son up and make him copy postcards of Montmartre. The wretch, he said, was beaten at home and rewarded at the end of the day with litres of red wine.

Utrillo, too, contributed to the Valadon myth. He wrote of her, in verse and prose, as an impossibly saintly woman, the embodiment of all female virtues. Occasionally he complained that she exploited him and once remarked that she had flirted so outrageously on a visit to Georges Aubry, a collector friend of his, that she had provoked scenes and jealousy and the trio had to leave prematurely.

Suzanne was in her late fifties at the time, still a bohemian and still

Suzanne Valadon ou l'Absolu —

Il faut être dur avec soi -

avoir le but de ma vie — équilibre —
la conscience — se regarder en face.
Ce surplus — cette haine et cet
excès d'amour — il faut le déverser

il ne faut pas mettre la souffrance
dans ses désirs mais on a
tout de même rien sans
souffrir ×

Ça m'a pris si jeune, a
huit ans ça y était — j'écrivais
sur ce que je voyais — j'aurais
voulu atteindre, démonter,
pour garder, les arbres les
jambes — sûrement je devais
demander ça à ceux d'eux
× Aucun livre ne m'a remise
j'avais ? j'étais à bonne école
avec la solitude — cette école
exagère — J'avais une seule
amie une vieille fille de 78 ans

158 355 bis

'Suzanne Valadon ou l'absolu'.
These jottings, scribbled in pencil, reveal a rare glimpse of the artist's inner life.
Her musings include memories of her difficulties as a child, gripped by the need

4

qui savait 7 langues (Félix Roussel
avocat à la cour d'appel)
J'ai été gifflé dans ma couleur
parce que j'ai dit la vérité
La peinture c'est la plus
difficile pour être grand

L'art c'est pour éterniser cette
vie que nous cletestons mais
nous adorons son mystère —
Y amon mettre un acte —
J'adore les lettres —

La musique est l'invention
la plus épatante pour l'homme

j'etais hanté — mon abalot
d'enfant pensait trop —
J'etais un diable j'etais
un garçon —
Le souvenir de la vie
je le peuplais quand j'etais
rentrais —
J'ai peint à 14 ans

356

to sketch the world around her; of her troubled relationships with other people;
and of her lifelong efforts to curb her tempestuous nature and find meaning in a
disjointed existence. Yet her revelations pose as many questions as they answer.

standing out against the fashion. By the mid-1920s the decorative arts were in vogue and stylish young girls with bobbed hair, short skirts and slender figures all the rage. The paintings of Marie Laurencin, delicate and suitably 'feminine', represented the ideal of French taste, and a host of new female painters were producing 'women's art'. Sympathy for a woman painter who insisted that nothing could be too ugly to paint and was careless of her appearance was waning fast. The quarter that Valadon had loved all her life had changed too, become smarter and more expensive, to cater for the transatlantic tourists who came to see 'Paree by Night', tour the night-clubs and drink wine at prices beyond the reach of local artists.

The visitors searched vainly for traces of Montmartre's romantic past. From 1909, when Picasso and Co moved from Montmartre to Montparnasse, the excitement of the modern art scene was to be found in the studios and cafés of the Left Bank. Montmartre traded on its history, as it does today, selling postcards, cheap souvenirs and sex at the foot of the hill, while high up in the crowded Place du Tertre 'artists' offer to immortalise the tourists by painting their portraits in fifteen minutes.

Valadon had grown up in the heady years of the 1870s and 1880s, when memories of the Commune were alive in Montmartre and a working-class girl of spirit and beauty was acclaimed as a heroine. In those days, however, only the privileged daughters of wealthy families could afford to study fine art, since no state education was available. Valadon had to make her own way, impelled by her urgent desire. She grew up as the Impressionists struggled to impose their vision, at the beginning of a great revolution in art. In the streets and cafés she mixed with the painters and poets. She visited the artists in their studios, watched them intently as they worked, listened to their conversations and studied their paintings. Until she was in her thirties she had not visited a museum and had little access to books or magazines with reproductions of works of the past. Montmartre and its artists were, literally, her school and her university.

'The great Valadon', as her admirers called her, figures as the picaresque heroine in a number of sultry novels, but biographical material about her remains sparse, much of it unreliable. The Valadon anecdotes, recalled by painters, writers, critics and hangers-on, are bathed in the glow of memories of their own younger days –

remembered, misremembered, exaggerated or distorted. As a result of the inventions of the press, the deliberate misinformation by friends and acquaintances and even by the artist herself, contradictions and errors cascade through the Valadon story.

In 1947 Geneviève Barrez, who posed for Valadon and wrote her doctoral thesis about her, begged the organisers of a retrospective exhibition, 'Hommage à Suzanne Valadon', held at the Museum of Modern Art in Paris, not to reveal the artist's true age. For some twenty years her birth date was officially regarded as 1867, a vanity Valadon had practised to conceal the fact that she was born two years earlier.

Valadon's own duplicity makes it harder to sift fact from fantasy and discover how much truth lay in the legend. Yet whatever her vices or virtues the sheer quality and volume of her work suggest that she kept her art at the centre of her chaotic existence. Valadon herself wrote: 'The purpose of my life: equilibrium.'

When I began to research this biography, I was forced to cast my net wide to compensate for the scarcity of documentation and reliable sources. I discovered that there was a Valadon faction and a Utrillo faction and I had to try to steer my way between them. As well as trawling the biographies of Valadon's famous friends, it was vital to find out about the lesser-known artists, the minor Impressionists whom she knew.

Acquaintances in France proved unusually helpful. Neither her birthplace, Bessines-sur-Gartempe, in central France, nor her château in the hamlet of Saint-Bernard in the Beaujolais country is accessible by public transport and I had no car with me. But in Limoges a man in a bar, whose in-laws came from Bessines, chivalrously offered to drive me the twenty-odd miles to the house where she was born, then showed me the church where she was baptised and a street named after her. In the library of Villefranche-sur-Saône, north of Lyon, I was fortunate enough to meet the former lawyer's clerk who had been present when Valadon bought her château in 1923. He drove me to Saint-Bernard, took me round the estate and gave me copies of invaluable Valadon documents.

Gradually the trail grew warmer. I became involved in writing about Valadon for a large exhibition held at the Fondation Pierre Gianadda in Martigny in Switzerland in 1996. The curator of the exhibition, Daniel Marchesseau from the Musée d'Art Moderne de la Ville de Paris, guided my steps. I met a doctor who had bought a painting from her as a young

man and a former journalist who had known Valadon in the 1930s when she herself was an art student. Through the great generosity of Madame Jeannette Anderfuhren at Valadon's own gallery, Pétridès, I received copies of unpublished Valadon letters. Eventually I met surviving members of Valadon's family and saw a family tree. At last, for me, Valadon was no myth.

Nevertheless the first fifteen years of the artist's life remain largely undocumented and unknown. To understand the young Valadon, one must look to the streets and the cafés, the newspapers, chronicles and characters of old Montmartre.

At this distance in time, some parts of the Valadon story can never be known. She sometimes stayed with her lovers when she was in her twenties, and precise addresses during that time remain elusive. There are unexplained inconsistencies and tantalising clues that lead to an impasse. It would be a bold biographer who claimed to fathom the whole truth about the elusive artist. But Suzanne Valadon's art is imbued with the spirit of life and truth as she saw it. I have tried to follow the course of that life and of that art.

JUNE ROSE
London
March 1997

1

Mysteries

uzanne Valadon's powerful paintings – her portraits, still lifes, landscapes and especially her nudes – suggest a forceful personality at work. The artist gloried in strong colours, dramatic contrasts and sensuous subjects; her untutored art sprang from personal instinct and inspiration. Although she lived through an extraordinary period of innovation in France, moving among Impressionists, Cubists, Fauves and Surrealists, and absorbed influences from her contemporaries, Suzanne Valadon remained original and fiercely independent in her work. Earthy, plebeian models were to her taste, and she painted them with passion and violence, tempered by acute observation. Through her vibrant paintings, and the drawings that so delighted Degas, Valadon learned to distil and discipline her own unruly temperament.

The mainspring of creation is always a mystery, but with Suzanne Valadon one can trace the overlap between art and life. In contrast to the bold contours that define her work, the outline of the artist's early years appears shadowy and blurred. Until she burst into the model market of Montmartre in 1880 at the age of fifteen as a beauty, she was of no particular interest to the art world, an illegitimate country girl growing up in Paris. No personal correspondence from her youth appears to have survived; at the time no one would have thought that her letters were worth keeping.

To this day it proves difficult to disentangle the bare facts of her early existence. The catalogue of the first major Valadon exhibition for thirty years, in 1996, contains two different accounts of her infancy.[1] Yet the register of births at Bessines-sur-Gartempe, a small town twenty miles north of Limoges in central France, records the undisputed facts of her origins.

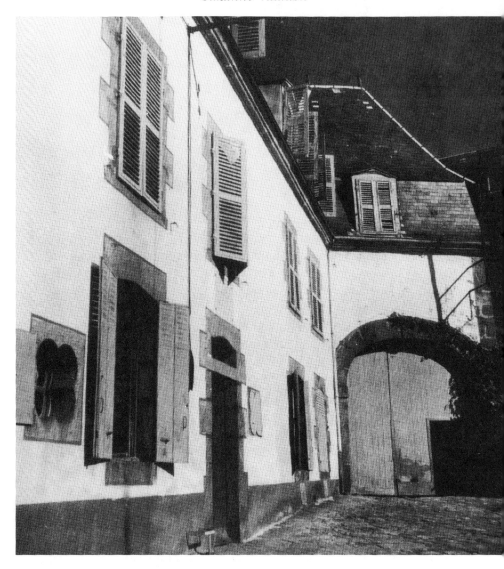

The inn where Suzanne Valadon was born.
Her mother served as a sewing maid in
the solid, unpretentious building.

In the year eighteen hundred and sixty-five, on the twenty-third of September at four o'clock in the evening, we, Pierre Paul Émile Dumonteil, Mayor acting as Registrar in the commune of Bessines, chief town of the canton, arrondissement of Bellac in the department of Haute-Vienne, received the visit of François Peignaud, blacksmith, aged thirty-eight, residing in the town of Bessines, who presented to us a child of the female sex, born that same day at six o'clock in the morning in the house of Madame Guimbaud, widow, to Madeleine Valadon, sewing maid, aged thirty-four, and to an unknown father . . . and to whom he stated he wished to give the first name Marie-Clémentine. The foregoing declaration and presentation of the child were witnessed by the innkeeper, Clément Dony, aged forty-four, and another blacksmith, Armand Chazeaud, and were signed by all present.[2]

In her passport issued in 1931 when she was sixty-six, Marie-Clémentine has become Suzanne Valadon, a professional name assumed early in her career. The artist has also altered her year of birth from 1865 to 1867.[3]

The inn in which she was born, the Auberge Guimbaud, still stands: a long, low, two-storey, shuttered granite villa, solid and unpretentious on the hill of Bessines-sur-Gartempe. In 1949 at a posthumous ceremony in her honour, a plaque was placed on the building and a street named after her.

When she was a small child, Marie-Clémentine's very existence was regarded as a disgrace, and the artist never returned to her native town.[4] For a fatherless girl born to a sewing maid in the mid-nineteenth century the prospects were bleak. Fortunately relatives in the close-knit community in Bessines rallied to help mother and child.[5] François Peignaud and Clément Dony, the men who had registered the baby's birth at the town hall, were Madeleine Valadon's second cousins. A more important source of assistance was her grandfather's cousin, a Madame Catherine le Cugy, known as the widow Guimbaud, who kept the local inn. The widow had employed Madeleine Valadon six years earlier, and when the baby was born she stood by her. Not that the arrangement was pure charity. Madeleine worked hard at the inn in charge of the laundry, washing, ironing and mending all the bed-, bath- and table-linen. Her duties were heavy: loading sheets, pillow-cases, bolster-cases, towels and tablecloths into huge tubs; pouring a boiling solution of wood cinders on to the soiled linen to cleanse it; carting the laundry to a nearby stream to rinse it; then sorting and mending when necessary.

In recognition both of her years of hard work and of her kinship, Madame Guimbaud helped Madeleine during her pregnancy. Her newborn baby was wrapped in diapers and swaddling clothes, according to local custom, and laid in the Guimbaud family cradle.[6] As soon as she could, Madeleine went back to work. Little Marie-Clémentine was handed over to her grandmother, Marie Dony, who looked after the child for eighteen months. When the old lady died the infant was shunted off for three years to yet another of the clan, Madeleine's cousins who lived in the nearby village of Mas Barbu, her late husband's birthplace.

Madeleine Valadon, thirty-four at the time of her daughter's birth, had been extremely unlucky in her men. Born on 6 October 1830, she had been a respectable woman who at the age of eighteen had married Léger Coulaud, a blacksmith, mechanic and locksmith thirteen years her senior. The couple had two children, a son named after his father who died in infancy and a daughter, Marie-Alix, Valadon's half-sister, born in 1852 when her mother was twenty-two.

In the little town of Bessines, blacksmiths played an important part in local life. They not only repaired the shoes of the horses and the men, but also mended farm implements and machinery; some even helped with the maintenance of farm buildings. In this region of granite hills, chestnut trees and arid soil, the living was poor, and payment to Coulaud sometimes took the form of potatoes or the abundant chestnuts. Léger Coulaud, fired with the ambition to better himself and his family, struck up a friendship with an older, wealthier neighbour. Pierre-Louis Planchon was a watchmaker and jeweller, and for years the two men experimented in minting false coinage.

One evening in the autumn of 1856 they were supping together at an inn a few miles from Bessines after an outing to a local fair. Coulaud took out a forty-franc gold coin to pay their bill and asked for change. At that time forty francs was a large amount of money and the landlord's wife grew suspicious. After they had left the inn she informed the police, who arrested both men and searched their houses for evidence. In February 1857 Coulaud was tried and sentenced to hard labour for life, for what was considered an extremely serious offence.

The affair, of course, caused a great scandal in Bessines. The Limoges newspaper reported the trial in detail.[7] The wretched Coulaud was tipped into a cart by armed guards and sent off to a penal colony in

French Guyana, while his better-off partner was able to afford to appeal against the sentence.

Two years later in 1859 Léger Coulaud died in prison. Madeleine must have found the blame and condemnation of the neighbours and the sympathy of her husband's friends hard to bear. She was not yet thirty, with a six-year-old daughter to support; still 'fetchingly pretty',[8] she had a string of admirers among the locals and visitors to the inn. Despite warnings from the widow Guimbaud and her helper, the widow Betout, Madeleine fell pregnant.

To this day the identity of Marie-Clémentine's father remains unknown. Local people gossiped about a neighbour of hers, a Don Juan; some said a miller. In old age, according to one account, Madeleine admitted to having been 'seduced on a very cold day in January' by a miller.[9] When a millstone fell on her seducer and crushed him to death, Madeleine felt that he had received his just deserts! In another mood she might say that her lover was a construction engineer who fell from a bridge and was drowned in a swift river.[10] The notion that after her husband's disgrace and death Madeleine went to work in an inn in a neighbouring village, Saint-Sulpice-Laurière, was current for years. Her lover was believed to have been an engineer from Paris, working on the new Paris–Toulouse line, completed in 1865, the year of the baby's birth.[11] None of these stories can be verified but the local Bessines archivist is convinced that Madeleine was working at the Auberge Guimbaud until after the baby was born, and her version seems the most credible.

Marie-Clémentine never knew her father and grew up accustomed to regard women as the strong and dominant sex and men as weaker and less predictable. In her paintings years later her unconventional view of the role of the sexes is strikingly reflected.

Madeleine Coulaud showed her independence by reverting to her maiden name when her husband died, but in the years immediately after Marie-Clémentine's birth she grew moody and depressed. Two men, her husband and her errant lover, had let her down badly and 'she may have sought solace in drink'.[12] In her later life she was certainly fond of the bottle.

In the mid-nineteenth century the Limousin countryside was deeply traditional; local customs revolved around the cycle of births, marriages and deaths. The plight of the disgraced widow, now with a child born

out of wedlock, must have been chewed over endlessly in the long winter nights. Madeleine at least had the satisfaction of knowing that her tiny daughter, safe with relatives, was warm and well fed. Where her elder daughter, Marie-Alix, lived is not known; her name rarely crops up in accounts of Marie-Clémentine's childhood. Madeleine worked hard at the laundry and remained taciturn, yet she suffered from the boredom and the blame of the small community and the scoldings from the two older women who ran the inn. As Marie-Clémentine grew from babyhood to become the slight but sturdy little girl that her later development suggests, Madeleine began to dream of escape.

The new railway system offered the lower classes the freedom to travel far from the inhospitable Limousin countryside. Many artisans from the Limoges district – bricklayers, stonemasons, carpenters – had been tempted by the news of work in the expanding capital, and the exodus from the country was growing. When travellers came home to Bessines for Christmas or other family gatherings, they told stories of the wonders of Paris: the new broad streets lit by gaslight; the tall buildings; the pavement cafés; the variety of horse-drawn carriages and the elegantly dressed men and women.

Madeleine convinced herself she would make a better living in Paris. Through relatives she discovered that she had an aunt on the Ile Saint-Louis working as a milliner who agreed to take in her little family for a time. Then, with a courage which her daughter was to inherit, she left the safety of her home town, one day in 1869 or 1870, to travel the 250 miles to Paris.[13] Madeleine herself was nearly forty when she made the journey; Marie-Alix was seventeen or eighteen and Marie-Clémentine was a child of four or five. The family did not stay long with Madeleine's aunt, Marie-Anne Valadon, and no further mention of this relative has been found. Madeleine decided to move to Montmartre, a move which was to transform Marie-Clémentine's life.

No doubt it was the cheap rents of the largely working-class district north of Paris that first attracted Madeleine; but in the mid-nineteenth century Montmartre still retained the air of a village. Although it was only half an hour's walk down to the *grands boulevards*, the air up on the hill was cleaner, and there were two windmills, gardens and stray farm animals. From the top of the hill, as yet uncluttered by the edifice of Sacré-Cœur, one could see the entire city below, yet still escape from the press of traffic in the streets, the crowds and the noise. Horse-drawn

omnibuses did not venture up the steep slopes; cabbies had to be bribed with a generous tip to manœuvre their vehicles up the cobbled streets. Few people were to be seen, there were no police about in the lanes, and the little shops selling groceries smelt of the country. The potent wine from the straggling vineyards was affordable too.

On the lower slopes at the foot of the hill, Montmartre had already acquired a reputation as the cheapest and most daring pleasure centre of Paris. Local toughs, working girls and domestic servants with an eye for opportunities roamed the streets and haunted the cafés and bistros. Standing in the shadows behind the rows of gas-lamps, the sinister figures of pimps and madames could be glimpsed watching the prostitutes as they paraded up and down.

Madeleine Valadon found cheap lodgings in one of the new tenement buildings in the Boulevard Rochechouart, one of the liveliest streets in the district. In contrast to the silent country lanes around Bessines, Madeleine now saw men and women strolling along the streets, peering into the open stalls and shops or visiting the cafés at all hours. The clatter of horse-drawn trams and carriages never seemed to stop. Two popular dance-halls with gaming-rooms, La Boule Noir and L'Élysée Montmartre, opened their doors at five o'clock in the evening. Visitors of all classes came there to amuse themselves, and the dancers performed quadrilles with great abandon. It was in the Boulevard Rochechouart, to the music of *Orpheus in the Underworld,* that the French cancan was born. Ironically the Boulevard Rochechouart was named in memory of a pious Mother Superior of the Benedictine convent at the top of the hill of the 'Mount of Martyrs'.

The village of Montmartre, so intimately linked with Valadon's career as an artist, had an early history as uncertain and scandalous as her own. Before Christianity came to France the Druids of Gaul had celebrated their rites high on the hilltop. Later the Romans built temples to Mars and Mercury there. A certain Denis or Denys was sent as a missionary to convert Gaul to Christianity but was beheaded for his faith. Decapitated but unbowed, the martyr picked up his head and washed it, then walked on to the next village, Saint Denis, where he found a pious woman willing to bury him. A church was built on his burial ground and all the Kings of France are interred in the Abbey of Saint-Denis. Pilgrims visited the cave on the hill of Montmartre where the saint was executed. By the twelfth century a large abbey had been erected on the

heights. A Benedictine order of nuns known as the Abbesses or Ladies of Montmartre presided over the life of the village. They owned the buildings and lands including the vineyards and the famous windmills on the ridge. On saints' days and at fairs, pilgrims flocked to the heights; soon the Ladies of Montmartre gained a reputation for levity. In the seventeenth century, soldiers billeted themselves on the abbey, with predictable consequences. Taverns, gaming-houses and brothels sprang up all over the holy hill, exploiting the past with their inn signs: 'The Arms of the Abbess' and 'The Image of Saint Anne'.

Later still, the gypsum quarries on the south side, which provided the plaster for Paris, gave shelter to drunks stumbling home and ruffians on the run from the police. Eventually crime of every kind including murder became commonplace, until ordinary citizens began to fear the place. The French Revolution ended the rule of the Abbesses and destroyed the abbey; by the middle of the nineteenth century Montmartre was respectable again, separated from Paris by a wall, and a toll had to be paid to enter the capital. This made wine cheaper in the village and encouraged the growth of working-class cafés and dance-halls.

Ten years before Madeleine and Marie-Clémentine Valadon arrived in Paris, however, Montmartre was annexed by the city and became the eighteenth arrondissement of Paris. But the village clung on to its independence. Painters, writers and musicians gravitated towards Montmartre, attracted by the sweeping views of the city below, the northern light, the legend, the ruins and an indefinable atmosphere of wit and gaiety. In 1843 the poet Alfred de Musset had written a short story set in Montmartre, 'Mimi Pinson', and for the artists and writers who lived there his heroine became a symbol of romance. Mimi Pinson, like her namesake in *La Bohème,* lived in a garret, filled her window with flowers and gave her favours to her student friends, all for love. A house on the hill was named after her and Mimi Pinson's cottage was later painted by Maurice Utrillo. Writers and painters had begun to express in their work a new sympathy with the lower classes, dismissed in the past as comic and ignorant. In Montmartre the very air seemed freer, the men and women more independent; the possibility of social as well as sexual congress with the girls who worked long hours in milliners' shops, the laundresses and the maidservants, seemed exciting and unpredictable.

For the future Suzanne Valadon, the importance of a new attitude to women, the new realism in art and the beginnings of social mobility can hardly be exaggerated. Although she was poor and fatherless, she was in her rightful place in Montmartre. For her mother, however, the move to Paris had proved disappointing. With examples of the fine sewing for which she was renowned in Bessines, she had hoped to find work in the burgeoning fashion industry in the capital. The milliners' shops and the couture workshops understandably preferred to employ pretty young girls, whose presence was good for business. Madeleine did not know how to approach the affluent families that could afford work of the quality she produced. In desperation she took a job cleaning and scrubbing offices to support herself and her daughter. Often Marie-Clémentine was left with the concierge promising to keep an eye on her.

Many of the working people of Montmartre were newcomers too, evicted from their homes in central Paris by redevelopment. In 1856 Baron Eugène-Georges Haussmann had begun the process of ruthlessly modernising the medieval city, razing the winding alleys and narrow streets of the slums and tearing down ancient churches and chapels to create the *grands boulevards* of today. 'Paris was slashed with sabre cuts and disappeared in a cloud of smoke,' wrote Émile Zola. Haussmann's reforms, designed to create an elegant city, improve health and root out crime, had dispossessed large numbers of the lower classes: 20,000 houses were demolished in the centre of Paris and 40,000 new houses built at an exorbitant cost.[14] In the process of demolition tens of thousands of workers were evicted peremptorily from their lodgings. They could not afford to live in Haussmann's new multi-storey buildings where rents had doubled. Forced out of the heart of the city, the workers moved to the fringes of Paris, to live in slum buildings often as insalubrious as the dwellings that Haussmann had pulled down.

Montmartre, fortunately, was spared Baron Haussmann's attentions. The old houses with rambling gardens and outbuildings offered great possibilities to the artists, who converted the stables, barns and wooden sheds into studios with large windows. Now art students and young painters began to move from the Latin Quarter to look for lodgings in Montmartre. Up on the heights they felt geographically and spiritually removed from the Academy of Art and the deadening art establishment; unlike most villages, Montmartre had style and a shrewd cynicism. Certain cafés became known as artists' haunts where the talk was of

painting, poetry, music. Art was all; the girls and hangers-on as well as the aspiring artists flaunted their disdain for conventional morals, manners and, particularly, the government's heavy-handed censorship of artistic expression.

In an age before cinema and television, Napoleon III and his ministers valued their painters and sculptors. After the inauguration of the Second Empire in 1852, leading artists were required by the court to glorify the emperor and raise the tone of public life by depicting scenes of great victories in battle or noble tales of Christian or classical origin. A painting was judged largely by its intellectual content, its edifying effect, and great emphasis was placed on the 'perfect finish' of the work. Nudes shown in a suitably uplifting context, but as titillating as possible, were popular. At a time when the press was rigorously censored and writers exiled or subjected to petty prosecution, works of art were scrutinised for potentially subversive qualities. Through the person of the Director-General of Museums and Superintendent of Fine Arts, Count Émilien de Nieuwerkerke, the establishment exercised a covert censorship over artists' work. Count Nieuwerkerke was virtually an artistic dictator: he personally supervised the Académie des Beaux-Arts and also presided over the jury at the annual Salon, the huge official 'art shop'. The young realist painters, more interested in reflecting the modern world than conforming to the jury's expectations, suffered rebuffs, while those who were willing to please, gifted artists among them, won gold medals and fat commissions to decorate palaces and public buildings.

By 1863 the despotic system had led to rebellion. Some 2,000 paintings and a thousand sculptures were rejected by the Salon that spring. Perturbed by the number of complaints he had received, the emperor decided to view the rejected work himself. After a visit to the Palais de l'Industrie – built to show the world the glories of the Second Empire at the 1855 World Fair (Exposition Universelle), where the Salons had since been held – he made a sensational announcement. The emperor decreed that artists refused by the Salon jury should be allotted seven spare rooms in the Palais de l'Industrie to show their works to the public; then the people could judge for themselves. Some of the most eminent painters of the nineteenth century accepted the imperial invitation. Paul Cézanne, Camille Pissarro, James McNeill Whistler and Édouard Manet, all rejects, exhibited their work at the Salon des

Refusés. The exhibition attracted a record number of visitors intrigued by the publicity. Fashionable society, egged on by the press, came to mock, to stare at the unusual works in horror and titter or hoot with laughter.

Manet's large painting, *Le Déjeuner sur l'herbe*, drew the most fire; the emperor himself denounced it as 'immodest'. The painter depicted four young people enjoying a picnic in the open air, the two girls naked, the men young dandies fully dressed. It was not the nudity but the realistic treatment that shocked the public. 'Yes, there they are under the trees, the principal lady entirely undressed . . . another female in a chemise coming out of a little stream that runs hard by and two Frenchmen in wide-awakes sitting on the very green grass with a stupid look of bliss. There are other pictures of the same class which lead to the inference that the nude, when painted by vulgar men, is inevitably indecent,' blustered P. G. Hamerton, the English critic from the *Fine Arts Quarterly Review*.[15] Picasso greatly admired Manet's masterpiece, on which he based a painting of a (fully clad) family, *The Soler Family* (1903). In 1911, when she was forty-six, Suzanne Valadon painted an open-air scene, *La Joie de vivre*, which suggests that she too had studied Manet's work.

The courage that the revolutionary painters showed in defying both public and official opinion gradually undermined the standards of the official Salon and eased the way for independent artists in the future. A quarter of a century earlier a small group of half-starving painters, led by Théodore Rousseau and Jean François Millet, had made a stand against the Salon. They had lived on the edge of the forest of Fontainebleau in the small village of Barbizon and painted scenes of the forest and of peasant life, devoting themselves to a pure study of nature and ignoring the demand for landscape as a setting for grandiose tableaux from history or mythology. Year after year their work was refused by the Salon, pronounced decadent and subversive: 'This is the painting of democrats,' Count Nieuwerkerke remarked haughtily, 'of those who don't change their linen, who want to put themselves over on men of the world: this art displeases and disgusts me.'[16] The poetic landscapes and studies of rural life were dismissed, their bearded authors feared and hated, suspected of being political revolutionaries as well as artistic rebels.

In the case of their contemporary, Gustave Courbet, the fears were justified. Courbet's grandfather had been an ardent revolutionary and

his grandson was a socialist who produced powerful paintings of peasant life – in the inn, the studio and the fields – which were considered scandalous. With an unsentimental eye he painted poachers, nude models and boozy working girls. At the World Fair in 1855 the jury rejected some of his major works, so Courbet defiantly exhibited his own 'ugly' paintings in a shed he paid for himself, close to the grandiose Palais de l'Industrie. His realism and his insistence on painting the truth as he saw it cleared the way for the vision of Suzanne Valadon. 'I grew up among giants,' she was to say years later.[17]

Marie-Clémentine had arrived in Paris in the closing phase of Napoleon III's flamboyant reign. The nephew of Napoleon Bonaparte was keen to reinstate France as a great power and to restore *la gloire*. In Valadon's world of the slums only innuendo and echoes filtered down from the last of the glittering masked balls in the Tuileries in 1869, where guests waltzed to the music of Johann Strauss and the emperor and his court paraded their bejewelled mistresses. Paris in the Second Empire was obsessed by pleasure; and thousands of prostitutes – from the *grandes horizontales*, the spoilt darlings of the dandies, to the *comédiennes*, who were semi-amateur, the *lorettes*, the grisettes and the *cocodettes* – catered for every stratum of society. Those high-class gossips, the Goncourt brothers, wrote the inside story of the emperor's couplings: 'Each new woman is taken to the Tuileries in a cab, undressed in an ante-room and taken naked into the room where the Emperor, likewise naked, is waiting for her by Bacciochi [presumably a courtier] who gives her this warning . . . "You may kiss His Majesty anywhere except on the face."'[18]

As well as having a vast sexual appetite and a taste for gorgeous spectacle, Napoleon III was ambitious to improve the condition of his people. He initiated schemes to establish workers' cities and had homes for injured workers and centres for maternal welfare built. In the early years of his rule the economy grew, industrial production doubled and foreign trade increased. Great banking concerns, such as Crédit Lyonnais, were established; and Bon Marché and other department stores were constructed. With prosperity, however, speculation raged and the wealthy new bourgeoisie benefited at the expense of the workers, whose wages remained depressed. As a result, relations between the classes became increasingly bitter. The poor of Montmartre and other working-class areas were constantly in debt. Many survived only

by frequent visits to the pawnshop, where family mattresses were regularly pledged to stave off hunger.

By the end of Napoleon's reign, world economic conditions had deteriorated and the emperor's quest for *la gloire* had failed. A series of costly foreign adventures had all ended in disaster. By 1870 the ageing and ailing emperor, who suffered from a large stone in his bladder, was out of luck and out of favour. In latter years he had tried to placate the intellectuals and the working class by reforming the laws on press censorship and allowing the workers the right to assembly. It was all too late. The press attacked him mercilessly and the republican clubs that sprang up plotted sedition. The people wanted their liberty and their republic.

Napoleon, envious and alarmed at Prussia's growing power under Bismarck, was dismayed when Prussia advanced a minor German prince as candidate to the vacant Spanish throne. Although the claimant backed down, Napoleon rashly demanded further guarantees for the future. Public opinion on both sides was inflamed and Napoleon declared war precipitately, with an army that was unprepared and undermanned. The French welcomed the conflict with their old enemy in a ferment of patriotism. Crowds waved flags and cheered in the streets. But the Prussian army, well organised, highly trained and equipped with modern weaponry, was soon routing the French. Throughout the summer German artillery continued to pound the French army and thousands of Frenchmen in brilliant uniforms, bright-red trousers and plumed shakos, were slaughtered on the battlefields. Six weeks after war was declared came the devastating news that the Prussians had broken the French line at Sedan and the emperor himself, taken prisoner, had surrendered to the Prussians.

The fury and humiliation of the French people turned on the regime and republicans thronged the streets in protest. Two days later the Third Republic was proclaimed, charged with the impossible task of winning a war that was already lost. In Montmartre the people greeted the new regime with scenes of wild enthusiasm. At last, the workers believed, they would regain their liberty and their revolutionary ideals.

At the time of these great events a mystery surrounds Marie-Clémentine's whereabouts. The first book written about her during her lifetime and approved by Valadon includes a mention of a brief stay in Nantes when she was a child.[19] Early in 1870 her half-sister Marie-Alix

had married a well-to-do market gardener and moved out of Paris to the coastal town in western France. According to her niece's account, Marie-Clémentine visited Nantes 'about 1870' and stayed there for some years.[20] Since the niece, Marie-Lucienne (later Marie Coca), had not been born when her aunt came to Nantes and told the story sixty years later, she cannot be relied upon completely. On the other hand, Valadon herself was selective in her regard for the truth. With the outbreak of war in July 1870, it would seem natural for Madeleine to have asked Marie-Alix to give shelter to her younger sister from the dangers of Paris. By the age of four, Marie-Clémentine had learned to run about the streets by herself, but she was devoted to her mother, and the parting from her, the third in her short life, must have been painful. As for Marie-Alix's husband, Georges Merlet, he can hardly have been delighted to welcome a small bastard into his new home. Illegitimacy was regarded as an appalling stigma in those days, and, as if to confirm the prejudice against her, Marie-Clémentine behaved badly. She was, she confessed herself, a wilful child,[21] and she probably offended the citizens of Nantes with her tomboy ways. She preferred boys to girls, ran about barefoot and revelled in dirt. 'Water is for washing pigs,' she bawled.[22] Marie Coca, who was fond of her aunt, concluded that Valadon must have been a dreadful little girl, 'épouvantable', and that it was probably Georges Merlet, a short-tempered man, who decided to pack her off back to her mother in Paris.[23] For a child to be rejected so young, particularly a child as acutely aware as Marie-Clémentine, it must have been distressing. Instead of crushing her, though, it made her more defiant than ever.

Marie-Clémentine was almost certainly still in Nantes when the siege of Paris began in September 1870. Madeleine, however, suffered with her neighbours in Montmartre, existing on bread, potatoes and coffee as prices rose and food grew scarcer. The winter was severe and by then even the upper class dined out on horse and donkey. Around Christmas the public's favourite animals from the Zoo, Castor and Pollux, two young elephants, turned up as carcasses at Roos, the English butcher in the Boulevard Haussmann.[24]

The defeated French signed an armistice in January 1871. In the capital the news was greeted with a mixture of anger, shame and relief. Traces of war remained everywhere: shops kept their shutters up for most of the day; food was still very scarce; and in Valadon's own street, the Boulevard Rochechouart, the dance-hall, L'Élysée Montmartre,

remained silent. During the war L'Élysée had been converted into a factory for manufacturing balloons, the only means of escaping from the embattled city – used to spectacular effect when the left-wing Minister of the Interior, Léon Gambetta, sailed out of Paris on 7 October 1870, to rally the masses in the provinces. A 'balloon post' kept communications open during the war.

The avant-garde artists of Montmartre, colleagues who met regularly at the Café Guerbois, had responded in different ways to the war. Auguste Renoir, who had been trained to paint on porcelain, was sent to Bordeaux with his regiment and later to the Pyrenees, where he found himself training horses. Claude Monet, who had married in June, left his wife and child in Le Havre and sailed to England in a desperate attempt to earn money by selling some paintings. Camille Pissarro took refuge with his half-sister in London. Paul Cézanne went to live with his mistress, Hortense Fiquet, at L'Estaque on the Mediterranean, hiding the liaison from his father and avoiding the patriotic fervour of his home town of Aix-en-Provence. The two upper-class members of the

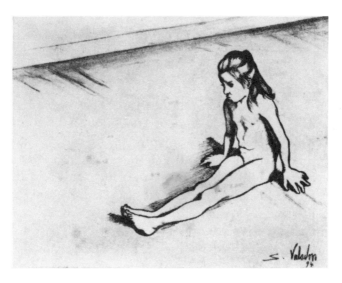

Little girl Nude, Seated on the Floor, 1894.
The artist Camille Pissarro bought this striking drawing by Valadon. The image evokes her own description of herself as a perverse child:
'I was a devil, I was a boy.'

group of realist painters, Edgar Degas and Édouard Manet, both gained commissions in the National Guard because of their social standing. Degas enlisted in the infantry but was transferred to the artillery because of poor sight in his right eye. The painter Berthe Morisot, who married Manet's brother three years later, quipped that Manet, always the dandy, 'spent the siege changing uniforms'. After the surrender Manet went to join his family, whom he had sent for safety to the south of France, while Degas remained in Paris until March, 'the same as ever, a little crazy, but charming and witty'.[25]

For the artists who had rallied during the war, the conflict was over; but in the left-wing battalions of the National Guard the mood remained defiant. After the armistice in January, National Guardsmen swept down on central Paris to capture 'their' guns before the enemy could confiscate them. The people felt they owned the weaponry, since many guns had been bought by national subscription. A large delegation from Montmartre hauled some 200 guns heroically up the narrow lanes to the heights of Montmartre and parked them beside an old windmill used as a dance-hall, the Moulin de la Galette, with sentries posted beside them.

On 1 March 1871 German troops goose-stepped through Paris in a triumphal victory parade. Shops remained closed in the sullen, silent city, their windows draped in black 'in mourning for Paris'; the sense of humiliation was profound. Afterwards, Parisians set to purging the streets of the enemy presence, scrubbing them clean and lighting bonfires.

The situation was explosive. Adolphe Thiers, the chief executive of the new republic, ordered the regular army to retrieve the guns from Montmartre by stealth. At four in the morning of 18 March two brigades of soldiers marched silently through the Boulevard de Clichy and Boulevard Rochechouart. Some stayed to guard the streets, others marched up to the hill, overpowered the sentries and commandeered the guns. In an hour it was all over. But there was one drawback: the army had forgotten to order the teams of horses needed to tow away their booty. By dawn a woman soldier of the National Guard, schoolteacher, revolutionary and poet, Louise Michel, managed to escape. She rushed down the hill, her gun slung on her shoulder, shouting 'Treason!' The Montmartre Vigilance Committee beat the drums to rouse supporters and before long the streets were impassable, thronged with National Guards and women and children. The women of Montmartre were

furious and voluble. 'If they had only let us guard the guns,' said one woman, 'they would not have been captured so easily.' The women offered the soldiers of the line bread and wine as they remonstrated with them. 'Where are you going to take the cannons? Berlin?' they taunted. Many of the regular soldiers defected and refused to fire on the workers of Montmartre. The streets were blocked all day and the mob captured and killed two generals in the mêlée.

The government retreated hastily to Versailles and the capital defiantly held its own elections. On 26 March the Commune of Paris was proclaimed, empowered to govern the capital on a municipal basis.

The Communards' plans for reforming and improving the lot of the workers were wide-ranging and ambitious. The role of the women who had backed the Commune so passionately was acknowledged and an all-female commission on education for girls was set up at a time when only one child in three enjoyed the benefit of any formal education. The forward-looking Communards also discussed nursery education for the children of women factory hands. But before the new Commune, hampered by internal division, could implement a programme of social reform and organise an efficient armed force, the national government in Versailles was planning its destruction.

Within a month the regular army was attacking the National Guard and inflicting defeats. The Montmartrois had a fierce sense of loyalty to their quarter and defended it with passion. 'We were a little more alive then,' wrote Louise Michel, 'with the joy of feeling in our element in the midst of an intense struggle for freedom.'[26] On 21 May army troops marched on Paris, taking both sides of the river and advancing on the Hôtel de Ville, the Commune's headquarters. The National Guard fought them from one cobblestone barricade to the next, in desperate, if ill-organised, resistance. Urged on by hysterical crowds, the rebels shot down monks and policemen and set alight the symbols of Napoleon III's power – the Tuileries Palace, the Palais-Royal, the Royal Mint and the Hôtel de Ville. The Luxembourg and the Louvre were badly damaged. The regular army shot men, women and children in wholesale slaughter. In the course of that 'bloody week' some 20,000 Communards were killed, while the regular army lost a thousand men.

The Commune lasted only two months, but the spirit of revolt, and the legends and memories of the heroism and the terror, lingered for years. More than ever Montmartre became the symbol of freedom and

revolution in France and beyond. The interlude had a profound effect on the people of the village. Whether or not Marie-Clémentine was there at the time, she heard stories of the bloodshed and the glory all through her childhood. They fed into the craving for drama and excitement in her temperament and she never lost the fiery spirit of rebellion. A century later Valadon was described by a Swedish writer as 'the last fighter of Montmartre'.[27]

After the war the gulf between the artists of Montmartre and the bourgeoisie grew wider. Gustave Courbet, the dedicated revolutionary, had been the most active of the artists. During the Commune he had been elected as representative of the people and appointed president of a General Assembly of Artists. He abolished the Académie des Beaux-Arts and the system of awarding medals and commissions at the Salon. The Vendôme Column with its statue of Napoleon I on top was regarded by the Communards as an intolerable reminder of Bonapartism and militarism and in May the column was toppled and destroyed, to the cheers of the crowd. When the Commune was defeated, Courbet, in his early fifties, was arrested and charged with complicity in the destruction of monuments. He was sentenced to six months' imprisonment and ordered to pay 250,000 francs towards the reconstruction of the Vendôme Column. To escape the crippling fine, Courbet fled to Switzerland, where he died in 1877. The official artists now reinstated remained profoundly suspicious of artistic rebels, and their prejudice against the anti-Bonapartist Courbet extended to the Impressionists.

The war had interrupted the café life of Montmartre, but by the close of 1871 all the progressive artists of Montmartre had begun to meet again at the Café Guerbois, No. 11 Rue des Batignolles, a haunt of theirs since 1866. The Boulevard Rochechouart abutted the Rue des Batignolles (now the Boulevard Clichy), and as a small girl buzzing around the streets Marie-Clémentine Valadon must have peered through the café windows at the bearded men in frock-coats talking and gesticulating over mugs of coffee or beer. The group later to be tagged the 'Impressionists' met there every Thursday evening. Manet, who came from a wealthy family, had tables near the front door permanently reserved for himself and his friends. The Empire-style café, all white and gold with red banquettes and gilt gas-lamps, served as an informal club for those united in their disgust with the fashionable and stereotyped art of the Salon and determined, as Manet put it, 'to be themselves'. The

artists who straggled in when the light had gone were neither very young nor obviously bohemian – all men in their late twenties or thirties. 'All these people are *salauds*,' Paul Cézanne grumbled. 'They are as well dressed as notaries.'[28] Among the group that included Degas, Manet, Monet, Pissarro and Renoir, Cézanne alone refused to conform to bourgeois dress. He was only in Paris for half the year and he came in looking deliberately unkempt, with a battered black hat, a long coat buttoned to his boots and baggy trousers. Cézanne, who was a boyhood friend of another regular, Émile Zola, would sit in a corner listening suspiciously and saying little. If he disagreed with the opinions expressed he would get up abruptly and leave. Cézanne reserved his particular scorn for Manet, who always appeared impeccably dressed with silver-topped cane, doeskin gloves and a silk topper. On one occasion, after shaking hands all round, Cézanne refused to offer his hand to the man-about-town: 'I haven't washed for a week, Monsieur Manet,' he growled, 'so I am not going to offer you my hand!'[29] There were inevitably more profound disagreements among men with such disparate backgrounds and pictorial styles. Nevertheless the painters and those writers who championed their cause in the press found the meetings at the Café Guerbois stimulating and encouraging.

The group gave vent to their feelings at the success and high prices gained by academic painters but they also discussed their methods (which were disliked almost as much as their subjects), the new colours made from synthetic pigments and the availability of ready-made paints in tubes which made it so much easier to paint out of doors and to work with a wider range of colours. Now they could apply the paint directly on to their palette or canvas, rather than grinding the pigments into powder and mixing them in a medium before the paint could be used. They discussed the difficulties of painting shadows and light. The main topic, however, was the argument over painting *en plein air*, out of doors. These serious and differing artists were united in one respect: despite every discouragement they intended to represent the modern, everyday world as they perceived it. Their interest was in painting barmaids and boating parties, railway stations and inns, rather than grandiose scenes of dead emperors or Greek nymphs bathing in a grove. Since they needed the chance to show the public their canvases and to sell their work, they also argued about the best way of breaking into the Salon.

All of them, with the exception of Cézanne, had had at least one painting accepted. Some of the group favoured sending in their tamest work to please the jury. Not Cézanne. He advocated sending in the most 'offensive' work to the Salon and his paintings were never accepted by the official body.

In December 1873, when Marie-Clémentine had turned eight, Claude Monet proposed that the friends who met at the Guerbois show their paintings in a special group exhibition. Degas, more canny, insisted that some painters who were admired by the Salon should be included so that the exhibition was not considered too radical. Ironically Édouard Manet had scored a great success at the Salon with his painting of the engraver Bellot drinking a 'Bon Bock' at the Café Guerbois. He felt that his colleagues had deserted him and refused to join in the rebels' plans. In December 1873 a joint-stock company was formed, with Monet, Renoir, Degas, Pissarro, Alfred Sisley and Berthe Morisot among its founder members. Propriety did not permit Berthe Morisot, a gifted open-air painter, to sit with the men in the café. In terms of official acceptance she was the most successful among them, her work having already been exhibited nine times at the Salon. Courageously she agreed not to submit any work to the Salon of 1874 in spite of Manet, soon to be her brother-in-law.

The modern painters deliberately chose to open in April two weeks before the official Salon. Among the exhibitors were Cézanne, Degas, Renoir, Monet and Morisot. Their glorious landscapes, so familiar today, met with a downpour of derision. Faced with the new techniques and colours, the critics ridiculed what they termed 'absurd daubs'.[30] 'Messieurs Monet and Pissaro and Mlle Morisot etc. appear to have declared war on beauty,' one well-known critic remarked.[31] Another declared that the artists must have loaded a pistol with various hues of paint, fired it at a canvas and then signed their work. The critics rivalled each other in their sarcasm. Louis Leroy from the *Charivari* spoofed the show by pretending to report the comments of an academic painter confronted by Monet's masterpiece *Impression: Sunrise*. 'Impression – I was sure of it,' he mocked. 'I was just thinking that since I was impressed there had to be some impression in it . . . and what freedom, what ease of workmanship! Wallpaper still in a rudimentary state is more finished than that seascape.'[32] Ironically, the painters were labelled 'Impressionists' after Leroy's sarcastic review. Most of the group,

particularly Degas, disliked the description. From the standpoint of its reception, this first exhibition of 'the Impressionists' was a disaster. The critics sneered at the paintings, the public ignored them and sales were depressingly small.

Marie-Clémentine was too young to have visited the exhibition, but in writing about her development as an artist she confessed that it was 'the palette of the Impressionists that enchanted me'.[33] By the time the Impressionists first grouped together she was already gripped by the need to express herself in pictures. While the Impressionists were painting under umbrellas in the open air, Valadon was scribbling on walls, on scraps of paper, anything she could scrounge. She coaxed a coalman to give her broken pieces of charcoal and drew boldly on the pavement of the Place de Vintimille. When she showed her mother her handiwork – and she was always trying to win her mother's praise – Madeleine was appalled and scolded her for not getting on with her needlework. As a child she sensed that she was special, although she had no idea what her future might be; 'she was certain that when she was grown up she would be one of the rare ones – one of those whose lives were apart from the masses',[34] and that is how she seemed at any rate in the memory of neighbours. To gain attention and sympathy she took to attending funerals in the Montmartre cemeteries, according to one account. Her performance achieved unexpected rewards when 'at Père Lachaise a bereaved young widow comforted her and gave her some money, all in the belief that the child was one of her dear departed's little mistakes.'[35]

Although she was immensely appealing with an oval face, dark-blue eyes and cognac-coloured hair that would darken as she grew older, Marie-Clémentine was too much of a tomboy to bother about her appearance. What she liked to boast about, even as an adult, was her agility and physical fitness. She would climb on walls and fences, shouting: 'I am a monkey, I am a cat.' One day she alarmed the neighbours by clinging to a french window, six storeys high, yelling to the terrified onlookers to stop shouting at her because the fire brigade was on its way. In another episode she captured a runaway cart-horse on the Place Blanche, soothing and stroking the animal while everyone else scattered for cover. Her friends were few, and unusual. 'I had one friend of seventy-eight who knew seven languages,' Valadon wrote in her 'confessions'. 'I had a good school – solitude.'[36]

Madeleine sent her to a convent in the Rue Caulaincourt, hoping the nuns would teach her manners as well as the rudiments of education. The emphasis was on religious teaching, which for Marie was a singular failure, and the memory of school kept her away from church all her life. She had no patience to sit still, darting off at every opportunity to revel in the freedom of the streets. Pupils were taught to memorise long texts of approved authors; fortunately, she loved poetry and could recite the fables of La Fontaine into old age. The figure of Francois Villon, the outlaw poet, gripped her imagination and she paced the cobbled streets with long masculine strides, often in bare feet, hands clasped behind her back.

The only times she could keep still and concentrate were when she was drawing. On Sundays she would lie on her stomach all day long on the roof of the tenement building in the Boulevard Rochechouart, staring down at the people, who looked like moving ants, and watching the sky and the clouds and the colours. At night she would climb into her bunk and sketch arms and legs in chalk. 'How did I do it?' she wrote when she was a well-known artist. 'Today I couldn't even draw a sugar bowl from memory.'[37] For Marie-Clémentine her chalk or pencil was her means of communicating her feelings, her impressions, her reactions to a cruel and exciting world. She did not think of her scribbling as art nor long to be an artist. She was a wild little girl, with an extraordinary sensibility. According to one story, however, one day when she was seven or eight she stopped to watch Renoir at his easel in the Rue Lepic and solemnly advised him to keep on with his painting and not be discouraged, because she was sure that he had a future.[38]

Unconsciously, Marie-Clémentine was absorbing her first lessons in art. As she grew up, the village on the heights was losing its innocence, the refuge for unknown artists was becoming the haunt of pleasure-seekers from all over Paris. For an unprotected girl, already showing signs of a disturbing beauty, the milieu of the anarchic artists and the artistic cabarets, the bars and dance-halls where criminals and bohemian drifters gathered, was full of promise and a hint of danger.

2

Street Life

From the age of eight until the end of her life Marie-Clémentine Valadon struggled with her need to put the world down on paper. 'It seized me so young,' she revealed; 'at eight years old I wrote down what I saw, I wanted to grasp and demonstrate [the reality of] the trees and limbs so that I could keep hold of them.'[1] Marie-Clémentine felt such a stinging joy in the natural world, the people, the movement of water and clouds, that she could only express her wonder in images. Her strength as an artist lay in her experiencing the world through her senses as she absorbed and devoured the passing scene.

In the daytime Montmartre looked idyllic, a welcome oasis from the teeming streets of the city below: 'Here is the calm of a country churchyard everywhere . . . Thatched houses confront you and across low walls you see old-fashioned gardens with apple trees in blossom and borders girded in with neatly trimmed box-hedges,' wrote a correspondent of the *Paris Magazine* on visiting the quarter.[2] In the evening as dusk fell, Montmartre changed its character. The café-terraces on the slopes and the dance-halls at the foot of the hill twinkled with orange gaslight, and *café-concerts*, *caf-concs*, sprang to life. Local singers sang sentimental, subversive songs, and poets, chansonniers and painters drifted in to drink and gossip and rail against the establishment. Jules Simon, Minister of Education in the 1870s, warned that the growing number of *caf-concs* in Paris were 'distributing and selling poison among us'.[3] At times of political unrest police spies often infiltrated the cafés. As the decade wore on, anarchists, artists, homosexuals and lesbians gravitated towards their favourite Montmartre haunts to growl their discontent and mock the most cherished of bourgeois values.

During the 1870s Marie-Clémentine acquired a basic education at a convent school. In later life she expressed herself vigorously in writing,

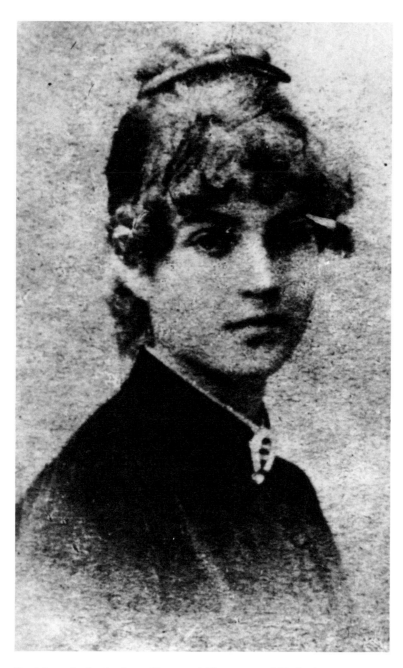

In 1881 at the beginning of her modelling career. Valadon's
wistful expression would soon become sterner and more
wary as she learned to cope with the vagaries of the
artist's world.

making up for what she lacked in accuracy of spelling and knowledge of grammar with the energy and intelligence of her letters. As no reports or correspondence from her schooldays can be traced, the year she left school is unknown. One of her biographers suggests that she went out to work at the age of nine, which would have been in 1874;[4] others that she was thirteen or fourteen.[5] Since Madeleine, striving to do the best for her daughter, was always impecunious, it seems more likely that Marie-Clémentine left the convent when she was eleven or twelve, an age when working-class girls of the day were expected to earn their living.

In keeping with family tradition, Marie-Clémentine was apprenticed first as a seamstress to a milliner's workshop on the Rue de la Paix, decorating hats and headdresses.[6] Marie-Clémentine was nimble-fingered and practical and found no difficulty with the work. But she loathed the artificiality of the workroom where she was required to sew ribbons, tinsel, feathers, flowers and birds on to the large elaborate hats of the period. By temperament she was unsuited to regular, routine employment and one day she walked out of the hated job. She tried to break the news to Madeleine by telling her that she had 'found a better job looking after rich children in the Tuileries'.[7] More credibly she drifted in and out of casual work, selling vegetables in the scabby open market at Les Halles, waiting at table and washing up in a café, and, for a time, making wreaths in a factory. According to one biographer, she was remembered by some of her contemporaries passing the Rue Lamarck as 'a wild, tiny figure trotting between a pair of percherons held by their halters or bobbing along on a horse's back, executing handstands, headstands, somersaults and cartwheels'.[8] That sounds a convincing picture of the rebellious adolescent. No factual evidence of her occupation at the time exists but the thread running through all the stories indicates a reckless, indomitable courage.

While Madeleine drudged to provide for her, sometimes cleaning offices at night, Marie-Clémentine snatched her freedom, breaking out of the squalid one-room lodging to roam the streets of Montmartre. 'I thought too much,' she wrote of herself as a child. 'I was haunted, I was a devil, I was a boy.'[9] In retrospect it seems surprising that Marie-Clémentine herself was not snatched up to service the growing number of brothels, both official and unofficial, in the quarter. In the second half of the nineteenth century prostitution was tolerated in Paris more widely than in any other capital. The city even boasted a directory of

prostitutes, the 'Guide Rose', and Montmartre in particular was already a byword for naughtiness and sexual escapade. At night on the Boulevard Rochechouart, where the Valadons lived, pimps prowled on the lookout for young virgins, and rouged tarts minced up and down in the shadows. Marie-Clémentine's agility and sheer waywardness may have saved her. She was slightly built and quick on her feet, and street life had taught her to be wary. She went where she pleased and could not be coaxed or even bullied against her will without violent protest.

The attractions on her doorstep were dazzling. There were two public dance-halls in the Boulevard Rochechouart, La Boule Noir and the more celebrated L'Élysée Montmartre, again restored to its pre-war glory. In the evenings the music of the waltz blared out from L'Élysée and occasionally displays of fireworks sizzled and sparked in the night air. In 1875, when Marie-Clémentine was almost ten years old, the Irish writer George Moore visited the dance-hall with a woman friend and wrote a glowing description. 'The trees are beautiful,' he said, 'they are like a fairy tale; and that is exactly what they were like, rising into the summer darkness, unnaturally green above the new electric lights!' George Moore was so carried away by the poetry of the spectacle that he failed to notice that the palm trees he admired were made of zinc – the experience was too heady: 'In the middle of a circle of white gloves the orchestra played . . . and everyone whirled his partner as if she were a top . . . The people rushed to see a quadrille; and while watching them I heard that a display of fireworks was being arranged.'[10] The walls of the huge salon were painted with cascades and plantations, and the premises boasted a large chalet with gaming-rooms and a restaurant 'built with the most refined comfort'.

In the 1880s the band leader at L'Élysée Montmartre, Dufour, reintroduced the French cancan and the dance-hall became more risqué. As the brass band struck up, agile, insolent girls pushed to the centre of the floor and kicked up their heels, standing on one foot and aiming the other as high as possible. The crowd stamped and cheered as the dancers revealed glimpses of frothy petticoats and knickers. To a crescendo of excitement the girls pirouetted, turned cartwheels and ended up in a triumphant demonstration of the splits.

Marie-Clémentine enjoyed anything unusual, like the street fairs with their travelling acrobats, the boxing booths and little carts selling sticky sweets. The year that George Moore described his visit to L'Élysée

Montmartre, 1875, another entertainment which could not fail to appeal to a curious, imaginative child was in construction at No. 63 Boulevard Rochechouart. The Cirque Fernando, a large wooden structure built to resemble a circular tent, was to become a permanent circus for the quarter. By the time Marie-Clémentine had her tenth birthday, brilliant posters printed in three colours advertised the attractions: acrobats clinging to the new flying trapezes; dainty equestriennes in frilly skirts perched on a troupe of white horses; top-hatted monkeys and snarling lions and tigers. If the reality of the Cirque Fernando that year was a band of scraggy horses, a donkey and a clown, for the children of Montmartre it was still magical. The show started at 8.30 in the evening with the parade and the fanfare of brass, and Marie-Clémentine would have wriggled to the front of the crowd to crane for a sight of the animals and stars of the circus.

The artists of Montmartre, notably Degas and Toulouse-Lautrec, discovered new themes in the movement, colour and inherent pathos of circus life. Some thirty years later Picasso too visited the circus often and drank with the clowns and jockeys of Montmartre, enjoying the company and the casual spirit of circus people. In the city itself on the Champs-Élysées visitors judged circus performance as high art; the new 'opera of the eye', as the critic Théophile Gautier styled it, became the rage. Audiences reserved their wildest applause for the ballerinas of the ring, the equestriennes. Whether these were exponents of the *haute école*, booted and spurred, brandishing their whips, or the prettily dressed bareback riders, the onlookers were intrigued by the relationship between woman and horse, and prominent equestriennes attracted a strong personal following. In the Third Republic the aristocracy, deprived of influence and with increased leisure, fostered the cult of the circus. In certain circles physical fitness became almost an article of faith: members of the upper class exercised in private gymnasia and vied with each other in knowledge of the feats of professional gymnasts and acrobats. Experts in horsemanship deplored the style of the nineteenth-century American circus, where animals and artists often travelled hundreds of miles before a show. French connoisseurs liked to see animals in peak condition and looked for more highly polished performances in Paris.

In 1879, when Marie-Clémentine had turned fourteen, a new circus was about to be launched to cater for aristocratic tastes. It was a private

venture conceived and paid for by a lawyer with an inherited fortune, Ernest Molier, who owned a large house in the Rue Benouville, close to the Bois de Boulogne where the upper class exercised their horses. Molier put the stables of his house at the disposal of the riders; then he began to plan a magnificent folly. He converted his house into a circus, constructing a standard ring, 13 metres in diameter, with boxes and stalls for the audience. His amateur circus, he vowed, would uphold French culture as he and his friends understood it.[11] All Molier's efforts were expended to stage one or two elaborate gala performances a year in front of an élite invited audience.

Marie-Clémentine heard about this circus from two young painters she met in a smoky Montmartre inn, the Auberge du Clou on the Avenue Trudaine. Comte Hubert de Larochefoucauld and Théo Wagner, both circus enthusiasts and excellent gymnasts, boasted to Marie-Clémentine about their friendship with the owner of the new enterprise and, to her great excitement, offerred to introduce her to Ernest Molier.[12]

Molier was a bachelor of thirty, a dark-haired Lothario with a tapered moustache. He said of himself that he was a man with an eye for a woman and a horse and he evidently saw Marie-Clémentine's potential. Despite the vogue for equestrienne acrobatics, Marie-Clémentine worked mainly at the bar and on the trapeze for six back-breaking months. She had a natural suppleness and strength which surprised the experienced athletes, but mistakes and falls were inevitable. François Gauzi, a painter who later lived in the same building as Valadon, wrote that Molier had coached her to become a circus performer and a woman of the world by judicious use of 'patience and the whip'.[13] Whether that was poetic licence or the real price she paid is uncertain. Apart from his gala performances, Molier also arranged 'pantomimes' for a select audience of men, using nude girls almost twenty years before Paris night-clubs began to show 'Les Girls'. At the circus Marie-Clémentine learned of a side of life she had not yet experienced in Montmartre. Years later, trying to express her feelings, Valadon wrote that 'in order to achieve greatness one must learn to take knocks'. 'Be hard on yourself' was her motto.[14]

During the months of training at Molier's circus Marie-Clémentine's life was transformed. She spent most of her time in the stables or in the circus ring mixing with the red-coated riders, nearly all rich eccentrics.

In her free moments she never stopped drawing; the poses she saw from the trapeze and the movement of limbs in the ring provided excellent studies for her work.

How much Madeleine Valadon interfered in her daughter's life remains a mystery. Marie-Clémentine's first surviving drawing of her mother made in 1883, when the artist was eighteen, shows Madeleine in her early fifties, her head erect. Even then she looks years older than her age, wrinkled and harassed, but her stance suggests a flash of that pride that her daughter displayed. In all later drawings and paintings Valadon portrays Madeleine as a shrewd and wary peasant, bowed down almost beyond endurance by a hard life, too tired to fight.

Marie-Clémentine's harsh introduction to work and womanhood at Molier's hands helps to explain something of her temperament and her art in later years. Unlike Renoir's women, her nudes never linger seductively to pleasure men or be caressed. Valadon's sullen girls appear apprehensive of their womanhood, trapped in awkward positions and aware of their vulnerable flesh. In the pastel *After the Bath*, now in the Petit Palais in Geneva, a naked girl lying across an armchair looks nervously over her shoulder and a sense of menace pervades the painting.

For all the pain and physical challenge, Valadon's time as an acrobat at Molier's circus was the most intense in her young life. Significantly it is the only job mentioned in her pre-modelling days in the first book written about her, by her friend Robert Rey.[15] She spoke of her life in the circus nostalgically into old age, and perhaps she would have remained a circus artist for years. One night in March 1880, however, when she was only fourteen, a bad accident cut short her career. Marie-Clémentine was rehearsing for a grand gala evening, swinging from a trapeze, when she fell to the the ground. She hurt her back badly and was sent home. For weeks she was forced to rest and afterwards her back was never strong enough to risk the strain of circus stunts.

By the time she recovered from her fall, Marie-Clémentine was almost fifteen. A photograph taken in her teens reveals her as a dark-eyed, delicate beauty with well-shaped eyebrows and regular features, her thick wavy hair pinned up at the back with a small fringe in front. All her life Valadon dressed with an austere simplicity and even as a young girl she often wore high-necked black dresses. Whether that was Madeleine's influence or Valadon's own realisation that her looks needed

no gilding is unknown. She was aware of her appearance, yet seemingly careless of it. She had lovely colouring – an ivory skin, eyes which she described as 'blue as Sèvres china'[16] and auburn hair. Although cosmetics were popular with all classes in the second half of the nineteenth century, Marie-Clémentine disdained make-up.

From an early age she was introspective and fiercely discontented, and her inner life seemed to preoccupy her. 'The purpose of my life: equilibrium,' she wrote in personal papers when she was well into her thirties; yet unruly passions had buffeted her since childhood: 'One must unload this excess of hate and this abundance of love.'[17] By the time she expressed those feelings in writing she knew that it was only through her art that she could channel her overflowing emotion.

The earliest examples of Valadon's accomplished drawings of herself and her mother, the only models she could command, date from 1883 when she was in her eighteenth year. She kept only the two, the red-chalk drawing of Madeleine and a pastel of herself, but they reveal an astonishing boldness and confidence for a girl who was completely untutored and suggest years of lonely, diligent preparation. Since she was a small child Marie-Clémentine had intuitively practised for her life as an artist. Not only did she scribble compulsively on any sheet of paper, even – to Madeleine's anger – on the walls of their lodgings. She was also intensely curious, visually curious, with a craving to understand people by their facial expression and their bodily gestures. When her mother was out working Marie-Clémentine watched the passing show. She noticed the workmen in blue smocks standing in grimy narrow doorways, smoking their pipes; the women in shabby peignoirs, bowed down with heavy baskets; the long-haired art students with flapping trousers lolloping down the road. Sometimes she would stand in the dark on top of the hill, staring for as long as she dared at lovers in the lanes. She had always known the naked body, her own and her mother's, and regarded her liberty as natural.

The freedom she savoured was denied to the growing number of privileged and carefully chaperoned young women art students, taught in segregation at the expensive Académie Julian or working in life classes where part of the body might be studied but rarely the whole. These young women who trained as artists ached for the independence of an unchaperoned young girl, able to stop and gaze wherever she pleased.

What I long for is the freedom of going out alone, of coming and going and sitting in the seats of the Tuileries and especially of the Luxembourg, of stopping and looking at the artistic shops, of entering churches and museums, of walking about the old streets at night: that's what I long for and that's the freedom without which one cannot become a real artist . . . that is the principal reason why there are no female artists.[18]

Marie Bashkirtseff, a minor realist painter, wrote that heartfelt lament in her journal in 1879. She was obviously unaware of the work of the talented Berthe Morisot, who had studied under Corot and exhibited with the Impressionists since 1874. But Berthe Morisot, a great-granddaughter of the painter Fragonard, came from a privileged and cultivated background. Her father provided both his daughters with a drawing master and their own studio. Among the working class even the notion of a woman painter was unheard of.

At the age of fourteen Valadon began, with great misgivings, to paint. 'I painted with whatever I had, indiscriminately . . . I was so wild and proud that I did not want to paint,' she confessed. 'I tried to make my palette so simple that I wouldn't have to think about it.'[19] For fifteen years she made her own colours, painfully aware of the difficulty of the medium. None of her early efforts at painting survives; she must have destroyed them all. Yet she continued to draw with an instinctive and growing confidence. After her accident a sense of urgency, of the need to practise and improve her drawing, made it impossible for her to settle. She occasionally took in sewing to earn a few francs, but the humdrum work frustrated her. All she wanted was to become a 'real' artist but she had no idea how to attain her ambition. Valadon's closest contact in the art world was her friend Clelia, an Italian girl who worked in the risqué profession of artist's model.[20] Clelia obligingly took Marie-Clémentine round the studios where she worked and introduced her to sculptors and painters.

In the past, artists had made do with plaster casts, ancient engravings and careful copies from the Louvre, but, in the new age of realism, live nude models were eagerly sought. In the mid-nineteenth century an influx of beautiful young girls from the slums of Naples had flooded into Paris and by the 1880s a thriving model industry was established in Montmartre. On fine Sunday mornings, in the Place Pigalle, would-be models draped themselves around the fountain dressed up in brightly

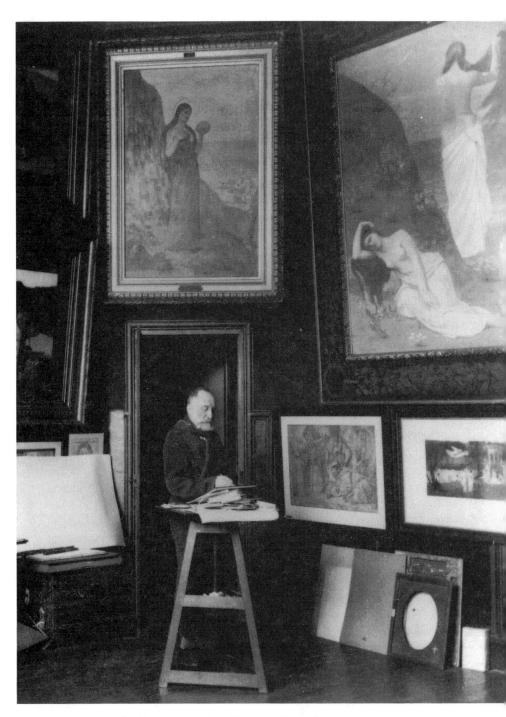

Pierre Puvis de Chavannes in his Place Pigalle studio, c. 1885.

coloured rags as nymphs, shepherds, cherubs and Greek gods. All the models – bronzed Italian girls, 'Neapolitans as ready to prostitute themselves as pose',[21] dark-eyed Jews, youths dressed in tight trousers – hoped to catch the eye of the painters taking coffee or absinthe in the cafés opposite. Their dream was to be chosen by a famous painter who would pay them well – ten francs for a session of four hours – and make their names. The least desirable option was to pose in an art school or professional painter's studio for twenty or thirty high-spirited young men.

Artists rarely found their ideal of beauty from one girl or one youth. They would select limbs from one model, a stance from another, the face from a third. Marie-Clémentine's attributes were spotted by a well-known painter who had lived in the Place Pigalle for almost thirty years. Pierre Puvis de Chavannes was already much admired for his vast idealised landscapes painted on canvas to decorate public buildings, the Panthéon in Paris, the town hall in Poitiers, and galleries and museums all over provincial France. Puvis planned his huge compositions meticulously, and something in Marie-Clémentine's sinuous small body and her grace of movement, coupled with an elusive androgynous quality, convinced him that she would fit ideally into his timeless landscapes. She had at that stage a classical form and a romantic air ideally suited to his work.

One story goes that Puvis spotted Marie-Clémentine one Sunday when he was peering down at the model market from a window of his chintz-curtained apartment. In another version the artist noticed the girl when she arrived at his door to deliver a basket of sweet-smelling laundry from her mother. In yet a third account, Marie-Clémentine was inside the apartment with the laundry where a colour-grinder, also waiting for Puvis, was making advances to her. 'Who is this charming person?' Puvis demanded when he walked through the door.[22] Marie-Clémentine did not reveal how she came to know Puvis when she gave an interview on her life as a model over forty years later. She merely told the critic Adolphe Tabarant that she had worked for Puvis for seven years from the age of fifteen. 'I can tell you that I am abundantly represented in most of his work,' she said, still proud to have modelled for such an eminent artist.[23]

Pierre Puvis de Chavannes, over forty years older than Marie-Clémentine, was a figure of authority and distinction. A seventeen-year-old English art student, William Rothenstein, visiting Paris eight years

later, found Puvis less inspiring in person. After taking dinner with the great man, he went back to his room disappointed: 'Could this rubicund, large-nosed old gentleman, encased so correctly in a close-fitting frock coat, looking more like a senator than an artist, be the Olympian Puvis?' he mused.[24] Tall and portly, finely dressed, Puvis was known in Montmartre as 'the peacock' and mocked by other Montmartre artists for his pomposity. There was nothing of the bohemian about this creature of habit, who politely received visitors in his apartment in Pigalle before nine in the morning wrapped in a brown dressing-gown. Promptly on the hour he was ready to leave for his vast studio at Neuilly, just outside the city boundary north-west of Paris.[25]

Puvis took Marie-Clémentine to his quiet home surrounded by a garden in the Boulevard du Château. There he shut himself up to work in a large sunlit room furnished with the necessities: ladders, colour tables and deal stools. On the walls hung huge canvases six foot wide. Once settled, Puvis puffed his pipe and rarely spoke except to give Marie-Clémentine instructions on a pose or a gesture. If he was blocked he would sing or snooze for a few minutes.

From the garish world of the circus Marie-Clémentine was transported to bright Elysian groves where nymphs and shepherds, muses and saints appeared at Puvis's command. As a young man, the son of a mining engineer, Puvis had travelled twice to Italy, and the early Renaissance frescos he saw in Arezzo left a lifelong impression upon him. He did not attempt wall painting himself but mixed plaster with paint in his huge compositions to give an illusion of density. 'The landscape', he once pronounced, 'must awaken dreams and strike chords of feeling to summon a mood of solemnity.'[26] He created an atmosphere of serenity in his studio with his light muted colours, his flat rhythmic designs and simplified outlines.

Puvis was methodical in his work; to a young undisciplined girl that must have been a revelation. 'Leave nothing to chance,' he once said. 'Put your central figure and your background in boldly . . . These are the first things the eye needs. Afterwards you may add the ornament . . . nothing is more likely to produce a good effect than being true to life.'[27] He believed that abbreviation and simplification were the secrets of composition, and Marie-Clémentine absorbed valuable lessons as his landscapes emerged. For Puvis a single work took years to complete: a year or two to produce the cartoon, a simple monochrome drawing, then

about the same time to create the finished painting to his satisfaction.

Puvis was one of the rare artists who was admired both by the moderns, who were seeking to portray the immediacy of everyday reality, and by the academic painters concerned to dignify nature and to relate improving stories of the past in sombre, polished colours. Somehow Puvis contrived to build a bridge between old and new. His personal vision transformed the conventional scenes and the pale tones of his neo-classical landscapes peopled with statuesque figures had a profound influence on modern artists from Cézanne, Gauguin and van Gogh to the early Picasso.

Marie-Clémentine did not dare reveal to the great man that she too yearned to become an artist: 'I was in awe of him, I didn't know how to talk to him and I didn't dare confess that I was trying to draw myself, that since the age of nine I had sketched on any scrap of paper that came my way, much to my mother's annoyance.'[28] Instead of asking for Puvis's help, Marie-Clémentine characteristically decided to glean what she could by watching and listening. She noted how he held his pencil and his paintbrush, how he prepared his palette.

Life in the studio was austere and disciplined. Every hour Puvis broke for ten minutes' rest, and for lunch they ate slices of good bread with cherries in brandy. When he was working Puvis did not receive visitors – with one exception: as Marie-Clémentine put it, when 'the princess arrived the silence was broken for a moment.'[29] Princess Cantacuzene, a married Romanian noblewoman, had absorbed Puvis in a love affair for twenty years; towards the end of his life, when the princess was free, the couple were married. The grand passion of the two middle-aged lovers was courtly and luxurious, remote from the brief, fumbling encounters that took place in the streets of Montmartre.

Puvis spent hours alone with his model, who was frequently bare-breasted or draped to the thigh in diaphanous material in the role of a nymph or a muse in Greek mythology. The ageing painter was known by some to be lecherous: according to one anecdote, he once asked a young model 'if she would like to see the cock of a great man'.[30] Marie-Clémentine herself sometimes referred to Puvis as her lover, and after Valadon's death her second husband alleged that he had found a legal document in which Puvis promised to support Valadon financially by regular payments. No record exists, since the document was then torn up. The rumours were far-flung enough for Puvis's great-nephew, René

Puvis de Chavannes, to attempt to defend his great-uncle's reputation after Puvis's death in 1898 by announcing that since there was no legacy left either to Valadon or to her illegitimate son, Maurice Utrillo, Puvis could not have been the father.[31] The evidence clearly points to a liaison – hardly a love affair – between the fifty-six-year-old artist and his model. For a young girl the occasional coupling cannot have been exciting, although Puvis was almost certainly kind and considerate. Marie-Clémentine's own comments suggest that their relationship, despite moments of intimacy, remained distant. Often in the evening they would make the hour-long walk back from the studio in Neuilly to Montmartre: 'He was quite charming. He spoke slowly and gently but he never stopped talking. He was as curious as a woman and he gossiped, he chatted about everything, and I listened, walking a few paces behind him without saying a word.'[32]

Marie-Clémentine mentioned specifically only one painting in which she had modelled for Puvis, his huge allegorical mural, *The Grove Sacred to the Arts and Muses*, now in the Musée des Beaux-Arts at Lyon. The painting was acclaimed as a great success in the Salon of 1884 and she was proud of her role in it. The huge work, set in an imaginary landscape, personifies the Arts and Muses in tranquillity, with Architecture seated on a column, Sculpture standing statuesque beside her and Painting receiving a tribute from a child who strews flowers at her feet. The Muses read, meditate, float in the air plucking a lyre or contemplate the lake. It is not possible to recognise Marie-Clémentine in the stylised figures, but she showed Adolphe Tabarant a photograph of the painting when she granted him a rare interview and pointed out where she appeared.

'There I am, and again there, that's me. Almost all the figures in the painting have something borrowed from me. Puvis would ask me to adopt an attitude, a movement or a gesture. I am the ephebe plucking a branch from the tree and he has my arms and legs. I posed not only for the women but for the young men. They were peaceful hours I spent in the large studio at Neuilly!'[33] In her interview Valadon used the term 'ephebe' (a Greek youth on the brink of manhood) and almost certainly Puvis explained to her the classical allusion. Through him she gleaned her first notions of the world of artistic salons, of exhibitions and dealers.

Since Valadon's acceptance by the artistic establishment was slow and grudging, when she gave an interview on her past she understandably preferred to emphasise the eminent painters she had sat for, such as

Puvis, Renoir and Toulouse-Lautrec. But in her youth she posed for a number of other painters, some of them now completely forgotten. In the 1880s she modelled for both nymphs and dryads in Jean-Jacques Henner's pastoral painting *Melancholy*. Henner, the son of an Alsatian farmer, became famous and rich in his lifetime, a member of the Institut de France and Grand Officer of the Légion d'Honneur.[34] She also modelled for Princess Mathilde, Louis-Napoleon's cousin, who kept a literary and artistic salon; for Jean-Louis Forain, a minor Impressionist; and for foreign artists working in Paris – the Czech, Vojtech Hnais; the American, Cornelius Howland; the Italian, Giuseppe de Nittis; and the German, Gustav Wertheimer, among others.

Her new status as a model gave Marie-Clémentine an entrée into the cosmopolitan and virtually classless world of the artists, who shortened her name to a more manageable 'Maria'. She was often invited to studio parties and to the cafés and taverns where painters, models and critics congregated. In her teens Marie-Clémentine began to visit the Lapin-Agile and for sixty years she was at home in the unpretentious inn where the great names of modern art were to meet. A rustic building high up on the hill of Montmartre, the Lapin features in guidebooks today. The two-storey, ivy-covered cottage, with a tiled room and a small yard with a wooden bench as front garden, acquired a glamour for generations of Montmartre artists. Originally it was known as the 'Thieves' Inn', in acknowledgement of the apaches who combed the district. In the late 1860s during the trial and execution of Troppman, a serial killer of his day, the enterprising innkeeper decorated his walls with paintings revealing the most shocking contemporary crimes and renamed his inn 'L'Assassin'. It had a ring.

In 1880, for aesthetic reasons, the inn changed its image for the last time. André Gill, a witty cartoonist, was commissioned to create a new sign. Gill painted a tipsy rabbit leaping out of the cooking pot, a bottle of wine balanced on one paw. The Lapin à Gill soon became the Lapin-Agile, and painters, poets and local inhabitants came to enjoy the easy camaraderie, the old French songs belted out and the welcome from regulars at the tavern. Strangers, particularly bourgeois strangers, met with a cool reception. The locals liked to keep the inn, where apaches still raided and at least one murder was committed, to themselves.

All over Paris the fashion for entertainment in small, easy-going cafés was taking hold. The *café-concerts* hired amateurs or poorly paid

professional singers to entertain the customers. The singers poured out plaintive songs that spoke to their audiences of the difficulties of their lives – of landlords and concierges, mothers-in-law and wronged wives. They were immensely popular. Maurice Chevalier began his career in a *caf-conc* before becoming a world-famous star. Montmartre had two or three *caf-concs* but the clientele in the quarter had a craving for a wittier and more aesthetic form of entertainment.

In December 1881, not long after Marie-Clémentine had turned sixteen, a new attraction burst on Paris from Montmartre: the *cabaret-artistique*. Le Chat Noir opened on the Boulevard Rochechouart and transformed the seedy street into an attraction for fashionable and artistic crowds. The cabaret began as an intimate meeting-place for anti-establishment and very young poets, painters, singers and actors whose heroic efforts left them with a thirst. A bearded bohemian, Rodolphe Salis, an unsuccessful painter himself, had rented a shop at No. 84 as a studio. Salis enjoyed the company of artists: he had belonged to a talented literary group in the Latin Quarter, 'Les Hydropathes'. Egged on by friends, Salis decided to turn his premises into a cabaret and launch a new career for himself as *gentilhomme cabarétier*. Le Chat Noir, named after one of Edgar Allan Poe's stories, was designed as a cabaret where Salis's cronies could parade their talents, drink beer freely and shock the bourgeoisie with their outrageous wit. Since the Paris Commune of 1871, Montmartre had become a symbol of rebellion; artists were feared more than ever by respectable people and regarded as dangerous anarchists and revolutionaries.

Salis invited the most talented young painters of the quarter to decorate the walls of a room on the ground floor of the former shop. Théophile-Alexandre Steinlen painted posters and signs; Adolphe Willette created a stained-glass window. The tapestries on the walls were covered with coats of arms, swords, helmets, javelins, pots and pans, stuffed owls and china cats, flocks of slender, immodest nudes covered in rose petals and haloed in gold. Genuine antiques jostled with bric-à-brac, exquisite old furniture with the most perfect modern bad taste. With its blend of the beautiful and the grotesque, the sacred and the profane, the room made an intriguing backcloth to the idealism and cynicism of the performances.[35]

Artists, writers, poets, journalists, actors and singers met there every Friday to drink, smoke, play the violin or guitar, sing riotous old songs,

recite new poems and flirt with the grisettes. The new cabaret soon drew the crowds, especially on Fridays, and if there was an overflow the waiters brought out the bill of fare and drinks to customers waiting on benches in the street. The passing bourgeois saw the Chat Noir as a peepshow into the artist's life, and critics from the press soon got word of fresh talent in Montmartre.

The cabaret comprised a long low room divided by a half-curtain. The larger, front part of the room with a bar at the side was set aside for casual customers. Salis himself often served the beer and the artists swore he spat in it. The back part of room, reserved for the artists, was titled grandly 'L'Institut'. By the flicker of gaslight a Dante circle and a Shakespeare circle recited the classics in a haze of wild spirits and high art. Performances were improvised and spontaneous. Poets and singers sprang up on to a small platform to deliver their new creations unannounced. Sometimes speakers from the street were invited on to the platform but were soon pushed off if they sounded boring.

Two weeks after the cabaret opened, Salis printed a journal from the premises, *Le Chat Noir*, as a record of new work performed at his cabaret, persuading his gifted friends to contribute a little sketch here or a poem there. He paid his contributors and performers with beer, food and sometimes free lodging. He also encouraged outrageous practical jokes. For example, six months after the cabaret opened, an obituary notice of the proprietor's death appeared in his paper; then a sign was hung outside the premises announcing that the Chat Noir was open for 'national mourning'. The shutters were put up, the room was draped in black and funeral candles were lit. A cello on a trestle covered with black serge served as a coffin. The painter Paul Signac, dressed as a nun, knelt in prayer beside it. Astounded customers were admonished to sprinkle 'holy water' on a skull beside the coffin and to drink more beer. For Salis, the ultimate showman, nothing was sacred.

In the paper, *Le Chat Noir*, it was a point of honour to ignore the existence of other districts of Paris, and Salis, who claimed with some justification that he had invented Montmartre, awarded himself medals for his creation. His flair brought in talented artists and talented audiences to enjoy the stimulating scepticism and artistic experiment that broke down class barriers. Among the distinguished visitors were the actress Sarah Bernhardt, the radical Interior Minister Léon Gambetta, the writers Alphonse Daudet, Guy de Maupassant, Victor

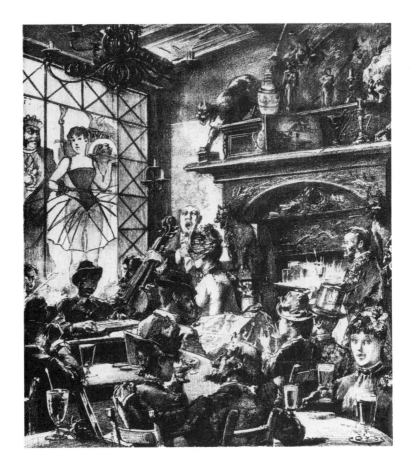

Rodolphe Salis

LEFT The Chat Noir, the first
artistic cabaret in Paris, opened in
Montmartre in 1881. The new tavern
acted as a magnet to the aspiring
young talent in the locality.
BELOW LEFT Rodolphe Salis, the
red-haired proprietor, was a failed
artist himself who encouraged and
exploited his protégés. They
sketched, recited and sang for their
supper.
BELOW RIGHT Aristide Bruant, later
immortalised by Lautrec's poster,
sang his anarchic and irreverent
ballads at the Chat Noir.

THIS PAGE

ABOVE RIGHT Painters and poets met to drink cheap wine and talk of high
art at the sign of the Lapin-Agile.
BELOW The Moulin Rouge, opened in the autumn of 1889, heralded the
more hectic and commercial night-life of the 1890s.

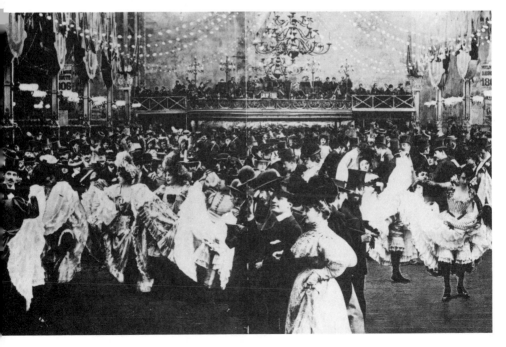

Hugo, Paul Verlaine and Émile Zola, and the musicians Charles Gounod, Jules Massenet and the young Claude Debussy, who sometimes led the singing, as well as a host of painters. The cabaret became a roaring success. In the early years Salis undoubtedly exploited his friends' talent but equally helped to make many reputations.

Freedom of expression was part of the Chat Noir's attraction, and the girlfriends of the artists flirted and drank with their companions. Yet, in spite of the licence, Salis was jealous of the tone of the place. One night he defended his cabaret against a crowd of armed pimps who tried to force their way in. 'I stood in the doorway and refused them admittance and got a couple of knife wounds in my left side for my pains,' he told a reporter from *Le Temps* in 1896.[36] One of his waiters died from stab wounds to the head and Salis was accused of 'murder by misadventure' but acquitted. He claimed that his *cabaret-artistique* had transformed the Boulevard Rochechouart, 'which had been mainly frequented by prostitutes and pimps', into the nursery of literature and art.

Salis's fierce defence of his clientele may have saved Marie-Clémentine from the rapacity of the pimps; she was one of the many charming girls who enjoyed the evenings there. Years later she made a list of the literary friends of her youth, all well-known characters from the Chat Noir.[37] Émile Goudeau, the humorist poet who was the leading spirit of the cabaret and the first editor of its paper, was one name on her list. Another was Alphonse Allais, the comic writer who sent in a sheet of hardboard painted white, entitled *The First Communion of Anaemic Young Girls in the Snow*, to an exhibition of the 'Incohérents' held at the Chat Noir. Many of the so-called 'Incohérents' could scarcely draw; their exhibition anticipated the Dadaists and Surrealists and its mood was unmistakably modern. Marie-Clémentine – Maria Valadon – was now a member of the enchanted circle at the Chat Noir and the Lapin-Agile. For the first time in her life she discovered friends who shared her interests, friends of her own age with as much vitality and innate talent as she had herself. In that atmosphere of lively, art-loving young people she blossomed. The solemn, wilful child and the solitary, sullen adolescent became a beautiful, spirited young woman with a wicked sense of fun. That is how art critics and journalists remembered her at that time.

One Sunday afternoon Maria staged a spectacular entrance at the Moulin de la Galette, sliding down the banisters wearing only a mask,

to the delight of the dancers. The unsophisticated dance-hall at the top of the Rue Lepic, a fashionable tourist trap nowadays, was then a popular working-class haunt. The old mill, the subject of Renoir's sunlit masterpiece, still had a rustic charm. On fine Sunday afternoons donkey races as well as dances were held in the gardens. In the evenings paper lanterns hung from the trees to illuminate the dancers. Indoors the old mill had been converted into a large square hangar with a raised platform for the band. Between dances couples sipped spiced mulled wine and munched the delicious *galettes*, cakes which were the speciality of the house, made by the miller. Men paid 25 centimes to enter and 20 centimes for each dance. The midinettes, the seamstresses and shop assistants, watched by elderly chaperons, waltzed to a ten-piece band.

Then in 1881, when Maria was enjoying life as a model, she met a man whose energy and spirit matched her own. He was a goodlooking student from Spain, tall and dark, three years her senior, and his name was Miguel Utrillo. Miguel, who had already trained in engineering, was studying agronomy but drawn to the artist's life by Montmartre and the new cafés. A man of many gifts, he could not settle and he began to send art criticism to Spanish newspapers. When the Chat Noir opened, Miguel found a natural home, enchanted by the witty irreverence in the air.

He and Maria became great friends; he was delighted to discover how talented she was; and she in turn was delighted by his enthusiasm. 'At a time when no one paid any attention to me he encouraged and supported me . . . Besides, he painted and drew,' she said.[38] They egged each other on to boisterous stunts. One night Miguel rode backwards on a donkey into the Moulin de la Galette; on another occasion he arrived at L'Élysée Montmartre pushing a cart full of fish with a giggling Maria close at hand.

Early in 1883 Miguel, dressed in the velvet jacket and broad-brimmed hat that for him was almost a uniform, gave a memorable performance at the Chat Noir. Late one night he jumped on to the platform to stage a ritual Catalan candle dance dedicated to departing churchwardens, the Bal del Ciria. For two hours Miguel subdued the rowdy audience with his stylish footwork, accompanied by Catalan songs and humour. For his finale he executed a lightning display of dance steps, contrepas and sardanas, to the spectators' huge enjoyment.

The couple were very close, though two such passionate and gifted personalities naturally quarrelled. Then, for an unknown reason, perhaps financial, Miguel decided to put an end to his drifting student life and earn his living as an agronomist. He left Paris in the spring of 1883 to travel in Belgium, Germany and France, but the two friends evidently kept in touch during his absence. Maria was convinced Miguel would come back to her; all her life she kept a passport delivered to him by the Spanish consul in Hamburg in 1884. When she was a middle-aged woman she recalled their time together: 'With Michel [Miguel] I spent the best years of my youth . . . We lived an artistic and bohemian life [*une vie d'art et de bohème*].'[39] That implies that Maria and Miguel were lovers, although she always denied it. At the time he left, her own life was opening up.

Maria had begun to frequent the Café de la Nouvelle-Athènes, a haunt of the Impressionists which had supplanted the Café Guerbois in the mid-1870s. The café, across the street from the model market in the Place Pigalle, was nicknamed the 'Intransigeants' after the group's first disastrous exhibition. A huge dead rat painted on the ceiling reflected the mocking spirit of Montmartre. Manet and Degas, who lived locally, came in every evening for years. The most bohemian of the crowd, Marcellin Desboutin, amused everyone with his good humour and conversation. Painter, engraver and author, he had lost a fortune, bought and sold a large castle in Florence and translated the whole of Byron's *Don Juan* into French without being able to find a publisher. In his painting *L'Absinthe* Degas cast Desboutin as a drunk, necktie askew, hat battered, leaning on a marble table smoking a pipe at the Nouvelle-Athènes, remote from his companion, an actress from the *demi-monde*, Ellen Andrée. Degas placed the glass of absinthe – the cloudy greenish liquid known as the 'Green Fairy', with its bitter aftertaste and aura of danger and decadence – in front of the woman. He made preparatory sketches at the café, then painted the picture in his studio, meticulously experimenting and retouching.

For modern painters the heated discussions on aesthetics at the café in the Place Pigalle were the best means of keeping in touch with modern art. 'I have heard you profess that to paint it is absolutely necessary to live in Paris,' Paul Gauguin grumbled in a letter to his friend Camille Pissarro, who was living in the country. 'No one would say so at this moment when the rest of us poor wretches are going to the Nouvelle-Athènes to be roasted.'[40] Gauguin had already exhibited with

the group and was about to throw up his secure job as a stockbroker to commit himself passionately to painting. The 'roasting' he referred to almost certainly came from Degas, who distrusted his colleagues' dependence, as he saw it, on their transient impressions of light and shade on landscape. He disliked the term 'Impressionist', convinced that an artist would get better results by painting what he had seen in retrospect, 'allowing imagination to collaborate with memory'. As for Manet, although he was admired by the Impressionists and had helped Monet as well as other members of the group, he refused to exhibit with them. The discussions on modern art at the café, so important to the younger painters, were dominated by Manet and Degas, the two established artists on the fringes of Impressionism.

Claude Monet, desperately poor and unsuccessful, spent most of his days roaming along the banks of the river Seine, sometimes painting from the makeshift studio on his boat. Although he had initiated the first Impressionist exhibition, he hardly bothered to visit the café. Pissarro, with his kindly face and white beard, turned up about once a month when he was in town; Renoir, who lived nearby, often spent his evenings there. Cézanne had to be persuaded to call into the Nouvelle-Athènes when he was in Paris. On the odd occasions when he did appear – dressed in blue overalls, white linen jacket and a dented hat – his appearance had 'a certain success' according to the influential critic, Edmond Duranty. But Duranty feared that Cézanne's contempt for conventional dress amounted to a 'dangerous demonstration'. Gossip grew about the painter's habits, and the Irish writer George Moore, who had first come to Paris to study painting, spread it like dung. Moore repeated the stories of Cézanne wandering the hillsides in jackboots and leaving his paintings in the fields because no one took the slightest interest in them. In dismissing Cézanne's painting as 'art in delirium' George Moore was merely echoing popular opinion. Manet and Degas were amused by the foppish Irishman with his strange manners and hilarious French and they both painted him. Moore carefully soaked up the wit and malice of the artists' talk and found it excellent copy. Although he only stayed in Paris during the early years of the Nouvelle-Athènes's popularity, he left a graphic description of the atmosphere. 'I did not go to either Oxford or Cambridge,' Moore wrote in his *Confessions of a Young Man*, 'but I went to the Nouvelle-Athènes.' He remembered it with nostalgic affection:

Ah the long evenings when there was a summer illusion, the grey moonlight on the Place where we used to stand on the pavements, the shutters clanging behind us . . . I can hear the glass door of the café grating the sand as I open it. I can recall the smell of every hour. In the morning that of eggs frizzling in butter, the pungent cigarette and bad cognac; at five o'clock the fragrant odour of absinthe; soon after the steaming soup ascends from the kitchen; and as the evening advances, the mingled smell of cigarettes, coffee and weak beer . . . The usual marble tables are there, and it is there we sat and aestheticised till two o'clock in the morning. The kitchens of the Nouvelle-Athènes were open all night and artists who needed to sop up their drink could fry eggs in the early hours.[41]

Three younger painters, friends of Degas, often joined the older man at the Nouvelle-Athènes – Jean-Louis Forain, Federico Zandomeneghi and Jean-François Raffaelli. Maria Valadon modelled for two of them, Forain and Zandomeneghi. All three artists practised a diluted form of 'realism', as Degas preferred to call it, and were tolerated somewhat grudgingly by the older Impressionists. Raffaelli, pushy and prolific, was most resented by the group; his watered-down, anecdotal paintings of street scenes in the suburbs of Paris had brought him a certain success. Forain, the most gifted, was strongly influenced by Degas, and drew caricatures for satirical journals.

Degas, who came from a partly Italian background, loyally befriended the Italian colony of artists working in Paris and it was through his influence that Zandomeneghi exhibited with the Impressionists. A man in his thirties, the son of a Venetian sculptor, Zando had worked with the Macchiaoli in Florence, a group of painters influenced by the Impressionists. The Macchiaoli simplified the distribution of light and shade with blobs of colour (*macchie*) but their adaptation of the Impressionist technique never attained international prominence. Zando was a cultivated man, proud of his heritage and convinced that his lack of success was due to French chauvinism. Renoir teased him about his grievance but Degas remained loyal to the man he nicknamed 'The Prince'. In the end even Degas managed to offend his friend when he invited 'the Prince' to pose for him. 'Why not?' he asked. 'You have nothing better to do.' 'One does not speak like that to a Venetian,' Zando retorted.[42]

Discussions about art at the Nouvelle-Athènes were dominated by the men, but Manet's favourite model, Victorine Meurent, was one of

the few women to join in. Victorine took up painting herself for a time until she succumbed to alcohol and began playing the guitar in the rough bars of Montmartre. Valadon's presence at the café is confirmed by a painting of her made by Zandomeneghi in 1885, when she was twenty, entitled *Femme attablée dans un bistro* or *Au Café de la Nouvelle-Athènes*. In the canvas the model sits facing the artist across the table with his own image reflected in the mirror. An air of alertness and intelligence makes it clear that this young woman is no vacuous little model but a comrade and a companion. A letter from Zando among Maria's papers reveals that they remained friends for years; but it is impossible to deduce from the tone whether or not they were lovers.[43]

By the end of 1882, when she had turned seventeen, Maria had worked as a model for just over two years. Many of the artists she sat for were young and struggling like herself and the dates and details of most of the canvases in which she appears are irretrievably lost. Yet Maria Valadon had established herself as an intelligent and hardworking sitter, highly recommended by the artists for whom she modelled. Her unusual looks and her application to a task, which for her own reasons she found totally absorbing, had helped her to gain an excellent reputation.

3

Transformation

By the close of 1882, Auguste Renoir was searching for a new style. On a visit to Italy the previous year he had been dazzled by the works of Raphael and the wall paintings at Pompeii. The painter was convinced that he must find his way back to the Old Masters and to a clearer, more linear form of art: 'I felt that I had wrung Impressionism dry,' he wrote. 'I finally came to the conclusion that I knew neither how to paint nor how to draw.'[1]

Renoir had come to dislike the informality of the Impressionists, intent on capturing the light and colour of the fleeting moment, and after 1882 he refused to exhibit with the group. When the Impressionists' dealer, Paul Durand-Ruel, offered him his first major one-man show in Paris in April 1883 he was pleased to accept. For this exhibition Renoir planned to paint three large dance panels.

In Renoir's classical crisis it was natural for him to turn to Puvis de Chavannes, the artist who had succeeded in adapting classical traditions for his rather stiff idyllic scenes painted in pale colours; and it was equally natural for Puvis to recommend Maria Valadon as a model.[2] Maria herself, whose memory was not always reliable, recalled Nini Gérard, one of Renoir's models, introducing her to the painter.[3]

At forty-one Renoir was restless, ambitious and extremely susceptible to the pretty girls he loved to paint. Although he had a mistress, Aline Charigot, who was eager to marry him, when he dined out he presented himself as a single man. Aline bore him a son, Pierre, but not until the boy was five did the couple marry.

Maria agreed to pose for him, and at first artist and model worked well together. Valadon revelled in each role she took on and entered into the spirit of the painting. At seventeen she had worked and played for three years with the artists of Montmartre, by no means the haughty virgin in

56

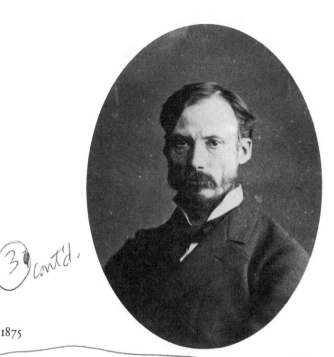

(3) cont'd.

Auguste Renoir in 1875

the white gown of Renoir's *Dance in the City*, yet too passionate by nature to be a mercenary tart. In Maria's circle casual lovemaking was accepted, and Maria took her pleasures lightheartedly, enjoying the excitement and attention that her lovers brought her. Besides, the working girls of the quarter, the girls who danced at the Moulin de la Galette, enjoyed a certain licence: 'Moral freedom was not reprehensible for a girl so long as she stayed at home and helped her mother,' wrote Renoir's friend, Georges Rivière. The Moulin was a respectable playground for high-spirited young shop-girls: 'They gambol and prank and joke and guy one another. They play tag and between the dances race after each other and under the chairs and tables.'[4]

In the beginning the friendship between Renoir and Valadon was enchanting. Maria had a chance to dress up and make believe, and Renoir, agreeable and amusing, delighted in pleasing her. For the *Dance in the City* Maria needed a pair of long white gloves to match her ballgown. Although her figure was voluptuous, she was so tiny that the painter had to scour Paris to find a pair small enough to fit her. Renoir hated the ugly women's clothes of the period, she remembered:[5] the styles seen in Seurat's masterpiece *La Grande Jatte*, with women encased in whalebone corsets and hampered by skirts with huge bustles. He liked his girls to look pretty and tempting, in flowing dresses with plunging necklines.

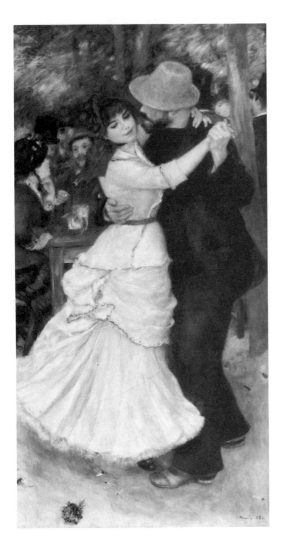

LEFT *Dance at Bougival,*
1883.
OPPOSITE LEFT *Dance in
the City,* 1883.
OPPOSITE RIGHT *Dance in
the Country,* 1883.

Valadon claimed that she had
posed for all three of Renoir's
famous dance panels. According
to Montmartre gossip, however,
Renoir's fiancée, Aline Charigot,
was wildly jealous of his
attractive model and rubbed out
the face of her rival in *Dance in
the Country,* insisting on
modelling herself. The girl in
this painting certainly looks
plumper and more available
than the heroine of the other
two dances.

For the *Dance at Bougival* Maria posed in the studio on the Rue
d'Orchampt. With the coming of the railway, young Parisians who
could not afford carriages travelled by train to the riverside on fine
weekends. In 1881 Renoir had painted his Aline, a blonde, as the girl in
a straw hat petting a poodle in *The Boating Party Lunch*. The artist
worked on the tiny isle of Chatou near Bougival and was well known in
the area – which may explain why he did not take Maria to Bougival.
For the *Dance at Bougival* Renoir, who was fascinated by women's hats,
posed Maria in a flattering off-the-face bonnet with flying ribbons. She
wore a flounced balldress with short sleeves, tightly fitted around her

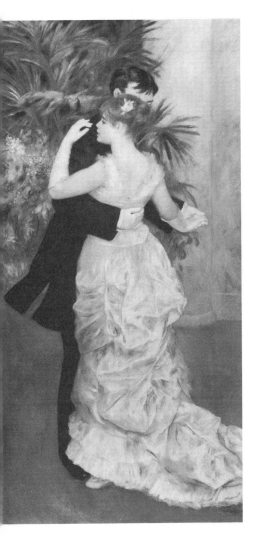
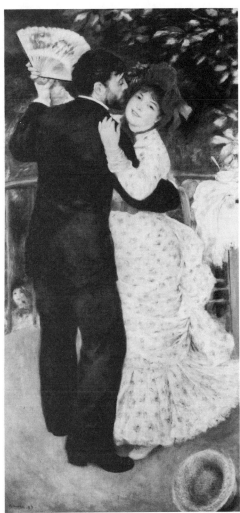

breasts. Paul Durand-Ruel decided to send the *Dance at Bougival* to London and the painting was on display at Dowdeswell's galleries in New Bond Street from April 1882.

The identity of the model in the third painting, the *Dance in the Country*, presents a problem. When she was in her fifties Valadon told her friend Adolphe Tabarant, the art critic, that she had posed for all three dance paintings: 'I am the dancer who smiles as she falls into the arms of her partner, and I am also the fashionable young lady in long gloves and a dress with a train. I also sat for a scene at Bougival. As for the nudes, Renoir painted several of me.'[6] Valadon produced

59

yellowing photographs of the *Dance in the City* and the *Dance in the Country* to show the critic.

According to Montmartre gossip, Aline Charigot, wildly jealous of Maria, burst into Renoir's studio one day and peered at his easel. When she saw Maria's face in the *Dance in the Country*, she shrieked at Renoir in fury and rubbed out her rival's features. Renoir, duly contrite, repainted the *Dance in the Country* using Aline as his model. Her suspicions were confirmed a few days later when she found Maria in Renoir's arms in the studio. She seized a broom and pushed Maria out of the room.[7]

The female partner in the *Dance in the Country* certainly looks coarser and clumsier than Valadon, and lacks the dainty, almost ethereal quality with which Renoir imbued her. Despite her contribution as a model, Maria's name is not associated with the painting: the credit went to her rival. A seamstress who occasionally modelled, Aline was two years older than Maria, eager to settle down and bear Renoir's children, and undoubtedly a better choice of partner for the painter.

Renoir, the son of a poor tailor, was born in Limoges, the nearest city to Maria's little town of Bessines in central France. Although the two shared a regional background they were totally different in outlook and temperament. Renoir professed an almost apoplectic conservatism, ranting against modern ways and modern women: 'I think of women who are writers, lawyers and politicians as monsters, mere freaks . . . the woman artist is just ridiculous,' he wrote to the critic Philippe Burty five years later.[8] And he told his son Jean that he was afraid education would produce women who didn't know how to make love well. All he wanted from his models, he said, was that their skin should take the light and that they should be graceful and enticing: 'When I've painted a woman's bottom so that I want to touch it, then [the painting] is finished.'[9]

'He fell in love with me,' Maria revealed later. But her tone in referring to Renoir was acid: she called him a 'tomato sauce' painter, 'a good painter, all brushes, no heart'.[10] Maria modelled for Renoir until 1887 when he completed his ambitious work, *The Bathers*. Maria posed for all three bathers; as the naked girl on the left of the painting, her hand is raised in a gesture of rejection, her breast pointed provocatively. She also posed for *The Plait*, a statuesque portrait of a magnificent young woman beneath a tree, her ivory bosom swelling from her chemise, her attention focused on plaiting her auburn hair, a hint of

disdain in her pink pursed lips. 'Renoir plastered me with make-up,' Valadon later complained.[11] Maria stands out so defiantly from the majority of girls in Renoir's pictures, eager, complaisant and docile, that one senses a hostility between painter and model.

Renoir eventually did discover that his model was an aspiring artist when one day she was late for a session and he went to fetch her. Arriving in her room, he found his model sitting at her easel, drawing. Amused at first, he glanced at the work; then he studied her drawing more carefully and was impressed. 'You too, and you hide it,' he said;[12] but he made no offer of help or guidance.

Maria modelled for Renoir in the flush of her youth, from the age of seventeen until she was twenty-two. These were the golden, carefree years of Montmartre. The strange assortment of artists, workers and petty criminals who peopled the quarter asserted their right, even their duty, to enjoy life and take it lightly. The Montmartrois often moved secretly without paying their rent, borrowed their landlord's clothes to pawn and set their dogs to pilfer chops or sausages. In the spring, when models posed in courtyards and back gardens, as Maria posed for Renoir in the leafy garden of the Rue de la Barre, the ideal of the artist's life, capricious and unconstrained, was played out against a still semi-rural background under the shade of horse-chestnuts, acacias, poplars and scented lilac.

'Every human being has the right to be free' – the theme song of Gustave Charpentier's opera *Louise* composed in the 1890s – echoed the mood of Montmartre in those years. For women the freedom was often short-lived. In the spring of 1883, as a consequence of her liberty, Maria inevitably fell pregnant without a partner to support her. Miguel Utrillo had left France, piqued, perhaps, by Maria's flirtations with other men, and it was uncertain when he would return. The following September Renoir went on holiday to Jersey. There were rumours that Maria accompanied the painter, only to be packed off humiliatingly when Renoir received word that Aline was on her way,[13] but this seems unlikely. Renoir would hardly have risked further scenes with his fiancée by taking along a model six months pregnant.

Maria's first surviving self-portrait dates from that eventful year. She drew herself in pastel in a simple blue dress, her hair scraped behind her ears. The artist looks out on the world, defiant and mistrustful, her chin pugnacious. In September 1883 she turned eighteen and her baby was due at Christmas.

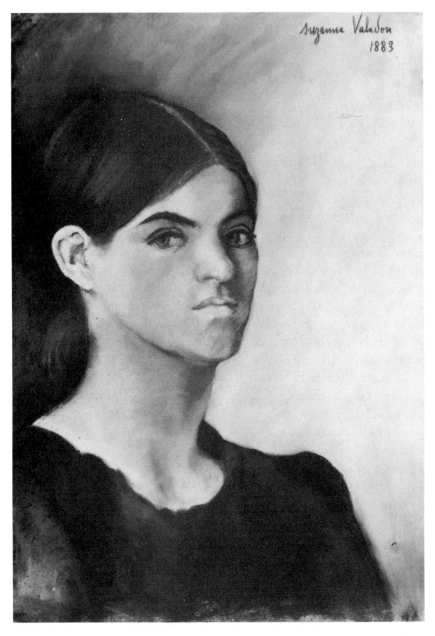

Self-portrait, 1883.
Valadon's first known work in pastel, an austere and unflattering self-portrait, shows a remarkable confidence and vitality for an untutored artist.

A son was born to Marie-Clémentine Valadon at lunchtime on 26 December 1883, Boxing Day. She gave him the name Maurice. The Valadons had moved lodgings more than once since they had come to Paris, and when the baby was born they were living in a flat at No. 7 Rue Poteau, a gloomy little street at the foot of the hill of Montmartre which had once housed a public gallows. Maria described herself as 'seamstress' on the birth certificate, a more respectable-sounding occupation than 'model'. 'Father unknown' was the bleak explanation of the other parent's identity.

Guessing the name of the baby's father passed the time for gossips in the bars and cafés of Montmartre, with a wide range of 'suspects': 'The Breton waiter at Père Lathuile's restaurant, the postman Leconte, Degas's young friend Zandomeneghi, the sailor Guichet' were mentioned as her lovers. The opportunities suggested were chuckled over too: 'a sudden disappearance in the forest at Fontainebleau, a rented room above the stationer's shop in the Rue Custine, a bacchanal necessitating a call by the police in the studio of Louis Anquetin [a talented art student and friend of Toulouse-Lautrec], such was the substance of her amours,' wrote one biographer.[14] The strongest probability was that Maria simply did not know the identity of Maurice's father. When asked she usually evaded the question or replied in vague terms.

Miguel Utrillo, Renoir, possibly Puvis were the likeliest candidates. Valadon herself apparently slipped in another, distinctly undesirable candidate, some forty years later through the first biography of her son Utrillo. The book was written by Adolphe Tabarant, who states positively that the defaulting father was a drunken insurance clerk, Adrian Boissy, who worked for the Arbeille insurance company, an 'incorrigible bohemian' who spent his nights drinking in the bars of Montmartre when he was not painting excruciatingly bad pictures.[15]

A later biographer elaborated. One Monday night, Maria was persuaded to join a group of students visiting the Moulin de la Galette. The Moulin changed character on Mondays, when gangs of thugs, pickpockets, prostitutes and drug addicts took over the premises and the usual clientele sensibly stayed away. Maria went along for a lark, but in an instant high spirits turned to panic. 'The lights went out. There were feminine screams and flying fists. A knife flashed. And she [Maria] found herself, terror-stricken and weak, in the arms of Adrian Boissy . . .

He bundled her off to his studio flat off the Place Pigalle. There he plied her with drink which she dared not refuse. And in the course of one frightful, hideous night, he cruelly raped her.'[16]

By the time Tabarant's book appeared, Utrillo was known both as a famous painter and as a hopeless drunk. The author states that Boissy's father was an alcoholic and his mother committed suicide. Valadon's critics suggest that Boissy's name was introduced to protect Valadon from the charge that she, as a mother, was responsible for the terrible curse on the boy.[17] That cold December afternoon when Maurice was born, Boissy offered Pernod all round at the Lapin-Agile, drank himself into a stupor and finally passed out. After that he also bowed out of the Valadons' life.

In the little room in the Rue Poteau, Madeleine and Maria were intent on feeding and clothing the baby. To both women it seemed natural that the infant should be cared for by his grandmother. That was, after all, what had happened to Maria when she was a baby. As a model she could earn quite well, especially when she got her figure back and could pose in the nude. Her mother was shrewd enough to realise that even a beauty, especially a beauty with a child, stood more chance of finding a husband if she left the confines of the home.

As soon as she was fit, Maria took up her old life, modelling in the day and going on to studio parties and cafés. Her friend Zandomeneghi had moved to a tall, newly built, four-storey house in the heart of Montmartre, on the corner of the Rue Tourlaque and the Rue Caulaincourt. Through the Italian, Maria and her family managed to find three rooms on the first floor where Zando lived. Maria must have been assisted with the rent by one or more of her friends, possibly Puvis or Miguel Utrillo. Family expenses had increased and income diminished, since Madeleine was no longer earning. The new house, full of struggling artists and art students, was a more congenial setting for Maria, and the extra space made it possible for her to draw with a modicum of privacy. No work survives from 1884, the first year of her son's life, but the rebellion in the art world that year was to have a profound effect on her future.

Attempts had been made under the Third Republic to liberalise the Salon, the official art exhibition. In 1881 the state had finally abandoned its supervision and the selection of paintings was delegated to a jury made up of those artists who had exhibited in the Salon. But too many

members of the jury re-elected their old cronies, including academics from the École des Beaux-Arts. Year after year rebel painters with a fresh approach found a large 'R' on their canvases.

Those painters now regarded as geniuses in our century – Cézanne, Monet, Renoir – were rejected or deliberately 'skied', their paintings hung so high on the walls as to be virtually invisible. In 1881 Monet had one painting accepted by the Salon and a second rejected, while two of Renoir's works were hung in the Salon. But both painters protested to the Minister of Art at the poor display of their work and Monet never again submitted his work to the official body. Renoir, with an eye to business, justified his decision to attempt to please the Salon jury in a letter to his dealer. 'There are in Paris scarcely fifteen art-lovers capable of admiring a painting without Salon approval,' he wrote; 'there are eighty thousand who will not buy even an inch of canvas if the painter is not in the Salon.'[18] Cézanne hoped vainly all his life for acceptance by the Salon, believing that it was the only way to convince the people of his native Aix that he was a serious artist.

The opening of the Salon each May was an important date in the society calendar. The president and his entourage, solemn, top-hatted gentlemen in frock-coats, sporting their medals, arrived in the morning. Until lunchtime they processed through the iron and glass buildings of the Palais de l'Industrie, modelled on the Crystal Palace, in an aura of self-congratulation as they passed the paintings and large sculptural figures in bronze or white marble. After a fortifying lunch of salmon and tournedos, the presidential party returned to open the exhibition to a favoured audience of Parisians, eminent artists who lived in splendid apartments in the seventeenth arrondissement with studios like great banqueting halls, and ladies in large hats with their grave escorts, more interested in seeing and being seen than looking at the new work. Although the opening of the Salon was a society occasion, more and more people from all classes were beginning to visit the exhibition during the summer. On Sundays particularly, when entry was free, a stroll round the Salon became a form of popular entertainment and in 1884 nearly a quarter of a million visitors passed through the Palais. Puvis de Chavannes's *The Sacred Wood* was the triumph of the Salon that year and Maria was proud that she had posed for so many figures in it.

In Paris the number of art schools both for men and for women was growing and naturally the students poured into the Salon to view the

year's offerings and pass their judgement. One mischievous young art student, the Comte Henri de Toulouse-Lautrec, was particularly intrigued by Puvis's masterpiece. At nineteen, Henri was already the monitor of the students who worked under the supervision of Fernand Cormon, a successful painter, popular with his pupils because he allowed them to embrace new ideas. Henri preferred the work of the Impressionists to the high art of the Salon and he found Puvis's work pompous and pretentious. He persuaded a group of fellow students to make a parody of the great work, to prove that *The Sacred Wood* was merely a modish landscape, easy to ridicule. The young men profaned the sacred wood, peopling it with fashionable painters, a gendarme closely eyeing the scene and Lautrec himself, his back turned on the Muses, apparently relieving himself. Toulouse-Lautrec signed the parody – his own gesture of rebellion against the Salon. He was enjoying his first taste of freedom from family protection. His mother, the Comtesse Adèle de Toulouse-Lautrec, had decided somewhat reluctantly to leave her son in Montmartre with friends while she settled into her new château at Malromé, in the vine-growing country near Bordeaux.

Rebellion was rife in the art world that year. In May 1883 a new independent Salon had opened its doors to the work of hundreds of talented young painters and sculptors who had been rejected by the official body. Modern painters had already gone beyond Impressionism, experimenting with new forms and groping for new content. Odilon Redon, the most striking of the artists to be labelled Symbolist, was striving to express a new mood of mysticism rather than to create optimistic paintings of summer sunlight. A friend of the poet Paul Verlaine, Redon often conceived his haunting dark images as illustrations to poems. The artist gave himself up to fantasy and nightmare and anticipated Surrealism by more than forty years. 'Everything takes form when we meekly submit to the uprush of the unconscious,' he wrote, and added: 'While I recognise the necessity for a basis of observed reality . . . true art lies in a reality that is felt.'[19] His beautiful hallucinatory drawings were too much for the jury of the official Salon and Redon became a founder member of the new independent Salon.

Georges Seurat, another leading rebel, was attempting to extend the boundaries of realism rather than delve into the psyche. Seurat

studied the properties of colour scientifically and evolved a new technique. He broke down the colours in nature into their constituent elements and juxtaposed tiny dots of pure pigment straight on to the canvas instead of mixing them first. At a distance the tiny dots would optically fuse together so that the viewer would glimpse the effect of light and shade of the sun on water or of a shadow on grass. To the jury Seurat's startling landscapes of dotted colour and Redon's perversely beautiful charcoal drawings of monsters were equally unacceptable. But in the new anti-Salon Salon, the Groupe des Artistes Indépendants, as their name implies, would accept dissimilar artists united only by a desire to show their work to the public, free of juries, cliques and prejudice.

The new group held their first exhibition in a wooden shed in the Tuileries Gardens in May 1883, with Odilon Redon acting as chairman of the self-appointed committee. Their first effort was a shambles. As the administrators had no notion of business, scandals and quarrels erupted: one committee member charged expenses for a fishing rod, another charged for a bribe to a concierge, and the treasurer threatened to shoot members who demanded a financial statement. After three weeks the exhibition closed and a new, more solidly based organisation was formed, the Société des Artistes Indépendants. Membership was open to all; the Salon had no jury; artists working in the same vein were exhibited side by side.

From December 1884, the Salon des Indépendants grew both numerically and in importance and for more than forty years represented every trend in modern art from Pointillism to Fauvism and Cubism. The new Salon banished the snobbery and artificiality of much of the high art of the past. To Maria Valadon, a self-taught artist with no professors to recommend her, the Salon des Indépendants offered a glimmer of hope.

In 1884 Henri de Toulouse-Lautrec, already known as a caricaturist by fellow students, was on the lookout for potential markets, noting that magazines and journals often printed the work of unknown artists. He was staying in Montmartre with René Grenier, a wealthy dilettante and fellow student, and his beautiful wife Lily. Lily Grenier, a country girl who had once been a model for Degas, was admired by all the students including Lautrec. At home with the Greniers he revelled in games of dressing up – as a woman, a Japanese and a choirboy. But despite

reassuring letters to his mother the Comtesse, telling her that he found the Montmartre cafés boring and preferred to stay at home, Henri relished the riotous night-life of the quarter. In the dance-halls and on the streets he noticed girls he longed to paint and he was particularly captivated by the laundresses and midinettes, working girls with strong arms, free and unchaperoned. Every human curiosity could be found on the streets of Montmartre and Henri noticed with glee a dwarf, a Monsieur de la Fontenelle, a young man much smaller than himself; he regularly stopped to talk to him.[20] Lautrec once told Gustave Coquiot, the critic, that he 'longed to find a woman uglier than himself so that he could breed a monster'.[21] Indeed, as his art reveals, he delighted in *jolies laides*, talented, fascinating, unusual young women.

That he was ugly, almost grotesque, was undeniable; his nose was large and bulbous, his lips thick and flabby and his chin covered in a black stubbly beard. He was a little less than five feet high, his body normal-sized but with short, knock-kneed legs and powerful truncated arms with crabby fingers. Lautrec was afflicted with a rare disease associated with inbreeding, pyknodysostosis, which stunts the growth of arms and legs in adolescence. In the streets he cut a strange figure, hobbling unsteadily on stubby legs with a stick which had been hollowed out to hold a glass container, filled up each day with brandy or absinthe. Even indoors he wore a low bowler hat and peered short-sightedly through his pince-nez. Lautrec usually wore black-and-white checked trousers that exaggerated his odd looks. Yet he radiated vitality and a piercing intelligence, and it was not only his title and aristocratic airs that attracted women. The wags of Montmartre nicknamed him 'the coffee spout' and he prided himself on his sexual drive.

His own father was a roué, who lived apart from his wife in order to satisfy his omnivorous sexual appetite, eccentric to the point of exhibitionism. Even as a very young man, Henri observed the oddities of society with an ironic detachment, inoculated against moral indignation despite his mother's piety. But his affliction had made him acutely sensitive to other people's reactions and he saw through pretension and sham. Fortunately he possessed enough charm to allow his friends to ignore his disability and recognise both his talent and his kindness to those whom he grew to trust.

In Cormon's studio, Toulouse-Lautrec and a close friend of his, Louis Anquetin, led student opinion. Great things were expected of Anquetin,

the boldest and most innovative of the students in his experimental work. The son of a butcher, the large, handsome, broad-chested young man was welcome in the most progressive cabarets of Montmartre. Henri rarely went out alone and was grateful for Anquetin's burly, reassuring company.

To this day Lautrec's name is linked with that of Aristide Bruant, the poet-singer in the broad-brimmed black felt hat and flowing red scarf of Lautrec's poster. Bruant first made his name at the Chat Noir, bawling out songs of the underworld, about prostitutes, pimps, rag-pickers and thugs, to audiences almost hysterical with enthusiasm. In 1885, when Rodolphe Salis, the Chat Noir's flamboyant proprietor, moved in torchlit procession to larger premises in the Rue Victor-Massé accompanied by banners, drums and waiters in uniforms of the Academy pushing handcarts, Bruant took over the lease of No. 84 Boulevard Rochechouart. He opened a rival cabaret on the premises, renamed it Le Mirliton (The Reed-Pipe), and adopted many of Salis's ideas, inviting clever young artists to redecorate it.

Bruant advertised his cabaret as 'the place to visit if you want to be insulted' and lived up to his word. He swore at his clientele individually or collectively when they came in, describing them as *cochons* (swine) or *un tas de salauds* (a bunch of louts). With his coarse, louche and sometimes sentimental songs, he knew how to appeal to the customers: before he began to sing, he would glance round disdainfully at his chorus: 'As for you, herd of camels, try to bray together, will you?'[22]

In his twenties Toulouse-Lautrec became friendly with the older painter, Federico Zandomeneghi, who had exhibited at all the Impressionist exhibitions, and for a time was influenced by Zando's work. In the spring of 1886 Lautrec's family gave him an allowance which enabled him to rent a studio, separate from his lodgings. It seems to have been the ubiquitous Zando who arranged for the young man to rent rooms in the building where both he and Maria Valadon lived. Henri took a huge room on the fourth floor for his studio. On the floor below, his father, the Comte Alphonse de Toulouse-Lautrec, stored his collection of armour, furniture, antique art and bric-à-brac which his son secretly despised. A narrow iron staircase from Henri's studio led up to a small attic where François Gauzi, another student from Cormon's atelier, lived. Zandomeneghi occupied the ground floor and Maria, her mother and the baby the first. Rumour reports that Lautrec had met

Maria at a wild studio party in the early 1880s. He certainly painted her in 1885.

At that stage in his career it was difficult for Lautrec to find a model with an established reputation, so he was delighted to be so close to an attractive girl he admired. Toulouse-Lautrec drew and painted Maria several times.

In the mornings he usually went to Cormon's atelier and worked in his studio in the afternoons. If the weather was fine, Lautrec often painted in a wild garden at the back of the Boulevard Clichy owned by an elderly photographer, le Père Forêt. Occasionally the old man would come down to practise archery in his garden, but otherwise Lautrec and his model were secluded in the long grass, shaded by lime trees, plane trees and the lilac bushes that Maria loved. Lautrec was considerate to his models, and when they broke for a rest there was wine from the family's country estate and goose pâté from home. In 1885 he painted Maria out of doors in a butterfly hat with a veil, looking severe and tight-lipped, curiously anonymous, her face a forbidding blank. In his portrait Maria appears much older and more sophisticated than her twenty years. Although Lautrec was the elder by ten months, Valadon had known so much more of life as a working girl and a mother that she appeared to him more worldly than she was. Lautrec still depended on an allowance from his wealthy family for his existence.

Maria's circus background appealed to Henri. His father had taken him to the circus as a child and in Montmartre he often visited the Cirque Fernando. He prepared a huge canvas and invited Maria to pose as a rider on the saddle of a horse about to jump through a paper hoop held by a clown. Henri had to perch on a nine-foot ladder to work at this circus painting, now unfortunately lost.

For a time a real friendship grew up between the two young people. In Henri's studio, art lost its pompous aura and became fresh and exhilarating. The room itself intrigued Maria. The parody of the painting she had posed for, Puvis's *Sacred Wood*, was pinned up, unframed, opposite the bay window. An old oak chest and an enormous easel dominated the room. Guests could squat on the huge divan or perch on footstools. There were also two chairs. The model's platform in the middle of the room was stacked with portfolios, magazines and tracing paper. On a table were heaped curios, a pair of dumb-bells, a game of ball and peg, boxes full of Japanese trinkets including a lacquered Samurai helmet that Henri particularly treasured. Among the

jumble of papers was a fine Hokusai print and photographs of paintings by Uccello and Carpaccio. Near the door stood a table stocked with a connoisseur's variety of drinks and spirits.

Encouraged by Lautrec, Valadon began to browse among his books, and the selection she borrowed is revealing. On one occasion she took home Friedrich Nietzsche's *Genealogy of Morals* and Ludwig Büchner's *Force and Matter* as well as the poems of contemporaries who appeared at the Chat Noir, Maurice Rollinat and Jehan Rictus, and of Baudelaire. Toulouse-Lautrec, with his eccentric background, was probably the least class-conscious artist she had ever met; through him she gained an invaluable introduction to literature and art, and to a human menagerie of Montmartre types.

Everyone assumed that they were lovers: Henri had a keen sexual appetite and Maria had seen too many bizarre sights on the streets of Montmartre and at the circus to be shocked at his appearance. It is difficult to say for certain, because all the stories about Henri's 'romance' with Maria come from his friends. 'He chased me,' she told a young art student, Geneviève Camax-Zoegger, at least forty years after she had modelled for Toulouse-Lautrec.[23] But whether he caught her was a question Valadon left open. On balance it seems probable that they were lovers, the opportunities were so inviting. Maria admired Lautrec for his skill as an artist and enjoyed his biting wit; for her, at that stage, sex did not need to involve deep feelings. Henri, according to friends' accounts, was at least infatuated if not in love: 'Lautrec may have been too demanding a lover . . . if Maria disappeared for several days, Lautrec would become anxious, then distracted, and end by accepting the most improbable explanations and then forgiving her.'[24]

Lautrec's friend François Gauzi was convinced that Henri was obsessed by Maria and that she led him a fine dance. One afternoon when Gauzi was painting in his studio in the attic at the top of the building, he heard an urgent ring on the doorbell. Henri stood outside pale and anxious.

'Come quickly,' he said. 'It's Maria and she is threatening to kill herself.'

'Oh, it's just one of her jokes,' Gauzi replied in disbelief, but he saw his friend's distress and walked down with him to the first floor, where they heard raised voices.

'You've made a fine mess of it!' Madeleine was shouting. 'You've frightened him away and he won't come back now. Fine progress you've made.'

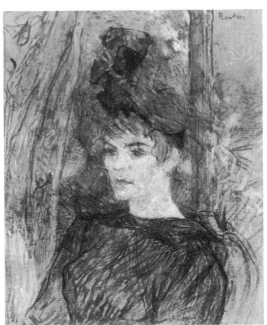

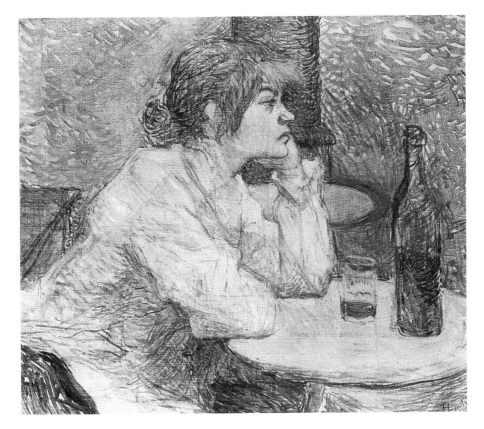

ABOVE This amusing double photograph of Toulouse-Lautrec was composed by the artist himself.

OPPOSITE Toulouse-Lautrec trawled the most expensive milliners' in Paris looking for creations for Valadon.
ABOVE LEFT The reality, Valadon in 1885.
ABOVE RIGHT Lautrec's interpretation: *Madame Suzanne Valadon, artiste-peintre*, 1885.
BELOW *The Hangover*, 1889.

Lautrec always represented Suzanne as a severe, almost intimidating figure. After they had drifted apart he drew her as a drunk – but still a formidable woman.

The women were apparently discussing a plan to trap Lautrec into marriage and he was understandably hurt and humiliated. 'On leaving me,' Gauzi wrote, 'he probably went back to his studio and lay down on the divan, lost and miserable, shaking with sobs.'[25] Gauzi, of course, was no impartial witness. Maria had modelled for him too, and there is no means of knowing what had passed between them.

Perhaps Henri as a young man suffered more frustration than his outward swagger suggests. An unpublished drawing of Lautrec's lovely landlady, Lily Grenier, the full-breasted wife of his friend, performing fellatio on him, while the artist reclines fully dressed on a couch in blissful concentration, may well be a fantasy.[26]

In a letter to his mother dated spring 1886, he is clearly trying to make light of his distress and convince himself that he needed his model for purely professional reasons:

> My dear Mama,
>
> My tonsillar troubles are ended but my model is threatening to leave me. What a rotten business painting is. If she does not respond to my ultimatum the only thing I can do is to bang out a few illustrations . . . [27]

When Maria was with him, Henri enjoyed introducing her to his friends. She was tiny, one of the few women who did not look down on him, and he liked her to play hostess at the Sunday afternoon 'at homes' he held. As his guests arrived, Lautrec greeted them wearing a large white apron, with a towel over one arm. An American friend had taught him to shake cocktails and he produced the most outlandish mixtures often in primary colours. *Le Gin Cocktail* (1886) was the very first illustration of his that was published.[28]

The talk at the parties was brilliant, the food, cooked by Maurice Joyant, a former schoolfriend and amateur chef, superb. Lautrec, for reasons that one can only guess at, encouraged his guests to drink spirits or wine by putting goldfish in the carafes of water. The drink loosened tongues and the atmosphere of the studio became too wild for one or two of the guests. Young Émile Bernard, a talented seventeen-year-old student from Lyon, was shocked by the conversation 'peppered with obscenities', the joking and womanising and the assortment of visitors. As well as the most gifted young artists in Paris, hangers-on from bars and 'bad places' turned up.

The dancer La Goulue was a favourite of Henri's, and Bernard remembered meeting her there. She was famous even before her meteoric career at the Moulin Rouge for her plump pert looks, her graceful dancing and her gross appetite. Her real name was Louise Weber; her nickname literally means 'the Glutton'. La Goulue, like Valadon, had been a laundry girl and a model. When she danced she possessed the crowd, and Jean Lorrain, a brilliant journalist who spent five years in Montmartre in the 1880s, described her vividly:

> La Goulue! Springing out of a tumbled froth of swirling lace and expensive undergarments trimmed with delicately coloured ribbon, a leg appears, pointing straight up . . . a leg held stiff and straight, gleaming silkily, clipped above the knee by a garter of diamonds; and the leg quivers, witty and gay, voluptuous and full of promise, with its mobile disjointed foot seeming to wave to the packed throng of onlookers all round . . . the star of Montmartre risen in the moonlight . . . and the ghostly sails of long-gone windmills, a tinsel glory both freakish and sordid, a gutter bloom caught in the beam of electric light and suddenly taken up by fashion.[29]

In the evenings Toulouse-Lautrec, often accompanied by Maria and Anquetin, visited the Mirliton. His excursions to the night haunts of Montmartre were of practical value to the young artist. The cafés provided him with marvellous subjects and at the Mirliton Bruant hung his paintings. Lautrec drew a number of covers for Bruant's magazine, the most famous of them a portrait of a prostitute at Saint-Lazare prison wearing a grubby white matron's bonnet with strings, the bonnet which marked out women with venereal diseases, writing a letter to her pimp. Among the hotchpotch of papers in his studio, a letter from a young woman convict in Saint-Lazare to her pimp revealed how carefully Lautrec researched his subjects.

Valadon continued to absorb a broad education. At the Mirliton Lautrec would usually drink only weak beer but he liked to stay out late. Often he and Maria would go on to the dance-hall L'Élysée Montmartre, trying to get in without paying, just for fun. After switching to red wine or absinthe, they bowled home in a taxi at two in the morning. Even Lautrec, who had extraordinary stamina, would doze off on the way home. 'I've been having a very good time lately here at the Chat Noir,' he wrote to his mother in July 1886. 'We organised an orchestra and got the people dancing. It was great fun, only we didn't

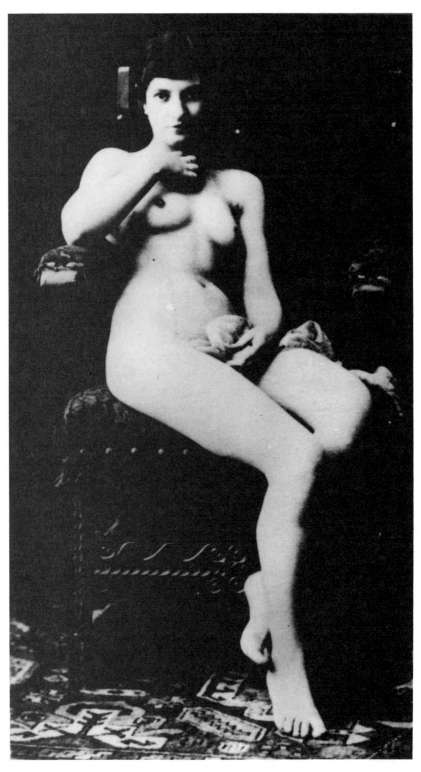

A rare photograph of Valadon, aged twenty-one, in an erotic pose.

get to bed until five in the morning, which made my work suffer a little.'[30] For Maria, who was of course modelling, the strain was greater. She had her mother and her son at home, both clamouring for her attention.

Toulouse-Lautrec was officially still head student at Cormon's atelier, although he now attended only sporadically. In the autumn of 1886 his interest was arrested by a new student, a gaunt intense man with red hair and pinched features, Vincent van Gogh. The two recognised each other's talent immediately. Van Gogh was impressed by the vitality of Lautrec's line, his effective use of colour and his clever observation, while Lautrec discerned the intensity and originality in Vincent's wild struggles to paint still lifes and Montmartre landscapes. Vincent became a regular visitor to Lautrec's on Sunday afternoons. In his thirties and disappointed with his own progress, van Gogh hoped to find encouragement and reassurance from the younger painters. Their indifference made a vivid impression on Valadon, who years later recalled:

> [Vincent] would arrive carrying a heavy canvas under his arm which he would place on an easel in a well-lit corner of the room, waiting for someone to notice him. No one was in the least interested. He would sit down scanning the others' faces and sharing little of their conversation. Eventually tiring he would leave, carrying the latest example of his work. Nevertheless he would come back the following week and use the same stratagem. Painters are such swine.[31]

No doubt as an artist as yet unrecognised she felt van Gogh's plight keenly.

Encouraged by Lautrec, the painter who had yearned to become a priest began to spend more time in the bars and cafés than studying in the studio; van Gogh had developed a taste for absinthe. The pair, with Maria sometimes accompanying them, would visit Le Tambourin, a cabaret and restaurant known for its excellent Italian food. Lautrec painted van Gogh's portrait at the restaurant, a man in a trance, haunted by a vision. La Segatori, an ageing beauty and former model from Naples, agreed to provide van Gogh with meals in exchange for his paintings and also posed for him nude. Bar gossip had it that van Gogh paid his dues to his model at night.

Lautrec enjoyed playing host to his bohemian friends and shocking the bourgeois whenever he had the chance. In 1887 he left the Greniers,

to move next door and share a flat with a Dr Bourges, a relative and friend. He invited Maria over to dine tête-à-tête one night. They were served dinner by Léontine, the faithful cook. While waiting for dessert, Henri decided to liven up the evening. 'Take off your clothes,' he said to Maria. 'It will be fun to watch Léontine's face when she comes in.' Maria stripped quickly leaving only her shoes and stockings on and sat at the table with an air of affected propriety. Lautrec rang for Léontine, who came in, gave a start of surprise and then served the dessert as if nothing had happened. But the next day she was extremely upset and complained bitterly to the doctor. Monsieur Henri had behaved very badly towards her, she said, and she was a decent woman, deserving of respect. Bourges was furious and reproved Lautrec. 'You behaved in a thoroughly indecent fashion,' he said. 'One must preserve a certain decorum in front of the servants. By all means undress your models in your studio, but see that they stay dressed over dinner. Léontine will leave us if you continue in this way.' 'But Léontine was quite wrong to be offended,' Lautrec replied gravely. 'She knows perfectly well what a naked woman looks like and I had only taken my hat off.'[32] This story, repeated in all the books about Lautrec, is of course told from his point of view – as are all the stories about the couple – and one longs to know her side of the affair. Whether Valadon, who was a proud woman, enjoyed her part in humiliating the cook remains in question.

Very little of Valadon's own work from those early years remains, but in 1885 and 1886 she made two drawings of her son Maurice. She drew a study of his hands, which look far too large for a two-year-old, and a head of Maurice in red chalk, a delicate and accomplished work. Not a tinge of the chaos in the artist's personal life can be found in the clarity and authority of her line. And in this drawing, at least, the criticisms of Maria as a callous mother who preferred to be out enjoying herself rather than caring for her son are contradicted by the tenderness in the work.

For a working-class woman to become a professional artist in the late nineteenth century was virtually impossible. There was no state education in fine art available for women and the expense of studying in a painter's atelier or in a private academy was out of the question for Maria. She had no encouragement at home and stumbled into the art world, impelled only by her urgent desire. Her liaison with Lautrec gave her a unique apprenticeship which she used intelligently. Valadon gleaned an idea of lithography from watching Lautrec make the initial

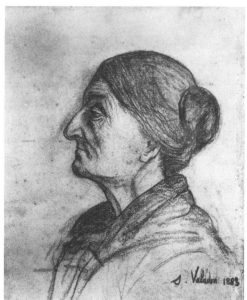

LEFT *Maurice Utrillo as a child,* 1886.
RIGHT *The Grandmother,* 1886.
A feeling of family pride and tenderness is self-evident in
Valadon's drawings of her mother and her infant son.
Maurice was brought up mainly by Madeleine.

drawing for his illustrations, then trace the outline to indicate the
partition of the different colours. When the drawing was photographed
and fixed to a metal plate, Lautrec worked on it again. She noted his
simplified drawing and use of heavy black outline to emphasise
character, his large oval palette which was never cleaned, and the narrow
range of colours he employed. When she went back to her room she
practised her drawing.

Maria in her twenties was no longer the awestruck adolescent who
had posed for Puvis, too timid to tell him of her yearning to become an
artist. Even if it is true that Lautrec discovered her drawings by accident
when he visited her rooms, it seems equally credible that she found the
courage to show him her work, as Tabarant suggests.[33] Henri was her
friend, her intimate and her own age. Fortunately he was a man of great
discernment and he realised at once that Maria possessed an
extraordinary natural gift. She showed him the portrait of Maurice aged
two and the confident drawings of herself and her mother.

'Are these your own work?' he asked her. 'Nobody helped you?'
Maria insisted sullenly that she had had no help.

Straight away Lautrec borrowed a few of her drawings and pinned them up on his wall, then showed them to his neighbours, Gauzi and Zandomeneghi, asking them for their opinions without telling them the artist's name. Both thought the work was good.

Lautrec was bubbling with enthusiasm and he and Zando decided that Degas must see Maria's drawings. That in itself was an enormous compliment: to the younger painters Degas was an idol, the one living artist Toulouse-Lautrec respected and admired. Lautrec marvelled at the sense of movement in Degas's work and was influenced by his arresting angle on contemporary life. Degas captured, as if with a camera, 'snapshots' of an acrobat high up in the big top clinging by her teeth, or a dancer fastening her ballet shoe. As a man Degas had a sour reputation for his biting wit and morose manners. Yet his advice was sought by dealers who bought modern work and he was known to champion younger artists.

Zandomeneghi was acquainted with Degas but he shrewdly suggested that they first approach Paul Bartholomé, a more intimate friend of the great man. Toulouse-Lautrec and Zando called on Bartholomé, taking Maria and her box of drawings with them. A painter who had not yet changed his course, Bartholomé was to make his name later in France as the sculptor of a huge First World War monument to the dead. When Bartholomé examined the drawings he too was astonished and enthusiastic. He agreed that Degas must see her work and wrote a letter of introduction.

Maria went to visit Degas in a state of high tension. She had heard that he was a misogynist who guarded his privacy fiercely, a bachelor in his fifties who lived with his housekeeper. Years later, in an interview with an art critic, she talked about that first meeting with Degas.[34]

Zöe Closier, Degas's middle-aged housekeeper at No. 37 Rue Victor-Massé, peered over her glasses hesitantly when she opened the door. During the day Degas shut himself up in his studio on the top floor of the house and Madame Closier knew he hated to be disturbed. But the sight of Bartholomé's familiar writing reassured her and she called Monsieur Degas. He came down, neatly dressed, and looked quizzically at the beautiful young woman, whom he had already noticed modelling

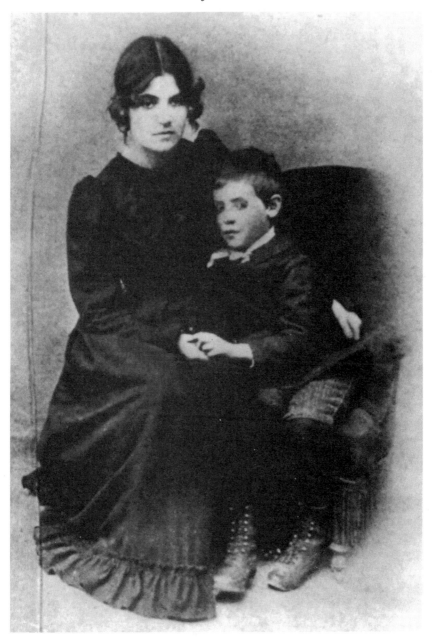

With Maurice in 1890. Not yet seven, her son was
a delicate and moody child. In this photograph he seems
to snuggle for safety into his mother's lap.

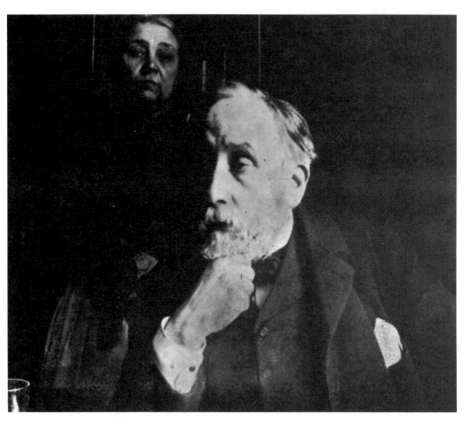

Edgar Degas and Zöé Closier in the 1890s. Zöé, Degas'
housekeeper, not only cooked and cleaned for the artist, she
also read the newspaper to him as his sight was failing.
BELOW Degas, *After the Bath*, c. 1890–1892.

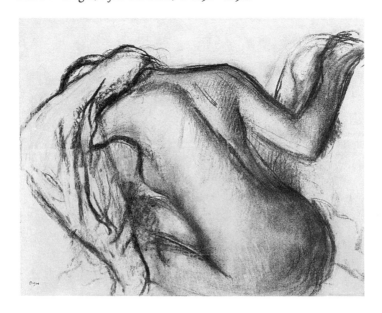

in Montmartre. Without speaking he accepted the portfolio of drawings she offered him. Then he settled down to concentrate on the work.

Degas's own art was imbued with a study of the past, and he was wary of self-taught artists. For years he had experimented with different forms – drawing, painting, sculpting, print-making, even photography – always seeking perfection, loath to part with his work, which he always considered unfinished. A complex man, he had a passion for drawing and his own collection included works by Ingres, Delacroix and Hokusai as well as many moderns.

'He showered me with praise,' said Valadon after the ordeal was over.

That afternoon Degas neglected his own work, talking and listening to Maria. He was amazed that a girl from her class, a model, could work with such dedication and flair, and asked her how she could afford artists' materials. By the time she left, dazed with joy, Degas had bought his first Valadon, a drawing in red chalk of a girl getting out of the bath titled *La Toilette* but undated. He hung it in his small dining-room. 'You are one of us,' Degas told her.

'That day I had wings,' she said.[35]

4

The Joy of an Artist

From the day that she met Degas, Valadon's status changed. She still earned her living as a model but she could now take herself seriously as an artist and work at her drawing openly. Degas's active daily encouragement buoyed her up: 'I was accepted as one of the household . . . I called every afternoon. Often I met Bartholomé, who was an inseparable friend, also Rouart [Henri Rouart, an industrialist with a fabulous collection of paintings, and a childhood friend of Degas] . . . If I happened to miss a few days, his housekeeper would come to my place to remind me . . . The excellent, honest Zöé, her eyes were so beautiful and gentle, as beautiful as Degas's. She must have been a provincial beauty, sturdy and sound. I can see her now, coming and going, keeping a watchful eye on everything.'[1]

A curious bond grew up between Degas and Maria. She was in her mid-twenties; he was over thirty years older, the son of a wealthy banker with family connections to the Italian aristocracy. The ageing bachelor was disarmed by Maria's talent, her candour and her grace of movement. More than anything, he admired her uncompromising dedication to her work. 'You have to be hard on yourself' was her motto and he well understood it. Degas liked to appear hard and cynical, but in secret he could be an affectionate and generous friend. In October 1890, about the time that Maria first met Degas, he wrote a conciliatory letter to an unsuccessful painter friend: 'In the course of our long relation on the subject of art, I have been, or have seemed to be, hard with you . . . I was particularly hard on myself . . . because of a sort of passion for brutality in me, which sprang from my doubts and bad humour.'[2]

'I was never Degas's model, although that story was repeated a hundred times,' Valadon insisted.[3] When a critic voiced what many were

thinking and asked her if she had been Degas's mistress, she said candidly that she would have slept with him out of gratitude, but Degas, who was rumoured to have contracted syphilis in his youth, was afraid of women.[4]

Despite the great difference in age and class, the two gradually became colleagues who respected each other. In the cultivated atmosphere of Degas's large studio, Maria absorbed an increased understanding of the ways in which artists created their paintings. In his studio Degas kept swathes of material of different colours and texture for background, an impressive collection of ballet shoes and tutus, a zinc bath and a violin. As for Degas, Maria brought freshness and youth into his crusty bachelor life. Although she did not model for him, he undoubtedly captured the essence of Maria's gestures and expression in his art, for he always emphasised the importance of working from memory as well as imagination. He liked her to tell him the gossip and news of the young artists, and one day he questioned Maria about Toulouse-Lautrec. 'They say he is painting a little in your clothes,' Maria replied. Lautrec was beginning to exhibit works on Degas's themes – the music-hall, the *café-concerts*, dancers and musicians – and to work from unusual angles to highlight movement. 'He may borrow my clothes, but he'll have to cut them down to size,'[5] Degas retorted, with a flash of that acid wit that made him feared in artistic circles.

Now that Maria was a favourite of the one painter he admired, Lautrec would not have been human if he had not felt a twinge of envy. His own admiration for Degas showed itself in an extravagant display of hero worship. One night Lautrec invited a party of artists to a lavish dinner in Montmartre. When the meal was over, the host 'silently signalled the company to follow him to the Rue Frochot and up the three flights of steps which led to the Dihau family's apartment. Scarcely stopping to greet Dihau, Lautrec guided his guests to the portrait by Degas of the musician playing his bassoon in the orchestra and announced triumphantly: "There's my dessert!"'[6]

Since Valadon lived in a legendary era, the stories about her and her famous men friends are inconclusive and sometimes contradictory. How long Maria and Henri remained intimate is therefore unclear, although François Gauzi wrote that Toulouse-Lautrec quarrelled finally with Maria after overhearing the plot to trap him into marriage.[7] Without firsthand documentary evidence and dates, however, the most valuable clues to their relationship remain the artist's portrayal of his model.

Between 1887 and 1889, Lautrec painted Maria in a work entitled *Poudre de riz*. The tin of face powder in the title stands on a table in front of her, while Maria herself is seen as a *demi-mondaine*, full face, her hair caught up in a chignon at the back, with a small fringe in front. Maria's strong, dark eyebrows almost meet in a frown, her eyes look appraising and wary, her mouth is firmly set, her whole expression challenging. Since Maria hated make-up and any kind of artificiality, the choice of subject seems perverse.

The third painting he made of her is even more unflattering. In *Gueule de bois: la buveuse* (*The Drinker* or *The Hangover*), Valadon sits slumped, her elbows resting on the table, her hand under her chin, a bottle of wine, half empty, beside her glass. Lautrec painted Valadon in profile, a sullen curve to her mouth, her retroussé nose coarsened; yet he gives her a latent strength in her long straight back. Although the room is topsy-turvy, a picture on the wall askew, one would not be surprised to see this 'drunk' jump up and straighten herself. In all three portraits Lautrec shows Maria with a blank-faced stubbornness and sophistication, almost as if the artist feels thwarted and frustrated by his model. As well as the painting Lautrec made a drawing of *The Drinker* which was published in *Le Courier Français* on 21 April 1889.

Toulouse-Lautrec is credited with finding Valadon her professional name as an artist. 'You who pose for old men,' he sneered, 'you should call yourself Susanna.' He was apparently making a witty allusion to the 'chaste Susanna' of the Apocrypha, the faithful wife spied on by two elders when she was bathing in her garden. The two old men lusted after Susanna and when she repelled their advances they falsely accused her of adultery. This subject had been popular in French painting since the Renaissance. Perhaps Lautrec had Gustave Moreau's painting of Susanna, holding a towel discreetly to hide her sex, specifically in mind. In French the name Susanna is Suzanne, and the artist signed all her works 'Suzanne Valadon' or 'S. Valadon'. Strikingly, in her signature, she writes her surname Valadon more firmly and in larger letters than her adopted name Suzanne.

The evidence suggests that Valadon signed and dated her early drawings years *after* she had produced them. In her self-portrait of 1883 she signed herself 'Suzanne Valadon' although she had not yet met Toulouse-Lautrec and adopted the new name he suggested. That year she had also drawn her mother and titled the drawing *The Grandmother*,

but Valadon did not give her mother a grandson until 26 December 1883. It seems probable that it was only when she first came to exhibit her work that she signed and dated it.

In 1885 Valadon turned twenty and until she was almost thirty her life remained confused and chaotic. No work between 1886 and 1889 seems to have survived. She was living very fully, modelling and caring for her little boy when she could. Maurice was a delicate child, given to fits and sudden, uncontrollable tantrums. An early photograph, taken with his mother when he was five or six, shows him shrinking nervously into her lap as he peers out at the camera. His grandmother, Madeleine, adored the child but often felt at a loss with him. According to Valadon's family, Madeleine gave the little boy sips of wine to calm him.[8]

Valadon made several drawings of her son naked – crouching in an awkward position, or stretched out sleeping. That in itself was a novelty, since children were idealised in drawings and paintings, pictured in their best clothes looking cherubic. Even then Valadon's interest in the body's expression and the individual anatomy of each human being was apparent. Maurice was to become a favourite model: her son's 'skinny body and air of suffering' moved her, she said. 'He already had the forehead of a poet and a lost look.'[9]

The artist was struggling with the problems of combining motherhood with a career and a life of her own at a time when technology promised to change the daily lives of men and women almost beyond recognition. Paris celebrated the centenary of the French Revolution in 1889 in an orgy of commercialism. An International Exhibition opened in May, and thousands of Parisians, provincials and foreign tourists crowded the streets. Guns fired, flags flew and brilliantly coloured fireworks fizzed in the sky. The star attraction – Gustave Eiffel's iron tower, at 300 metres (1,000 feet) the tallest building in the world, erected for the occasion – proclaimed the supremacy of Paris. Although educated taste in the city professed to find the new edifice a blemish on the skyline, to dine on the platform of the tower and look down at the city's silhouette glowing in the setting sun became a fashionable pursuit. Scientific invention dominated the Exhibition. The vast Hall of Industry was filled with machinery, and the Thomas Edison Pavilion drew the crowds in their millions to see the workings of his telephone and telegraph key. At night, Edison's new miracle, the incandescent bulb, brilliantly illuminated the main buildings.

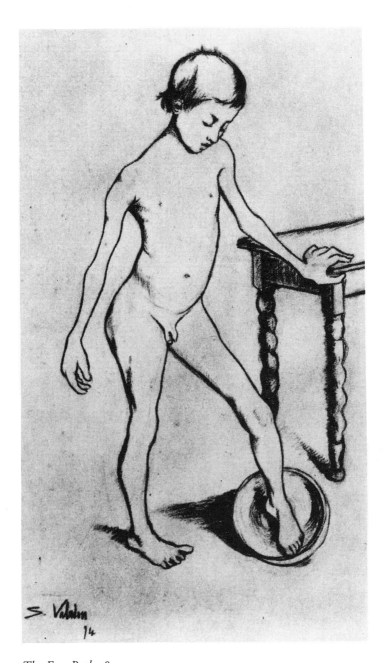

The Foot Bath, 1893,
No doubt Degas saw this drawing of Maurice as
an example of the 'wicked and supple' line he so
admired. He bought it and was to collect twenty-six
of Valadon's drawings and etchings in all.

If science was in the vanguard at the noisy World Fair, fine art limped behind. An exhibition at the Palais des Beaux-Arts claimed to represent the best of French art in the last century, but only the earlier works of the Impressionists were included and contemporary art was barely acknowledged. The defiant new generation, challenging the Impressionists and struggling to free itself from the limitations of the realism of the previous generation, was excluded altogether.

One of the most original among them was Paul Gauguin, who with a group of fellow artists including Émile Bernard had been working at Pont-Aven in Brittany. The group practised Gauguin's theory, painting flat areas of strong colour to enhance the dramatic power of their work, rather than reproducing objects realistically. In their search for a primitive mode, they used bold outlines to form rhythmic patterns. When these artists submitted canvases to the art section of the International Exhibition and their work was rejected, they decided to mount a challenge to official taste. By chance the opening of the Café Volpini in the grounds of the Exhibition was delayed by the failure of a delivery of gilt mirrors for Signor Volpini's rooms, and the café proprietor was persuaded to fill the spaces on his red plush walls with modern paintings. The show that opened in Volpini's café in June was dominated by the powerful canvases of Gauguin.

A man in his forties, Paul Gauguin had thrown up his career as a stockbroker, abandoned his wife and children and had travelled to Martinique in his quest for an ideal setting for his passion for painting freed from the traditions of Western art. Driven home by illness and poverty, in 1888 Gauguin had spent a disastrous two months in Provence with van Gogh which culminated in the famous attack and self-mutilation by the Dutchman.

The modern work shown at the Café Volpini had little appeal for the public, who were still hostile to Impressionism, but for younger painters it was important. They were attuned to a mystical, quasi-religious mood in painting and poetry, a reaction to scientific materialism, which drove painters to attempt to blend states of mind and dreams with their perception of the outer world: 'By arrangements of lines and colours,' Gauguin wrote, 'using as pretext some subject borrowed from human life or nature, I obtain symphonies, harmonies that represent nothing absolutely *real* in the vulgar sense of the word.'[10]

For Suzanne Valadon it was the brooding landscapes, the savage simplified forms outlined in black and the brilliant use of colour of Gauguin and his followers that intrigued her. She admitted years later that she had used those techniques in her work 'without a trace of aesthetics or artiness'.[11] Florent Fels, a contemporary critic, tried to prove that Valadon had modelled for Gauguin: he even reproduced a portrait that he said was of her, but his argument is not convincing.[12]

Despite the official disregard of artistic innovation, the International Exhibition of 1889 proved a stunning success, attracting 33 million visitors from all over the world. Among them was Miguel Utrillo, who had left Paris six years earlier and now returned to the capital to review the Exhibition for several Spanish newspapers. He lodged for a time with a group of Catalan artists in the room above the Moulin de la Galette. A painting of him by his friend, Santiago Rusinol, reveals Miguel as quite the dandy, with a wing-collar, soft hat, suit and stick, dignified and reflective. Miguel stayed on in Paris as art critic of the leading Barcelona newspaper, *La Vanguardia*, still haunted by the dream of Montmartre. Through the network of the quarter he found Maria Valadon again and they resumed a close, quarrelsome intimacy. Miguel drew her looking thoughtful and somewhat severe, wisps of hair escaping from her bun, with the caption 'In Memory of the Seven Years War'. The 'war' ended in 1890 with Miguel living on the Boulevard de Clichy, not far from Maria's home.

Since Toulouse-Lautrec had his studio in the house where Maria lived, he knew of her friendships with other men, but by then he was a man-about-town, with many women friends, including La Goulue. In 1889 Toulouse-Lautrec had exhibited at the Salon des Indépendants and was soon to make his name as poster artist and painter at an outrageous new attraction in Montmartre, Le Moulin Rouge. The pleasure palace, the size of a railway station, advertised itself as the 'rendez-vous du high life' and cast a red glow in the sky with its four illuminated vanes revolving above the entrance. Inside, cancan dancers kicked their legs high, exposing silk petticoats to the din of brass and cymbals blaring out the tunes of Offenbach. Spectators stood on raised platforms around the main dance floor to watch the girls. 'Male customers were quickly invited to buy drinks by ladies gaily dressed in many colours with huge feathered and be-flowered creations on their heads,' a young Englishman, C. B. Cochran, observed.[13] Outside, a huge papier-mâché

elephant with a fair booth in its belly towered beside the stage. The Moulin Rouge, 'the biggest market for love in Europe', vulgar, blatant and hugely successful, proved a natural home for Lautrec's talent. His brilliant paintings and lithographs decked the lobby and linked his name to the cancan dancers and the revellers who frequented the pleasure market. The English art student who visited Paris in 1890, William Rothenstein, was struck by Lautrec's apparent callousness. 'Lautrec', he wrote, 'seemed proof against any shock to his feelings . . . He wanted to take me to see an execution; another time he was enthusiastic about operations before clinical students and pressed me to join him.'[14]

The gross commercialism of the Moulin Rouge pushed up prices in Montmartre and in time made it impossible for artists and artisans to live in the immediate district. The opening of the Moulin Rouge also heralded a period of more systematic exploitation of sex on the lower slopes of Montmartre. The night spots competed to satisfy the public's appetite for 'sin'. Guests were invited to enter *L'Enfer*, Hell, through a huge, gaping devil's mouth. Above the entrance naked women plunged into cardboard flames and inside waiters dressed as skeletons brought ghastly-looking drinks. In Heaven, next door, barefoot angels in white nightdresses served the customers. Events described as black masses or medieval balls served as licence for excess. The bourgeoisie, whether local or foreign, swarmed into Montmartre – the English, in particular, in search of the saucy Parisian girls of the Belle Époque. The Prince of Wales was a frequent visitor to the Moulin Rouge, and Toulouse-Lautrec painted one of Queen Victoria's subjects, a keen womaniser, in *L'Anglais du Moulin Rouge*. The number of brothels in the streets around Pigalle doubled; by 1900 there were 127, each with its characteristically large, illuminated street number on the door.

The dance-halls, music-halls and brothels marketed art, sex and drink in an atmosphere which combined aestheticism with gross humour. Le Pétomane, a great favourite at the Moulin Rouge, played an amazing repertoire of tunes by breaking wind. He advertised himself as 'the only performer who doesn't pay composers' royalties'. In the hectic *fin-de-siècle* mood, astrologers, clairvoyants and spiritualists attracted enormous followings. As early as 1886, a newly founded magazine, *Le Décadent*, had identified the prevailing mood in Paris: 'the increasing refinement of feeling, of taste, of luxury and pleasure, neurosis, hysteria,

hypnotism, addiction to morphine, charlatanism in science'.[15] The young aesthetes, disillusioned with scientific progress and an increasingly mechanised age, reached back to primitive art, to religion, to the occult and a shoddy mysticism as an antidote.

The sunlit optimism of the Impressionists was off-key and the new generation of artists, loosely labelled the 'Post-Impressionists', were no longer interested in faithfully recording their observations of the natural world. They wanted to express their inner world, the ideas, moods and fantasies 'of the modern soul', through the language of symbols, lines and colour. They began to stress the significant role of decoration in art. 'Remember that a painting, before it is a war-horse, a nude or some anecdote or other, is essentially a flat surface covered with colours assembled in a certain order,' wrote the twenty-year-old Maurice Denis in 1890.[16] Denis, like Gauguin, was associated with the Symbolists, artists influenced by poetic and occult theories. Painters as diverse as Seurat, van Gogh and Munch were regarded as part of the reaction to Impressionism. Since the idea or the meaning in Symbolist art was often vague, the distinctions between the different schools were not always clear, even to art dealers in the Paris of the 1890s, who sometimes exhibited them together.

By her dismissal of 'aesthetics and artiness' Suzanne Valadon had clearly stated her position. She was an instinctive artist, suspicious of theory and eager to express her own feelings: 'I admire sincerely those people who profess theories of art. But I have noticed that the most opposing theories can serve to justify the same masterpieces. I believe that nature imposes the true theory. Has there ever been a painter who chose what he wanted to paint in the real sense of the word? Everyone paints as he sees, that is to say everyone paints as he can.'[17]

In the 1890s Maria, encouraged by Degas, had begun to work seriously as an artist, using her son, her mother and herself as models and the unadorned furniture of everyday life – a bare table, a chair, a bed and a bath – as background. Degas, who had catholic tastes and a deep knowledge of art, fortunately encouraged her to have faith in her own vision; Bartholomé too was supportive. At New Year she usually sent a letter of greeting to both men (though unfortunately none of these letters has survived). Bartholomé replied to her on 6 January 1891 to wish her a good year's drawing and better health. She suffered badly from coughs and colds in the winter. On 10 May 1891 he wrote again in response to another letter:

Chère Mademoiselle,

Why do you always thank me? You brought me one day the real joy of an artist and it is I who am indebted to you.[18]

He was obviously referring to the first day she visited him, bringing her drawings and hoping for a letter of introduction to Degas.

Valadon's drawings provide the most reliable guide to her interests as a young woman, and in 1891 she had a new 'model'. She drew a head and shoulders of Miguel Utrillo no fewer than four times that year. In one sketch she sees him as a bohemian in profile, shaggy-looking, with a pipe; in another he looks studious and introspective; in a third, three-quarter face, Miguel appears handsome and distinguished and, in a fourth, evasive and distant. Although Valadon always denied vehemently that he was her lover, he did play an important role in the life of the family during 1891, when Suzanne was increasingly worried about her son, a lonely, timid little boy given to strange moods. At school he was studious but avoided the company of other boys and his shrinking attitude provoked bullying.

Despite Suzanne's denials, it is clear that she and Miguel were lovers. From his portraits Miguel looks very much the Spanish grandee; apparently he never considered marrying his turbulent Suzanne. By then she had begun an affair with a friend of his, Paul Mousis, a wealthy stockbroker from a strict Catholic family who was besotted with her. Yet Miguel was, perhaps, troubled by doubts about the paternity of Maurice. In January 1891 he made an extraordinary gesture: he formally adopted Maurice as his son in an 'Act of Recognition of Maurice Valadon-Utrillo' at the town hall of the eighteenth arrondissement, making sure first that the boy could keep his French citizenship. Whether Maurice was his natural son, whether the action was purely quixotic, or whether by giving Maurice a name he intended to pave the way for Suzanne to marry and thus to salve his own conscience remains unanswerable. In fact Maurice was said to resemble his adoptive father closely.

According to Montmartre gossip, Valadon, desperate to give her son a name in order to marry a rich suitor who would only take the boy on if his real father was known, poured out her troubles to Miguel. The sympathetic Spaniard asked her who Maurice's real father was. Valadon hesitated: 'It could have been Puvis or it might have been Renoir . . .'

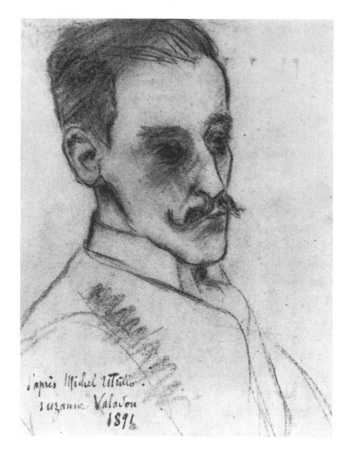

Miguel Utrillo,
1891.
One of the four
drawings that
Valadon made of
Miguel in the year
that he formally
'acknowledged'
Maurice as his son.

'Well,' answered Miguel with a flourish, 'they are both fine artists, I would be honoured to sign my name to the work of either of them.'[19]

After Miguel's death in 1934, his two legitimate sons visited Suzanne to offer Maurice a share of their father's estate – the entitlement of an illegitimate child under Spanish law – but she signed a disclaimer.[20] Another document, signed by Puvis, and guaranteeing support for Valadon and her child, was said to have been torn up after Puvis's death.[21] So the paternity of Maurice Valadon-Utrillo remains as enigmatic as Valadon intended it to be.

Maurice's health continued to be a worry and in 1891 Suzanne took him to see a paediatrician at the Kremlin-Bicêtre Hospital. Child psychiatry was at an early stage; the doctor diagnosed mental debility and recommended sending the boy away to an institution. Suzanne, horrified, refused. She made a drawing of Maurice, aged seven, that year.

Degas found it surprising that, with her irregular lifestyle, Maria (he always called her Maria) could be so singleminded when it came to her art. She seemed to be more alive, more concentrated, when she was working. Throughout her strange friendship with Degas he introduced her subtly and indirectly to new techniques, new ways of looking at art. At first he was irritated by Suzanne's obstinate refusal to take advice, then he came to respect her integrity. He admired her independent spirit, teased her slyly and called her his 'terrible Maria'. 'He was almost scandalized', according to the eminent critic Claude Roger-Marx, 'that the daughter of a washerwoman who had never studied art instinctively possessed such authority'; that in spite of her beauty, her grace and her wayward love affairs she had 'so much control of herself faced with a blank sheet of paper'.[22] Degas's insistence that colour was subservient to line put him out of step with the other Impressionists, but it was the strength and boldness of 'Maria's line' that Degas most appreciated. For the first time in her life Valadon enjoyed the sensation of being taken seriously as a colleague by an artist of the first rank. It can be no coincidence that during the nineties the subjects chosen by Degas and Valadon overlapped: girls bathing, drying themselves and dressing. They both viewed their models with a penetrating and unsentimental eye. According to the contemporary art critic, Florent Fels, occasionally Valadon's drawings were mistaken for Degas's and sold for very high prices.[23]

In the past Degas had spoken scathingly as only he could of the failings of women artists. Berthe Morisot, he grumbled, painted her pictures as one might 'make hats'. As for Mary Cassatt, the American Impressionist who was a friend of his on and off for some twenty years, he stood in front of a Mother and Child painting by her and remarked: 'Hmm, Baby Jesus with his nanny.'[24]

Apparently Degas did not exercise his caustic wit at Suzanne's expense. Perhaps the huge disparity in their social standing made him feel more at ease with her, less threatened than with other women. Her total lack of pretension as an artist appealed to him; and then of course she was hauntingly beautiful, unlike the middle-aged Mary Cassatt. In his late fifties Degas was very conscious of growing old; his eyesight was failing and he turned increasingly to sculpture, modelling figures in red wax. Degas's commitment to his work and his ruthless rejection of unwanted distractions affected Maria deeply. 'I drew feverishly so that

when I couldn't see any more I would be able to use my fingers,' she wrote years later.[25]

The intense excitement of working close to a major artist and developing her own talent competed with many other demands on Maria's time. As a lover, a mother, a daughter and a model she lived in a constant state of agitation. Her work as a model was still important to her and the gossip that she was an aspiring artist flew round the studios.

In May 1891 Suzay Leudet, a young art student, was painting in a class held in Jean-Jacques Henner's studio in the Place Pigalle. Mademoiselle Leudet, who was working on a figure representing death, draped in a voluminous shroud, was impressed by the intelligence of the model, Maria Valadon, and the tirelessness with which she held the pose. For an hour at a time Maria lay in the attitude required, then she was allowed ten minutes' rest before she resumed work. Each session lasted four hours and the model was hired for a week. After the final session Maria dressed quickly and left the studio. Henner, a highly respected academic painter, turned to Hector Le Roux, a younger colleague who had been supervising the class, and Suzay Leudet heard him say: 'That little model, did you know that she paints?' 'What's her work like?' asked Le Roux. 'Terrible, but all the same it's gratifying to know that it was through contact with us that she had the idea of becoming an artist.'[26]

These rumours that the 'little model' had turned her hand to drawing reached the new art galleries too. Francis Jourdain, an art student in the early 1890s, recalled an incident around 1892 when he was helping to hang an exhibition of 'Impressionists and Symbolists' in a small, untidy shop in the Rue Le Pelletier. The owner, Le Barc de Boutteville, held up two drawings to show him: 'Not bad, eh? They're by a little model who has never had a day's tuition. Watching one of her patrons drawing, she took a notion to try it herself. One would never think that they were done by a woman.'[27] The previous year Le Barc, a flamboyant, bearded character who had made his money through selling Old Masters, had been persuaded to promote the avant-garde. He would buttonhole his visitors endlessly in garrulous efforts to make a sale. Despite the poor lighting and inexpert hanging of the pictures, and the 'annoying verbiage of Monsieur de Boutteville', Paris intellectuals felt obliged to attend the exhibitions he held because the excitement, wrote the critic Albert Aurier, was such that the new shows formed part of the attack by

young artists on an age of 'exclusive materialism'.[28] It is unlikely that Suzanne had anything so pretentious in mind; but she was exhibiting with talented young artists, including Toulouse-Lautrec. 'Her line was firm, spontaneous and emphatic,' wrote Jourdain, 'and she drew with dogged courage and surprising character.'[29]

In 1892 Suzanne drew her first female nude, a small sketch of a girl bending over a washbasin, so reminiscent of the angle and candour of Degas's drawing at the time that it seems possible that he allowed her to share his model and work in his studio. That year at last she overcame her old fear of painting and began to experiment in oils, painting an old woman reading a story to a child, the subject of a preparatory sketch, and a young girl crocheting – conventional subjects. She worked with surprising confidence and some charm, but her early surviving paintings lack the daring individuality in line and colour that would distinguish her later work.

Valadon's life was now so tangled – with her art, her friendship with Degas, her modelling, her difficult son and ageing mother, and her hectic flirtation with Paul Mousis – that she had less time to spend with Miguel. A talented writer, artist and scientist, he had yet to find a clear sense of direction. For him the Chat Noir held an endless fascination, absorbing his imagination. In 1897 he was to open a cabaret of his own in Barcelona, Els Quatre Gats, a favourite haunt of Picasso.

At the Chat Noir, at the height of its elegance in the 1890s, guests were welcomed by a Swiss doorkeeper complete with halberd, sword, knee breeches and silk stockings. Art lovers and socialites from all over Europe came to see and be seen at Le Chat. One night the Prince of Wales arrived and was greeted by the proprietor, Rodolphe Salis, who used the prince's full title in a seemingly deferential manner. 'And how is that mother of yours?' Salis then asked, delighting the crowd.

The glory of the new Chat Noir, which attracted full houses every night, was the shadow theatre designed by Henri Rivière, an ingenious young artist who derived the original idea from Punch and Judy shows. Rivière's productions were ambitious, using large, coloured figures cut out of zinc or card and panoramic scenery. Marvellous effects of changing skies, storm and sunshine and daylight fading into darkness were produced by tricks of lighting and by the use of enamelled mirrors which moved horizontally and vertically in grooves. The cut-out 'actors' were projected on to a screen lit by acetylene gas-lamps; an illusion of

depth was created by projecting the puppets at varying distances. Singers and musicians performed in the background and sometimes the author recited the dialogue in front of the screen, accompanying himself on the piano. Gustave Flaubert's novel *The Temptation of St Anthony* was interpreted to the acclaim of a distinguished audience which included the poet Paul Verlaine and the composers Claude Debussy and Erik Satie. For modern artists Rivière's flat cut-out figures painted in vivid colours reflected a departure from realism in sympathy with their aims. Miguel Utrillo was captivated and apprenticed himself enthusiastically to the shadow theatre. His scientific training proved helpful in his schemes for lighting and animating the large cut-out figures which he later designed with great success.

Through Miguel's involvement with cabaret life, Suzanne met painters and musicians as well as wealthy bourgeois. In her late twenties the pace of her life quickened as once again she was attracted by a man of extraordinary talent.

In 1890 Erik Satie, a struggling young musician, settled in Montmartre, where he took up the post of conductor of the Chat Noir orchestra and piano accompanist in the cabaret. Once Miguel Utrillo's success with shadow plays was established, a rival inn in Montmartre, L'Auberge du Clou, decided to open its own shadow theatre for the Christmas season of 1892. Miguel Utrillo was asked to direct the play and design the décor, while his colleague, Erik Satie, was invited to compose a 'Christian ballet', *Uspud*, to a libretto by his friend, the writer and poet, J. P. Contamine de Latour.[30]

Satie's ballet in three acts, designed to 'dumbfound the public', was described by the librettist as 'above the appreciation of anyone here below'.[31] The audience at the Auberge du Clou, who barracked and jeered at the curious spectacle, certainly agreed with that verdict. Uspud, the hero, is haunted by the vision of a beautiful woman dressed in gold, with a dagger at her breast, personifying the Christian Church. When Uspud turns away from her embrace, monsters and demons set upon him. The woman in gold plunges her dagger into his breast, and in a trance-like state Uspud sees the light. A giant crucifix appears, to the accompaniment of a heavenly choir, proclaiming the power of the Almighty. The beer-drinking visitors to Le Clou found the phantasmagoria inexplicable and indigestible. Erik Satie's witty and esoteric music was unfamiliar to them and they turned on Erik Satie for

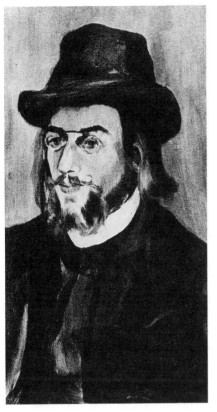
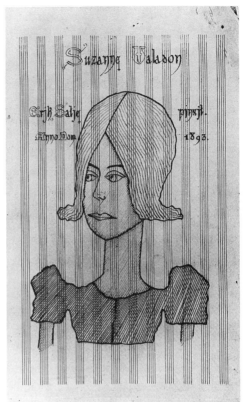

LEFT *Portrait of Erik Satie*, 1892–3.
In one of her first oils, Valadon painted
Satie as a bohemian in a battered hat.
RIGHT Satie's pen drawing of Valadon, in red ink,
gives her an air of doll-like severity.

the sparsity of his score. Satie, in top hat and frock-coat, bravely defied
his detractors and bet them that he would get his work performed by
the Paris Opera.

Several times Satie wrote to the director of the Opera, Monsieur
Bertrand, and his librettist, Latour, called with a friend at Monsieur
Bertrand's private house, leaving visiting cards with threatening
messages. Satie informed the director that by dismissing a work without
hearing it he was neglecting his duties. The composer strengthened his
campaign by circulating copies of his letters at the Auberge du Clou. On
17 December 1892 Bertrand finally bowed to the pressure and received
Satie and Latour at the Opera. 'This leads me to believe', Satie wrote to

a friend, 'in an early performance in the winter of 1927 or, at the latest, that of 1943.'[32] Satie eventually won his bet: his ballet *Uspud* was performed at the Opéra Comique in 1979, almost ninety years later.

Valadon watched the drama with interest, full of sympathy for the gifted, unrecognised David attacking the Philistines. To crown his 'victory', Satie decided to have the libretto printed and illustrated with extracts from the score. On its cover is a charcoal drawing of the two authors, Erik Satie and Contamine de Latour, signed Suzanne Valadon.

Unfortunately we only have Erik Satie's account of the intense love affair that developed between them: 'On the 14th of the month of January, in the year of grace 1893, which was a Saturday, my love affair with Suzanne Valadon began,' Satie noted in ornate handwriting. Two days later another momentous event took place. Satie, known as Monsieur Le Pauvre, lived in a tiny box of a room at the summit of the hill of Montmartre, on the top floor of No. 6 Rue Cortot, 'well above my creditors'. 'On 16 January 1893 my friend Suzanne Valadon came to this place for the first time in her life,' he added.[33]

Satie fell hopelessly in love with Suzanne and proposed to her soon after their meeting. He explained his assets with care: 'I breathe with caution, a little at a time, and I dance very rarely.' He was, in fact, only twenty-six years old, a few months younger than Suzanne, who prevaricated: 'She had too many things on her mind to get married, so we never brought up the subject again.'[34]

For Valadon, Satie, later known as the 'father of modern music', was an entrancing companion. Through her lover, whose conversation was 'almost divine' according to Ernest Legrand, his composer friend, Suzanne met Debussy, Ravel and other young musicians of the day. She came to appreciate music increasingly – 'the greatest invention for mankind,' she wrote later.[35] When Suzanne was able to disengage herself from her family, her afternoon sessions with Degas and evenings with Miguel Utrillo or Paul Mousis, the two lived a brief idyll. Satie took her to the Luxembourg Gardens to sail toy boats and wrote her passionate letters.

Valadon painted one of her first oils of Erik Satie, a clerical-looking person with battered tall hat, long flowing hair and a beard, a sweetly sensuous mouth and an air of prim irony behind his pince-nez. The attractive mood piece, shown without the distraction of background accessories, is painted in bold strokes of blues and greens. Satie in turn sketched Suzanne on a music sheet. He saw her as a severe, doll-like

figure, with elongated neck, bulging, hooded eyes, her hair high like a wig. She is wearing a dress with a rounded neck and high puffed sleeves.

Despite his contact with the Chat Noir, Satie was an unworldly young man, inexperienced with women and hampered by his poverty. Suzanne initiated him into the full-blooded pleasures of sex and her timid lover was lost in his first passionate affair – and fearful of losing his mistress. On 11 March 1893, when they had been lovers for barely two months, he wrote the only surviving letter to his love, a carefully designed missive bearing a coat of arms in peacock blue displaying a chicken with the motto: 'Aigle ne puis, dindon ne daigne, poule suis' ('Eagle I cannot be, turkey I deign not to be, chicken I am').

> Dear little Biqui,
> Impossible to stop thinking about your whole being; you are inside me completely; everywhere I see only your exquisite eyes, your gentle hands and your little child's feet.
> *You* are happy; my poor thoughts will not wrinkle your clear forehead; neither will you worry about not seeing me at all.
> For me there is only the solitude that creates emptiness inside my head and fills my heart with sadness.
> Don't forget that your poor friend hopes to see you at one at least of these three rendezvous:
> 1 This evening at my place at eight forty-five
> 2 Tomorrow morning again at my place
> 3 Tomorrow evening at Dédé's (Maison Olivier)
> I should add, darling Biqui, that I shall on no account get angry if you can't come to any of these rendezvous; now I have become frightfully reasonable; in spite of the great happiness it gives me to see you.
> I am beginning to understand that you can't always do what you want. You see, little Biqui, there is a beginning to everything.
> With warmest love [*Je t'embrasse sur le cœur*]
>
> > *Erik Satie*
> > 6 Rue Cortot[36]

The month that he wrote that touching letter, Satie composed a series of Gothic dances with Gothic subtitles which read like a balance sheet of his buffeted emotions: 'On the occasion of a great sorrow'; 'On behalf of a poor wretch'; 'When it is a question of forgiveness for insults received'; and 'On having allowances made for one's faults'.[37] He had learned, to his cost, that a love affair with Suzanne comprised as many disappointments as delights.

As he had acknowledged in his letter, she had too many commitments to give herself up to him. Maurice, now aged nine, was troublesome, showing signs of his uncontrollable fits, resentful, no doubt, of Suzanne's frequent absences and bitterly disappointed that although he had a father in name he saw less and less of him. Miguel was more and more taken up with the shadow theatre. He had joined a French group, Les Ombres Parisiennes (The Parisian Shadows), and travelled with them to Chicago in March 1893, to take part in the World Fair. Suzanne, engrossed in her new affair, was convinced that Miguel would come back to her as he always did.

On Easter Sunday 1893, Erik Satie presented Suzanne with a fragment of song entitled 'Bonjour, Biqui, Bonjour'. He was trying hard to be reasonable and to contain his feelings. Suzanne maintained silence over the relationship. At that stage in her life, her love affairs seemed to pass over her like sunshine. As a young girl she had been taken up and dropped by men; now she soaked up her lovers' talent – she always chose talented men – and then left them. When she was eighteen the academic German painter, Gustav Wertheimer, had painted her prophetically as a mermaid, luring men to the depths, in his work *The Kiss of the Siren*. Satie evidently saw her as a *princesse lointaine*.

Yet she was also a down-to-earth woman who loved her family, her food and her creature comforts. Two letters, mislaid for years, came to light in 1996. They reveal Valadon in 1893 as a generous, affectionate, struggling young woman. Both letters are addressed to her half-sister, Marie-Alix Merlet; the first is undated:

My dear sister

For several days I have been quite seriously ill and today I'm writing to you from my bed [illegible word].

I'm sorry, therefore, for not having thanked you earlier for the parcel you sent, which gave us great pleasure. Mother put the goose on the spit and since then we've been feasting ourselves.

Mother is delighted; she says she has at least 2 pounds of fat.

As for the feathers, which Marie [Marie-Lucienne, Valadon's niece] intended for her grandmother, in fact I am the one who has used them, as pens for writing with, all the while thanking you most sincerely.

I can't help scolding you for the expense you have had, seeing as you don't have much money either at your disposal. However, my dear Marie, remember that if you wanted to come to Paris I could always send you the money next month for your journey. In your next letter give me

details of your health and your plans because if you must leave Amiens to go to Le Croisic you'll tell me that.

We were very pleased to learn that your sweet Marie [-Lucienne] was going to set herself up in business. I'm quite sure she'll soon get a lot of work and that she'll be successful. With a mother like you she should be very clever. Tell darling Marie to write to us often. I find her letters so amusing . . .

Dear sister, I'm going to stop chattering on because I can no longer write, I don't have an ounce of strength.

With love to you, kind sister, with all my strength and all my heart, Mother joins me in sending all of you her love, waiting to be able to hold you in our arms in Paris.

Your loving sister

Maria Valadon

We found the butter excellent, so much so that I would be keen to have some sent here every month, if that wouldn't put you to any bother or inconvenience. That is, in the event of my being able to send you a money order to the value of 8 pounds of butter, plus the total cost of carriage, so if you know a reliable firm perhaps it could undertake the dispatch itself, without your being involved.

What I'm asking you for is information. I don't wish, for anything in the world, to force you to send the parcels yourself and give you any trouble whatever.

Again, thank you, and love to all of you.

Maria Valadon

11 Rue Girardon
Montmartre[38]

Perhaps Suzanne got her butter: but the second letter, thanking Marie-Alix, sees her ill again.

Sunday 31 [month illegible] 93

Dear Marie,

My delay in thanking you was due to illness, because again I'm prevented from going out. I have to stay in my room, but there's nothing surprising about that because last year at the same time I was in bed with pneumonia. Anyway that's enough about me.

Thank you very much for all your parcels which were excellent. I don't usually like sausages but I feasted on yours. As for the chicken I have never eaten any that was so tender. Regarding the black puddings I am really annoyed as I was obliged to watch them being eaten, because of my lousy illness.

Dear sister, do assure little Christiane [Marie-Alix's younger daughter] that she will have a fine baby but make her be patient for a few days, because I absolutely cannot leave my room and I need Mother near me, otherwise I would have sent her to the [*?bourse*], but it's a matter of a few days, especially as it's terribly cold and I can't stop coughing.

Mother joins me in sending all of you all our warmest love, and sending our best wishes,

Your loving sister

Maria Valadon[39]

One would have no idea, from those letters, that the writer was the femme fatale of Satie's fevered imagination. She sounds a considerate young woman, concerned for her family. In September 1893 Valadon would be twenty-eight; she drew a beautiful self-portrait with a new maturity. Her hair, parted in the middle, is coiled round her ears, her face is fuller, her gaze gentler and her sensuous mouth full of promise.

5

The Country Wife

The end of the love affair with Suzanne almost unhinged Erik Satie. For six months he had lived a dream, enchanted by her presence, her lovemaking, her imagination. When the dream shattered and Suzanne abandoned the world of make-believe, Satie was distraught. In fury he lashed out at her, accusing her of infidelity and promiscuity in a series of proclamations, couched in precise and bitter terms and posted up in his window in the Rue Cortot.[1] Later he gave his friends two different versions of the rift. In one he said that he had pushed Suzanne out of his window and then rushed to the police station to confess the 'murder'. Suzanne had survived, he explained, because she had been trained as an athlete. In the second version he maintained that he had appealed to the police for protection from his mistress's harassment.

Despite his histrionics he was genuinely heartbroken. On a small poster, written in blue and red ink, he noted, 'my love affair with Suzanne Valadon . . . ended on Tuesday the 20th of June', and he pinned a lock of her hair to the paper.[2] A letter to his brother Conrad, written on 28 June 1893, probably reveals his true feelings:

> I have just broken finally with Suzanne.
> I shall have great difficulty in regaining possession of myself, loving this little person as I have loved her ever since you left; she was able to take all of me.
> Time will do what, at this moment, I cannot do.[3]

After the affair, Satie was never known to love again. 'You want to know why I'm not married,' he told his sister-in-law: 'fear of being a cuckold, just that.'[4] When he republished the libretto *Uspud* two years later, he used Valadon's drawing again on the cover but removed her signature.

In October 1893, as if by way of consolation, Erik Satie formed a curious sect called the Metropolitan Church of the Art of Jesus the Leader. He appointed himself 'Parcier', an ancient form of shareholder, and Maître de Chapelle. Through his one-man church, Satie began to hurl a series of accusations against prominent intellectuals in a crusade to cure the ills of society by poetry and music.

Despite his creative achievement and important influence on modern music, in February 1925 Erik Satie died in extreme poverty of double pneumonia. Afterwards his brother Conrad found a pile of letters addressed to Suzanne Valadon but never sent. He told her of the discovery and in the summer of 1926 she replied in great excitement:

> Dear friend,
> Your very pleasant letter arrived just as I [*sic*] about to leave Paris – an emergency forces me to put off your visit – if however you can – wait until the last week of August, for I should be back in Paris then.
> The meeting will be a very moving one and so many memories are heart-rending indeed and yet very sweet to me.
> With warm regards, my friend.[5]

Overcome, no doubt, with emotion, Suzanne signed her name twice. Yet when the letters were delivered to her she read them and burnt them, as if to draw a line under the love affair. Only in that letter does one gain a sense of Valadon's affection for Satie.

Over thirty years earlier her much publicised affair and its aftermath had sparked off more gossip in the cafés of Montmartre about Suzanne Valadon's manipulative sexual conduct. With this lover, however, nobody could accuse her of gold-digging.

Suzanne's other lover, Paul Mousis, was a native of Montmartre and knew Erik Satie, as he had known Miguel Utrillo, through the night-life of the quarter. Somewhat surprisingly, Mousis was stolidly waiting for her when the affair ended. Compared to a penniless musician, Mousis, a stockbroker in an important firm, Bel et Sainbénat, knew that he was a better prospect. Mousis was also a wealthy man in his own right: one of his aunts was said to be worth millions.[6] Mousis's official address was the family home at 13 Rue Clignancourt, but he spent most of his time with Suzanne. The material advantages of his friendship can be detected in her drawings. In 1894 a new model appears, her Breton maid Catherine, dressed in apron and clogs, taking Maurice to school.

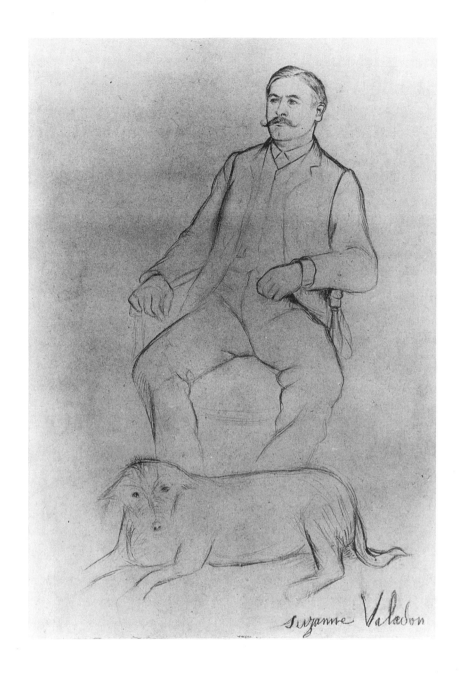

Portrait of Paul Mousis, 1894.
Valadon made a pictorial record of everyone of importance in her life. This sketch of Paul Mousis, the wealthy stockbroker who was to become her husband, emphasises his solidity and his authority.

Paul Mousis remains something of an enigma. 'A worthy philistine' is how they described him in Montmartre circles, a good bourgeois, and his name was mentioned with a certain respect. One can only conclude that in the wild, artistic crowd Mousis stood out as well behaved, pleasant and above all solvent. No stories attach to him, either comic or malicious, but a pencil drawing by Suzanne in 1894 offers an insight into his character. Mousis is leaning back in his armchair, a man of substance, tall, well built, with a large moustache, looking out rather sternly, with an Etruscan-style dog lying at his feet. Mousis's gaze and gesture leave one in no doubt of his authority. After a succession of indecisive and timorous lovers, a practical man who wanted to marry her was a novelty, at least.

Catherine Taking Maurice to School, 1894.
Thanks to her wealthy suitor, conditions in Valadon's household improved and a new figure, Catherine, a maid, enters her repertoire.

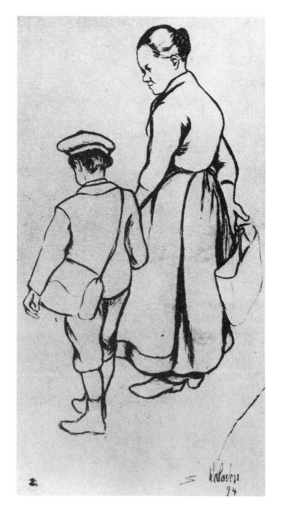

Under Mousis's protection, Suzanne could afford to give up modelling and work at her easel. By 1894 she had grown in confidence and was drawing magnificently. With the active encouragement of both Degas and Bartholomé, Valadon made an audacious bid to win the approval of official artists. In 1890 the authority of the official Salon had been undermined yet again. Four leading artists from the Société des Artistes Français had seceded from the official Salon to set up their own, semi-official society with slightly more liberal rules. The Société Nationale des Beaux-Arts held its annual Salon at the Champ de Mars, and Puvis de Chavannes, Suzanne's first employer, was among the four founders. The other three were Ernest Meissonier, a painter who commanded the highest prices in Paris, the sculptor Auguste Rodin and the painter Eugène Carrière. This new Salon had gained a high reputation in its three years of existence and attracted artists of the calibre of Alfred Sisley and Gauguin.

Normally exhibitors were invited by fellow painters or recommended by their Beaux-Arts teachers. Suzanne went to see Puvis de Chavannes, obviously hoping that he would sponsor her application to submit her work to the Société Nationale. If Suzanne had believed that Puvis would be swayed by sentimental considerations she was disappointed. In his seventieth year and one of the most famous artists in Paris, Puvis had become even more pompous. The idea of permitting an untutored model of his to exhibit appalled him. 'What an idea!' he exclaimed. 'You have not had any training. Whose pupil are you? What will people say?'[7]

Bartholomé, always a loyal friend, tried another approach. He knew the president of the new Salon, Paul Helleu, a fashionable portrait painter, and wrote him a tactful letter:

> My dear Helleu,
> Four or five days ago, a poor woman arrived at my house carrying an enormous parcel of drawings. She wants to exhibit at the Champ de Mars and was hoping for a sponsor. I do not recommend her to you. I merely ask you to look at the drawings signed 'Valadon', when they are brought before the Selection Committee. You will see that they have serious defects, but I think that they also have such unusual qualities that you will probably be glad to accept them.[8]

Against the odds the Salon accepted five of her uncompromisingly candid drawings: *The Grandson's Toilet*; *Grandmother and Grandson*; and three studies of children. The exhibition opened on 25 April 1894,

and for three months Suzanne Valadon's drawings of her scrawny son and her wrinkled mother were on view to the nation. By contrast, the well-known Impressionist, Berthe Morisot, produced elaborate paintings of delicate young women, pensive on sofas, surrounded by flowers, plants and lace curtains or looking lovingly on cherubic babes nestling in their cradles.

The extent of Valadon's achievement can be best measured against the efforts of trained and well-to-do women artists who were struggling for recognition. In 1881, soon after Valadon had begun to pose as a model, a group of women artists formed the Union des Femmes Peintres et Sculpteurs and worked hard to promote female artists, holding an annual exhibition. Yet in 1894 the untrained and unaffiliated Valadon was the only woman to exhibit at the Société Nationale. That same year Virginie Démont-Breton, the president of the Women Artists' Union, was awarded the Légion d'Honneur for her work. At a dinner given in her honour, Madame Démont-Breton urged women artists to create 'feminine' art. 'Let us never try to fight our natural tendencies,' she said. 'Why should the brush and pen be at war with the needle and crochet hook? Why should art conflict with the many small cares which make up the happiness and wellbeing of our husbands and families? Let the art that fills our lives surround our children's cradles with poetry.'[9] The drawings that Valadon exhibited at the National could not be considered 'women's art'. There was nothing pretty or even pleasing about them. They were too vividly alive – sullen, adolescent children in awkward poses that ignored the conventions, unadorned and quite unselfconscious in their nakedness.

One enlightened critic singled out Valadon's work for praise, but the press cutting was sent, by mistake, to Jules Valadon, a mediocre academic painter. Furious, Monsieur Valadon sent the notice on to Valadon with a covering note, telling her to sign her name in full in future, since an 'S' could be mistaken for a 'J'. She ignored his demand and continued to sign herself 'S. Valadon' when she felt like it.

In July, just as the exhibition was closing, Degas wrote to her in the Rue Girardon. He had not managed to visit the exhibition until it was about to close, although, of course, he had seen her work and even bought a drawing before the opening. 'You must have taken your drawings away from the Champ de Mars, illustrious Valadon,' he wrote playfully, 'so come and bring me mine tomorrow morning. Bartholomé

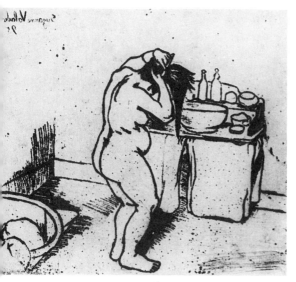

LEFT *Catherine Doing her Hair*, 1895.
Degas taught Valadon to etch on his own press. But she
did not realise that if she etched her signature on
the plate it would be printed in reverse.
RIGHT *Catherine Nude, Drying Herself*, 1895.

will have written to you about a drawing he was terribly anxious to possess. Is he suited?'[10]

Degas and Bartholomé delighted in the progress of their protégée, who that year produced twenty-one vivid, expressive drawings of her mother, her son and herself. Her maid Catherine also posed for two nude drawings. In November, Degas wrote again, a breathless letter:

> Terrible Maria, yesterday at Le Barc de Boutteville, I wanted to buy your excellent drawing, but he did not know the price. Come, if you can, tomorrow about 9.30 with your portfolio to see if you don't have something even better.[11]

Degas addressed his letter to Nos 2–4 Rue Cortot, where Mousis had rented a studio for her, in a building that was subsequently demolished.

Mousis had begun to exert great influence over Suzanne: he persuaded her that it would be better for the family, which consisted of Maurice, nearly eleven, and Madeleine, aged sixty-four, to live in the country. He rented a comfortable house for them all at No. 18 Avenue de Saint-Denis, Pierrefitte, a village on the Seine fifteen miles north of

Paris. Although the house was in Pierrefitte it was so close to the neighbouring village of Montmagny that they could get off the train from Paris at either station. Their new home, next door to a baker's shop, was on the village street, set in pleasant countryside surrounded by apple orchards. During 1895 Mousis took his new family more firmly in hand: he placed Maurice in a private boarding-school at Pierrefitte, to complete his primary education, with Madeleine living nearby in their house. He and Suzanne spent the week in Paris and visited Pierrefitte at weekends and holidays.

While Madeleine and Maurice still posed for her, Suzanne now used her two maids, Catherine and Louise, as models for her nudes. Two nude studies titled *My Chamber Maid* suggest that she was growing accustomed to the role of Madame Valadon-Mousis, the form of address that Degas used. In an undated letter written about that time, Degas, who was out of Paris, reminded her that on his return they would concentrate on soft-ground etching.

Soft-ground etching came into use in the late eighteenth century as a means of reproducing crayon or pencil texture. Degas obviously saw it as a means of extending Maria's freedom of expression and giving her the possibility of selling more of her work. The advantage of this technique was that Maria could still draw in pencil or red chalk without having to learn to wield an etching needle or burin. In soft-ground etching the artist draws directly on to a thin sheet of paper laid over the metal. The plate (copper or zinc) is coated with an acid-resistant ground, mixed with grease to keep the ground soft. The pressure of the artist's pencil removes the ground, and when the plate is bitten in an acid bath the lines are fixed. Renoir used the technique for his voluptuous drawings and Degas rightly saw it as a suitable technique for Valadon.

Degas himself was a perfectionist. In etching he would sometimes rework an engraving twenty times before he was satisfied and finally spoil the plate. The first etching Valadon made, *Catherine in the Tub*, was produced on Degas's press. The printer she later employed was astounded at the force with which she drew. 'The artist has driven her line straight, like a ploughman,' the critic Claude Roger-Marx wrote of her etchings; 'the acid foaming in the furrows will enlarge them still further . . . It is almost as if a sculptor had defined the planes, contrived

the profiles and given so much weight to each form, particularly to the nudes, which have the brilliance and hardness of marble, although they are produced on white paper.'[12]

During 1895 and 1896 Valadon made a series of twelve etchings, austere in both tone and content, showing Catherine and Louise bending over to sponge themselves, or stretching to dry themselves, sprawled on a sofa, with a background of a tub, a door, a chair merely suggested, as the artist concentrates on the line and tension of the nude body. By that time her etchings were beginning to be published by the dealer Ambroise Vollard, and thanks to Degas's intervention her work was gradually reaching a wider public.

Professionally Valadon had blossomed in the past three years, but she was over thirty and still unsettled, with both Maurice and Madeleine now dependent on her. Paul Mousis, two years her senior, was enthralled by his mistress. He was convinced that she would make him an extremely desirable if unconventional wife and was trying to persuade his strict Catholic family to accept a union between them. Suzanne was full of hope, dividing her time between Montmartre and the country and enjoying a more comfortable life than she had ever known.

Neither Madeleine nor Maurice was happy with the new arrangement. Maurice had hated the country from the start. He was a timid, hyper-sensitive boy, convinced that his bullying by the village children had begun when they spotted him wearing an immaculate white beret. The sturdy sons of market gardeners and farmers marked Maurice down as a sissy, mocked his Parisian accent and teased and tormented him at his boarding-school. He later described the Institution Molin as 'a splendid building with a huge orchard and lawn, a vast playing field and mediocre tuition'.[13] For her part, Madeleine missed the bustle and vitality of the crowds, the shops and the traffic of Montmartre. In Pierrefitte, with its population of less than 3,000, there was, inevitably, gossip and speculation about the strange family.

For a time in 1895 Maurice's cousin, Marie-Lucienne Merlet, had come to liven up the household, but by New Year's Day 1896 she had left. Suzanne and Mousis were in town and twelve-year-old Maurice was left feeling bored and neglected. Prompted by Madeleine, he decided to appeal to his 'real' father, Miguel Utrillo, with an exaggerated account of his woes:

Dearest Michel,

I couldn't start the year without telling you that I love you and think of you often . . . You are my father. Why don't you come and see us? . . . I am alone with Grandmother. Mother has gone to Paris to work. [She] is quite unhappy and always sick, you wouldn't recognise her, she's aged so much . . . Monsieur Paul [Mousis] came to put me in a boarding-school in Pierrefitte and since we've lived here he hasn't come back and it's been three months since we've seen anyone. I'm rather bored and quite sad and so is Grandmother. I've wanted to write to you for a long time but Maman didn't want to give me your address because she said you didn't want to see her any more. But I begged her, so this morning, before she left for Paris, she gave it to me, but she didn't want to hear that I was writing to you. Dearest Michel, I'm not writing because I want you to send me a New Year's present. Anyway I'm too old now and I don't care for presents. I only want one thing and that is to see you soon . . . If you are angry with Maman, Grandmother says that you should address your letter to her. [She] sends you a kiss and I love you with all my heart and hug you as hard as I can.

Your son, who would very much like to visit you,

Grandmother is sending you a portrait of Mother when she was twelve years old . . . She wants you to see how much it looks like me. But because Mother knows that Grandmother found the portrait, send it back to us as soon as you have looked at it, so that Mother doesn't find out that we sent it to you. I send you another kiss, Papa. Write to me soon,

Maurice Utrillo

Here is the address: Madeleine Valadon, 18 Avenue de Saint-Denis, Pierrefitte (Seine).[14]

Maurice and Madeleine were obviously trying hard to bring Miguel back into their lives, fearful that Paul Mousis would snatch Suzanne away from them altogether. Despite his material generosity, they found Mousis chillingly remote.

They were too late. Seven months after that pathetic letter was written, on 5 August 1896, Suzanne Valadon and Paul Mousis were married at the town hall of the eighteenth arrondissement. 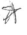 Mousis had finally persuaded his parents to give their consent to the match. In the register, the bride was described as 'Marie-Clémentine, artiste peintre'. She docked two years off her age, stating that she was born on 23 September 1867.

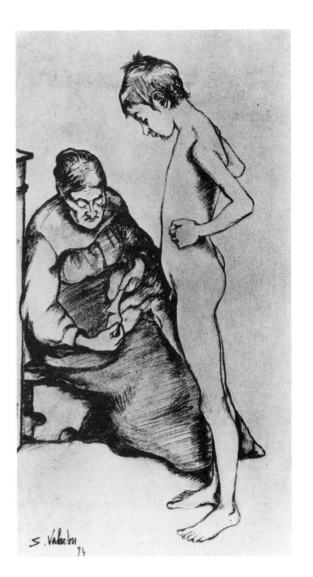

Maurice Nude, Standing, and his Grandmother Sitting, 1894. Her immediate family remained Valadon's main models.

Paul Mousis rented a studio for his wife, with living quarters for the couple, in a mellow, seventeenth-century mansion with outbuildings and a rambling garden filled with fruit trees, No. 12 Rue Cortot. The quiet, airy house with its thick walls was popular with artists. In the 1870s Renoir had rented a studio on the site of the old stables. He was painting the *Moulin de la Galette* at the time and Rue Cortot was conveniently close by.

Mousis gave Suzanne a tilbury with a strong mule to pull it, so that she could drive herself about. From the village to Montmartre, driving

briskly, she could make the journey in forty minutes. Adolphe Tabarant, the critic, remembered the stir she caused when she clattered up the hill in the mornings with her five large wolfhounds.[15] In both her homes Suzanne could now indulge the passion for animals she had felt since childhood. In the garden at 12 Rue Cortot she kept goats and also a melancholy doe, which stayed until she found she could not care for the animal properly and sent it to the zoo.

Despite Maurice's fears for her, in the early months of marriage Valadon worked fruitfully and inscribed the word 'Pierrefitte' on three of her drawings of the nude. In the country at Pierrefitte she also painted the first of her smouldering works on the theme of youth and age. In *Grandmother and Little Rosalie* a sour-looking, wizened old woman is towelling the bottom of a well-fed, complacent young girl. After that magnificent outpouring, Valadon almost stopped working as an artist, as her *catalogue raisonné* reveals.

For the first time in her life she had to conform to routine. As a wealthy businessman, Paul Mousis might enjoy the night-life of Montmartre, but he demanded a high standard of order and comfort in his household. Suzanne employed servants but there were still meals to order, two households to run and a position to uphold as the wife of a prominent man. After her thirty years of freedom and the hectic social whirl of Paris, domestic life, whether in Paris or in the quiet, dark nights in the village, could grow oppressive.

Suzanne did glory in her garden, planted and dug in it, worked with the gardeners and studied the trees, shrubs and flowers, gaining an intimate and practical knowledge of horticulture. With abundant timber available, she discovered that she had a talent for making furniture. Using the most basic tools, a saw, hammer and file, Suzanne would first fashion a small model of an upright chair or armchair in white wood. When she was content with her design, she would saw off lengths of oak as she needed, to produce solid, rustic pieces, in contrast with the ornate furniture of the Second Empire popular with the bourgeoisie at the time. One or two of her neighbours in the country bought Valadon's furniture, and Mousis took some examples to his office to sell to business colleagues.

Maurice's unhappiness in Pierrefitte marred any peace Valadon might have found there. He was lonely and isolated, bored at home and bullied at school. Since his stepfather kept him well supplied with

116

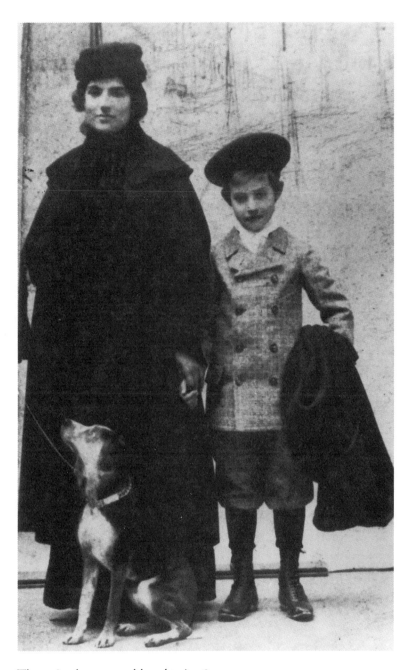

The artist, her son and her dog in 1894.
Both Suzanne and her son look better dressed and
almost bourgeois compared to the earlier photograph of 1890.
Notice particularly Maurice's boots.

pocket money, Maurice tried to win popularity by sharing out sweets. But the other children sensed his fear and goaded him to see when he would break out into one of his fearsome rages.

With extra responsibilities at home, Valadon could not visit Montmartre as often as before, and Degas, for one, felt her absence. An undated letter from him, acknowledging her New Year greetings, was probably written in 1897. He had come to count on her visits and was missing her: 'When fancy takes you or you have the time to come to Paris do not fail to come and see me. – I have a small commission for you from one of my friends, M. Dumont, a painter.' He signed the letter 'Your old Degas'.[16] In another letter, postmarked 1897, Degas wrote: 'It is necessary, in spite of the illness of your son, for you to start bringing me again some wicked and supple drawings.'[17] And in a third letter, marked only 'Tuesday', Degas returned to his point:

> I heard from Zandomeneghi, my poor Maria, that after your son, you yourself had been very ill. I am writing to remind you again that once you are on your feet you must, seeing that your livelihood is now assured, think of nothing but work, of using the rare talent that I am proud to see in you: these terrible drawings, I should like to see some again. One must have more pride.[18]

Degas seems to have appointed himself the guardian of her talent and was quite prepared to remind his 'terrible Maria' that now she had a husband who could provide for her and her family her duty was to express her real talent.

A hundred years ago for a wife and mother to be encouraged by a man to place her professional skills above her family duties was extraordinary, even in artistic circles. Edgar Degas was an ardent Frenchman, a believer in the mystique of the army and an anti-Semite, who was to quarrel with lifelong Jewish friends over the notorious Dreyfus affair (when a French Jewish officer, falsely convicted of spying for the Germans, was exiled, pardoned and finally reinstated in the army in a case which split the country). For all his prejudices, with Valadon Degas was a radical. Even men with progressive views were opposed to the increasing prominence of women in the arts. 'Woman', wrote the novelist and critic Octave Mirbeau, who had championed the Impressionists, 'is not a brain, she is a sex and that is much better. She has only one role in this world, to

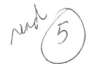

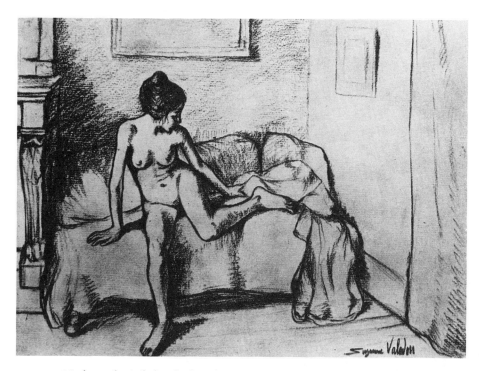

ABOVE *Nude on the Sofa beside the Chimney Piece*, 1894.

For the first ten years of her life as an
artist Valadon concentrated on
drawing. She worked frantically to
'capture a moment of life, full of
movement and intensity, not to make
beautiful pictures to be framed'. Her
works on paper, the most intimate and
instinctive examples of her art, reveal
her world with unflinching realism: the
skinny children, the elderly servants
and the back-street beauties struggling
to present a brave appearance.
Her hard, firm line allows for no
sentimentality, but the expression of
the body and the shading of vulnerable
areas of flesh reveal her compassion and
humanity. She drew less after the 1890s
but still produced remarkable work.

RIGHT *Nude, Back View*, 1895.

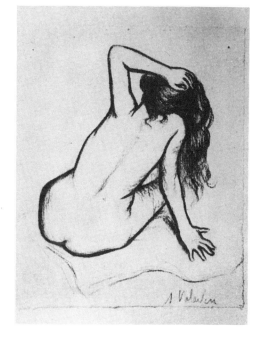

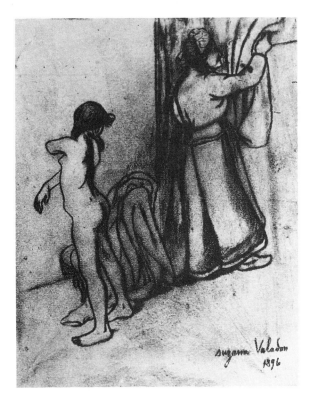

LEFT *Little Girl Nude
with Servant at
Bath-time*, 1896.
A further example of
Valadon's growing ability as
a print-maker.
BELOW *Young Woman doing
up her Stockings*, drawing,
1896.

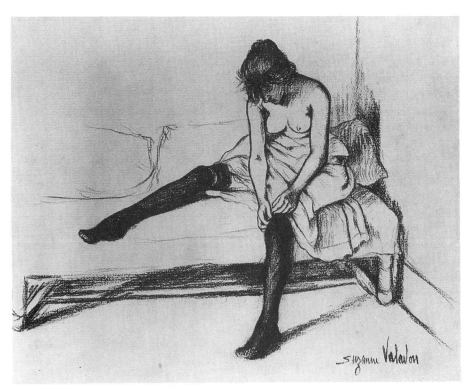

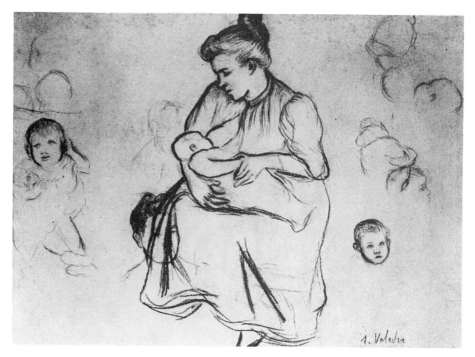

The Nursing Mother, c. 1900.
The only time that Valadon touched on the topic of maternity. After four years of marriage to Mousis, was she hoping for a child?
BELOW *Young Girl Nude in Bath Tub*, 1910.
In her forties Valadon discovered a rebirth of passion and her radiance released a softer, more sensuous flow to her line.

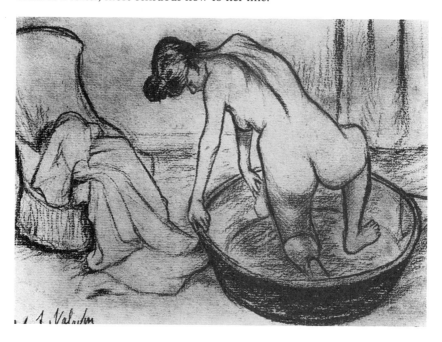

make love, that is to perpetuate the race. She is not good for anything but love and motherhood. Some women, rare exceptions, have been able to give the illusion that they are creative, either in art or in literature. But they are either abnormal or simply reflections of men.'[19] Mirbeau's outburst, typical of male opinion at the close of the century, was provoked by a request from two women writers to join the Society of Men of Letters. With such rank prejudice among cultivated men, it seems unlikely that Valadon would have been able to make her way as an artist without Degas's vigorous support.

Ironically, while Valadon was burdened with domestic duties her work was beginning to attract attention in the small art shops of Montmartre. The young and ambitious dealer Ambroise Vollard relied for advice in his early years on artists of the calibre of Pissarro and Degas. His untidy little shop at No. 4 Rue Lafitte contained an impressive stock of Cézannes and Gauguins, and from 1896 he began to include Valadon in his catalogues; he published several of her etchings in 1897. In a letter to his son Lucien, who was in London, Camille Pissarro enclosed Vollard's catalogues and mentioned some 'good things and some atrocities'.[20] The good things Pissarro singled out included a Bonnard, a Vuillard and a study of a nude woman by Suzanne Valadon. All through the nineties, while Degas went about quietly promoting her work, the dealers Arsène Portier, Le Veel and Le Barc de Boutteville stocked her drawings and etchings. Sales were rare, however; strikingly, it was her fellow artists, such as Pissarro, Degas and Bartholomé, who bought her pictures and recognised her ability. The general public – accustomed to centuries of images of the nude which were voluptuous or delicate, titillating or sentimental – did not take to a realism that was almost brutal. Her work did not attract the buyer looking for a pleasing picture to decorate the wall.

During 1897 Valadon produced nothing she cared to keep and only one drawing of a nude in 1898, but thanks to Degas's influence her existing work continued to be seen. In May 1898 the International Society of Painters, Sculptors and Engravers held a huge show at the fashionable Prince's Skating Rink in Knightsbridge in London. Among the French artists represented were Degas, Monet, Toulouse-Lautrec and Valadon, who had two engravings on show. Degas's friendship with James McNeill Whistler, president of the International Society, had undoubtedly brought her to English notice.

With age, Degas's passion for fine drawing seemed to increase. That year he sent a few lines pleading to his dealer, Paul Durand-Ruel: 'Do not deprive me of the little copy of Ingres, do not affront me and grieve me thus, I really need it . . . I thought about it all night.'[21] In his sixties he was set in his ways and becoming something of a recluse, yet to Valadon he remained always accessible and playfully affectionate. 'I found your good wishes, terrible Maria, on my return from Bartholomé, who read us yours over a meal, where they were brought up to him . . . You will give me much pleasure and not disturb as you fear if you come one evening. Above all bring your beautiful drawings,' he wrote in their usual exchange of good wishes in the New Year of 1898.[22]

Family life was again disruptive. Early in 1898, Paul Mousis, increasingly successful in business, decided they should move to a more imposing rented house nearby, No. 3 Rue de Paris, the Villa Hochard, just opposite the tramway stop. But Suzanne's principal worry was Maurice. He had completed his primary education at the local boarding-school and was now enrolled as a day boy at the Collège Rollin in Montmartre where he had studied in relative contentment before the family left Paris. Maurice commuted by train to and from school, which he enjoyed. When he came home, however, he was forced to spend most of his free time with his grandmother. He worshipped Suzanne, who had always been an elusive mother, yet when 'Monsieur Paul', as he continued to call his stepfather, was at home, Maurice kept out of his way. Grandmother Madeleine had remained a peasant, her conversation larded with superstition and repetitive tales of the Limousin countryside. In latter years she looked to a liberal intake of red wine for consolation.

Much to his grandmother's dismay, in his teens Maurice too began to develop a taste for wine. He was quite a good scholar, winning a prize for mathematics and an honourable mention in French in 1897–8. But at weekends and in the holidays he grew bored and by the time he was fifteen he had begun to call into local bars to down a glass of red wine or absinthe. After school in Montmartre he would sometimes sneak into the nearby Café des Oiseaux for a drink. His bad behaviour was noted: his school reports at that critical stage were full of reproofs for absence from class, for slacking and not doing his homework. Madeleine tried to warn Suzanne that Maurice was running wild, demanding drink when he came home and threatening to jump through the window or break

the drinks cabinet if he was thwarted; but Suzanne, who had a horror of authority and a sympathy with rebellious youth, at first refused to believe the bad reports. The crisis came in January 1900, when Maurice had just turned sixteen. The college authorities found his school work unsatisfactory and decided to keep him down for a year. Mousis was a well-meaning stepfather within his limits, but now he felt that Maurice had let the family down and should be taken away from school. Hard work and the discipline of earning his own money, he reasoned, would steady the boy and settle him down.

In February 1900 Maurice Utrillo started work as an office boy with one of his stepfather's English business acquaintances. After three or four months in his first job, where he proved as ill at ease in the business world as he had been in the village, his stepfather managed to find him a post as a clerk in the prestigious Crédit Lyonnais. At least he looked the part, smartly dressed in a dark suit with an umbrella and bowler hat; and he was good at figures. He came to see the bowler hat as a symbol of the business world he hated. One evening, however, when his bowler was dented in a prank, Utrillo hit a colleague over the head with his umbrella in revenge. That abruptly ended Maurice's career at the bank.

Two or three other attempts to settle the youth failed hopelessly. He became withdrawn and irritable, his only consolation drink. A dance was held in the village every Sunday night; sometimes Maurice would drop in, but instead of joining in the dancing he would stand on the edge of the floor and make faces at the dancers. Often he came home bloody, his clothes dishevelled from a fight. One night he arrived back without his watch; it had been stolen at a rough bar not far from home. Almost every evening, when Mousis returned from the city, there was a scene and a scandal, with the stepfather infuriated by the disruptive youth and Valadon defending her son stoutly.

Valadon's career as an artist was inevitably neglected. She never forgot her New Year's greeting to Degas but his replies were growing more wistful. He and Bartholomé had dined together, he told her in a letter dated 3 January 1900: 'we remarked that every year on the same date we received a letter from Maria wishing us all the best, without the pleasure of seeing her drawings and seeing herself. And then, do you still draw, excellent artist?'[23]

The two drawings that Valadon did make in 1900 are so uncharacteristic that it is doubtful whether she showed them, even to

Degas. For the first time she turned to the theme of maternity, in a tender sketch of a nursing mother looking down anxiously at her baby. In an even more mysterious sketch, *Two Infants at the Breast*, she drew two babies sucking at the nipples of almost invisible breasts. Since her drawings provide the most intimate record of her life, they must raise the question whether at the age of thirty-five Valadon was hoping to have a child by Mousis.

That year Suzanne also painted her first still life, a simple composition of three apples and a pear resting on a white dish rimmed with blue. This quiet work – reminiscent of Cézanne and Gauguin, whom she admired – is a careful and excellent study. One senses that against all her instincts Suzanne had been drawn into the role of country wife, missing, perhaps more than she realised, the excitement and stimulus of Montmartre.

Life in the capital as she had known it was changing. Rodolphe Salis had died, and the Chat Noir, which had fostered so much talent, had closed. Electric signs of every colour flicked on and off along the boulevards and the first automobiles and motor taxis trundled along the streets, greatly outnumbered by the fiacres. The telephone was widely used by the better off, although Degas despised the gadget and resented having to answer it 'like a servant'. Electricity had replaced gaslight in the streets and the silent cinema was immensely popular.

All the innovations of the period were reflected in the vast World Fair of 1900 which extended from the Place de la Concorde to the Eiffel Tower. At the opening in May, the presidential party crossed the new bridge, the Pont Alexandre, escorted by cavalry, saluted by cannon fire, and with a choir chorusing Saint-Saëns's 'Hymn to Victor Hugo'. To the waiting crowds the President proclaimed 'an important stage in the slow evolution of work towards happiness and of man towards humanity'. Fifty million people from all over the world visited the Fair, eager to see the fashions in Art Nouveau, the wonders of technology, X-ray, photography and wireless telegraphy – and everywhere there was cinema. For months the banks of the Seine were transformed by the façades of ornate buildings illuminated at night by twinkling lights. Old Paris on the right bank of the Seine was completely eclipsed by the International Exhibition display on the left bank. The international pavilions included a pastiche by Edwin Lutyens of an Elizabethan manor house; a mosque and minarets; the Venetian San Marco; and a

trans-Siberian railway where a mujik in belted blouse served tea against the moving scenery of Siberian deserts.

Despite the 'moving photographs' and 'electrified dancing' at the exhibition, the old guard still abhorred modern art. At the opening of two huge painting exhibitions in the Grand Palais, the seventy-six-year-old academic painter, Jean-Léon Gérôme, barred the way to the Impressionists' room dramatically. 'Stop here, Monsieur le Président,' he implored, an arm outstretched: 'That way lies the dishonour of France!'[24]

Artists from all over the world defied the advice and poured into Paris to see the work that had caused a revolution in their world. In late October, shortly before the Exhibition closed, a stocky nineteen-year-old Spaniard with blazing eyes arrived at the newly opened Gare d'Orsay. Pablo Picasso had come with a friend to see his own painting, *Last Moments*, displayed at the Spanish pavilion. The naturalistic early work depicted a young priest praying beside a dying woman's bedside. Picasso visited exhibitions to study French painting and to sample bohemian life in Paris. In the autumn of 1900 he settled in an empty studio high up on the hill of Montmartre and was soon enjoying himself in the haunts that Valadon had frequented fifteen years earlier, the Lapin-Agile, the Moulin de la Galette and the Cirque Fernando. Miguel Utrillo, who appears in a Picasso sketch of the time, was among the group of Catalan friends who visited the International Exhibition with Picasso. Three years earlier Miguel had founded the Quatre Gats tavern in Barcelona, which at this time was a centre of great cultural excitement. Els Quatre Gats was modelled on the Chat Noir, with a shadow puppet theatre and its own little magazine. The young Picasso, whose family had gone to live in Barcelona, was invited to design menu cards and flyers for the tavern.

On the first night in Picasso's Montmartre studio, the Barcelona friends got drunk together: Miguel Utrillo wrote nursery rhymes, Picasso sketched the drinkers and another friend sang bawdy Latin songs. There is no evidence to suggest that Miguel visited either his adopted son or his former lover before he returned to Spain; but Maurice mentions the World Fair in his autobiography, so it seems certain that Valadon, who was her son's cultural mentor, would have visited it too.

Even as a very young man, Picasso, the son of a drawing master from Malaga, was ambitious and purposeful, determined to make a career

with his gift. Through the network of Catalan friends he discovered a woman dealer, Berthe Weill, interested in promoting young artists. Berthe Weill was the first to buy works from the young Spaniard – three pastels of bullfighting scenes in 1901 – and by 1902 she stocked paintings by Matisse too in her little gallery at No. 25 Rue Victor-Massé, close to Degas's house. Degas shunned Berthe Weill and her gallery because she was Jewish, and as a woman, living mainly in the country, Valadon lacked the confidence to approach sympathetic dealers herself. Later Berthe Weill did promote Valadon's work with great enthusiasm and gave her a solo exhibition in 1915. But for years Suzanne paid a high price for her isolation.

In 1901 Degas was still doggedly trying to spur her on. Unfortunately none of her letters to him survives. 'Your letter always reaches me punctually with its vigorous, engraved lettering,' he wrote. 'It is your drawing that I no longer see. From time to time, I look at your red chalk drawing, still hanging in my dining-room. And I always say: "That she-devil of a Maria, what talent she has . . ." Why do you show me nothing more? I am getting on for sixty-seven.'[25]

But there was nothing: no paintings, no drawings, no etchings. That year, in September, she was horrified to read of the premature death of Toulouse-Lautrec at thirty-seven years old, almost her own age. In the years since they had been friends and lovers in the Rue Tourlaque, Suzanne had become the bourgeoise, the rich man's wife, while Lautrec had created his magnificent posters, kept a room at his disposal in the most luxurious brothel in Paris, in the Rue des Moulins, enlivened the Paris scene with his wit and elegance – and died from drink and dissipation. He had died at his mother's estate at Malromé, and Suzanne remembered the Malromé pâté and wine they had enjoyed in the days when she posed for him the garden of le Père Forêt. Later, she said she had wept for a week.[26] Her sorrow was partly grief for remembered generosity and friendship, partly grief for her own youth, and it was compounded by fear for her son.

Approaching twenty, Maurice continued to drift without occupation, to drink when he could and to cause trouble wherever he went, in his own and neighbouring villages. The neighbours were constantly complaining. Paul Mousis had invested in land at the top of the hill, the Butte Pinson, at the end of the tramway. There he decided to build a house for the family, in its own grounds, with railings around, out of

earshot of the neighbours. Then in February 1903 the family moved back to 12 Rue Cortot, their rented apartment, and Mousis decided to make another attempt to force Maurice to settle down, placing him back in his first commercial job as office boy. For a few weeks Utrillo submitted to performing boring tasks for meagre pay, but he soon managed to subvert his position and bring about his dismissal. Other jobs were found for him, including a spell in a factory, making lampstand bases. They all ended in failure and his drunken bouts became more severe.

For Valadon the return to Montmartre proved almost miraculous. In 1902 she appears to have made only a handful of drawings, including an amusing nude of a young boy with barely visible private parts, examining a garland of leaves, a self-portrait and two nudes. But in 1903 her pencil flowed. She made at least twenty-one drawings exploring the positions of the nude, affectionate portraits of her small dogs, Loubie and Denis, her first flower drawings and a delicate self-portrait, partially destroyed by Trompette, another of her dogs. Throughout her life Valadon's work, especially her drawings on tracing paper, suffered occasional damage, either from her beloved dogs or from her family.

She also painted two versions of a major work, *The Moon and the Sun*, or *The Brunette and the Blonde*. In her painting, which has an unusually playful mood, the standing blonde is fingering part of a garland of flowers twined round the brunette's head; the young women look affectionate and physically close. Despite her candour, Valadon painted naked women with great compassion. The sudden return of her creative gift after almost seven years of barrenness must point to a release and an inner freedom that she found in working and living again in Montmartre, close to her old friends and her old haunts.

During the summer months the family went to the country. A family friend, Dr Ettlinger, had suggested to Suzanne many times that she should teach her son to paint. The doctor believed that working with his hands might prevent the poor youth from harming himself and provide an outlet for his nervous energy. The notion of art as therapy was unheard of at the time, but Valadon, desperate to find a way of saving her son, snatched at the idea. She began to give Maurice daily lessons.

Utrillo at first resented the tuition but Suzanne was vigorous and insistent. She mixed his paints in a single palette, made up of five

colours: two chrome yellows; a vermilion; a deep madder lake; and a zinc white. Later he was to say that it was his mother who gave him the taste for the white that figures so prominently in his work. Suzanne herself viewed his painting as a useful exercise to keep Maurice occupied, until one day she noticed a landscape on his easel. 'You're doing quite painterly work,' she told her son dourly. 'You're not just a drunk! Now you need to learn to draw.' Maurice baulked at any discipline but Suzanne insisted on his carrying out the exercises in drawing she gave him and when he was at home his stepfather would brook no disobedience.

The family celebrated Christmas, Maurice's twentieth birthday and the New Year of 1904 in Montmartre. For eight days Maurice went on a wild binge. Early in the morning of 9 January he stormed into his mother's bedroom and threw himself on top of her, knife in hand, in a state of frenzy. Before he could be restrained, he had smashed chairs and thrown them out of the door, breaking the windows. He possessed a pistol and live ammunition and flew into a worse rage when the weapon was confiscated.

Paul Mousis sent urgently for the doctor, who examined Utrillo, now morose and silent. The patient was pronounced in need of institutional care – which was what his stepfather wanted. With the concierge and an old friend of the family acting as witnesses, Maurice was ordered by the police to be confined for treatment for alcoholism in the Hospital of Sainte-Anne. The hospital was run on prison lines, with the physician in charge, a Dr Vallon, assisted by two housemen and a staff of burly, uniformed men to ensure that the patients were safely confined inside the securely locked and barred building. From the date of his entry Maurice was labelled a 'lunatic', a diagnosis he deeply resented. Three years earlier when he visited the Bicêtre Hospital, the psychiatrist in charge had noted what he described as a schizophrenic condition, due, he remarked, to the alcoholism of Maurice's father (assumed to be Adrian Boissy) and to his mother's extreme excitability. Suzanne was deeply upset but at the same time relieved that he was at last to be treated for his dipsomania. For four months the house in the Rue Cortot remained peaceful; then in mid-May Maurice was released from hospital, officially 'cured', although his sobriety was short-lived. The family moved out to their country house. The cure seemed to have left Utrillo calmer and yet sapped him of all vitality: the youth was flat and

listless, shrank from company and rarely spoke. Only scientific and technical magazines seemed to interest him and he put them away reluctantly at mealtimes. For hours he would stroke the cat or stare fixedly at a spot on the wall.

Gradually Suzanne coaxed her son to go out into the fields with his easel and start to paint again. Between the autumn of 1903 and the winter of 1904 Utrillo produced about a hundred and fifty paintings and drawings which subsequently disappeared. Significantly he signed his works 'Maurice Valadon' or 'M. U. Valadon'. As this was confusing to dealers and clients, after 1906 Maurice was persuaded to sign himself 'Maurice Utrillo, V.' The 'V' for Valadon presumably helped him to cling to his fragile sense of identity. His new 'father', Miguel Utrillo, who had acknowledged him at eight years old, had disappeared from his life.

For inspiration he turned, as always, to Suzanne. She had spoken to him of the Impressionist landscapes of Alfred Sisley and the young painter became obsessed by the need to measure up to Sisley's standard. 'When I myself believed what I painted was good, I mused: "It is Sisley all right. Why Sisley I shall never know. I had seen nothing of that master's work but I had heard mother talk of him . . .".'[27] Apparently it did not occur to Suzanne to send her son to study art, so he developed his talent as she had done, by gradually gaining in confidence and skill. As Maurice concentrated on his new passion for painting, the bond between mother and son deepened. 'Monsieur Paul' with his talk of money and the material world seemed a stranger in the house, a shadowy figure in their lives. 'He knew nothing of artistic matters,' Utrillo said later. When Maurice broke out and came home drunk his mother invariably took his part. 'You make more fuss if Maurice gets the perspective wrong in a drawing than if he comes home smashed out of his mind,' Mousis complained.[28]

Suzanne was forty in 1905. With her deep-blue eyes, her hair parted down the middle, darker now, her tiny figure slim but curvaceous, she was strikingly handsome. 'She seemed to dance rather than walk. She had something of both an Amazon and a fairy,' an admirer more than twenty years her junior wrote.[29] The admirer was André Utter, the son of a Montmartre plumber. He saw her first in 1906, when he was convalescing near her suburban home. He was training as an apprentice electrician but had ambitions to become an artist. The family, of Danish

origin, lived in the Rue Clignancourt in the heart of Montmartre, and André, the adored only son, was spoilt by his mother and four sisters. Handsome and virile in his electric-blue workman's overalls, André was easily seduced by the bohemian life of Montmartre. He soaked himself in Baudelaire, Verlaine, absinthe and red wine, and was extremely popular with the girls as well as the young painters and poets. For all his drinking and swaggering, Utter had a genuine appreciation of art which he deepened by visiting artists' studios and museums and reading books on art history. But the dissipation of Montmartre told on his health and when he was only twenty, in the summer of 1906, his parents decided to send him to the quiet of Pierrefitte to recover from too many wild nights. His ever-indulgent mother secretly pressed money on him.

At Pierrefitte André Utter met Utrillo painting in a field and came to set up his own easel beside him. As Maurice had been drinking, after a time Utter helped him home, where he met his stepfather. The next day Maurice introduced him to Suzanne, who was pleased to welcome any friend of her son, especially an artist. She showed him some of her own recent work, one or two pastels, drawings and engravings.

Back in Paris, Utter resumed the bohemian life with gusto. He wrote later of the parties where painters, writers and poets and their girls crowded on to sofas or perched on the floor, eager to swallow the little white hashish pills, washed down by tea strongly laced with cheap alcohol, which left the company even more befuddled and with a raging thirst. In 1907 Amedeo Modigliani, the young Italian painter, had exhibited for the first time in Paris and Utter met him in 1908. Modi, avid for new sensations, experimented enthusiastically with hashish, morphine and opium; he soon lost his bourgeois bloom and became as poor and wretched as many of the other gifted artists of Montmartre.

André Utter was different. In the daytime he worked as an electrician in a decently paid job and after his roisterings he always went back to his parents and his comfortable home. He painted at weekends and on fine summer evenings, serious about his art. He took to placing his easel near to Valadon's studio in the Rue Cortot, so that he would be sure to catch a glimpse of her bounding downstairs with her dogs. One day when she was passing she called out to him: 'You can't paint the earth in the same way that you paint the sky.'[30]

Valadon had never really suited the role of a rich man's wife. Good works or fashionable charitable committees were not her style. Her

generosity was spontaneous and immediate. In 1906, for instance, Gino Severini, an Italian painter new to Paris, was painting outdoors in bitterly cold weather, and as Suzanne passed by, bundled up in a cloak, she peered at his work. 'It's too cold to sit there,' she said brusquely and instantly whisked the astonished young man – a complete stranger – to a nearby bar for a glass of grog.[31] Such impulsive gestures came naturally to Valadon.

Utter could not put her out of his mind; sometimes he dreamt about her. Then, one day in 1909, when he caught sight of her at her studio window on the Rue Cortot, she grinned at him and asked what he was working on. He told her it was a self-portrait. 'I'd like to see that,' she said, and invited him to bring her his canvas the following afternoon. According to Utter she liked what she saw and asked if she could show his work to Degas, who, in his turn, encouraged the would-be artist to persevere.[32] That part of Utter's account seems unlikely, since by that stage Degas was becoming more and more averse to meeting strangers. What does ring true is that Suzanne told Utter something of her life and showed him her work; and an intense love affair began.

For Utter, brought up in a respectable artisan family, Valadon represented the dream and the embodiment of bohemian life. He conceived a real and enduring passion for the woman and her work. Utter was twenty-three, Suzanne forty-four, but at the time the age difference seemed to him totally unimportant. Two drawings Valadon made of Utter in 1909, however, suggest that young André did make an effort to look older and more serious. In the first, full-faced sketch Utter seems an appealing, baby-faced youth. In the second, a profile, he appears as a grave young man, with a beard.

Utrillo, three years older than his mother's lover, remembered the meeting between Utter and Valadon in 1909. He was in awe of his mother, boasted about her and felt intensely possessive, his feelings jumbled up in the misery inside his head. Suzanne herself wrote years later that the meeting with André Utter represented a 'renewal of her life'.[33] The only written evidence from that time consists of a note from Valadon to Utter, dated Thursday 23 September 1909, written on her husband's monogrammed writing paper. 'Monsieur,' she wrote, carefully formal in her address: 'I forgot yesterday that I have my model on Friday and Saturday. I must therefore rearrange our visit to the museum for next Tuesday . . . If you can, come and call for me as arranged.'[34] By November they had become lovers.

Their outing together was to the first private museum in Paris, Gustave Moreau's house in the Rue de la Rochefoucauld, the street where Valadon had lived as a child. Moreau, a minor Symbolist painter, who was renowned for his teaching at the École des Beaux-Arts in the 1890s, had left the nation a legacy of hundreds of his paintings and drawings and his home after his death in 1898. Among his students were Matisse and Rouault. That autumn day Valadon and Utter visited the house and studied the exhibits, many depicting eternal woman, decked in ornate jewellery and set in a world of fantasy.

Although Suzanne had gleaned a knowledge of the great draughtsmen from Degas and knew the works of the Impressionists, for years she had lived apart from the revolutionary artists of more recent times. By 1909 clusters of painters, writers and musicians were working together in a frenzy of creative excitement, meeting in cafés, cabarets and hashish dens, where they clowned, experimented and evolved bold new theories to confront an age in which the individual's inner world was dissected by psychoanalysis and the outer world was menaced by technology. Part of André's appeal for Valadon was his easy friendship with the young generation of international artists, who were to become leaders of new movements in the new century, men of the calibre of Picasso and Matisse. Through André, Valadon discovered the world of her younger contemporaries, the Cubists and the Fauves, the group of artists centred on Matisse who painted their pictures in intensely vivid colours. 'Exactitude is not truth' was Matisse's watchword. A derisive critic had labelled them the 'Fauves', wild beasts, and their work provoked an outcry among the public. Utter knew not only the painters but the critics and poets and was familiar with the modern art scene. As an artist, though, Utter was the pupil, anxious to learn from Valadon's growing mastery of line and form.

The affair was not merely based on art; an overwhelming physical attraction drew them together. For the first time in her life Valadon discovered a well of uninhibited sensual pleasure. Lovemaking for Valadon in the past had partly been a meal ticket, an entrée to a way of living, even a means of educating herself. She had enjoyed it, been a willing receptacle of the passion of older or less handsome men, but now the passion was shared and she was in love with a young man who adored her body and admired her as an artist. They were so much in love they could hardly bear not to touch.

That year Valadon exhibited her painting in the influential Salon d'Automne. Founded by a group of young and progressive artists in 1903, the new Salon, unlike the Salon des Indépendants which was open to all, decided to prevent slick, dated or simply bad art from swamping their exhibitions by appointing a jury of modern artists to screen entries. The new Salon, now held in the Grand Palais, had put on a series of important retrospective exhibitions, including those of Cézanne, Seurat and Ingres, and was regarded with respect. Suzanne herself wrote that Utter had introduced her to a new artistic milieu; it seems clear that it was her lover who prompted her to submit work to the Salon d'Automne.

Utter claimed that Valadon began to paint because of his 'pleading'. That was an exaggeration, since she had painted occasionally for sixteen years. But the new love, the new stimulus and André's devoted encouragement drove her to work furiously. In the four years between 1903 and 1907 she had produced only five paintings. In 1909, the year her love affair began, she painted at least eight magnificent works including *Summer*, which was exhibited at the Salon d'Automne; *Nude at the Mirror*, *After the Bath*; and, above all, *Adam and Eve*, using herself and her lover as models. Suddenly in her drawings and paintings her nudes seem comfortable with themselves, occasionally joyful in their physical expressions. Valadon was the first woman to paint a man and woman together in the nude but when the painting was exhibited later Adam's (André's) genitals had to be masked by a giant fig-leaf in deference to the prudery of the time. The painting, the largest Valadon had ever attempted, shows the couple in the Garden of Eden, Suzanne triumphantly holding up a ruddy apple while André has his hand lightly on her wrist. Writing about the so-called 'School of Paris', Bernard Dorival remarked:

> The originality of Suzanne Valadon is unqualified in these nudes . . .
> The uncompromising naturalism of the figures and the way she brings
> out the character of each with powerful feeling and sensuality, the
> almost caricatured look she gives to her own face . . . all these are
> peculiarly her own – like the deliberately coarse accent by which she
> arrives at a robust poetry, one that has a tang of the people without
> losing its rare distinction.[35]

Because the well-being of her family depended on concealing her growing passion, Suzanne tried at first to hide her feelings. Yet Mousis

could not have failed to notice her more frequent visits to her Montmartre studio and André's appearances there and in their country home. Maurice too watched the amount of time his mother and his friend spent together, leaving him the perpetual outsider. Suzanne, who loved to give presents, now began to indulge both her son and her lover. She was so happy that she was able to withstand the brooding rows and the reprimands from her aggrieved husband, ostensibly over her lavish expenditure.

Through André, Suzanne realised how much she had missed of the 'mad years' of the new century. He continued to introduce her to the international artists in Paris who were seeking to overturn the nature of perception, finding inspiration in primitive art and turning to individual intuition, distortion and fragmentation to renew their vision. Utter was of course already friendly with Modigliani, who came to admire Utrillo's talent and became a friend of Valadon's as well.

Before the end of the year, Suzanne was too much in love to care about concealing her affair, occasionally staying out all night. Paul Mousis discovered, to his chagrin, what most of Montmartre knew already: that his wife was deceiving him with young André Utter. In a violent fury, he threw her out of the studio, hurling easels, paints, canvases and drawings after her and viciously destroying some beautiful work.[36]

When the break came it was a relief. After thirteen years of affluent living, Suzanne was once again existing precariously as a bohemian artist and she could not have been happier.

6

Fulfilment

For Suzanne Valadon, 1909 was a miracle year and the sense of release that she felt after the break-up of her marriage to Mousis pervades her work from 1909 until the First World War. 'One of life's accidents caused her life to be renewed when André Utter married her, for through him she met his colleagues and friends,' she wrote.[1] They were not in fact married in 1909 but lived together openly in a studio in a small, one-way street, No. 5 Impasse de Guelma, a new building designed especially for artists' studios where Georges Braque, Raoul Dufy and Gino Severini were neighbours. After thirteen years in a respectable marriage, she was now surrounded by artists and in touch with the latest developments in modern art.

Suzanne always looked young for her age and she launched into her new life like a girl. Fernande Olivier, Picasso's mistress, remembered seeing the lovers, radiantly happy, strolling through the cobbled streets of Montmartre, Utter strikingly handsome in his blue workman's clothes, the favoured gear for radical youth. Valadon seemed to her the teacher, André Utter the pupil.[2] When the lovers happened to come across Maurice, stumbling by the roadside or slumped in a bar, they pulled him away and took him home.

They were cramped, of course, with Madeleine, now an old lady of seventy-nine, Maurice, Suzanne, André and the dogs all living in a small studio. Early in 1910, with Paul Mousis's consent, Suzanne moved her family out to Montmagny, to the little house in its own grounds that her husband had had built for the family on the Butte Pinson. Mousis now wanted to distance himself from his wife and her entourage. Bitter and disappointed, he lost no time in filing a suit for divorce. On the day of the hearing on 3 March 1910, Suzanne failed to attend the tribunal, so the case was heard in her absence. According to Mousis's lawyers and his

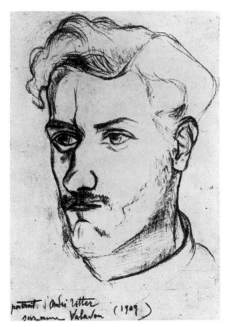
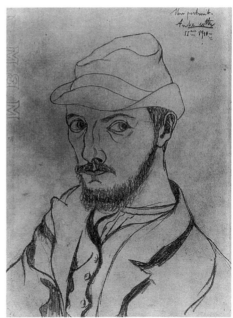

LEFT *André Utter*, 1909.
Valadon gloried in her lover's good looks and made many drawings of him
in the year that their love affair began.
RIGHT André Utter, *Self-Portrait*, 1911.
Utter was twenty-five when he drew this self-portrait; Valadon was a youthful
forty-six.

two witnesses, his only failure as a husband had been to be too good to
his wife; whereas Suzanne was said to have harried Mousis with
demands for money, insulted him, stayed out all night, and claimed
without any justification *'that her husband had harmed her artistic
career'*.[3] It is unlikely that Suzanne would have argued against any of the
accusations except the last. Paul Mousis had indeed hampered her
artistic development, although more out of insensitivity and a total lack
of understanding of her needs as an artist than from deliberate malice.
Judgement went against Suzanne but she was allowed to keep the house
in Montmagny and André moved out there to stay with her.

Valadon's fulfilment as a woman undoubtedly enhanced her creative
gifts. Both she and André Utter fostered the romantic notion that love
had made Suzanne a painter. She wrote of herself that around 1909 she
gave up drawing and engraving in order to paint but a glance at her

catalogue raisonné contradicts that view. [4] She continued to draw and to make a few engravings for years, but her drawing now became secondary and her production of paintings intensified after she met André. As Valadon herself noted in response to a questionnaire in the 1930s: 'her family portraits, her nudes, her still lifes, her landscapes, her flower pieces all date from that time [1909].' With no false modesty she described her painting 'in which the highly coloured surfaces were simplified, enlarged, without losing their subtly changing and balanced life, so that every day she worked with greater mastery'.[5] This growing sense of her own power lends excitement to her 'post-Utter' paintings.

Once she was free of a marriage that to her was a sham, Suzanne began to develop a strong awareness of her own unorthodox family. She had not used her son as a model at all in the years when she was married to Mousis; her husband would almost certainly have disapproved of a nude drawing of Maurice. And although Madeleine had served as a model for a grandmother often, in 1910 Valadon drew named head-and-shoulders portraits of the two, 'my son' and 'my mother', as if she were reclaiming the family. Around 1910 she also produced the first nude self-portrait, in outline, seated and quite unrecognisable, but she titled it *Suzanne Valadon assise*, in what seems like a gesture of defiance. For the next five years she drew and painted individual and group portraits of the people close to her: her lover, her son and her mother. The series culminated in a majestic portrait of Valadon herself as the centre of a family group, clear-sighted and strong, her long fingers on her breast, with her mother, bent and anxious, behind her and her son sitting beside her, lost, head in hand. André Utter, handsome and alert, flanks her right side, his head turned away as if to a brighter future.

In 1910, encouraged by André, she produced her first landscape, *The Tree at Montmagny Quarry*, a stylised, rhythmic painting in rich, dark colours evocative of Gauguin. The work was apparently made in high summer, and under her lover's guidance she had extended her palette from the cautious five colours she had used initially to fourteen. The new palette included yellow ochre, red sienna, light crimson lake, Venetian red, cobalt blue, deep ultramarine, English green and emerald green. To make black, which was important to her for outlining the contours of the figures in her painting, she blended ultramarine with sienna, vermilion and English green, or ultramarine with reddish brown. 'I tried to keep my palette so simple that I would not have to

think about it,' Valadon wrote. [6] She used neither black nor white and
no mineral spirit except unbleached linseed oil.

As telling as any diary, her beautiful drawings and paintings of the
nude in the first years with André echo her sense of release. Instead of
bending painfully over a bathtub or reclining awkwardly on a couch in
a bleak room, her nudes stretch and romp about on the grass in a new
mood of playfulness.

In Montmagny the lovers strolled around light-heartedly, impervious
to the curious glances of the villagers. As Paul Mousis was a landowner
and local personage, the sight of his wife tripping about the hillside with
her paintbox and easel accompanied by a handsome young man half her
age provided the neighbours with even more piquant scandal about the
family. Even Maurice sensed the happiness in the air; later he wrote
nostalgically of their simple life in the open air in 1910, of the pleasant
orchards, fresh vegetables and delightful vineyards of Montmagny.[7] But
as artists all three missed Montmartre, the stimulus and the company,
and they needed to visit dealers and colleagues, so they travelled by train
between the two very different villages. The novelty of the Valadon set –
mother, son and lover – intrigued the wits of Montmartre and it was
probably the poet and critic, André Salmon, a member of the Picasso
set, who first labelled them the 'terrible trio'.

Maurice was painting prolifically, producing atmospheric townscapes
of deserted streets, and both his work and his raging thirst for drink
were noted by local painters and publicans. Valadon had scarcely taught
him how to paint; she had merely introduced him to painting, and
other friends in Montmartre helped to guide him. But she did show her
son's work to colleagues whenever she saw an opportunity. As early as
1905 she had taken Utrillo's painting of a quayside in Paris to Anzoli, her
framemaker. The shopkeeper was the first to display a Utrillo publicly in
his boutique, where connoisseurs like Degas and Signac who frequented
the framemaker's would notice it. Valadon exchanged Maurice's
painting for one of the white oval frames that were fashionable at the
time.[8]

Utrillo was painting in the street and as soon as a work was
completed he would hawk it around before it was dry. A licence was
needed to sell works of art, but shrewd traders in the quarter in the pre-
war years, Jacobi the butcher and Serat the junk dealer, illegally placed
Maurice's works on the pavement outside their premises in Place Pigalle.

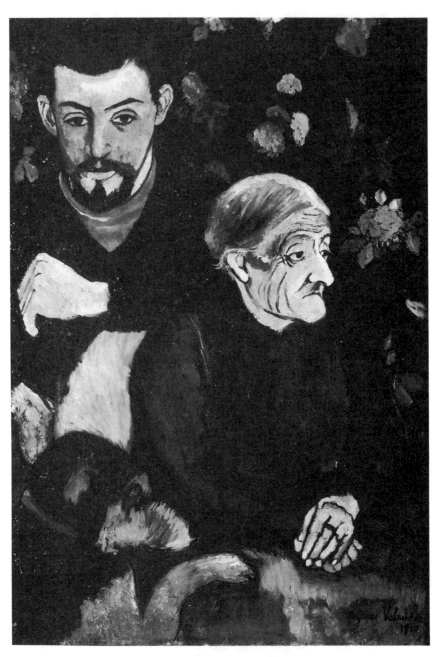

Maurice Utrillo, his Grandmother and his Dog, 1910.
In the first group portrait that Valadon painted, the figures peer out
awkwardly, the dog the most expressive, from a background of flowers.
Yet the work has an almost primitive power.

Any money Utrillo earned he would squander immediately and eventually come home drunk, his clothes tattered and his mood aggressive and confused. More and more Valadon became involved, as she tried not only to prevent Maurice's excesses but to protect her son and his work. Time and again she paid for the windows he had smashed, the bottles he had 'borrowed' and the glasses he had broken.

One day in 1910 Utrillo, dead drunk, barged into the opening of another artist's exhibition at the Gallery Druet, carrying an armful of his own paintings. He was chased out of the gallery by the indignant owner, although the firm's accountant bought a landscape for forty francs. Defiantly Maurice set up a stall in the vaulted archway leading to the gallery with a sign 'Exhibition and Sale of Paintings by Maurice Utrillo'. 'Five francs cheaper than you'd get inside,' he yelled to the critics and visitors in the gallery.[9] The critic Francis Jourdain, who was in the gallery at the time, was intrigued by Utrillo's work. Not only did he buy a painting (which he later sold) but he recommended the painter to his literary friends. Now in his late twenties, Maurice was already part of the Montmartre legend; and the poets and critics of his generation who wrote about him were unwittingly forcing Valadon into a secondary role.

In the early years of the twentieth century the Lapin-Agile, Valadon's old haunt, assumed a new importance as the village inn for local poets and painters, the spot where Picasso's gang always landed up after a night out at the circus or a prize fight. Picasso, his friend the poet Guillaume Apollinaire, fellow artists Georges Braque, André Derain, Maurice de Vlaminck and Juan Gris were regulars, sitting in summer under the cool of the acacia tree. Occasionally the older and more sedate Matisse would drop by. The new proprietor, Frédéric Gérard, who tried his hand at pottery and considered himself something of an artist, invited Picasso to decorate a wall. Picasso's painting *Au Lapin-Agile*, with the artist as Harlequin in the foreground, sitting beside a glum woman wrapped in furs and feathers, with Frédé strumming his guitar in the background, had pride of place in the *grande salle*. Paintings, including some by Valadon and Utrillo, as well as poems, posters and photographs, covered the walls and a life-sized crucifixion served as a hat-stand. Sometimes intense discussion would break out on the theories of art. One night three earnest young Germans badgered Picasso on aesthetics for hours until the exasperated artist pulled out a

pistol he carried and fired a volley of shots. The young seekers fled startled into the night.

Rumours about Picasso's new work were rife in Montmartre. He had a shocking new painting in his studio, it was said, but he refused to discuss it. By 1909 Picasso had, in fact, made his assault on traditional ways of representing the modern world. He was feeling his way towards a new style, having been profoundly influenced by the primitive Iberian sculpture of his native Spain, and by the artistic power of ritual African negro masks and sculpture he had seen in the ethnological museum in Paris. Cézanne's large retrospective exhibition at the Salon d'Automne in 1907, revealing the painter's emphasis on geometry in nature, had also inspired Picasso.

In his great revolutionary painting of 1907, *Les Demoiselles d'Avignon*, Picasso had begun to evolve his new style, now known as Cubism, in which the artist describes the scene from different viewpoints. In *Les Demoiselles* Picasso paints a crouching figure on the right of the picture as if he had looked at it from the front and the back. 'I paint objects as I think them, not as I see them,' he explained. That gave Picasso the freedom to paint still lifes and the women models he delighted in from any point of view or in fragmented parts. The effect *is* at first shocking, and even close friends, Matisse, Derain and Apollinaire, were dismayed by the work. The distinguished French painter, Georges Braque, was the first to recognise the potential of the new method. He worked closely and brilliantly with Picasso until the First World War as they developed early Cubism. Other artists, including Robert Delaunay and Juan Gris, interpreted Cubism in their own way. For many young radical painters and sculptors all over the Western world, Picasso's Cubism was the starting point.

After their Herculean labours in the studio, painters came to the Lapin-Agile to relax. Evenings at the inn held an unforgettable piquancy which captured the imagination of the writers of Montmartre. Francis Carco wrote a romantic account of his memories in *From Montmartre to the Latin Quarter*:

> Street girls and ruffians with a fondness for poetry mixed with the ordinary customers at Frédé's, addressed us as *tu*, bought drinks. These characters had soft hearts and 'artistic tastes'. All of them liked the casual life we led at the Lapin. And under the lamps, veiled with red silk scarves, and the low, painted ceiling of the main room, where

Frédéric sang, who would not have succumbed as though to a powerful drug? Neither dream nor pleasure approached the sensation. It was something else. A special kind of intoxication, a mingling of reverie and despair, indefinable, without echo. Like autumn rain that falls and stops and falls again, it caught hold of us, fondled us, enervated us. And it really did rain those nights – or else it snowed, while the drunkest of us stretched out on a bench, and inoffensive white mice, sly and unafraid, pattered across the chimney piece . . . The dense pipe-smoke added to the [atmosphere] and Frédéric, armed with his guitar, Mac Orlan [the French writer, Frédé's son-in-law], dressed in cowboy fashion, the dampness of the walls, the barking dogs, the secret despair of each of us, our poverty, our youth, the time that had gone by – all these completed it.[10]

Unlike the young artists at the Lapin, Valadon was a middle-aged rebel, a timeless gypsy, who had given up a comfortable home and an affluent life. Only through André had she come to know the enormously influential band of writers and artists who formed Picasso's gang. She was accepted by the young as a character: they admired her style, her talent and her dogged will to work and liked to hear her stories about Toulouse-Lautrec and the other great men for whom she had modelled. Her friends in the world of art were all old now: Degas was seventy-six; Renoir, increasingly crippled by rheumatism, was almost seventy, and living in the south of France; Puvis and Toulouse-Lautrec were dead.

Suzanne herself was forty-five, although she admitted, with reluctance, to forty-three. Thirty years earlier as a radiant young model she had been taken to the Lapin on the arm of a painter or an art student. Now she was the mainstay of the family and she brought André, an aspiring painter, with her. Valadon's canvases hung on the walls of the inn and paid for cheap, tasty meals and wine for the couple. Sometimes Utrillo barged in, late at night. He loved the Lapin and made several paintings of it.

The previous year, 1909, a new aspect of the revolution in modern art had been launched in Paris when the Italian poet, Filippo Tomaso Marinetti, published a Manifesto of Futurism in *Le Figaro* of 20 February. The new creed, in reaction to the Italian classical tradition, embraced the modern technological world, machinery, mass production, speed and violence and the energy of the modern city. In the Lapin, home of the artist, the Manifesto aroused excited argument

and derision. Then on 11 April 1910 a group of Italian painters led by Umberto Boccioni published a Manifesto of Futurist Painters, insisting:

1 That all forms of imitation should be held in contempt and that all forms of originality should be glorified.

2 That we should rebel against the tyranny of the words 'harmony' and 'good taste'. With these expressions, which are too elastic, it would be an easy matter to demolish the works of Rembrandt, Goya and Rodin.

3 That art criticism is either useless or detrimental.

4 That a clean sweep should be made of all stale and threadbare material in order to express the vortex of modern life – a life of steel, fever, pride and headlong speed.

5 That the accusation 'madmen' which has been employed to gag innovators should be considered an honourable title.[11]

The Futurists also called for a ten-year ban on the nude on the grounds that artists, obsessed by the urge to display their mistresses' bodies, had transformed the Salons into 'fairs for rotting hams'.

This manifesto confirmed in the public the notion that modern artists were indeed 'madmen'. Very few people had seen modern painting but everyone had heard of Picasso's geometrically shaped women and of the fragmented objects, seen from different viewpoints. The public's opinion of all the modern movements – Fauvism, Cubism, Futurism and the rest – was mocking and mistrustful. A cynical chronicler of the quarter, the journalist and novelist Roland Dorgelès, decided to tease the band of avant-garde painters and critics by playing a profitable practical joke. During the mild weather in 1910, he borrowed Frédé's donkey Lolo, tied a paintbrush to her tail and tethered the long-suffering beast with her rear end against a blank canvas. Dorgelès and his friends fed Lolo oats in Frédé's yard while squeezing tube after tube of paint on to her tail, as she swished it about. Dorgelès arranged for the newspaper *Le Matin* to publish a spoof manifesto signed 'Joachim Raphael Boronali'. The 'surname was an anagram of *aliboron*, jackass. The document advocated "Strength through Excess". The sun is never too bright, the sky too green, the distant sea too red, the dark too black. Destroy museums, trample on their absurd exhibits, scorn carefully finished paintings, instead dazzle and yell.'[12] The spoof was revealed before 'Lolo's' painting, entitled *Sunset over the Adriatic*, was exhibited at the Salon des Indépendants that spring. The *Sunset* was

the sensation of the Salon as crowds of curious visitors flocked to see the donkey's work. The joke was sufficiently near the bone to delight the public, who were baffled by the distortions and dogmas of modern art, and to anger many of the avant-garde. But many of them had moved to Montparnasse by then and rarely visited the Lapin.

In this climate Utrillo's evocative and reassuring paintings of familiar Montmartre streets, not only recognisable but also named, were beginning to attract both dealers and clients. In 1911, at the age of twenty-eight, according to his own account, he had his first experience of sex. A pathetic, lonely figure, Maurice had applied to enrol as a student in the École des Beaux-Arts, only to be rejected. Most of the other painters, with the notable exception of Modigliani, laughed at him. His work was individual, instinctive; he was completely outside the cliques and uninterested in contemporary theories of art. Suzanne tried to persuade him to visit the museums: he avoided the Louvre because of the crowds but occasionally visited the Musée du Luxembourg to gaze at the Impressionists. André Utter saw him as a tragicomic figure, and painted him in 1910 as Hamlet with a clown's hat on his head. When Roland Dorgelès met him, he was struck by Maurice's lack of ease in black clothes, the sleeves too long, and his chest caved in: 'His complexion was wan, his look blurred, his moustache cascading down his cheeks.'[13] He was a misfit, nicknamed 'L'Itrillo' (litre), and children stood behind him jeering when he painted in the open air, sensing his morbid terror. Eventually Utrillo took to shutting himself up indoors with picture postcards of streets and churches. Using a ruler and set-square, he produced his precise, poetic studies of streets, skies and walls. He experimented with different materials and often mixed sand and plaster with his paint to simulate reality.

Since his liaison with Suzanne, André, his former friend, had become more critical and less tolerant of Maurice. At first his 'parents' disapproved of Utrillo's refusal to paint outdoors. Later, when Suzanne was taunted that her son painted Paris from postcards, she remarked with withering fire: 'Some painters paint from nature and produce postcards: my son paints from postcards and produces masterpieces.'[14] She admired his desolate landscapes of Paris streets, overhung with leaden skies, and when he asked her of one painting 'Is it too ugly?' she replied, 'It can never be ugly enough.'[15] Yet Valadon was beginning to change her vision. In 1911 she spent most of her time on a large

landscape, *La Joie de vivre* (*The Joy of Living*). The composition was the most ambitious that she had attempted and she made three versions before exhibiting the large painting at the Salon d'Automne. In a glade in the woods, four nude women are drying themselves after bathing, watched quietly by a naked man standing a short distance away. André posed for all Valadon's nude male figures and she posed nude for him. Having modelled so often naked, she was completely unselfconscious about her body, and the naked figures in her painting reflect her freedom from false shame. Her nudes are at ease with themselves and each other, the curves of their bodies echoed in the branches of the trees. The scene has a timeless and idealised quality, recalling in its serenity the painting of Suzanne's first patron, Puvis de Chavannes. Only the rhythm, the mood and the flesh-and-blood poetry are all her own. Valadon made a self-portrait that year, mature at her easel, wearing a simple round-necked dress with a necklace around her throat.

She was offered her first solo exhibition in 1911 in a little gallery in the Rue Lafitte, the Galerie du Vingtième Siècle – the Gallery of the Twentieth Century. The owner, Clovis Sagot, enjoyed a reputation for spotting the best modern painters and had already bought early works by Picasso and Gris as well as Valadon and Utrillo. To give Valadon an exhibition was a special compliment, since Sagot usually hung a selection of the works of his artists on the walls. A former clown, Sagot liked to reminisce about his circus days, hoping that by parading his bohemian pedigree he would ingratiate himself with the artists, since the prices he paid for their work were derisory. Fernande Olivier found him sly and hardheaded. His gallery was sited in a former pharmacy; Sagot had inherited the stock and offered to treat needy artists with these patent medicines.

Clovis Sagot had hoped that the Valadons would sell well but the results were disappointing; the dealer blamed the failure on a series of robberies and brutal murders in the district which terrorised the public and kept them from venturing into the streets of Montmartre. At least Valadon's works were beginning to be seen by the public, largely through Utter's energetic encouragement. Six of her paintings were shown at the Salon des Indépendants and two at the Salon d'Automne.

Like his mother, Utrillo was beginning to attract attention in the art world, but while her work was appreciated mainly by fellow artists he was beginning to sell to the public. In the years before the First World

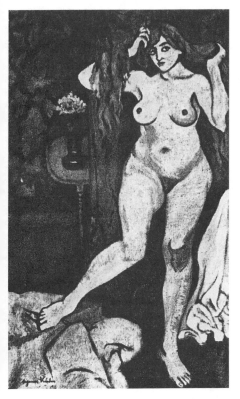 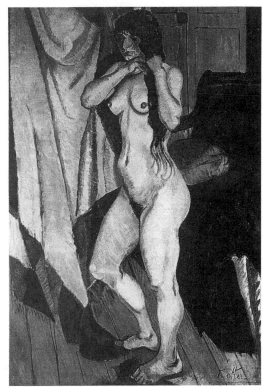

LEFT *Nude Brushing her Hair*, 1916.
RIGHT André Utter, *Suzanne Valadon Doing her Hair*, 1913.
Valadon and Utter shared a studio for years and often
posed for each other. As an artist Utter remained all his life
in the shadow of Valadon.

War a number of businessmen had begun to realise the market potential
of twentieth-century art and André Level, an enterprising young dealer,
bought up the work of promising new artists on their behalf. Even a
limited success for Maurice imposed a heavy penalty both on the artist
and on his mother. As soon as he had money in his pocket, Maurice
would head for the bars and drink until he was spent. Suzanne tried
desperately to keep him indoors, out of trouble. She came to dread the
late-night knock on her door from a police constable, who would
inform her that Maurice was, again, detained at the police station.
Whatever the hour, Suzanne would hurry along to pay the fine and
implore the authorities to release her son. Sometimes the police treated

the persistent drunk roughly, punching and kicking him in the struggle, and Suzanne would take Maurice home, dirty, resentful and confused. But she could not always succeed in saving him from himself.

In April 1911 Utrillo was arrested in the Place du Tertre for exposing himself in public and extreme drunkenness; in May he was sent to prison for a month for 'deliberately exposing his sexual parts' – ironic, that, for Valadon's son. A sketch she made of Maurice at the time, a study for the portrait of the family, seems to have been executed partly in sorrow and partly in pride. The drawing, on tracing paper, has been damaged: it shows Maurice sitting with his head in his hands, his shoulders bowed, a look beyond hope on his face. Suzanne signed the drawing, dated it and wrote, 'My son, an artist', on the paper.

Later that year the whole family moved back to a second-floor apartment at No. 12 Rue Cortot. A wooden staircase led up to their entrance. On the left was a big corner studio lit up by a huge skylight giving on to the gardens and facing north over the city; on the right was the little room overlooking the street where Utrillo would shut himself up to paint his views of Paris from postcards. The former occupier of the apartment, Émile Bernard, the artist who had worked in Brittany with Gauguin in the 1880s and was a friend of Valadon's from those days, had written over the entrance: 'He who does not believe in God, Raphael and Titian does not enter here.' The 'Trinity' were not entirely suitable on that count. Only Madeleine, in her eighties, clung to her peasant faith. Maurice, however, although unbaptised, yearned for religious solace and took some comfort from painting churches and cathedrals lovingly; neither Suzanne nor André was religious.

Suzanne and André worked side by side in the large studio. They modelled, clothed or naked for each other, criticised each other's work and fought fiercely over a dirty paintbrush or a lost tube of paint. They quarrelled loudly and made up with relish. Suzanne, in love for the first time, was openly demonstrative and the couple kissed and caressed in public. Utter was dazzled by the gifted woman who was his lover.

The idyll was marred for all three of them by Utrillo's wretchedness. Living at close quarters, André was increasingly exasperated by Utrillo's conduct and jealous of the sales of his painting, which he disliked. Utrillo, as always, was excluded, scared that his mother would tire of his scenes. Suzanne was torn between the two. She tried to prevent Maurice's worst excesses by entering into a contract on his behalf with

Louis Libaude, a dealer hated by all the young artists. A former horse dealer turned literary man, Libaude was too mean to buy a dealer's licence and acquired works of art, including early Picassos and Valadons, on what he termed a 'friendly' basis. He had no gallery and stored his collection in his flat. Picasso drew Libaude visiting a brothel, with the girls lined up for his inspection; the critic Francis Jourdain described him as 'a card sharper in a funeral hearse'.

Libaude bought his first Utrillo from Valadon at a very low price, under a pledge of secrecy. He would, he promised her, make her son's name. When he discovered that Utrillo was selling his paintings in bistros and junk shops Libaude was alarmed and decided to secure exclusive rights to the painter's work. He first invited Valadon to a meeting in 1910 and proposed giving Maurice a modest monthly retainer, to be paid to her, in exchange for the first option on his work. She was profoundly relieved, hoping that the arrangement would help Maurice control his behaviour. The following day she brought Utrillo, clean-shaven and neatly dressed, to see Libaude and sign a contract. At first Maurice was delighted to have a patron, but Libaude's constant interference and unwanted advice soon irritated him. The dealer even insisted that Valadon sign her son's work in a small, neat hand, since, he complained, Utrillo's scrawl across the canvas spoilt the painting.

Utrillo's craving for drink often drove him to beg Suzanne for money, fall into fits and then sneak out through the window. He was dominated by a fierce love for his mother – born, it would seem, from his disastrous childhood when Suzanne had taken lovers and left him largely to his grandmother's care. Also he had no father figure to fall back on. Miguel Utrillo had adopted him as a son when Maurice was eight but abandoned him two years later. His stepfather, Paul Mousis, had in Maurice's opinion banished him to boarding-school and then kept him at arm's length. Utrillo had coped by idealising his mother as a saint, mentally denying her weaknesses and revering her in a totally unrealistic manner: Suzanne was holy and by comparison all other women were sinners. He began to find pregnant women particularly offensive and, when drunk, would run after them, pull their hair and threaten to kick them in the stomach. Alcohol and drugs were his only escape from the horrors inside his head, and if he was desperate he would 'steal' his own paintings or Valadon's fine drawings to sell in a bar. To abide by

Libaude's contract, Suzanne kept some forty of Maurice's paintings and some of her own work locked in a wardrobe.

Maurice was working so feverishly that in the spring of 1912 he would turn up at Libaude's place several times a week with new canvases. On 18 April 1912 the dealer wrote to Utrillo rather than risk addressing Suzanne: 'Since the beginning of April you bring me a painting every two days. This is too much and I fear that this hasty production will harm your painting.' Libaude warned Maurice that he would only build a reputation by careful work. Utter, who had more financial sense than either mother or son, was always telling Suzanne that Libaude was exploiting Maurice, and the letter infuriated her. She replied herself, threatening to reveal the ridiculous sum that the dealer paid as a retainer. Libaude answered not to Valadon but to Utrillo: 'I have received a menacing letter from Madame Valadon . . . She spoke of divulging the price I pay you . . . I think I ought to tell you that if she carries out her threat, I will not buy any more of your paintings.'[16] The cheapskate dealer was playing on Maurice's addiction to alcohol and on Valadon's fears for her son.

Matters came to a head one morning in late spring 1912 when the critic Adolphe Tabarant received an express letter from Suzanne asking him to come to the Rue Cortot immediately. When he arrived he found her in bed, distraught and covered in black grease. She explained that after a night's drinking Utrillo had been rolled in grease by some hooligans. Utrillo had come home furious and started to smash everything. When Valadon tried to restrain him she too became covered in grease; her face, neck and arms were still black. Valadon asked Tabarant to intervene and entreat Libaude to pay a retainer of at least 300 francs a month in exchange for six paintings so that Utrillo could obtain treatment for his alcoholism. Libaude tried to wriggle out of his commitment, pretending that there had never been any agreement. In desperation Suzanne and André went together to beard Libaude. Tabarant described the scene:

> Libaude placed a table between himself and his visitors and clutched a bell in his hand. Then he screeched, 'The meeting is in session.' When Suzanne began to speak he jangled the bell to smother her words. 'Your son has the floor, Madame!' Libaude insisted. Maurice remained mute and when Utter tried to put in a word the ringing became frenetic. 'The meeting is adjourned,' Libaude pronounced with a final ring of the bell. [17]

Suzanne approached another dealer to pay the cost of drying Maurice out, and at that point Libaude grudgingly agreed to pay the 300 francs for Maurice's stay in a private clinic.

Dr Revertégat, who ran the institution at Sannois, a suburb of Paris, had a reputation for humane and intelligent treatment of his patients and Maurice seemed relieved to be sheltered and cared for. He was allowed to come and go under discreet surveillance and to paint outdoors in the quiet suburb. He told his mother that the staff treated him well and that his room was comfortable. He hated to be considered 'mad' rather than alcoholic and was particularly relieved to find that there were no mentally ill patients among the inmates. The food was excellent, although there was nothing but purified water to drink. The quiet regime, the routine, the absence of alcohol and, perhaps, of family tensions calmed Maurice and by the end of July 1912 he was considered well enough to return home.

To reinforce the treatment the family decided to take an extended holiday on the Ile d'Ouessant off the coast of Britanny. Suzanne, André and the dogs escorted Utrillo on a trip by train and boat to the island. The seas were stormy and Maurice found the treeless terrain bleak and gloomy, although Suzanne loved wild scenery. For Utrillo the island was, as the chroniclers called it, 'this earth of dread and land of the shipwrecked'. The barren rocks, the deserted heath, the scraggy meadow echoed his own mood of depression and nostalgia. Instead of diverting him from longings for the dangerous attractions of Paris, the holiday had the opposite effect: he secretly dreamed of the seething life of Montmartre. Utrillo painted a number of desolate wide landscapes; then Suzanne set up her easel behind him and began to paint landscapes too. She had not yet mastered the genre and was both admiring and envious of the way her son painted the sky. She produced a series of box-like, stylised paintings influenced by Gauguin, although only one of them features in her *catalogue raisonné*.[18] None of the three artists were at their best during their stay and by the end of October they were all delighted to return from their self-imposed exile. As André Utter wrote: 'The trip to Ouessant was epic. The dogs came along. It was a circus. How were we supposed to work under such conditions?'[19]

By 1913 Suzanne's status had changed from that of a rich wife to that of a poor divorcee. Her family was so hard up that she sold her only solid asset, the house at Montmagny. All three of them continued to

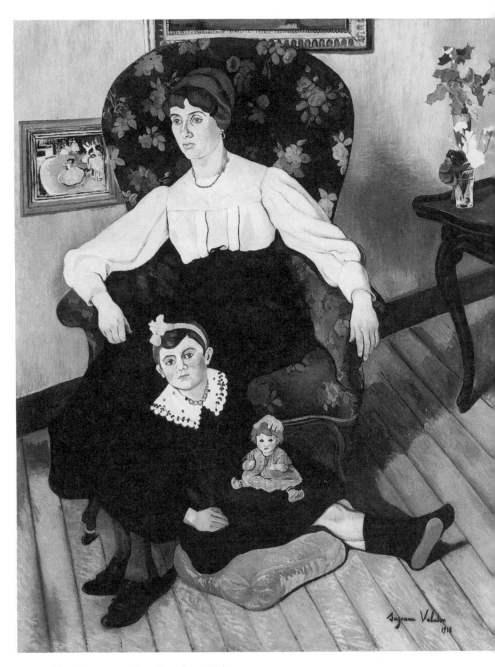

Marie Coca and her Daughter Gilberte, 1913.
Valadon shows great authority as well as a mastery of perspective in this
painting of her niece Marie Coca and her great-niece Gilberte, with the doll
making a third generation.

paint, but the money that their work brought in was swallowed up by drink, food and rent for the apartment in the Rue Cortot. Suzanne remained buoyed up by her love for Utter.

In 1913 her half-sister's family was in Paris. By then Marie-Lucienne, who had married Arthur Désiré Coca, had three children. Valadon painted a family portrait of her niece Marie Coca and great-niece Gilberte. Marie Coca, now forty, upright and dignified in a floral-patterned armchair, appears bored and detached, her adolescent daughter, perched on a cushion on the floor, uninterested in the doll she is holding. The room is sparsely furnished, uncarpeted, yet not without elegance. A table in the distance holds flowers, and on the wall, behind the armchair, hangs a painting of a ballet dancer – a clear tribute to Degas. The painting reveals Valadon's view of the mysterious distance and closeness of family members. Yves Deneberger, Marie Coca's grandson, remembers hearing stories from his mother, Gilberte, of how Valadon 'spoiled' her little sitter by giving her toys and sweets, much to Marie Coca's annoyance.[20] Valadon's large painting, *Marie Coca et Gilberte*, now hangs in the Musée des Beaux-Arts in Lyon. This group portrait has great authority, and the landscapes by Utrillo on either side seem slight in contrast.

In May 1913 Maurice's troublesome dealer, Louis Libaude, hired Eugène Blot's gallery for a solo exhibition of Utrillo's work, hoping to make a killing. Despite Libaude's efforts to publicise the show and his flattering preface to the exhibition catalogue, the critics were not enthusiastic and the public largely ignored it. Two paintings were sold for 700 francs each. Utrillo shrugged off the disappointment, leaving Suzanne to cope with the resentment of his disgruntled dealer.

The 'profane family', one of the many epithets attached to Valadon, Utrillo and Utter, visited Corsica, where they met Utrillo's painter friend, Augustin Grass-Mick, who had been engaged to decorate a local château and invited the trio to help him. They travelled to the north-west, about thirty miles from Calvi. Valadon was enchanted by the Mediterranean, the intense light, the mountains, the rocks and the southern sun – 'a sun unlike any other, exploding, caressing, adorning and embellishing,' she said.[21] With bold, firm lines and in vivid detail she painted a panoramic view of Corté, the main city of Corsica, from the mountains in the background, to the church and houses in the valley, to the cypresses and bridge and low stone walls in the foreground,

with each individual boulder outlined in an almost topographical work. She also painted impressive studies of olive trees and a view of the church at Belgodère. In the rugged, sun-scorched scenery Valadon gained a new certainty in landscape. 'Trees, sky, water and people move me deeply,' she wrote. 'It is shape, colour and movement that have made me paint in an effort to render with love and passion the things I care about so much. Nature is the yardstick by which I measure the truth in building up canvases. They are conceived by me but always driven by a feeling for life itself.'[22] All three painters enjoyed the wild scenery, the hot sun and dense forests; all produced good work. Even Maurice found life in Corsica agreeable. He noted that the wine was good, although his drinking was restricted, and that the spicy food was as tasty as in many a Paris restaurant.

Valadon was particularly fascinated by the poetry of the Corsican fishermen at work with their nets and began to make sketches for a painting, *The Casting of the Net*, a huge, stylised imposing picture of three naked fishermen, described by the critic Jeanine Warnod as 'the best of her large canvases'. André Utter, seen by Valadon as a pagan superman, posed nude for all three figures, on a remote Corsican beach, his genitals hidden by discreetly placed ropes. The painting she produced in 1914 was a bold celebration of the love of a middle-aged woman for a man twenty years her junior.

Valadon gloried in her lover's physical beauty. Before her passionate affair with Utter, most of the men she had known intimately had been poor physical specimens. There was Puvis, portly and ageing; Toulouse-Lautrec, sadly misshapen; Renoir, middle-aged when she was young. Miguel Utrillo, a handsome man, was of course an exception. Her ex-husband Paul Mousis was sturdily goodlooking, yet lacking in imagination. With Mousis she had plumped for security, but all her other lovers had been men of culture, invaluable to her artistic development. In André, Valadon had at last found a union of love and art.

After three months in Corsica, the trio returned to Paris on a rainy day in September 1913. Back in Montmartre, Maurice took up his self-destructive habits. He was thirty now, with no woman friend. He enjoyed a sporadic liaison with a kindly cabaret owner, Marie Vizier, the proprietor of A la Belle Gabrielle. The generous blonde sometimes allowed Maurice to stay the night, but when he had passed the limit she

too would beat him up and throw him out. Beneath the signature in one of his paintings he wrote, 'On the other side of this street I lived the happiest moments of my life', with an arrow indicating Marie, standing outside her café.

The other person who befriended Maurice in Montmartre was a former policeman who kept a café and shop, César Gay. The proprietor of the Casse-Croute was a reassuring, kindly man who liked to sit beside Maurice, watching while he painted. Monsieur Gay was delighted when the artist offered to teach him to paint. Maurice rented a little room above the bistro and on nights when he was too drunk to go home he stayed with César Gay and his wife.

Now that Suzanne was fulfilled and happy herself she longed to find her son a wife. She introduced him to several of her models – goodlooking, unpretentious girls, the kind she could keep an eye on. Her hope was that one of them would be able to steady him down and satisfy him; but her efforts were unsuccessful. To categorise Maurice's miseries and his sexual problems from this distance seems presumptuous. He was a 'mother's boy', perhaps a latent homosexual; his mother had looked to other people's sons for her fulfilment, latterly a friend of his own age. He seemed asexual but his libido was diminished by years of heavy drinking. Whether this drink problem derived from hungering for his mother in childhood, from sheer boredom or from a genetic predisposition remains another imponderable. At the root of his problems lay his unhealthy obsession with Suzanne and his lack of a father, or a father-figure. All one can say with certainty is that in his late twenties Maurice was ill at ease with the world and with himself, existing in a state of pent-up torment. His paintings, particularly in the years between 1906 and 1914, were illuminated by his bleak vision: walls defaced with graffiti, dilapidated houses, seedy streets and city churches were his only release. By the end of 1913, Maurice was in a poor state again and was persuaded to enter Dr Revertégat's institution for yet another cure. He spent New Year's Day 1914 in total abstinence.

Approaching fifty now, Suzanne had found the past five years the most fruitful of her life. In 1913 she had participated in a group show, held in Berthe Weill's tiny shop on the Rue Victor-Massé. Madame Weill, a knowledgeable and exceptionally scrupulous dealer, had built up a reputation as a champion of the avant-garde. Spaniards, Germans,

Italians, Japanese, Russians, Americans and English were now all part of the brilliant cultural life of Paris. Although artists from abroad were admitted to the artists' colony in Montmartre, as of right, the old-timers fought a rearguard action against the tourists and the commercialisation of the quarter and lamented its demise as the centre of the French rebellion against the philistines.

Valadon had grown up with the Montmartre of the artists and despised the daily destruction of the flower gardens and green spaces of the old village. The year that she had married Mousis, 1896, Montmartre had held a fête, the 'Vachalade', a festival of the *Vache Enragée* – literally the Mad Cow, but a term referring to down-and-outs – to raise money for poor artists and writers. The procession, heralded by trumpeters on horseback and a superb white charger, was followed by anti-landlord floats, a float celebrating the homeless (who slept outdoors, under the stars), 'A la Belle Étoile', and a comic float, 'Ma Tante', the popular name for the pawnshop. Artists from Montmartre and from the left bank had joined together in a supreme effort to revive the old, joyous spirit of Montmartre. But despite the stylish entertainment, the masked ball and fireworks, the organisers were better artists than businessmen and the grand fête had made very little money.

Degas, who had lived and worked for most of his life in Montmartre, was particularly distressed by the changes in the quarter. As he grew older, both his sight and his hearing were failing, but he remained obstinately independent. Every afternoon he would roam Paris on foot before turning in at 37 Rue Victor-Massé for dinner prepared by his faithful housekeeper Zöé Closier, and a cup of cherry-stem tea. To Degas the technological progress seemed to threaten his independence, although he did enjoy riding on the outside top deck of the omnibuses, watching the Parisians go by. In 1912 he was horrified by the news that the house he had lived in for over twenty years was due for demolition. At the age of seventy-seven, Degas had to find a new home. The sons of his old friend Henri Rouart helped him, but it was Suzanne, his 'terrible Maria', who understood that Degas would have been bored and disorientated in a brand-new block of flats in the suburbs. She found him an apartment at No. 6 Boulevard de Clichy, across the street from the Cirque Medrano, close to his old home, and helped to arrange Degas's studio and his art collection, which now included twenty-six of her drawings, to his satisfaction.

The old Montmartre and its old inhabitants were disappearing. On 20 June 1913 a farewell party was held at the Moulin de la Galette, 'La Fête des Adieux à Montmartre'. Fashionable women, *demi-mondaines* and grisettes mingled in the crowd with painters, politicians, musicians, writers and tradesmen to watch talented artists re-create the old carefree spirit. A final gesture, as the last of the windmills ceased to sail, was the election of the most beautiful girl as miller's wife.[23]

In 1914 a more devastating break with the past was imminent. But the artists' balls, the café conversations and the 14 July celebrations fizzed as brilliantly as ever, with no hint of the horror to come. Two weeks later, on 3 August 1914, Germany declared war on France; even in the artists' quarters of Montmartre and Montparnasse the mood sobered overnight.

La Coiffure, 1913. Valadon's thoughtful painting captures the tension between the naked ingénue with her future before her and the old woman in thrall to the past.

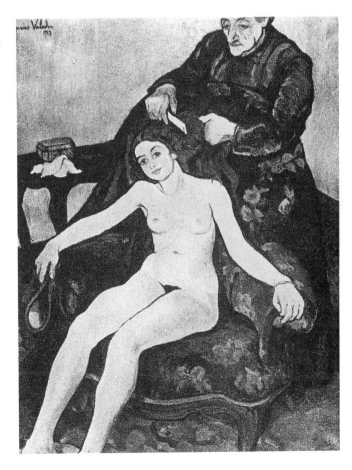

Within days the city was transformed. At night the streets were almost deserted. Cafés were ordered to shut by 8 p.m. and the restaurants by 9.30. Even in the daytime the city seized up. No buses ran; just a few trams with women conductors. Many small shops closed down altogether and the larger ones put up their shutters for most of the day. Outside the banks people queued for hours. No paper money was accepted, only silver and gold coins.

A mood of fervent patriotism pervaded France and even reached up to Montmartre. In the crisis art seemed of secondary consideration. The treasures of the Louvre were caged in iron crates; the Grand Palais was transformed into a hospital. The public suspected all foreigners, and many foreign artists hunted for their passports and packed to go home.

As the German army invaded Belgium, then northern France, thousands of young men hurried to the recruiting offices, to volunteer to defend France against her old enemy – André Utter, who was twenty-eight, among them. Suzanne was distraught at the thought of parting with her lover. To make it easier for the couple to be together on André's leaves, and so that Suzanne could receive a wife's allowance from the army, they decided to marry.

7

Separation and Success

The strange marriage of Marie-Clémentine Valadon and André Utter was celebrated at noon on 1 September 1914 at the town hall of the eighteenth arrondissement. According to the register, the bride was almost forty-seven (in fact she was within three weeks of her forty-ninth birthday) and the groom was twenty-eight. Aloïse and Eugénie Utter attended to give their blessing to the match but no one gave approval on Marie-Clémentine's behalf. By then her mother was nearly eighty-four and if her opinion was invited it is not recorded. Utrillo passed over the occasion of his mother's second marriage in the sad, sardonic memoirs of his youth.[1] The wedding was unusual, even by Montmartre standards, but by then the city was caught up in war fever. Four days after the marriage, fighting broke out on the Marne, when German troops advanced to within a few miles east of Paris, before being driven back by mid-September.

News from the front was sparse and rumour flew around Paris. All day long, newsboys ran through the streets with special editions of the papers which quickly sold out. Trains filled with wounded soldiers refused to carry civilians, and refugees from burning villages in Belgium crowded into the city with horrifying tales to tell. The powerful new explosives dropped from Zeppelins terrified the population. When the warning trumpets sounded the alarm, the lights went out and everyone scuttled to safety as searchlights probed the night sky for the enemy.

Since the general mobilisation at the beginning of August, most of the able-bodied men had joined up, in Montmartre as elsewhere; painters, sculptors, musicians, waiters all rallied to defend the motherland. In the Place du Tertre every little garret hung out a flag and the sign 'Everyone has gone to war' was chalked on the shutters of the closed shops scattered around the quarter. Many artists' models enrolled

in classes to learn bandaging; some became probationers in hospitals. Even the Lapin-Agile was pressed into service: a canteen was opened in the old inn, subsidised by the France-American Relief Committee, to serve cheap, nourishing meals for artists' wives and children. Berthe Gérard, the wife of old Frédé, managed to produce appetising lunches for the nominal sum of 25 centimes right through the war, sustaining many families in real need. The mood of the population was grim; the realities of war imposed 'a universal and systematic suppression of everything but grief and groceries', as Beatrice Hastings, an English journalist living in Montmartre who was Modigliani's mistress, reported.[2]

In lower Montmartre too, the raffish night-life of the quarter was severely curtailed. Night-clubs in Place Pigalle and Place Blanche, usually at their noisiest at four in the morning, now had to close at eleven. With foreign tourists gone and rich Frenchmen otherwise occupied, the gaming, the drug taking and the number of slim, painted girls walking up and down the streets diminished. The gendarmes who usually kept an eye on the prostitutes were engaged in war duties.

For Valadon the life went out of Montmartre when André went to join his regiment, in the 158th Infantry Division, stationed temporarily at Fontainebleau. The lovers had not been parted for five years and Suzanne missed André frantically. Within a month she left her mother and son and travelled to the country to be close to André when he had leave.[3] For a time she took work on a farm to support herself. She always enjoyed hard physical work and was good with animals.

In her absence, Utrillo, living above the bar at César Gay's place, began to write a disjointed autobiography, 'The Story of My Youth'. He dated it from Tuesday 13 October 1914; he must have started it just after Valadon had left Paris, in an effort to occupy himself in his loneliness. In the prologue he paid his mother an extraordinary tribute:

> From the depths of my soul I bless and venerate my mother, I look upon her as a Goddess, a sublime creature full of goodness, integrity, charity, selflessness, intelligence, courage and devotion. She is a noble person, perhaps the greatest pictorial luminary of the century and of the world . . . This elevated woman always brought me up in the strictest observation of morals, law and duty. Alas! I failed to take her good advice and allowed myself to be dragged into vice by frequenting impure and lewd creatures . . . and I, a faded rosebush, a repugnant

drunkard, was thus turned into an object of public scorn and ridicule. Alas, and a hundred times alas! May the author of my days forgive me.[4]

This pathetic outburst reveals the depth of Utrillo's yearning for his mother and the disastrously fanciful picture he had framed of her.

With Valadon gone Utrillo's world was shattered. He was fervently patriotic and longed to be in uniform, conscious that on his good days he looked perfectly healthy; but he was quite unfit for service. He had never been strong, but years of drinking had weakened his physique and blunted the intellectual ability that had seemed so promising when he was at school. He was only too aware of his inadequacy; and his mood darkened when German warplanes bombed Paris and leaflets from the air warned that the enemy was at the city gates. The thunder heard from German artillery massed along the Marne tormented his imagination; he translated his vision into fevered paintings, picturing ravaged villages. When he heard that the Cathedral of Reims, the Cathedral of Joan of Arc – 'his' saint – had been bombed, he translated the news into a painting of the cathedral in flames. (Utrillo had once seen a painting of Joan of Arc clad in a silver breastplate and had conceived a mystical attachment to her, revering her as a spiritual mother.) César Gay tried to keep a paternal eye on him but that proved an almost impossible task. Driven by his addiction, Utrillo would drink Madame Gay's eau-de-Cologne if he could find nothing better and break out of the window, jump to the ground and dive straight into a bar that sold ether across the counter. Then his delusions heightened and he sensed enemies everywhere: gangs from Montmartre hunting him down and spiteful women mocking him. Unconsciously, perhaps, he hoped for a crisis.

In December 1914 he struck an unknown woman in the street with a saucepan and broke the glass of a fire alarm. He was arrested and placed under observation in the cell of a special police hospital. Poor Maurice was always contrite; from his cell, he wrote a letter to his mother, begging her to forgive him, yet again, and assuring her of his devotion both to her and to his grandmother. Suzanne came dashing back to Paris to reassure the police commissioner that it was only when Maurice drank that he became violent, that he was perfectly reasonable when sober. She asserted her parental authority by informing the commissioner that Maurice had always lived with her, that she paid his rent in her name and provided for his needs, and that he owned no

furniture of his own. Maurice, she pointed out, earned money from his painting and that money enabled him to buy drink. After his outbreak, Maurice was confined for treatment and eventually released in January 1915.

In the first year of the war artistic life almost ceased, prices plummeted, and to sell became increasingly difficult. The large salons, the Indépendants and the Salon d'Automne, where Valadon had exhibited previously, had closed for the duration and Suzanne needed money badly. In 1915 she approached Berthe Weill, the dealer, and asked for an exhibition of her own and her husband's works in the small gallery at 24 Rue Victor-Massé. Sales from the group show at the same gallery in 1913 had been poor, but after the first year of the war the market had improved slightly and Berthe Weill, always a fighter for talented artists as yet unrecognised, agreed. 'I desire nothing more,' she told Valadon encouragingly.[5]

The exhibition was well attended but Berthe Weill recorded laconically that sales were practically nil. Suzanne herself was so disappointed that she later excluded the 1915 Weill show from her own record of exhibitions.[6] Certain discerning artists, Degas, Pissarro and others, had admired her work greatly; yet the majority, together with the general public, found her passionate painting too forceful and embarrassingly 'unwomanly'.

Gustave Coquiot, journalist, critic and fluent writer of puffs and prefaces for exhibitions, was one of the exceptions; he had written admiringly of Valadon's works in a book published in 1914.[7] In the depressed art market, Coquiot was seeking to establish himself as a dealer. Women's sexuality was a favourite theme of his, and earlier in his career he had also written salacious articles on Montmartre life. Suzanne and her work were much to his taste and he realised the potential of Maurice Utrillo's townscapes. He and his wife Mauricia entertained Suzanne, and sometimes Utrillo, lavishly in their comfortable home at a time when both painters were in need of warm hospitality. In 1915, a year in which Valadon produced very little other work, she was commissioned by Coquiot to paint both himself and his wife. Her portrait of Mauricia Coquiot, plump, décolletée and over-ripe, her bosom pressed against a display of orchids, was the most *mondaine* painting she had ever produced. She revealed Gustave Coquiot on her canvas as a heavy-jowled and manipulative figure. Later, Coquiot was to

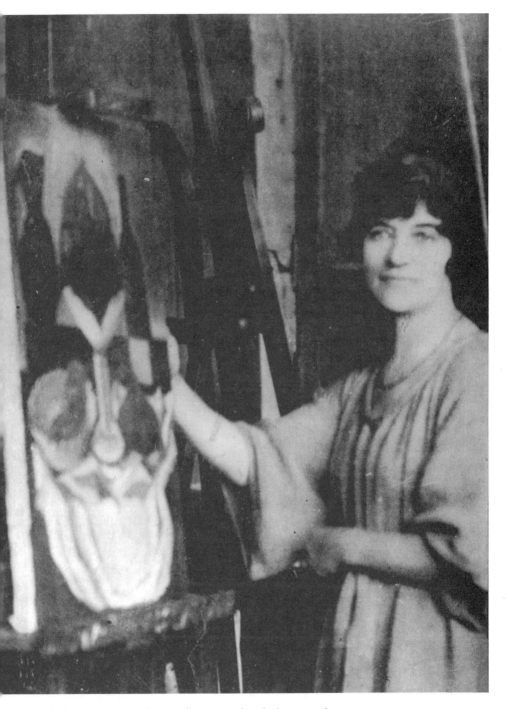

Valadon painting in her studio; an undated photograph.

warn would-be sitters that they should not expect 'a pleasant and attractive portrait from Valadon's brush'.[8]

Berthe Weill, who had become a good friend to Valadon, was wary of Coquiot. She noted that he wooed potential clients by wining and dining them expensively at his home and then producing one or two paintings from his stock, remarking: 'I bought this for a song from a poor devil who is half starving.' In her diary, later published, Weill mentioned a quarrel between Valadon and Coquiot. After Coquiot had boasted publicly that he had taken Valadon in and looked after her, Valadon accused him of obtaining her own and her son's paintings at ridiculous prices. Berthe Weill gave more credence to Valadon's side of the story.[9] Coquiot liked to brag that he 'sheltered' artists, but he always exacted a return. Women artists were particularly vulnerable to exploitation by some male dealers who expected payment in kind for their services. Marevna (Maria Vorobev), a Russian artist living in Paris at the time, wrote indignantly: 'Being a woman painter does not mean you are a whore!'[10]

The year was difficult for Valadon's whole family. In May 1915 Maurice was overjoyed to receive call-up papers from the military authorities, ordering him to report to the training centre at Argentan. A brief medical examination was enough to convince the army doctors that Utrillo was totally unfit for military service. Maurice felt that he had failed again; dispirited and disillusioned, a despised civilian, he retreated to Montmartre and to drink when he could find it.

On 20 June 1915 Madeleine Valadon died at the age of eighty-four. All through Suzanne's restless life her mother had been a rock, often disapproving, always anxious, but a permanent presence. The pain and sense of loss that Suzanne felt when she died may have come as a shock to her. Later she said that she had loved her mother more than anyone else. Perhaps because of the vagaries of her own life, she retained a fierce streak of family pride. She spent money she could ill afford giving Madeleine a decent funeral in the cemetery of Saint-Ouen.

To Valadon's joy, André was home on leave for Christmas, but the celebrations were marred by one of Utrillo's wild, destructive outbreaks. On 27 December 1915, the day after Utrillo's thirty-third birthday, Utter escorted his stepson to the asylum.

During 1916 Valadon was engaged on a beautiful series of nudes, employing a blonde girl called Gaby as her model. Valadon was unusually considerate to her models, since she had a unique understanding of the stress imposed in holding a particular position, and sensed when a model needed a rest. Gaby was an obliging girl who often helped Suzanne with the housework, as well as posing for her. Gradually Valadon began to feel that the goodnatured young woman might be the one to help Maurice to settle down, make him a good wife and steady him.

Utrillo, having languished miserably in an institution for most of the year, was discharged on 9 November and Suzanne went to fetch him home. Less than three weeks later she had arranged a wedding, high-handed in her desire to see her son cared for safely. 'Utrillo is to be married,' she wrote to her friend Adolphe Tabarant on 28 November and invited him to the celebration. Presumably Valadon used her influence as Gaby's employer to gain the girl's acquiescence; as for Maurice, recently released from the asylum, he was hardly in a position to make a strong stand one way or the other. At the last moment, however, Gaby took fright and called off the wedding, so Maurice was denied a wife. But Gaby continued to model for Valadon.

Her drawings that year, with her husband away at the front, her mother dead and her son incarcerated for eleven months, reflect both her loneliness and her physical longing. One drawing of a nude stretched out on a sofa, the long lines of her body not so much described as caressed, her eyes, her mouth, her breasts hungry for love, indicates a possible ambiguity in Valadon's own sexual desires. Bisexuality, particularly in wartime, was part of the artistic culture of the period, and Valadon was a sensual woman. Whether she was attracted to Gaby and whether that was part of the reason that Valadon wanted her model as a daughter-in-law remains an intriguing question. For art or for love she was *capable de tout*. Certainly that year her series of drawings of women dancers, often in pairs, touching each other, admiring a dress, pulling up stockings, pirouetting, suggests that Valadon found women sexy. She also produced two frankly erotic nudes – one in high-laced white boots, stockings and garters, the other in blue stockings – who, despite their déshabillé, look surprisingly prim.

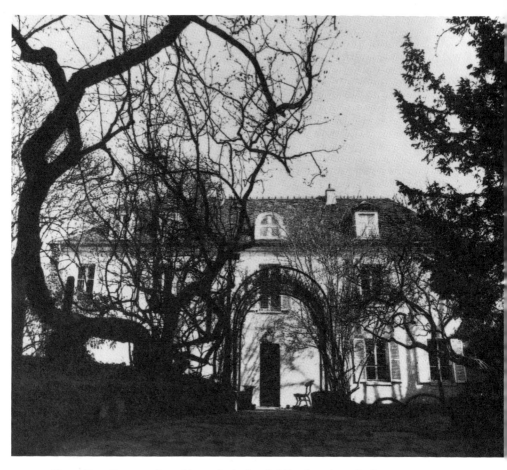

No.12 Rue Cortot where 'the unholy family' lived and worked
for some ten years. The building is now the Musée de Montmartre.
BELOW The first floor studio.

Contemporaries remarked enviously that Valadon neither looked nor acted her age. In her fifties she was as passionate and uninhibited as she had always been. The stories about her outrageous behaviour lent a dash of zest to the wartime gloom. One day Valadon was spotted in a café, wearing a corsage of carrots on her ragged coat and carrying a bouquet of live snails. If that tale was true, Valadon would certainly have cooked her accessories as soon as she got home! Another time Montmartre would be full of stories about Suzanne appearing in an outsize pair of Indian moccasins, with two cats in her arms and a goat at her heels. She had drawn her dogs for years, but her cats only began to figure in her paintings in wartime. Often friends would drop into her studio in the evenings, bringing their own food and an ample supply of wine, to picnic on the beds. On one occasion the poet Pierre Reverdy, who lived in the flat directly below Suzanne's studio, was driven mad by the noise of a hilarious party when he came home on leave. He fired his revolver into the ceiling in a vain attempt to quieten the noisy neighbours overhead.[11] But all the noise and all the tumult were Suzanne's way of fending off her loneliness. Despite the distractions she missed André unbearably and was worried by his letters, full of complaints.

At the end of 1916 the French army was recovering from the massive losses suffered at Verdun as well as on the Somme. A year of the bloodiest fighting was followed by an extraordinarily cold and prolonged winter. General Douglas Haig's diary recorded on 31 January 1917, 'The cold continues: the hardest winter I remember since 1880–81', and on 9 February: '25° of frost in places'.[12]

In Paris the city was brought almost to a standstill. Food shortages, caused by German U-boat activity and the occupation of part of France, forced crowds to queue for sugar, milk, fish and potatoes. Lamp oil was impossible to obtain and candles were scarce, but the worst shortage was of coal. All over Paris people lined up to buy a small bagful to heat their homes. Shop windows were frosted over and dustbins lay unemptied in the icy streets.

Suzanne, suffering like everyone else from the shortages and inflated wartime prices, was trying to help her husband. She approached Adolphe Tabarant and pleaded with him to use his influence to have André moved to a more comfortable post. Since she had lived for most of her life on the margins of society, she had learned to deal with difficulties by manipulation.

Suzanne Valadon

<div style="text-align: right;">Friday 16 February 1917</div>

Dear Monsieur Tabarant,

I no longer ask you to come up and see me, nor to make any approach.

I read in *La Griffe* that your work, which is so important for you, is taking up all of your time at the moment.

I am simply asking you to reply to me, by return post, *I beg you,* with the name of the administrative authority[?] where you had a request made for Utter; which I'm certain will enable him to return immediately.

Think of my joy and that of my poor Utter, on guard at night recently with *20 degrees of frost* below zero.

With friendly greetings,

Your most grateful

<div style="text-align: right;">*Suzanne Valadon*[13]</div>

The attempt was not successful, and three weeks later Valadon wrote again to Tabarant:

I'm writing this not to bother you yet again, but to keep you informed. Utter and I are both downhearted. He really is unlucky; his leave, which had expired during these past few days, has been refused, or at the very least postponed.

I hope you are in good health and therefore able to concentrate on your overload of work.

I enclose a catalogue.

We shall be very glad if you can spare a minute.

With thanks from me and from both of us,

Yours truly

<div style="text-align: right;">*Suzanne Valadon*[14]</div>

The catalogue that Valadon sent to her critic friend would have been the advance copy for Berthe Weill's show at her new gallery at 50 Rue Taitbout, where artists who had shown before with the dealer, including Valadon, Utrillo and Utter, were exhibited to the public. Valadon also exhibited work at Bernheim-Jeune with Utrillo and Utter later in the year.

After a fortnight Valadon wrote again to Tabarant, who was, apparently, still endeavouring to ease André's lot in the army.

<div style="text-align: right;">Friday 23 March 1917</div>

Dear Monsieur Tabarant,

Again I'm writing to you, to tell you that Utter – to whom I had conveyed your proposal for camouflage, putting him in the picture a bit,

<div style="text-align: center;">168</div>

but telling him that you were going to write to him to obtain his response . . . – has just written to me to say that he still has not received the expected letter from you. He asks me if Amiens could be an intermediate stage before being recalled to Paris, because that would be a very acceptable solution.

I fear I gave you his address incorrectly.

At any rate, here it is precisely: André Utter, Lookout Post No. 6, *Belleville-sur-Saône* (Rhône).

With warmest regards,

Yours sincerely,

Suzanne Valadon-Utter[15]

I've started something with a new model and would be glad if you would come with your friend.

These three letters, only recently discovered, reveal how devoted Valadon was to her husband, making immense efforts on his behalf. In her last letter to Tabarant, Suzanne gives a vital clue to the nature of the more congenial work that she hoped the critic would be able to arrange for Utter. By 1917 the French army were employing artists to paint patterns on canvas sheets which were then thrown over ships, aircraft, tanks and artillery to disguise them from serial observation by the enemy. This method of modern camouflage was first evolved on land in 1914 by Guirand de Scueola, a fashionable Parisian portrait painter serving in the artillery. 'The French general staff were impressed and de Scueola was rapidly promoted from private to lieutenant and put in charge of the first military camouflage section in the history of warfare . . . Other painters were recruited, including notable artists such as Segonzac and Villon, and a mobile corps travelled along the front line disguising artillery positions, airfields and observation posts.'[16] By 1918, 2,000 men and women were employed in French camouflage workshops, but despite Suzanne's efforts André Utter was not among them.

Utter's whereabouts during the spring of 1917 have not been established. Among French troops at the time, morale was extremely low. In April, with the severe winter barely over, the French army launched a disastrous offensive, and in the spring and summer soldiers in nearly fifty divisions resorted to mutiny. They refused to take part in further attacks, although they remained willing to defend their positions; they also complained vociferously of meagre rations and

insufficient leave. General Pétain, French Chief of the General Staff, after visiting troops stationed at the front, noted that in late May 'Demonstrations and disturbances occurred in an infantry regiment out of the line in Lorraine. In the Tardenois district the men of an infantry regiment shouted seditious slogans, sang the Internationale and insulted and molested their officers while the regiment was embussing . . . A serious extension of indiscipline and mutiny was reported from six infantry regiments, a battalion of Chasseurs and a regiment of dragoons stationed on the Aisne and farther south.'[17]

Since regiments of the 158th Infantry Division, which Utter had joined in 1914, were implicated, it is quite likely that he was involved in the mutiny. On 26 May, wrote Pétain, 'Three infantry regiments of a division [158th Infantry] recalled to the front after a rest period in the Aisne sent representatives to join in discussions at which plans for an attempted general mutiny were being hatched.' A few days later, 'the situation deteriorated and indiscipline spread to the majority of the regiments of eight divisions [including 158th Infantry].'[18] A combination of harsh discipline and improved conditions apparently restored the morale of the French troops and gradually the mutinies ceased as the fighting continued through the summer.

By June 1917 Valadon was devastated to receive news that André Utter had a bullet wound in his chest. His army surgeon, a Monsieur Latarjet, decided that the bullet was too close to his heart to be able to operate in safety and left it in his body.[19] Suzanne took the first train down to the military hospital at Meyzieu, just outside Lyon, where Utter was convalescing. Concerned as ever when she left Paris for Utrillo's safety, she placed him in the care of César Gay and his wife and wrote to him frequently.

At the time both Valadon and Utrillo suffered from being bracketed together in notices in the press. Maurice complained to his mother about a particularly annoying article, and in an undated reply Suzanne urged him to ignore the piece. The writer was an idiot, she said, incapable of understanding Maurice's art, but it was not worth getting angry. All critics were the same. 'Why introduce Suzanne Valadon in an article about your painting? You have enough talent for your work to stand on its own merit, and, as for me, I have too much to be confused with anyone else . . . Utrillo is Utrillo, Valadon is Valadon.'[20] She signed herself 'Suzanne Utter'.

From Belleville-sur-Saône on 28 June she wrote him a loving postcard: 'I have started to paint, and I think a lot about you and your talent which I would be so proud to possess.' She begged him not to drink and to behave well with Monsieur and Madame Gay, telling him she was going to explore the neighbourhood and would send him cards. 'Utter says paint, a man like you has too much talent to degrade yourself in drink.'[21] As Valadon and Utter toured the countryside in a horse and cart, staying in small villages and enjoying the wines of Beaujolais, Suzanne kept her word, scrawling numerous cards to Maurice, always begging him not to drink.

In August Suzanne and André returned to Paris briefly, to check on Maurice and arrange their work. Berthe Weill found their visit to her gallery an uncomfortable experience. 'Madame Utter is always embarrassing, but at least she doesn't look like a crazy old woman like Levitska [a Polish artist]. She is properly dressed and clean but a trollop [*une garce*] at heart . . . She kissed me when she came and kissed me when she left . . . I always stiffen in her presence. She overwhelms me.'[22] For her métier, Berthe Weill was a surprisingly prim spinster and her attitude prompts the suspicion that she may have felt attracted to Valadon, despite herself.

A week or two later, Berthe Weill called at the studio in Rue Cortot at Valadon's request, to look at the couple's latest paintings. Weill thought Suzanne's work was disappointing, but sensing the tension, with Suzanne on edge and her husband with clenched fists, she wisely said nothing. She took three or four of Utter's paintings back to the gallery with her and arranged with Valadon for work from both of them to be sent from Belleville-sur-Saône, where Valadon planned to stay for two months. There were no affectionate embraces when she left the Rue Cortot and Weill predicted privately in her diary that the couple would quarrel violently after she left.[23]

Back in Belleville late in August 1917, Valadon sent a characteristic note of pleading and remonstrance to Maurice: '*Cher petit* Maurice, I am anxious, be good, do not drink ever again, think of poor Utter and me.'[24] She wrote throughout the autumn in the same vein, pleading, as if with a child, for a word from her son, for his good behaviour, for news of everything he did. Meanwhile Maurice, obviously miserable, had sent her a distressing letter at the beginning of August. He loathed Montmartre, he wrote, and Marie Vizier, his former love from La Belle

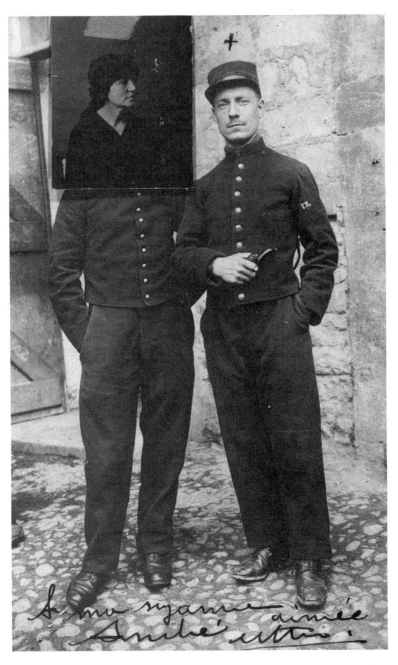

André Utter in wartime, with a photograph of Suzanne
Valadon inserted in the left-hand corner. The couple had
married soon after war was declared, and separation was a trial
to both of them.

Gabrielle, was an enemy. He had painted a picture for the local policeman, a good man. 'André Utter is a decent man and I envy him,' he said. 'Your place', he assured his mother, 'is in the Louvre; mine is in an asylum.' Maurice told her sadly that he now realised he had ruined his life by the age of sixteen and it was too late for him to carve a niche in the bourgeois world. Pathetically he asked his mother to call on him if she ever needed help. 'You would have more than a son, you would have a slave.'[25] Throughout August and September Suzanne sent anxious cards to Maurice pleading for news and a promise of sobriety. Since he could not give up drink altogether, she begged him to cut down his consumption.

Degas died in Paris on 27 September 1917 while Valadon was in the country. He was eighty-three and had remained as independent and irascible as ever, an old man with a white beard and bowler, restless until the end, riding on the top of the buses or walking the streets of the capital. Even in wartime over a hundred people attended the funeral at the Montmartre cemetery where Degas was buried in the family vault. Among the mourners were Suzanne's old friends, Bartholomé and Zandomeneghi, who had helped to launch her as an artist. But it was Degas himself who had nurtured Valadon's talent so carefully. He was the one man she had admired and respected; he was irreplaceable; and his death left a great vacuum in her life.

During much of 1918 Suzanne remained close to her husband, painting rural landscapes. That year she painted herself wearing a simple round-necked dress with a necklace. The self-portrait reveals a vigorous, amply built woman with luxuriant dark hair worn in a fringe; she looks out of the painting with yearning and a hint of mistrust. It is signed 'Suzanne Valadon, beside my husband André Utter in wartime, 1918'.

Alone in Paris Utrillo was finding life in wartime almost impossible to bear. In January 1918, which was another freezing month, the frost made vegetables scarce, and milk, eggs and butter were in short supply. Butchers closed their doors for three days a week and all food was expensive. Parisians had become inured to nightly air-raids, but on 30 January 1918 the Germans sent fifty much larger bombers over the city. That day Utrillo wrote to a Monsieur Henri Delloue, a junk dealer with a shop on the Rue Clignancourt, asking him to pay for a cure in a clinic. 'I am in a very bad state of nerves and of physical, intellectual and moral depression. I need looking after. I cannot work. I have written to my

mother who knows me so well, to ask her to explain my deplorable state to you.'[26] At Suzanne's anxious request, Delloue, who had been buying Utrillos since 1910, agreed to help on the understanding that he would be paid back in paintings when Utrillo was fit.

On 1 March Utrillo entered a clinic in Aulnay-sous-Bois. At least he was away from the city centre on 23 March when, without warning, Paris was shattered by twenty-five explosions in daylight. The danger came from the Germans' new extra-long-range guns, the Big Berthas, trained on Paris from some seventy-five miles north-east. Civilians were killed and injured in the shelling and the public feared that an advance on Paris would follow. Banks and ministries began to evacuate their records and documents, sometimes even their personnel. As dealers and those artists who could afford to leave travelled south, the price of modern paintings plummeted. Suzanne could not possibly have afforded to pay for Maurice's sojourn in a private clinic. For years she was distracted by the struggle to ensure that Maurice would receive humane private treatment as an alcoholic rather than be locked away with the violently mentally ill. 'I'm not mad,' he would say, 'I'm an alcoholic.' Suzanne herself would point out to critics that her son could not paint with such artistry if he were mad.

Utrillo had agreed to pay off his debts while he was in the clinic. On 23 March Suzanne wrote reassuringly to Henri Delloue about the arrangement:

> You are right . . . His best work is produced when he is completely sober and not, as so many of his admirers think, when he's in a drunken state. Like you, I think myself that it is best not to ask too much of him, that it is to say let him paint peacefully (quality is worth more than quantity) . . . he is honest, you know, and he himself will be happy to do the most he can.[27]

That letter does not sound as if Suzanne were taking advantage of her invalid son, as her critics have claimed, although in wartime, without Utter's protection, both painters were exploited. Utrillo fell prey to unscrupulous café owners and shopkeepers who realised that it was worthwhile bribing the painter with a bottle of wine in order to acquire a landscape or two. And when Suzanne came to be paid for a commissioned portrait the client would often reveal that he had already paid out the money he owed her to buy meals for her son.[28]

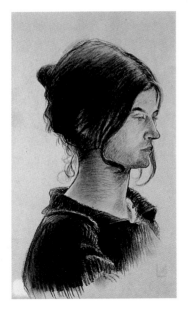

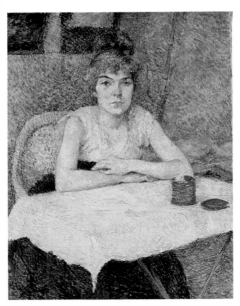

Portrait of Suzanne Valadon by Miguel Utrillo y Morlius, 1891–2.
RIGHT *Poudre de Riz* by Toulouse-Lautrec, 1885.
BELOW *The Bathers* by Auguste Renoir, 1884.

For years Valadon was defined by the vision of others: Miguel saw her as a thoughtful, determined girl; Toulouse-Lautrec as a bold and worldly minx; and Renoir as the eternal but elusive temptress personified in *The Bathers*.

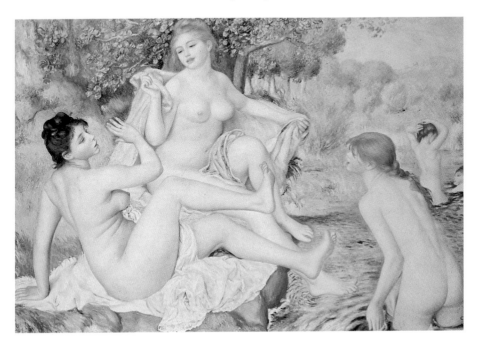

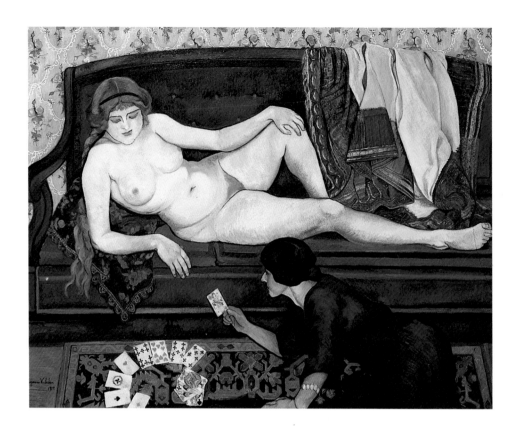

The Future Unveiled, 1912. Liberated from a dreary marriage and united with her young lover, Valadon glories in her subject's nudity yet treats it in a matter-of-fact manner.

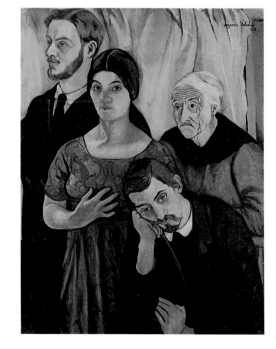

RIGHT *Portrait of the Family*, 1913. Valadon places herself at the centre of her unorthodox family, her son lost in dreams, her aged mother anxious and wary and her lover André Utter (on the left), the outsider.

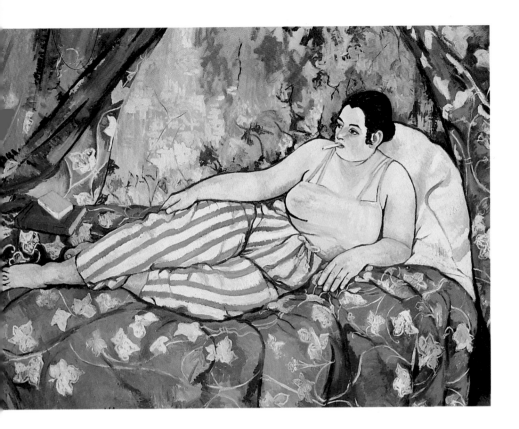

The Blue Room, 1923.
In this painting, bought
by the French state in
1926, Valadon fills her
canvas with richly
patterned drapes and
wallpaper. Yet the earthy
and self-absorbed model
remains the magnetic
attraction of the picture.

RIGHT *Madame Coquiot*,
1915.
Valdon herself was
becoming more worldly
when she painted her
first *mondaine* portrait.
The subject, her friend,
was the wife of a well-
known art critic.

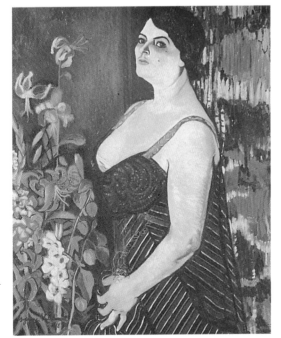

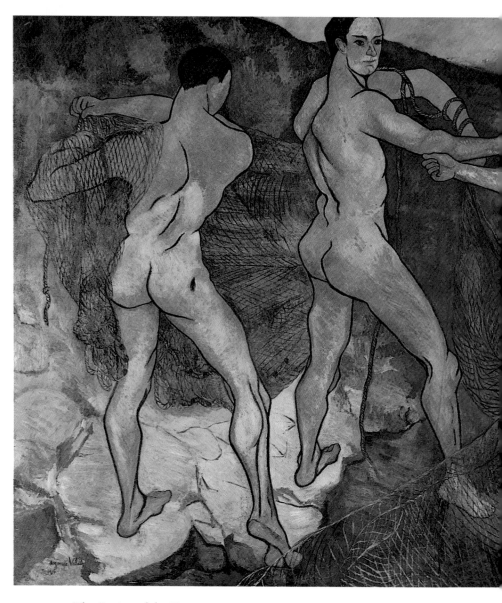

The Casting of the Net, 1914.
On the beach in Corsica the previous year,
Valadon had posed her young lover as each of
the three naked fishermen entwined in the
net in this vast painting. She was one of
the first women to paint a male nude.

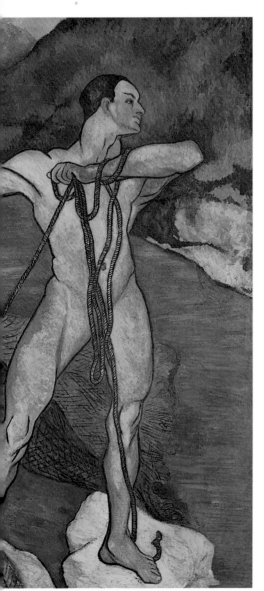

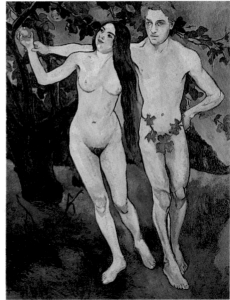

RIGHT *Adam and Eve*, 1910.
Equally in *Adam and Eve*,
with Utter and Valadon
as the biblical figures,
she celebrates their
joyous physical love.

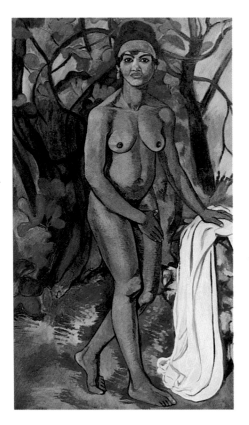

Black Venus, 1919.
The model for the artist's series of black nudes was a mulatto woman who was a mistress of Utrillo. Valadon delights in the dusky skin of her model, and her rich, shimmering colours hold echoes of Gauguin.

BELOW *Still Life with Violin Case*, 1923.
After the First World War, Valadon extended her pictorial range and painted intricate and complex still lifes with a marvellous skill.

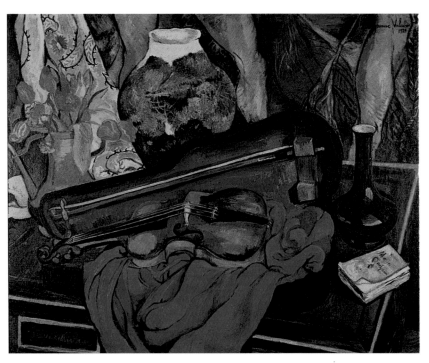

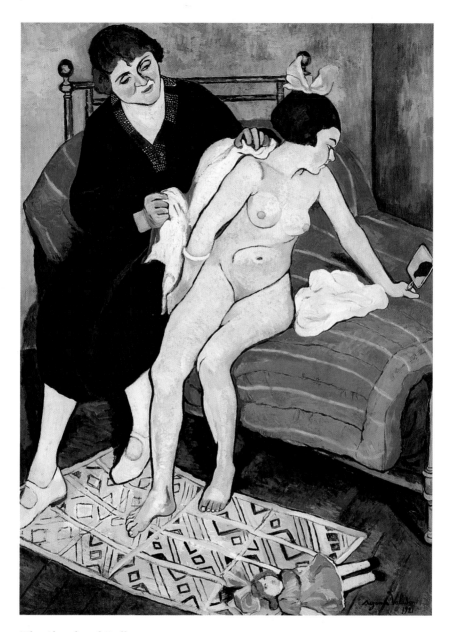

The Abandoned Doll, 1921.
One of Valadon's most telling pyschological paintings, *The Abandoned Doll* depicts a mother explaining to her daughter the physical changes that are taking place in her body as puberty approaches. The girl peers in her mirror to see if her reflection will reveal the new 'self', while the doll lies abandoned on the floor. Daniel Marchesseau, the organiser of the Martigny exhibition in 1996, belives that the painting reflects Valadon's own initiation into a harsh world, her fear and her curiosity.

Utrillo Painting, 1919.
By 1919 Utrillo had had a
major exhibition in Paris
and his sales figures were
impressive.
Valadon pays tribute to
her son's artistry as she
shows him concentrating
intently on his canvas.

RIGHT *Self Portrait with
Bare Breasts,* 1931.
As a mother, however,
Valadon suffered deeply
from her son's alcoholism
and instability. This
portrait at the age of
sixty-five reveals both the
self-knowledge and the
courage of the survivor.

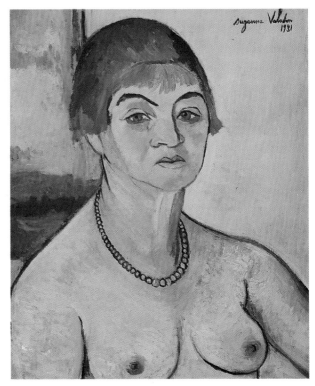

At last, on 18 November 1918, the armistice ended four years of war. Church bells rang out, flags flew, and men and women danced in the brilliantly lit Paris streets. Within days the capital changed from a citadel fortress to a city of pleasure. Business boomed, and the strains of jazz blared out from restaurants and cafés until the early morning. War-weary men and women converged on the beautiful city from all over the world. French food, French fashions, French girls were all the rage, and everyone wanted to buy French art. Utrillo's paintings of the streets of Montmartre became immensely popular; as his prices began to soar, the owners of cafés and bars who had invested a few francs in a drunk found that they had acquired valuable assets. On the hill of Montmartre, Suzanne Valadon was seen wrapped in nothing but fluttering flags of the Republic and a moth-eaten tippet.[29]

Before the year was out, André Utter came back from the war to Valadon and the studio at 12 Rue Cortot. A virile man with an easy charm, he had always been popular with the local girls. In the cafés and on the streets, laundresses, shop assistants and waitresses squealed in delight: 'Dédé is back, Dédé is back.'[30]

Despite his outwardly casual attitude André Utter was the only one of the three painters with a shrewd business sense. He was an accomplished painter, and his work was much influenced by Valadon, whom he admired profoundly as an artist. Back from the war, he decided to take charge of his 'two *enfants terribles*' and become their business manager. Utter's playful and apparently naïve manner was enormously successful with customers. He pretended to treat business deals as a joke, refused to be rushed and talked in terms of huge profits. 'A small exhibition is a fine thing – for small profits,' he told one customer.[31]

His confidence inspired Suzanne and in 1919 she painted with fervour: an intense and moving portrait of Utrillo painting; beautiful still lifes, some with her cat Raminou; landscapes of the Rue Cortot and the Sacré-Cœur; a series of five sensuous paintings of a mulatto girl who was for a time Utrillo's lover – almost a celebration of the peace. Four of her works were shown at the Salon d'Automne. Berthe Weill, who exhibited her drawings that year, commented on Valadon's growing ability but noted that she had many detractors: 'Her merit is that in spite of everything she makes no concessions . . . Great artist!'[32] Valadon's manner was no more flattering and ingratiating than her paintings; she could be offhand and dismissive to both critics and buyers.[33]

If his 'terrible Suzanne' or 'terrible Maria', as he called her when he wanted to tease her, was a difficult client for André to promote, Utrillo was easier. André did not care much for his stepson's work; privately he termed it 'the art of the boutique'. Nevertheless he recognised that, with French and foreigners alike, Utrillo's nostalgic painting struck a chord and gave the customers the opportunity to acquire a haunting memory of Montmartre. Utter was on good terms with pressmen, and knew how to talk and drink with them. He fostered the notion that it was chic to own a Utrillo, prompting his writer and critic friends to write puffs before sales and exhibitions. As early as February 1919 the painting *La Maison Rose, Rue de L'Abreuvoir*, which had been bought by a critic in 1910 for 150 francs, sold for 1,000 francs after the war. Utrillo's notoriety as a bohemian drunk with a dissolute mother added to his reputation as a bizarre and martyred genius, and the bartenders and waiters who had sneered at him and pushed him into the gutter now profited from his soaring prices.

Among the new patrons of art on the scene after the war were a Belgian banker Georges Pauwels and his gushing wife Lucie. According to Weill, the Pauwelses 'adored artists' and set out to ingratiate themselves with the modern painters.[34] Every month they held parties, where lemonade, a rather unlikely drink, sumptuous meals and other refreshments were served and poetry recitals figured on the bill of fare. Berthe Weill found the atmosphere at these gatherings too snobbish, too cold and calculating for her taste. No doubt it was in these circles that the Pauwels family heard about Valadon and Utrillo. Unannounced they decided to visit the family in the Rue Cortot, where they expressed extravagant admiration for the work of both painters. Often clients came to see Utter or even Valadon as a means of getting to Utrillo, but in this case Georges Pauwels particularly liked Valadon's work. Lucie Pauwels determinedly kept in contact with the artists, for whom the association had obvious benefits: the works of both Valadon and Utrillo soon figured in the Pauwels collection.

Meanwhile Utrillo's paintings continued to fetch astronomical prices and his slightest scribble was prized. By the end of the year he had his first major exhibition at Lepoutre's Gallery in the Rue la Boétie. Commercially he was perceived to be a more important artist than his mother and his work was increasingly remarked on by the critics. A framemaker told Adolphe Tabarant that of every ten pictures brought in

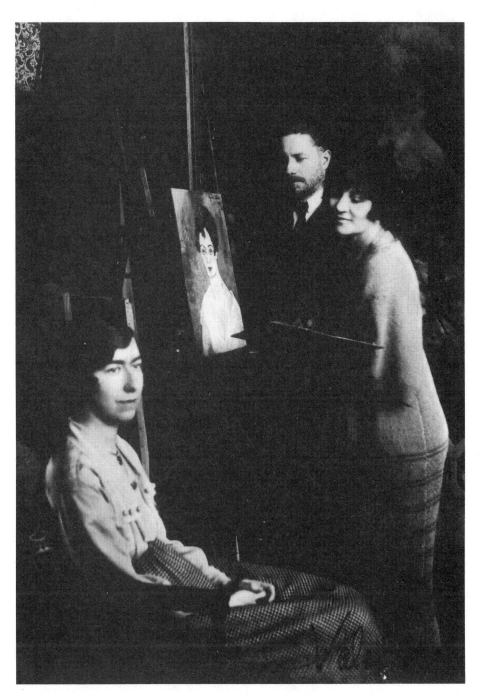

Valadon painting a model, with Utter looking on, 1919. Reunited with her husband, Valadon looks young and unusually coy.

for framing eight were Utrillos. In the rage for Utrillo, forgeries would soon flood the market and daubers were paid to 'copy' him. Even the imitations fetched large sums. 'It is a story unparalleled in the history of art,' wrote the critic André Warnod. 'Without any desire on his part a painter has attracted countless disciples who neither like nor admire their master.'[35]

Despite his success, Utrillo shambled about the streets drunk and despairing and in July 1919 Suzanne had to escort him once again to an asylum as a voluntary patient. His expenses of 720 francs a month for room, board and medical treatment were paid for by Zborowski, Modigliani's dealer, and two collectors. Maurice reimbursed them by painting under contract while receiving his treatment.

A month later Zborowski travelled to England to take over 150 works for an exhibition of modern French art in London. Modigliani, Picasso, Matisse, Derain, Vlaminck, Renoir, Utrillo and Valadon were among the artists on display in the Mansard Gallery at Heals in a show sponsored by the English writers Osbert and Sacheverell Sitwell, with the support of the critic and painter Roger Fry. Most of the artists were unknown to the British public, who found the new work baffling. 'Every day the tantrums, whether inside the Mansard Gallery or in the columns of the newspapers, increased,' recorded Osbert Sitwell.[36] A member of the Reform Club wrote a letter to *The Nation* denouncing the art for its immorality: 'I felt the whole show to be glorying in prostitution.'[37]

That autumn Utrillo escaped over the wall of the Picpus asylum and headed for Montparnasse where, as if by instinct, he found Amedeo Modigliani. The two painters, courteous and sensitive men before drink, exaggerated their reactions, covering each other with compliments and reassurances: 'You are the greatest painter, Utrillo . . .'; 'No, you are the greatest, Modigliani . . .' Modigliani managed to persuade the warm-hearted Rosalie, who ran a cheap Italian restaurant in Montparnasse, to feed them and they sank several glasses of wine. Utrillo had escaped from the asylum wearing his slippers, so Modigliani invited his friend back to his studio. There Maurice painted two street scenes of Montmartre, Modi took them over to Zborowski, who had returned from England, and Zborowski bought them on sight. With the money the two artists went out on another binge. What money they did not drink was folded into aeroplanes and sent gliding into the trees along the Boulevard Raspail. Finally, half conscious, they staggered back

upstairs to Modi's studio, where Jeanne Hébuterne, Modigliani's pregnant mistress, was faced with two hopeless drunks.

In the morning Utrillo vanished taking Modigliani's brown corduroy suit, which he pawned. When he returned his arms were filled with bottles of wine bought with the money from the pawnbroker. In the end Zborowski redeemed Modigliani's suit and persuaded him to go to bed, then took Utrillo home to his mother. A few days later Valadon escorted her son back to the asylum, and Maurice, who remained incarcerated for most of the year, never saw his friend again.[38]

In the last weeks of his life Modigliani visited Valadon and stayed in her studio in the Rue Cortot for several nights. He admired her as an artist and never tired of hearing her stories of the great men she had known. To both Modi and Jeanne Hébuterne, a talented young painter herself, Valadon was a friend who offered advice but never sat in judgement. All three painters shared an unapologetic and unfashionable idealism in their attitude towards their work. Suzanne recognised Modigliani's talent and appreciated the depth of his feeling for art and poetry. 'She is', Modigliani would say, 'the only woman in Paris who understands me.'

In January 1920 Modigliani died of tubercular meningitis in the Hôpital de la Charité and the artists of the city mourned him. Among those who followed the horse-drawn hearse to the Père-Lachaise cemetery were Picasso, Zborowski and Suzanne Valadon. Utrillo was still confined to the asylum, too ill to escort Modi on his last journey. The day before the funeral Jeanne Hébuterne, nine months pregnant, had thrown herself out of the window of her parents' apartment, unable to face life without her lover. Modigliani's death signposted the end of the reckless bohemian life of pre-war Paris.

The death of Renoir in December 1919 broke the last link for Valadon with her life as a model. In old age Renoir had lived in the south of France, crippled with rheumatism and arthritis. He painted from his wheelchair, a brush strapped to his hand, until the day of his death. Renoir died in his sleep of a ruptured blood vessel at the age of seventy-seven. A painting of anemones was found on his easel.

In the years immediately after the First World War, Valadon came into her own as an artist; she seemed, at last, to have found her rightful place within the art world. Her output in both painting and drawing was at its peak. In 1920 she was elected a member of the Salon

d'Automne and her works were sold at public auction, although they never reached Utrillo's prices.

Meanwhile her environment was changing. Even before the war ended, Montmartre had been invaded by British and American soldiers who swarmed up to the Place du Tertre to buy cheap wine and enjoy the view; soon new wine shops opened in the area. By the 1920s hot jazz had begun to replace the gypsy violin in the cabarets, and bright red motor cars, Renaults, Citroëns and Hispano-Suizas, whizzed up the hill, to the fury of the inhabitants. In Valadon's own street, the Rue Cortot, with its thick walls, a coal merchant had selected a site for his yards, destroying the peace of the old street.

The Montmartrois were not so much xenophobic as steeped in the history of their own country and their own quarter. There were strong characters up on the hill, and at the Lapin-Agile old Frédé and a band of artists and one or two shopkeepers decided to stir up public opinion against the destruction of old Montmartre. Enraged by the new buildings which marred the skyline of Paris, they formed an 'Anti-Skyscraper Party' with a revolutionary programme. The rebels voted to set up a 'free town' of Montmartre alongside the official town council. Their political programme included: self-government for Montmartre with fortified boundaries; the destruction of skyscrapers; the expulsion of clothiers, glassmakers, Cubists and Futurists; reform of the calendar with a ten-day week, consisting of six working days and four days of rest; a year of nine months, with December, January and February to be abolished; no winter (any snow purely imaginary); the beating of carpets, children and women strictly forbidden before 3 p.m.; all window-boxes to be planted with vines; no water to be drunk by the inhabitants; the installation of a safety valve outside the exit of the station (the Gare des Abbesses) to warn of the approach of foreigners; no person to pass more than twenty others in the Rue Cortot.[39]

Suzanne Valadon was one of the three women candidates in the 'Anti-Skyscraper Party', and she like the others was duly elected. In Frédé's premises, which he opened free to the cause, noisy meetings were held. Later rallies were held every Sunday in the open air and news of the campaign appeared in the local paper *La Vache Enragée*. *La Vache* came out whenever its owner, the poet Maurice Hallé, had the money. According to the paper, the Cubist Party, whose members included Picasso and Cocteau as well as Poiret, the designer, intended to tear

down old houses and build skyscrapers twelve storeys high. As for the Dadaists, who numbered Picabia among their ranks, their programme was: 'A dada, a dada, a dada. A bubu, a bubu, a bu-butte', and so on – which loosely translated meant that they planned to wipe the Butte, the hill of Montmartre, off the map.

In April 1920 the Anti-Skyscraper Party won the election hands down and on the 11th Montmartre was declared a 'free town', with its own rural constable and chief of the fire brigade. The 'mayor', Jules Dépaquit, a cartoonist, declared that his goal was to maintain the gardens and the picturesque aspect of the Moulin de la Galette as well as preserving this 'pinnacle halfway between earth and heaven'. In fact the serious aim was to help the penniless artists of the Butte, especially the poor children. Poulbot, the artist who drew the children of the slums, helped to set up a free clinic and dispensary for them.

To raise funds, the 'free town' organised inventive festivals and competitions: a mock bullfight; a procession of caterpillars, snails and slugs; an aquatic event which involved crossing Montmartre in a water-cart or a washbasin full of water on wheels; an angling competition; a race for song-writers and painters who had to compose a piece of music or paint a picture on a given subject. Proceeds from the high jinx were distributed to the poorer artists. At an annual fair, where dealers were barred, artists exhibited and sold their own paintings, which hung on small trees and shrubs.

Valadon was passionately opposed to skyscrapers. She made two paintings of the Sacré-Cœur viewed from her garden in the Rue Cortot. In the last, painted in 1919, the new tall buildings dominate the skyline and mar the view of the church.

Although Valadon had in no way joined the ranks of the materialists, life in the Rue Cortot was becoming more comfortable as she and especially her son were selling so well. Her painting reflects the family fortunes. Carpets cover bare floors; tablecloths and an occasional book or candlestick adorn the tables and her nudes pose on rich drapes. She had always loved flowers and now they had become the subjects of some of her beautiful still lifes. Her gallery of portraits included the middle class: art historians, gallery owners, curators, collectors and their wives. No longer are the subjects of her portraits the victims of society, brutalised by hard work; instead they are prosperous, respectable citizens. Valadon notes the trappings, the fur muffs, rings and bracelets

of the women, the stiff collars and watch chains of the occasional man she painted, but she goes to the vulnerable core of her sitters. Monsieur Mori, the museum curator from Monte Carlo, looks out of the painting with troubled eyes, his stance, hand on hip, mildly judicial.

Through Maurice's continual encounters with the police, Valadon had become friendly with Monsieur Zamaron, the *secrétaire général* of the Paris police headquarters, an enlightened man who collected works by Utrillo and Modigliani. She dedicated the painting of Madame Zamaron 'en toute sympathie' and showed the sitter with her head resting on her hand, an expression of thoughtful anticipation in her eyes. Valadon was middle class enough herself by now to employ an English housekeeper. She makes it clear in her painting entitled *Miss Lily Walton* that she respects her employee who quietly kept order in her chaotic household during the early 1920s. Lily Walton, sitting solidly in an armchair with Valadon's cat, Raminou, in her lap, gazes out of the painting with cool blue eyes, her hands capable and strong.

In her portraits the expression of the eyes and hands, the body's stance, reveal the character. She captures the rapt intensity of Utrillo painting by placing the seated figure of her son close to the easel, his eyes burning into the picture. During Maurice's spells in the asylum, where he was relatively well cared for, Valadon could concentrate on her work. She visited him regularly and took him out sometimes. But his stunning commercial success made life more dangerous for him in the asylum and more difficult for his mother. When two of his paintings were stolen by the gaolers, it upset Utrillo so much that he became violent. Visiting him in April 1920 Valadon was shocked to find that her son was confined to a ground-floor cell with bars on the windows. Furious and frustrated, she turned to their writer friends, Francis Carco and others, to try to mount a campaign through the press. Meanwhile she bombarded the police commissioners with protests. On 3 May 1920 she wrote an urgent letter:

> I write to solicit your goodwill and to ask you to release my son Maurice Utrillo . . . Up until now, and that was the express condition of his incarceration, he could go out when he wanted to, but I always took the precaution of escorting him myself or arranging for someone else to do so . . . About a month ago, my son, who is an artist and who works regularly at his easel in the hospital, had two paintings stolen from him. The thief was an employee of the asylum who admitted to the crime but I do not wish to prosecute.

It was after this episode that my son appeared over-excited when he was visited by Dr Briand, who ordered his committal. My son is suffering from the incarceration and is very despondent. He may be ill but he has never been dangerous, either to himself or to anyone else . . . I beg you to give me my son back immediately. I will look after him and should it become necessary I will place him in a private clinic in the country.[40]

In the meantime Utrillo attempted suicide by cutting his veins with a broken glass. Another arrest, a transfer of hospital and finally, in July 1920, Maurice was released from the asylum with Pierre, a burly Breton guard from the institution, to watch over him. For nine months Utrillo managed to remain sober enough to evade the law. In May 1921 he broke free from his guard, went on a binge, and was arrested again and sent to hospital. The constant worry of caring for Maurice and Utter's growing impatience with the situation came at the height of Valadon's artistic career. Despite domestic difficulties, in 1921 Valadon produced some twenty-seven paintings, including a striking *Portrait of Utter's Family*, shown in rigid postures, and *The Cast-Off Doll*, a sensual yet sensitive painting of an adolescent girl, nude as her mother dries her, turning away from her doll to her mirror a rite of passage painting of striking insight.

When Berthe Weill put on an exhibition for mother and son in June, Utrillo wrote to her from hospital, congratulating her on the success of the show and expressing regret at not being able to see his mother's work on display: 'she is an artist of the first rank, she paints marvellously well,' he wrote.[41] His letter hints at an understandable satisfaction that he, the 'mad' member of the family, was now in a position to patronise the great Valadon.

As usual, the critics had written enthusiastically about Valadon's work, but it was Utrillo's paintings that the public bought. Maurice had begun to people his urban landscapes with small figures of women with ballooning buttocks, an indication perhaps of his sexual frustration and the obsession with his mother that some thought was the root cause of his illness.

Utrillo left hospital at the end of August and was sent with his nurse to live at Anse, just south of Villefranche-sur-Saône, in the house of Marien Pré, a wartime comrade of Utter's. The couple went to the Beaujolais country to be near Utrillo, and Suzanne painted the landscape she had come to love, stark and earthy, with farmhouses and châteaux that stand solid and defiant of the elements.

In December Valadon held a solo exhibition in John Levy's Paris gallery and once again the critics were excited by her work. Robert Rey observed in *L'Opinion:* 'The painting of these noble nudes is so clean, so clear, so natural, the colours so bold, the line always expressive . . . I want to say and repeat that Suzanne Valadon is a very great artist, on a level at least equal to Berthe Morisot.'[42] Writing in *L'Œuvre* at the same time, Tabarant emphasised the vitality of her work, whether she was painting a nude, a landscape or a still life: 'this extraordinary woman breathes life into everything she paints; [she] is passion itself and one seeks in vain to find someone to whom she can be compared.'[43] André Warnod in *L'Avenir* pointed out the trait that Degas had admired so much: 'The pitiless line, precise and firm, may emphasise the defects, the wrinkled belly, the sagging breasts – a good drawing is not always pretty – but the flesh is always alive and beautiful just because one senses the breath that animates it and the blood that flows through it.'[44] Six months later, Florent Fels, writing in *L'Information*, commented: 'The material is rich and clear, the colour sober and vibrant, the strokes forceful and ardent. There is in the painting a confidence and a certainty that only those who have learnt to control their brushes have acquired.'[45]

The reviews can be read as comments on Valadon's character as well as her artistic ability. She was now highly regarded by both critics and fellow artists and her opinion was canvassed on matters of artistic importance. When the Salon des Indépendants was burdened by an excessive number of exhibitors after the First World War, Valadon was asked for her solution to the problem.

The Société des Artistes Indépendants had been founded almost forty years earlier, to give young artists a chance to display their work to the public without the filter of a selection committee. In the beginning only one or two hundred artists took the opportunity to send in works when the Salon was situated in a temporary post office building in the Jardin des Tuileries. Now the Salon des Indépendants held its exhibition in the vast Grand Palais and thousands of French and foreign artists sent in works to be hung for a modest fee. Even in the Grand Palais the walls were overcrowded and some thought the quality of the work submitted had deteriorated. The large number of women painters now able to gain professional training and eager to exhibit were blamed by many members for the crisis. For two years a special committee of the Indépendants had been trying to solve the problem.

In February 1922 a number of prominent members were invited to express their views in the new art journal, *Le Bulletin de la Vie Artistique*. Valadon's view was forthright and passionate:

> The Indépendants are in danger because they are resting on their laurels. In the past they have had more success than they had hoped. They have . . . shown all the audacity, displayed all the paradoxes, given art every freedom: have they fulfilled their role? Ought they to continue? To rejuvenate, to revitalise the active life of the Society it must above all guard inviolate its fundamental principle. No jury, no prizes, no placement, no exclusion. The placement committee must be selected by drawing lots.
>
> To keep the fighting spirit one must allow newcomers to exhibit and (to make that possible) one must introduce a new clause into the statutes of the society which would rule that, after ten years, those artists who have only exhibited at the Indépendants and those artists who have been refused by salons with a jury could no longer exhibit . . .
>
> In the last ten years we have seen Fauvism die, Cubism disappear and Orphism, Futurism, Dadaism and a sort of classicism arise. Whatever their merits, all these movements nurtured in the breast of the Indépendants are its life and its struggle and give the Salon meaning . . . Are the fighters of yesterday beaten? Have they given up the fight? Have they 'arrived'?
>
> . . . If the Salon were not full to overflowing as it is today, if new members were not able to join in great numbers, then the Salon would lose its useful function![46]

In its introduction to Valadon's contribution, the journal remarked editorially on her 'fine courage'. In her own words Valadon demolishes the myth of a beautiful, brainless model who turned into an instinctive painter with no interest in the theory of art. Even if Utter had helped her to formulate her ideas, since he had initially introduced her to the modern movements, the statement bears the passion and the authority of Valadon. In her remarks she gives no hint of special pleading for women; she had made her way alone and was uninterested in feminist struggles. Her burning concern was to give every aspiring artist the chance to exhibit.

For Utter the twenties were the good times and he recalled going out to cafés and restaurants almost every night, drinking with a group of their friends – poets, painters, musicians and critics. The wartime

quarrel between Valadon and Coquiot had long been patched up, and both Gustave and Mauricia Coquiot were among the inner circle. When he went out, Utter was not always accompanied by his wife, according to Lucie Pauwels. She remembered him as a dissolute man who often went off on wild jaunts with his cronies: 'They would get drunk and pick up one girl after another.'[47] Utter loved women and women loved Utter, but Suzanne was both emotional and possessive so he kept his amusements to himself. The situation in the studio was potentially explosive. Utrillo was at home by then, virtually under house arrest. Valadon and Utter had given a formal undertaking to the police to keep Maurice under constant surveillance with a nurse to watch over him. Forced to choose between living at home or in the asylum, Utrillo agreed to abide by the house rules. Anxiety that he might break out at any time created tension in the household, and Valadon and Utter often bickered.

Somehow, in this madhouse, Valadon found the commitment to work at her easel. In April and July 1922 Berthe Weill again exhibited Valadon and Utrillo, with predictable results. Despite her limited sales, however, Valadon's reputation was high. In 1922 the critic Robert Rey wrote the first book about her, in which he compared her work to the great masters of the French primitive school of the fifteenth century: 'What strikes one in any work by Valadon . . . in portraits inspired by the coarsest of faces . . . in the most rustic of her still lifes and in the least measured of her landscapes is the artist's superb style . . . style, that inexplicable quality which pervades a work of art and gives the faintest touch of the true master an aspect of eternity.'[48] In mid-June the Galerie Dalpayrat in Limoges acknowledged a local artist by exhibiting the works of all three members of the 'unholy trio'. They travelled to Genet in Brittany in the late summer and as usual all three painted the landscape.

By Christmas 1922 the family had much cause for celebration. Robert Rey's monograph was a milestone in Valadon's career, at a time when her work was growing stronger and more confident. Utrillo continued to produce paintings that delighted the public; Utter made marvellous strides as business manager for the pair. Valadon held an extravagant party in the apartment, with fine wines and food, and singing and dancing into the small hours. The guests included Monsieur Zamaron, the art-loving police commissioner, and his wife. Valadon's parties could

sometimes be uncomfortable, the laughter and goodwill exploding into a violent scene and exposing the tensions between the three. This time, however, even the strait-laced Berthe Weill thoroughly enjoyed the evening, and, she noted approvingly, Utrillo joined in the festivities and drank his watered wine in moderation. Everyone was relieved by Utrillo's good behaviour, but it was the prisoner's one-time gaoler, Zamaron, who was the most visibly impressed by Utrillo's moderation.

8

La Châtelaine

uzanne was in her late fifties in 1923. Her visual curiosity and her passion to express the complexities of form and of human nature were at their peak. She remained remarkably indifferent to business matters or money, happy for Utter to take charge of the practicalities.

As she grew older she painted more and more landscapes and still lifes, eager to infuse the canvas with her own sense of enhanced vitality. 'Nature has a complete grip over me,' she said. 'Trees, sky, water and people move me, deeply, passionately. Shapes, colours and movements make me paint with love and fervour in an attempt to do justice to the things that I care about so much. There is not a brush-stroke or a line in my paintings that is not rooted in nature. In building up my canvases I conceive the form, but nature is the yardstick by which I measure the truth in my paintings, always motivated by the feeling for life itself.'[1]

From 1920 onwards Valadon exhibited regularly both at the Salon des Indépendants and at the Salon d'Automne. While the Salon des Indédendants suffered from the success of its open-door policy, the Salon d'Automne had become one of the most important showcases for contemporary art in Paris. It was there, in 1923, that Valadon exhibited her boldest and most original portrait. *The Blue Room* is ostensibly a portrait of a woman lying on a bed; in other hands than hers it would have been an erotic painting. Her model, coarse, vibrant and completely self-absorbed, is deep in thought, an unlit cigarette in her mouth. Her ample figure, in pink petticoat and green-striped pyjama trousers, is framed by a beautifully patterned blue bedspread with pink and blue draperies around it. The woman may look provocatively sensual but Valadon makes it clear that she is no plaything; her model has a mind of her own. Beside her on the bed lie two books, one of them a notebook,

as if she had been studying. Valadon pays her the compliment of considering her as an individual. Having been a model herself, she refused to stereotype others. *The Blue Room*, much admired, was the first of Valadon's paintings to be bought by the state, in 1926.

Valadon sometimes made several versions of the same subject. In 1923 she painted one of her most beautiful works: *Still Life with Violin*. The violin case lies open on the table, displaying its deep-blue lining. Red tulips in a terracotta vase stand behind the case, dwarfed by one of the abundant round pots that Valadon loved. A heavy candlestick and a well-thumbed paperback are placed on the edge of the table, which looks full but not crowded. On the wall behind the table Valadon painted the lusty legs of a fisherman, taken from a favourite painting of hers, *The Casting of the Net*, which hung in her studio. That year Valadon's work could be seen all over Paris: at the Indépendants; at the

Maurice Utrillo,
Suzanne Valadon
and André Utter
in the Rue
Cortot studio,
1923.

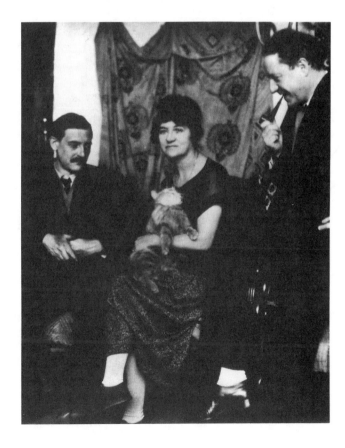

Salon d'Automne; at the Tuileries and in four different exhibitions at the Galerie Bernheim-Jeune, one of them a solo show of her pastels and drawings. Bernheim-Jeune was a leading venue for contemporary art in Paris, on the fashionable Boulevard Madeleine. Since the war, international interest in her work had quickened and her canvases could be found in Geneva, Brussels and Vienna.

She ought to have been better known in France by then. Robert Rey, who still admired Valadon and had commissioned family portraits from her, suggested that the reason for her partial neglect lay in her difficult personality. She shied away from publicity, implicitly discouraged compliments and mistrusted encouragement. 'Never, I think, was an artist more impolitic and more dismissive of criticism,' wrote Rey,[2] who subsequently became a curator at the Musée du Luxembourg. Good notices in the press were of immense value to artists, and occasionally critics expected favours in return. Nina Hamnett, a well-known English painter in Paris after the First World War, complained bitterly when the writer Waldemar George demanded 2,000 francs to include her in an article about English art. She refused and as a result received no press coverage at the exhibition she held in Lucien's Vogel's gallery in 1923.[3] One can imagine that Valadon, faced with similar demands, would have been scathing. From Degas she had acquired a horror of what he called 'frantic self-puffery', and a mistrust of critics, but had taken it to extremes. Like her late friend Modigliani, she detested artistic snobbishness and preciousness. At her own previews or *vernissages* she would appear casually dressed, in flat shoes, smoking a cigarette, and leave early, saying she had to go home to make the soup.

As a woman and a self-taught painter, Valadon had good reason to suspect the press, who often appeared more interested in her bohemian way of life and her drunken son than in her work. Her painting, by its variety of style, range and influences, resisted easy classification, yet Valadon secretly seems to have relished her status as an outsider. Although neither her prices nor her popularity ever equalled that of her son, she was not jealous: she wanted, she said, to be recognised, not known.

During the 1920s Utrillo's star continued to rise. André Utter described his stepson as 'the best commercial proposition for 100 years'. All over the world art journals featured studies of his work. For the forty-year-old artist *la gloire* meant nothing. He was still virtually a

prisoner, either confined to a nursing home, with occasional outings to the countryside escorted by a nurse, or shut up in his small room in the Rue Cortot, with its barred windows, where he painted or played with his electric train. Utter, however, still harboured ambitions as an artist himself. He was an able painter and his range included landscapes, portraits and nudes, but his output was small and beside Suzanne's bruising individuality and Utrillo's inspired innocence Utter's canvases appeared derivative. When he exhibited with them he was referred to as Valadon's husband or Utrillo's stepfather. Suzanne realised that it was her husband's lack of recognition as an artist that led to bitterness. 'If André had had more confidence he would have been less unjust,' she told Francis Carco years later.

Personal and professional rivalries built up dangerously among the three artists. For years Utrillo had concealed his jealousy of Utter, even from himself, but when he was at home he clung to his mother, to Utter's irritation. Utter resented Suzanne's maternal passion for her hapless son and dismissed Utrillo's art as trivial, even though it provided a rich living for the family. When Utter came home in a bad mood, he would vent it on Maurice, teasing and tormenting the wretch. If Suzanne intervened, husband and wife would quarrel violently and Utter would beat her, sometimes even destroying her work in his rage. Although Utter still admired Suzanne's work, indeed marvelled at it, he could not bear being passed over as an artist. When he was a youth in his teens, before he had even met Suzanne, André had led a dissolute life, experimenting in drink and drugs with the avant-garde. His passion for Valadon before the war had changed his life: he had been dazzled by her glamour, insatiably attracted, full of dreams of a glorious artistic future. After the war, Utrillo's desperate drinking, Suzanne's over-whelming dominance and his own position as manager of the two unruly artists had bred in him a cynicism. He was thirty-seven in 1923, glib, amusing and often out on the town, lunching and dining; and he had begun to womanise casually.

Suzanne, nearly sixty, battled furiously against the encroachment of age. Her hair, which had been the colour of cognac, darkened and thinned; her beautiful eyes were often overshadowed by dark-rimmed spectacles; and the proud posture of her youth had given way to bowed shoulders and sagging breasts. She never lost her challenging look. As an artist trained to observe, she saw her own defects clearly and angrily.

Her physical passion for André was still urgent, and although she might flirt wildly to provoke her husband she was intensely possessive. The unholy family lived on the edge of break-up, but their interests were inextricably linked.

In June 1923 Valadon and Utrillo exhibited together at Bernheim-Jeune in a major show which attracted great interest in the press; as usual, Utrillo's work sold far more than his mother's. In retrospect it is easy to see how much Valadon's reputation as a painter suffered from being labelled 'Utrillo's mother'. Even her friend Adolphe Tabarant paid tribute to her in print in a tone of tolerance: 'It is not possible', he wrote, 'to be a more ardent painter than this highly strung woman who fiercely and passionately battles with her paintings.'[4] But then the critic developed his main theme. While he pointed out that Utrillo, a born painter, owed his appreciation of art and his technique to his mother, Tabarant went on to compare him to van Gogh and to congratulate himself on being one of the first to recognise Utrillo, who had now won worldwide fame.

The cult of Utrillo's work is perhaps more understandable when contrasted with the revolutionary artistic movements of the time. In Paris from the beginning of the twentieth century the art-loving public had been besieged by dogma and challenged to discard all expectations of realism, of seeing things 'as they are' in works of art.

Fauvism in the early years of the century was followed rapidly by Cubism and Futurism. Then, starting in the First World War, the international anti-art movement, Dada, departed from tradition even further by questioning the meaning of art itself with the motto: 'Destruction is also creation'. Inspired by literary and psychoanalytical sources, writers and painters of the new post-war movement, Surrealism, explored the world of the unconscious. Surrealist painters created enigmatic images of dreams and hallucinations in their work which were both mocking and sinister. Lovers of modern art were now challenged to free their imagination in order to admire the weird, childlike images released in dreams.

In contrast to these difficult forms of art, Utrillo's pictures of the named and familiar streets of Montmartre, praised by respectable critics, appeared as an attractive alternative. His paintings held a hint of the sleazy glamour of 'old Montmartre'; before the war they were displayed in the bawdy inns and junkshops of the quarter. In post-war Paris they

became desirable properties for the home, valuable investments as well as evocative modern landscapes.

In May 1923 Utrillo was operated on for a double hernia. When he had recuperated, Suzanne, as always, hoped that a long holiday in the country would help to cure his alcoholism. Her son's doctors believed that Montmartre, with its underworld and easy access to unlimited drink and drugs, was damaging to Utrillo's well-being. Through her friends, the Czech painter Georges Kars and his wife Norah, Valadon found a solution for the summer for all her family when they invited the Valadon party to stay with them at their house at Ségélas in the Low Pyrenees. The year before, Suzanne had painted Norah as a calculating woman, with shrewd eyes, pursed lips and a chin disappearing into her neck – by no means a flattering portrait. She signed it 'amicalement à Mme Kars', a friendly, if not affectionate, inscription. To Madame Poulbot, for example, she dedicated a flower piece 'bien amicalement', and another flower painting of 1932 was inscribed to Madame Coquiot: 'à Mauricia, la grande, la belle Mme Gustave Coquiot'. Since the story of the Valadon family at Ségélas comes from Norah Kars,[5] the degree of friendship between the two women is significant.

The party set out in hilarious disorder. Six of them – the Karses, Valadon, André, Maurice and a beefy woman known simply as Paulette, cook, nurse and model to Valadon's household – all piled into the open car Georges Kars had rented. No one, not even Norah, was worried that Georges had never sat behind the steering wheel before. On the route south the party were pelted with hailstones, since nobody knew how to put the top up; they collided with a cow and lost a wheel on a steep mountain pass. Eventually they arrived, shaken but intact, at the Kars country home in Ségélas near the town of Orthez.

Paulette, stolid and unflappable, a former fish-seller in the Batignolles market, proved an enormous support on the holiday. In the magnificence of the Pyrenean foothills, Suzanne decided that Paulette would also make an excellent wife for Maurice. His doctors had hinted that a sexual disturbance might be the root cause of his alcoholism,[6] and Suzanne was always snatching at solutions. A normal married life might, she hoped, help to cure his drinking and stabilise his conduct. It would have suited Valadon to acquire a daughter-in-law who was biddable and a calming influence on the family. Paulette seemed acquiescent, even excited by the idea, so Suzanne threw a magnificent engagement party

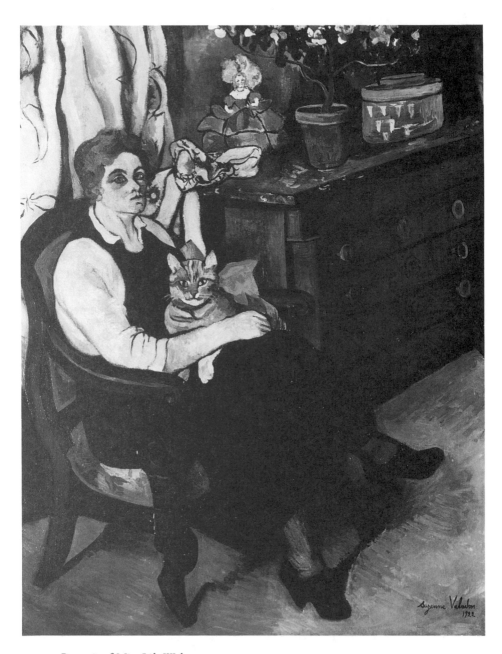

Portrait of Miss Lily Walton, 1922.
Valadon's English housekeeper in the prosperous post-war years is holding
Valadon's cat Raminou on her lap; both have alert and uncompromising
expressions. In this painting of a woman whom she obviously respects,
Valadon shows the range of sympathy in her portraits.

for the couple, scouring the town with Paulette for the cerise satin that the bride-to-be insisted on for her trousseau. Then, without warning, Paulette packed her bags and disappeared, just as Gaby, Maurice's first fiancée, had done during the war.

In the breeze of success, with the prospect of a contract for both Valadon and Utrillo in the offing, the mood of the holiday party was not dampened; but when they returned to Paris Suzanne determined to find a solution for her son. In 1921 he had lived for some months in the Beaujolais country near Villefranche-sur-Saône with the Pré family, cared for by a male nurse. Ironically, the head of the household, Marien Pré, was a wine-grower, but Maurice's intake had been strictly monitored and he was safe and reasonably content there.

Valadon loved the area; she had produced several landscapes of the countryside and in 1922 had painted two châteaux, one of them at a hamlet called Saint-Bernard. Now that they were in funds, the notion of buying a place of their own which could serve as a refuge for Utrillo seemed attractive. They travelled to Belleville-sur-Saône and found that the medieval castle Suzanne had painted was for sale. The tiny village of Saint-Bernard lies north of the city of Lyon, between the Massif Central and the Alps, near Villefranche-sur-Saône. Its fairy-tale castle boasted a moat, a well as water supply, a square gate-tower and a round tower; the house itself was a tall stone pile covered with ivy which commanded a view over the hamlet with its tabac and church.

When Suzanne and Utter saw it, the château was in a dreadful state of dilapidation, its staircases crumbling, and plaster flaking from the walls. There was even a sizeable hole in the floor of the great hall, which contained a large fireplace and chimney-piece. Despite the disrepair and lack of amenities, the couple fell in love with the property. By bartering Utrillo's paintings and also obtaining a large loan, they negotiated the sale and bought the château in Utter's name on 14 November 1923.[7] At a stroke, Marie-Clémentine Valadon, the illegitimate daughter of a seamstress, had become the mistress of an imposing château.

Only the gate-tower at the entrance was habitable. That was to be Utrillo's safe place, and a studio was built for him there. Two separate studios were constructed for Valadon and Utter in the main house.

Over seventy years later, Saint-Bernard is still inaccessible by public transport. The little inn, the church that Valadon painted from her studio and the plane trees outside the castle walls remain, but the

château is now being rebuilt as a luxury hotel. Old men still sit on the benches or play boule in fine weather; and in the silence of the evening one can imagine Suzanne's raucous laughter, Utter's oath as he drops his pipe and Utrillo appearing in the main hall, pleading for a drink.

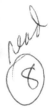

Back in Paris a contract was signed with Bernheim-Jeune, guaranteeing Utrillo and Valadon an income of a million francs that year, a vast sum at the time, and to them a fortune. For Valadon, who had known real poverty in her youth, the new-found wealth seemed unreal. The stories of her extravagance are too prolific to be discounted but they carry a whiff of exaggeration. By nature she was expansive, and having money she liked to share it. Wealth, she said, 'was of value to the bourgeois'.[8] One biographer has her costumed by the couture houses, although in her photographs she looks as simply dressed as ever. Utter, who appreciated the need to present a good appearance, encouraged her to buy a fur coat when they were visiting Lyon.[9] After much commotion in the Lyon store, she chose an astrakhan coat far too big for her, against the advice of both Utter and the shop assistant. When she left the store, after slipping on the escalator, she realised her mistake and threw the coat down in fury on the car floor, where it became the favourite mat for L'Abri and La Misse, her beloved dogs.

Her household now included not only a housekeeper, Lily Walton, but also a chauffeur, who wore white livery and drove their gleaming Panhard. Her dogs lived on *faux-filet*, sirloin steak specially prepared at the nearby restaurant, the Moulin Joyeux, and her cats enjoyed caviar on Fridays. She was credited with throwing parties with a touch of madness – 'a picnic in the Métro catered for by Maxim's, a soirée at the celebrated *maison close*, La Belle Poule, and a midnight supper among the tombstones of the cemetery St Vincent'.[10] Old Madeleine, buried at the cemetery of Saint-Ouen, was now ensconced in a family tomb engraved with the words 'Famille Valadon-Utter' in gold on the front and the dates of Madeleine Coulaud's birth and death.

Jokes about Valadon's extravagance circulated on the Butte and even appeared in the press.[11] Whether or not she actually collected fifty children from the streets of Montmartre on the spur of the moment and whisked them off to the Cirque Medrano, or sent the butcher's wife on a cure for lumbago to the Riviera for a month, her generosity was so great that it lent itself to legend. A friend, the sculptor Georges Salendre, remembered her surreptitiously slipping a large banknote to a

RIGHT Cartoon of the banquet for Suzanne Valadon at the Maison Rose in 1924, by the cartoonist Maurice Savin. Despite the caption, the large burly figure on Suzanne's right is believed to be the Prime Minister, Édouard Herriot. A photograph of the same occasion (BELOW) captures Suzanne in characteristically mischievous mood, although the guests seem to have changed places.

Le dîner de Suzanne Valadon : MM. Naly, Florent Fels, Mme Suzanne Valadon, le conseiller municipal Constant, MM. Utter, Vilbœuf, François Bernouard, Vertex, Mme Katia Granoff.

beggar and then denying that she was the donor.[12] Naturally neighbours and acquaintances gossiped about Valadon, but then they always had. The gossip had simply taken a different turn.

On the day Suzanne signed her first contract with Bernheim-Jeune, Tabarant organised a sumptuous banquet in her honour at the Maison Rose, the little pink house in the Rue de l'Abreuvoir in Montmartre, which still provides delicious food and drink on pink plates, at expensive prices. The guests at Valadon's banquet over seventy years ago included the writer Francis Carco, the critics André Warnod, Florent Fels and Gustave Coquiot, and the painters André Derain, Georges Braque and Jules Pascin. In a photograph of the occasion, Suzanne looks tiny, dressed in a suit with a white, somewhat rumpled blouse, peering out at the camera through her spectacles, her eyes twinkling in amusement. Utter, pipe in mouth, sits three places away, smiling too. A caricature of the banquet reveals that Suzanne, nearly sixty, was still seen by the press as sexually voracious. She is smiling lasciviously, and her breasts wobble above the table.[13]

This was the era for banquets in the art world. Two years later, in 1926, fifty artists including Braque, Pascin, Georges and Norah Kars and of course Valadon and Utter gave a banquet in honour of Berthe Weill, the little woman who had promoted the work of young artists and refused to exploit them. Once again the party was held at the Maison Rose, in a room filled with flowers and enlivened by jazz music.

During 1924 Valadon travelled regularly by car between Montmartre and Saint-Bernard. When the Panhard was in the repair shop, Suzanne, impatient, would hire a taxi to take her to her château, 350 miles away. At Saint-Bernard they lived in bohemian splendour. There was no running water or electricity but they had crates of wine delivered and indulged in alfresco lunches. Late in the evening, after drinking parties for local neighbours or guests from Paris, a field-mouse might scamper across the floor of the great hall, while the screams of night owls, sheltering in the ruins, echoed through the old buildings. Utter would scavenge and Valadon sometimes painted the contents of their country larder: freshly caught fish in *Fish from the River Saône*, lying in a basket, with a lemon, onions and garlic beside them; two rabbits newly shot, a hare, a duck, a pheasant, a partridge – all, of course, unplucked and intact. Occasionally she also painted her dogs L'Abri and La Misse, two soulful-looking, smooth-haired mongrels, her constant companions.

With money in her purse, Valadon filled her homes with roses, carnations, anemones, lilies-of-the-valley, tulips, poppies, yellow marguerites. She had only begun to paint flowers in later years but now they formed an important part of her work. Characteristically they were not pretty pieces but highly individual paintings, some flowers vividly, almost aggressively alive, others drooping as if sulking.

As soon as the château was at all habitable, guests from Paris – the Karses, the Coquiots, Utter's family – came down to admire the find and to enjoy the lavish and haphazard hospitality the Utters offered. Sometimes in the early mornings in fine weather residents of the small village awoke to the sound of revellers at the château.

In May 1924 Valadon and Utter returned to Paris for the largest and most publicised Valadon–Utrillo exhibition held at the Galerie Bernheim-Jeune. Utrillo, who had spent March and April in a private sanatorium at Ivry-sur-Seine, joined them in the Rue Cortot. More visitors and would-be buyers turned up at the studio, and Maurice had to be protected from the drinking and celebrations and the people who recognised him in the street.

One night he escaped from his room with barred windows in the Rue Cortot. Valadon and Utter searched frantically for him for two days. On the third morning a policeman from the station at the Place Dancourt knocked on the door, holding Maurice by the arm. The prisoner was wild-eyed, his head covered with a bloody bandage, but he was sober. The policeman explained that Utrillo had been picked up in the gutter, dead drunk; when he was locked in a cell he had gone berserk, banging his head against the wall with so much violence that he badly injured himself. Terrified that he would be forced yet again into a state asylum, Utrillo had sought a way out. Valadon was appalled at his suffering and nursed him devotedly until his doctor pronounced it safe for him to travel. At the end of June, Utrillo was placed carefully in the car, his head still bandaged, and Valadon had him driven straight to Saint-Bernard where she watched over him through the summer. By September Maurice was homesick for Montmartre, painting the Moulin de la Galette on the door of his fortress. A strict watch was kept on him and his mail and parcels were scrutinised.

Throughout that eventful year, Suzanne managed to produce twenty-two paintings – portraits, nudes and her first landscapes of Saint-Bernard, her own domain. The family now owned a magnificent retreat and the prospects looked bright. A sign of their social standing is

reflected in a portrait that Valadon painted of Louis Moyses, the tall, blond proprietor of Le Bœuf sur le Toit, the most stylish night-club in Paris in the twenties. Le Bœuf, on the Rue de Boissy d'Anglais, near the Madeleine, was named after the 'tango-ballet' created by Jean Cocteau and Darius Milhaud in 1920. Cocteau came late at night to the club, to play the drums with a black jazz band. As he put it: 'The Bœuf became not a bar at all, but a kind of club, the meeting-place of all the best people in Paris from all spheres of life – the prettiest women, poets, musicians, businessmen, publishers – everybody met everybody at the Bœuf.'[14] The spirit of Dada reigned in the noisy night-club. A brilliant light pianist, the Belgian, Clément Doucet, played 'Ain't She Sweet' and a Dada song, 'Eat Chocolate, Drink Cow', interspersed with Bach and Mozart. One evening Francis Picabia painted a realistic human eye on a vast canvas, *L'Œil Cacodylate*, and invited visitors to sign their names and add anything they wanted. Among the international set, the Prince of Wales visited with his girlfriends; so did Picasso in a red sweater, and Diaghilev, growing stout and middle-aged, with his monocle. Erik Satie, Suzanne's former lover, looking elderly in his blue serge suit, stiff collar and pince-nez, often appeared. So did the younger composers – Igor Stravinsky, small and dapper; and Darius Milhaud, the goodnatured Francis Poulenc and the other four avant-garde composers known as Les Six. Strangers spoke to strangers across tables in the smoke-filled elegance and intimacy of Le Bœuf sur le Toit.

This was the new post-war Paris, stylish, witty and loud. For Valadon the fashions for bobbed hair, cloche hats, slim dresses and short skirts and the smart Dada din had come too late. In the past she had always seemed younger than her age; her women friends noticed and resented it. Now she was almost sixty she could not hide the truth from herself. She painted a pitiless self-portrait, bare-breasted and scowling.

Utter, by contrast, revelled in the jazz age. He remembered 1925 as a wonderful, carefree year.[15] He recalled spending almost every evening in the cafés and restaurants of the Rue des Abbesses in lower Montmartre, with other artists, Gris, Braque and sometimes Picasso, all of them nearly twenty years younger than Valadon. Gustave Coquiot, who admired Utter's paintings too, threw a banquet for Valadon at the Maison Rose, when many bottles of good wine were sunk and the table was garlanded with flowers, and her husband remembered Suzanne's delight in the occasion. But the continual partying and racketing of the

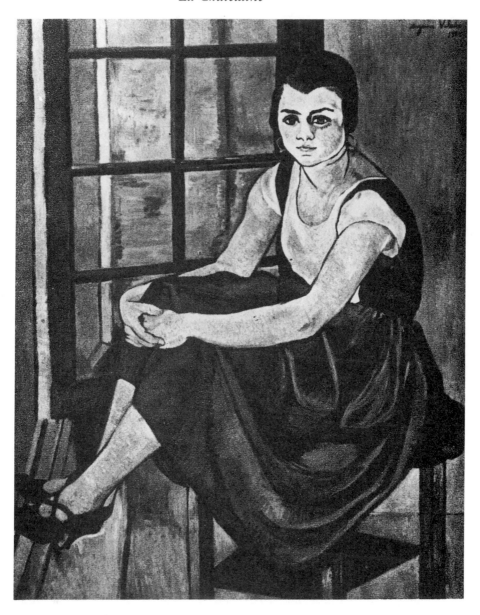

Le Repos, 1925.
This summer painting reveals both the sitter and
the artist in a mood of tranquillity.

year that Florent Fels called 'a long summer evening of delight'[16] told on Valadon's nerves and energy. That year she produced only eight paintings, three of them flower pieces and one, *Portrait of a Woman*, almost certainly a self-portrait, depicting a woman in a white blouse and pinafore dress looking rueful and resigned.

The vogue for youth, cocaine and the foxtrot was in swing in Paris as the jazz age reached its peak. Jules Pascin, the Bulgarian-born artist, a friend of the Utters, helped to launch it. Apparently always drunk, Pascin portrayed the nymphettes of the night-clubs and brothels in their flimsy chemises. Having spent many years in America, he was one of the first to herald the Bal Nègre, a modest night spot in the Rue Blomet where West Indian musicians met to play jazz and dance. Pascin hanged himself five years later, on the opening day of his own solo exhibition, at the age of forty-five.

The dazzle and danger of Paris lured adventurous foreigners from all over the world. Americans came to taste the sexual freedom and escape prohibition. Most made for Montparnasse, where the literary avant-garde, including Gertrude Stein, Ernest Hemingway and Scott Fitzgerald, held sway. The little bars and cafés were packed with writers, publishers and poets as well as aspiring authors and students seeking to make their mark. Galloping inflation in France had weakened the franc and increased the buying power of the dollar. The previous year the steamship companies had shrewdly introduced a third-class tourist fare for transatlantic passengers.

In 1925 Josephine Baker, a slim mulatto girl from St Louis, arrived in Paris and became the toast of the jazz age. To the pounding of a tom-tom, she made her début at the Revue Nègre at the Théâtre des Champs-Élysées. Baker was carried on stage naked, except for a large pink flamingo feather between her thighs, upside-down on the powerful shoulders of a tall black man. The pair performed a wild courtship dance which had the audience standing up, cheering loudly, some rushing towards the stage. That week Josephine Baker became a star. She settled first in Montparnasse, but when she heard the jazz wafting from cellars and sheds in the Rue Blanche and the Rue Pigalle she moved to Montmartre. In Montmartre night-clubs the Charleston was already popular, but it was the sinuous nineteen-year-old Baker, with her fingernails painted gold, who danced it on stage and sent Charleston fever raging through the city.

The hotting up of Montmartre, the invasion by American and English sightseers, transformed the character of the quarter. Old-timers like Valadon disliked the noise, the hordes of strangers and the motor cars. Little coffee shops where the pretty models and young working girls used to get a cheap meal disappeared, and the prices in the cafés rose prohibitively, making it too expensive for most artists to drink more than one glass of wine in the cafés they used to frequent. Valadon could afford the new prices but some of her friends could not. All her old haunts were revamped; the wasteland behind the Moulin de la Galette was built over with apartment buildings, and the Parc de la Belle Gabrielle, a green space, became an amusement ground with swings and switchbacks. Despite the invasion of the quarter after midnight and at weekends, the native Montmartrois gallantly attempted to uphold the traditions of art on the Butte. They organised concerts of old French ballads and meetings each Friday of a literary and artistic society, Les Meuniers de Montmartre (The Millers of Montmartre), whose motto was *Par l'Art pour l'Art.*[17]

An International Exhibition of Decorative Arts opened in the spring of 1925, housed in pavilions that stretched along the quays of the Seine. Although the pavilions had been planned and designed ten years previously, they were overshadowed by the high life of the river barges moored at the quayside. Le Bœuf sur le Toit had a boat where guests could dance and dine on the water, and Paul Poiret, the enterprising fashion designer who boasted that he had 'liberated the bust', had three gorgeous barges decorated by Raoul Dufy: *Amours*, a night-club restaurant; *Délices*, a theatre; and *Orgues*, where Poiret exhibited his *objets d'art* and his sumptuous fabrics and furnishings. Men in dinner jackets and women gowned elegantly by Schiaparelli crowded the banks of the Seine, and the bars were filled with Americans drinking champagne.

In the Pavillon de Marsan, a wing of the Louvre Palace, an exhibition of 'Fifty Years of French Painting' was organised by the influential critic, Louis Vauxcelles. Although considered radical, Vauxcelles had old-fashioned prejudices against 'lady painters'. He patronised them and insisted on placing them in a separate category. The women artists he favoured painted delicately in soft colours and produced idealised images of a French *forme féminine*, slender, elegant and vulnerable. Valadon's casually posed, powerful nudes were the antithesis of his

vision and she was not invited to exhibit. When Berthe Weill, furious at Valadon's exclusion, reproached Vauxcelles, he merely replied that she did not like Valadon's work. The humiliation was emphasised by the inclusion in the exhibition of a painting by Utrillo, *Rue à Montmartre*.

Berthe Weill feared that Vauxcelles would omit Valadon from his forthcoming book on French painting – and she was proved right. In his *Histoire générale de l'art français de la Révolution à nos jours*, Valadon's name does not appear in the section on contemporary women painters; yet all but one of the women artists he did include are barely known today. To Vauxcelles, women painters were unquestionably inferior, lacking emotional depth and creative strength. If women must paint, Vauxcelles insisted that their work should reflect the 'feminine' qualities of their sex: 'refinement and sensibility'.[18] Valadon patently did not fit into the new notion of womanhood, slim, chic and simpering; nor did she suit the noise and speed of the jazz age.

By contrast, Utrillo's reputation was now at its peak. A writer in *L'Art Vivant* claimed that he had done for Paris what Canaletto had done for Venice and Vermeer for Delft.[19] In 1925 he was invited through the dealer Paul Guillaume to design the scenery and costumes for Diaghilev's ballet *Barabo*, and he based the décor on the church at Saint-Bernard. That year Utrillo, aged forty-one, had been officially declared incompetent. This meant that all remaining legal authority over him, including sales of paintings, payment of debts, purchase of furniture and property, was transferred to his mother and stepfather. His total dependence tightened the screw on family tensions. According to one story, Utrillo pointed to Valadon and Utter in the street one day and said: 'You see that couple, I'm working for them, making their money!'[20] – which was substantially true.

All three were back together in Saint-Bernard in the summer. Despite the peace of the countryside and the space in the château, however, the stress seemed to grow more oppressive for all of them, cut off as they were from outside company. A letter from Utter dated 25 September 1925 suggests the torment: 'I ask forgiveness from my Suzanne, my beloved wife of whom I am so proud,' he wrote; 'I ask her forgiveness for the harm and insults and my temper which prevents her from living in tranquillity and working in peace.' Presumably he wrote to Suzanne in the third person to underline his respect. Yet his letter is not without irony: 'I profoundly regret that I am so weak that I cannot control or

tolerate my wife's state of nerves which is the cause of all the trouble,' he added. 'I only want to see her paint and I would do anything to make her change her mind and exhibit her beautiful paintings in Lyon, to show at last that a woman can be the greatest painter of all time . . . In the name of my love for her and for art and for others, I beg her to exhibit . . . I love everyone who loves my Suzanne and I will do anything she wants because she is always right.'[21] Utter had seemingly promised a Lyon gallery owner that Valadon would exhibit her works and was relying on his charm to win her round.

But Suzanne was deeply suspicious of André now, convinced that he had an assignation whenever he went out in polished shoes and a smart suit. In the country he favoured plus-fours and wore a yachting cap for boating on the river. Suzanne had grown more dishevelled and bohemian than ever, particularly when she was working. Professor Raymond Latarjet, her surgeon's son, who used to visit the family at Saint-Bernard in the twenties, remembers seeing her with streaks of paint on her cheeks. When she was concentrating on her work, she would absent-mindedly put her paintbrushes in her mouth the wrong way round.[22]

In the close-knit artistic world, the Valadon family dramas were legendary, and the directors of the Galerie Bernheim-Jeune, where Utrillo's and Valadon's paintings had successfully been shown, decided that giving the artists more cash would merely increase their wild habits. Instead, in 1925, they had a house built in Utrillo's name in a new street in Montmartre, the Avenue Junot, just down the hill from the Rue Cortot. In January 1926 the family left their apartment in the mellow old house in the Rue Cortot and moved into a row of modern dwellings. Utrillo's, No. 11, was the last on the left. The little house contained a kitchen, a dining-room and a large basement studio for Utter. Upstairs were two small rooms: one was Utrillo's bedroom with his wrought-iron bed; the other his studio-cum-cell where he worked and kept his playthings. In the garden a pavilion was built for Suzanne to use as a studio. The layout of the house had been carefully planned to give the three artists the space to work without disturbance. Nevertheless, terrible scenes erupted.

Part of the trouble was that Utter, who had done so much to promote his wife and stepson's work, still craved recognition for himself as an artist. Today, however, apart from one or two portraits of Valadon which

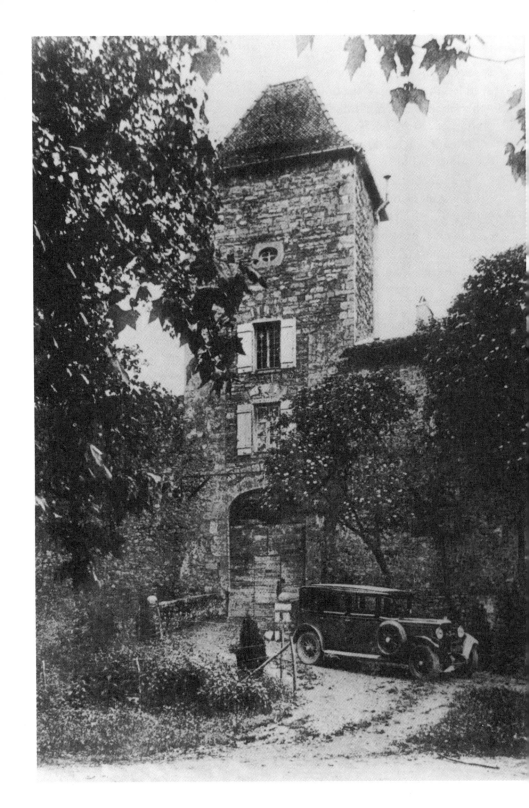

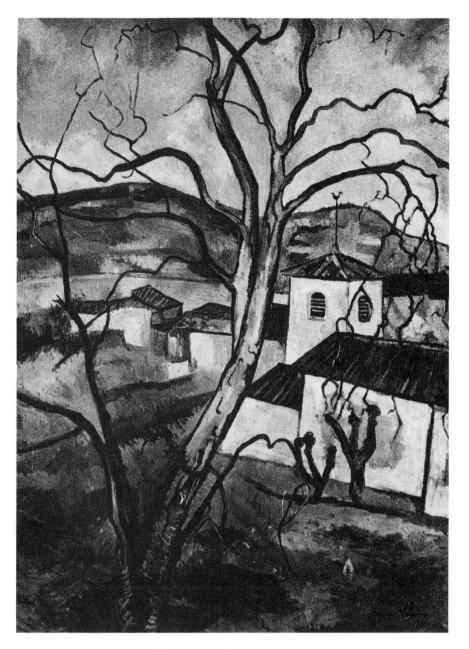

OPPOSITE The château of Saint-Bernard, Valadon's remote country seat on the banks of the River Saône.

ABOVE *Church of Saint-Bernard*, 1929.

The setting of Valadon's château inspired many of the artist's memorable landscapes.

are sometimes shown, his work is rarely exhibited and his name as a painter is almost unknown.

All three were temperamental. Utrillo was more or less docile unless he broke out, when he became uncontrollable and violent. Valadon was volatile, her moods changing unpredictably; while Utter, ostensibly the placid, serious member of the family, would change into a demon when drunk and lay about Valadon and Utrillo, sometimes damaging their work. Utter always blamed Maurice for their upsets, as an undated note to his wife makes clear: 'Wishing to be neither witness nor author nor victim of a tragedy, I must flee this ferociously sick man and this disastrous atmosphere.'[23] For her part, Valadon felt that since the war and with the family's prosperity Utter had become too bourgeois for her taste. She could not change; she found Utter's pretensions as an art dealer ludicrous and labelled him her 'little electrician'. One day, when the two of them were expecting guests at the new home, Suzanne was setting out a service of beautiful old coffee-cups when Utter suggested that it would be wiser not to risk using their best set. That infuriated Valadon. '"Me, I have friends, and if I don't offer them coffee in my best china, well, you'll see." And she smashed all the fine china cups in a blaze of temper.'[24]

During that summer of 1925 at Saint-Bernard, Suzanne and André, partly no doubt in an attempt to alleviate the tension, invited pleasant and placid members of the family to stay at the château. Valadon painted her niece Marie Coca and her husband's sister, Germaine Utter. Germaine had the blue eyes of the Utter family and long blond hair which she wore down to her waist. Valadon painted her sitting at the open window, looking down demurely; in another portrait she posed her by the window drawing back the curtain to reveal a vase of flowers on the sill. Honesty and a simple goodness show in her pleasant, undistinguished face. She and Maurice went for walks in the countryside, and Valadon hoped, as she always did, that perhaps Germaine would prove to be the wife Maurice needed, the influence that would change his life. Nothing, of course, came of it.

Utrillo stayed on at Saint-Bernard in the winter, strictly supervised by his nurse, but Valadon returned to Montmartre. Already the Depression had affected sales of her work, but demand for Utrillos held up. A lesser woman might have felt envious and bitter, but Valadon was genuinely proud of her son's artistic ability, the one bright facet of her life as her

marriage deteriorated. If she felt disappointed about the lack of interest in her own paintings, she kept her feelings concealed, although the contrast in their fortunes may have led her to doubt herself. In an interview with Maximilian Ilyin, who was writing a book on Utrillo, she praised her son at her own expense:

> The first stage in a painter's life is the response to a certain summons: the time when he is unaware of his power; the time of sincerity. The second stage begins with the moment when he discovers the conventional in art and the constraints of his profession, when he exerts himself to create the lie, which will henceforward be his reality. The third stage, which I shall undoubtedly never attain, is that in which the painter, liberated from the constraints of his profession, learns to control even his feelings and becomes a creator guided only by intuition. Well, my son reached that stage in an exceptionally short time – a few years.[25]

Looking at the paintings of Utrillo and Valadon today, one might consider her judgement to have been understandably awry. While Utrillo undoubtedly had an extraordinary facility and initially a poetic sense of colour and light in his glowing landscapes, his work developed in a repetitive and limited manner, successful because of its success. Valadon by contrast deepened her colour, broadened her subject matter and treatment, and improved the control and release of her emotions in her work. The French have recognised her place in art, awarding her two major exhibitions at the National Museum of Modern Art in Paris in 1947 and 1967, while Utrillo has received no such honour.

In 1927 five books about Utrillo appeared, one of them by Valadon's friend Francis Carco, containing her portraits of her son. Valadon made a witty painting which was adapted as a poster for a charity ball held on 20 May at the Gymnase Municipal. Valadon's original painting shows the back view of a nude girl painting a poster, her buttocks exposed to the viewer while she concentrates on her brushwork, a garland of roses trailing from her hand to her bare feet, scattering petals. In a pencil drawing of the poster, now in the Centre Pompidou, she experimented with a full-frontal portrayal of the painter. The implicit message was: keep your eye on the work. In 1927 Valadon painted another self-portrait, dignified and resigned. Her loyal friend Berthe Weill held a retrospective exhibition of her work at her gallery, but, despite critical acclaim, Valadon as usual did not sell well.

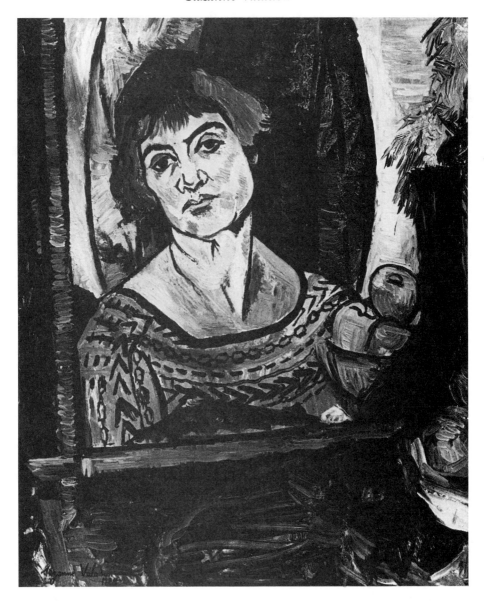

Self-Portrait, 1927.
Now in her sixties, Valadon faces herself with dignity and strength.

She and Utrillo were in Saint-Bernard in May while Utter stayed in Paris on business. He wrote to her detailing his timetable, as if to reassure her of his fidelity. That year Valadon produced several beautiful nudes and flower paintings as well as landscapes, one from the terrace of the château. In the late 1920s her dogs were her great consolation, companions on her painting expeditions. She loved the wide horizons of the country and her outdoor paintings have a sense of release about them. 'Everything is beautiful in nature,' Suzanne once confided to a friend; 'one has to know how to look.' She peered for hours at 'the elegance of a blade of grass, an insect perched on a buttercup, the hedgerow standing out against the horizon of the blue sky and the old apple trees which form the outline of our limited horizon'.[26]

Early in 1928 she finally agreed to have an exhibition at the Galeries des Archers in Lyon. By this time at least half of Valadon's output consisted of flower paintings. The models were on hand, free and amenable. She painted each individual flower in detail and her roses, her dahlias, her gladioli all reveal their 'personalities'. Abroad her work attracted favourable comment and some sales: her paintings were shown in Amsterdam and New York and an important article in a German journal, *Deutsche Kunst und Dekoration*, was published that year.

Meanwhile the local people of Saint-Bernard were picking up titbits of scandal whenever Maurice escaped on a drunken binge, and the village was well aware of the explosive atmosphere in the château. Madame Thiérot, Utrillo's nurse, wrote to Valadon complaining that gossips pointed her out in the village, whispering that she was the mistress of Utrillo, Utter and others.[27] Utter detested the woman. Eight years earlier, in August 1920, Utter had pledged to the police commissioner that he would take responsibility for his stepson at home. By 1928 he wanted to be rid of that duty. In an extraordinary document dated 1 August 1928, Utter gave Utrillo a week to move out of Saint-Bernard, declaring that his stepson was in a dangerous mental state and demanding that he leave Saint-Bernard permanently. 'His mother claims that he is in his own home and can stay as long as he likes,' Utter added. In fact the château was bought in Utter's name, mainly with money from Utrillo's paintings. 'While waiting I leave the conjugal home which has been entirely satisfactory.'[28]

André Utter was trying to bolster up his untenable position by a mixture of bullying and bluff. Everyone in Montmartre knew that he

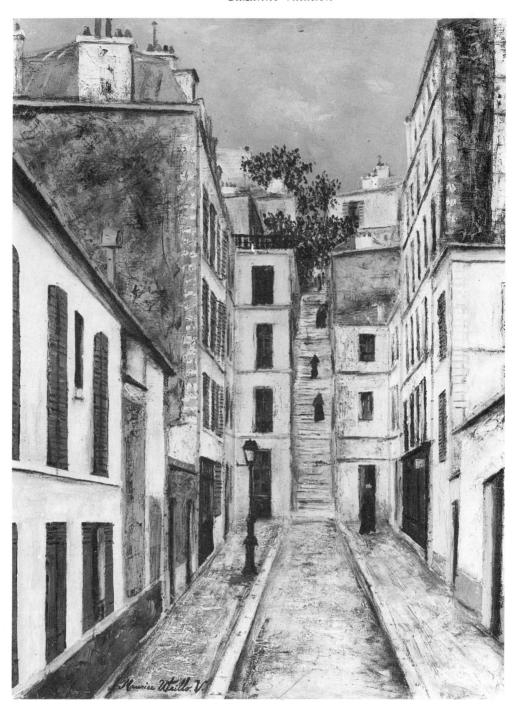

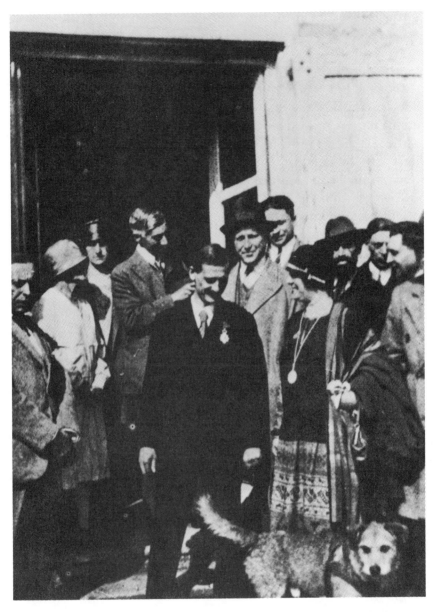

ABOVE In August 1928, Utrillo is awarded the Cross of the Légion d'Honneur at Saint-Bernard.
OPPOSITE Maurice Utrillo, *L'Impasse Cottin*, 1911.
Wherever he lived, Utrillo remained obsessed by Montmartre, although his doctors considered that the temptations of Montmartre were a danger to him.

squandered money on his mistresses, that he drank and plagued his wife and stepson. Suzanne was difficult, impulsive and often reckless, but never venal. To get his own way, Utter banked on her physical need of him, but on the question of her son she was unshakeable.

Valadon had a powerful ally in Édouard Herriot, the immensely popular radical Mayor of Lyon, who had graduated to national politics during the war and had served as Prime Minister for ten months in 1924 when he headed a left-wing coalition of radicals and socialists. Then for three days in July 1926 he had been premier again. Herriot was an eloquent orator and astute politician, but his ministries fell because of differences with the right over his financial policies. The post of Minister of Education from 1926 to 1928 suited his talents better; Herriot had a deep interest in and appreciation of the arts, and enjoyed visiting the three artists at Saint-Bernard and looking at their work. The writer Francis Carco also spoke up for Maurice, and three months after his stepfather's ultimatum Utrillo was awarded the cross of the Légion d'Honneur by the French government for services to art.

At the ceremony on 1 August 1928, Utrillo, in a well-tailored suit and waistcoat, sat on a wall of the château in the sunshine with Suzanne beside him, while artists and writers from Lyon and government officials arrived. After Édouard Herriot presented the award, Utrillo stood up, saluted and muttered a few words; Valadon wept a little and expressed her gratitude. Everyone knew that she had won a bitter-sweet victory. At the luncheon in the hall afterwards, Maurice seemed quite cheerful, stroking his ribbon. When the toast 'To the artist of the Légion d'Honneur' was proposed, he lifted his glass solemnly and said: 'A word of warning, gentlemen, mine is watered.'[29]

9

A Male Brutality?

By the late 1920s, Suzanne looked more and more to her art to sustain her: 'For me, painting is inseparable from life. I paint with the same obstinacy that I use, less vigorously, in my daily existence.'[1] That grit and willpower that Degas had admired so much in his 'terrible Maria' kept her going. Her private life, which had always been stormy, was now bleak. From girlhood onwards, her passionate nature had driven her, as she tumbled from circus to studio, from furtive affairs in street cafés to early motherhood. After the boredom of an affluent marriage, she had plunged, in middle age, into a tempestuous love affair. And now, after years of intense fulfilment with André Utter, her second marriage was drifting dangerously. By the end of the decade she realised that all that remained permanent in her rackety existence was her anguished love for her son and the growing strength of her work.

A self-portrait, painted when she was sixty-six, reveals both her remarkable courage and her disillusion. In what must rank as one of the most moving portraits of an ageing woman ever painted, she describes in devastating detail the ravages of time. Her brush spares nothing, neither the sagging breasts and darkened nipples, nor the shadowed eyes, the coarsened nostrils, the jaw distorted by ill-fitting teeth. Yet in the arch of the eyebrows, the proud tilt of the head, Valadon's self-portrait conveys the sense of a formidable personality.

For a former beauty, Valadon had very little personal vanity. In her self-portrait she wears a beige wooden necklace to tone with her skin. The only jewellery she ever permitted herself in contemporary portraits and photographs was a simple necklace. As she grew older, she became even more eccentric and careless of her clothing. She always wore flat-heeled shoes, often with short socks, dressed in skirts and jumpers, a

cloak flung around her shoulders and a felt hat crammed down on her
short grey hair worn in a fringe. She was living at No. 11 Avenue Junot
with Utter and Utrillo, but the trio had kept on the apartment in the
Rue Cortot, where Utter would often stay the night, calling in at the
Avenue Junot during the day. The art critic Jeanine Warnod still
remembers Valadon's visits to her parents for lunch in the Rue
Caulaincourt, accompanied by Utter. Although the child was used to
meeting 'artistic' characters, nevertheless Valadon seemed particularly
strange, with her mannish air and her gypsy-like appearance:

> Suzanne seemed to me very tiny and very old, with her wrinkled face
> . . . I was intimidated by the piercing eyes behind her glasses that
> seemed to look through you, and by her habit of blurting out exactly
> what she thought in few, well-chosen words. She would tell the most
> extraordinary stories, at one moment bursting out laughing and in the
> next inveighing against the injustice of people in high places: the dirty
> tricks played by painters; the fiddles perpetrated by the dealers.
> Impulsive, always ready to explode with anger, she was as extravagant
> in her generosity towards her friends as she was vehement in her
> exasperation at the unfairness of it all.[2]

In the summers Valadon escaped from Paris to her château at Saint-
Bernard, and between 1929 and 1931 she painted her domain: the
terrace; the château itself; the village church; a huge bunch of lilac in a
terracotta amphora; a pannier of ducks' eggs; a hare, hung in the pantry
beside a partridge, lying on a clean white cloth, a bowl of russet apples
behind it, her work a pagan hymn to the countryside. With their strong
outlines, rich colours and stark, massive volumes her canvases are
vibrant. Her earthy realism was, however, in direct conflict with the
fashionable new 'feminine' art in Paris. Throughout the twenties,
Suzanne had kept her distance from the smart styles sweeping the
capital, where art consorted with fashion in a dazzling display of chic.
The boundaries between high fashion and high art had blurred, and the
beau monde was made up of a brilliant clique of international artists,
poets, musicians, couturiers, dealers and impresarios who met each
other constantly at night-clubs, jazz cafés, concerts and elegant masked
balls. Artists, photographers and journalists from every corner of the
globe came to celebrate the supremacy of French style, and American
attitudes and American capital were beginning to influence French
behaviour. Fashion illustration in the increasing number of women's

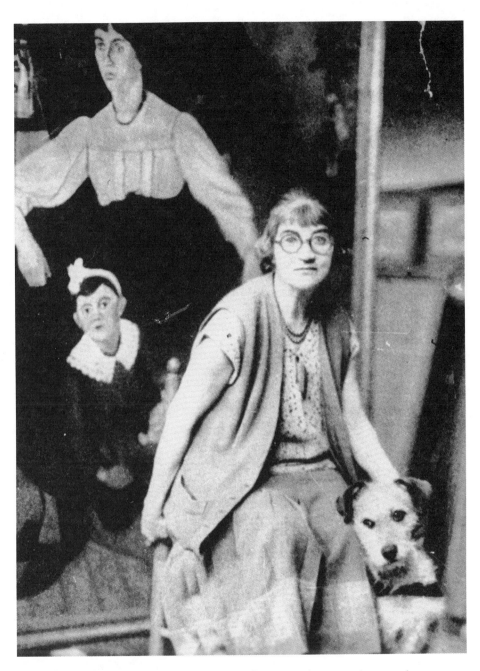

Valadon's moods were mercurial; she would fly into a rage one minute and burst out laughing the next. The camera has captured her, serene and dignified, with her beloved dog. Behind her is the painting she made of her family.

magazines created the illusion that modern French woman, slender, sleek and pouting, was an art form in herself. Flattering reflections of her could be found in glossy photographs and society oil paintings.

The woman artist who came to embody the new French woman and her pleasures, 'to represent the ideal of French taste',[3] was Marie Laurencin. Gliding effortlessly between the world of art and the world of fashion, she became the darling of society. Some twenty years Valadon's junior, Marie Laurencin was her opposite in every respect. Laurencin's dreamlike watercolours of slim, elongated child-women with almond eyes and bobbed hair were as artificial and modish as their creator. Laurencin prided herself on her 'femininity': she was demure, discreet and happy to defer to the male. Nor was she averse to displaying her 'womanly' qualities, almost to the point of caricature. 'Each day I make myself do some sewing, as it is the most feminine exercise there is: it reminds me that I am a woman,' she told her dealer.[4] Laurencin also confessed that her work was designed to titillate: 'My ambition is that men should feel a voluptuous sensation when they look at my portraits of women. Love interests me more than painting.'[5] Valadon, temperamentally incapable of ingratiating herself with anyone, took up her needle only for practical purposes and hardly needed reminding of her gender.

Then Marie Laurencin cultivated friends who could be useful, dealers and designers as well as the cream of the intelligentsia – Colette, André Gide, Jean Cocteau. She was often photographed in her tasteful home, looking svelte and sophisticated. Valadon, by contrast, lived in a perpetual state of chaos, and most of her friends remained the old-timers from Montmartre, quite out of place in the Paris of the day.

Had she really wanted to, Suzanne could have been a part of it all. During the war, in May 1917, the couturier Paul Poiret, who was enormously influential in the art world, had bought a Valadon nude as well as several Utrillos. But that was the summer André Utter had been wounded and Valadon's passion for her husband had outweighed her career ambitions. Instead of wooing the patrons of art, she had rushed to Utter's bedside, leaving Paris and its possibilities behind.

After the war, alarmed at the 'perfect army' of women artists from all over the world invading the studios and salons of Paris, and fearing that these women would 'destabilise the profession', the art establishment

favoured a delicate, feminine sensibility.[6] They judged women's art in a separate category and strong women artists were out of favour. Even in liberal, bohemian circles, women's ambitions were regarded as a threat to the male order, and it is worth noting that French women only gained the franchise in 1944. Valadon could not be classified as a 'woman painter' and indeed resisted the label. With her flat shoes, her raucous laugh and her cigarettes, she remained uncompromisingly herself and made no effort to adapt to current fashion. By the end of the 1920s, the critics were reproving her, with grudging admiration, for her 'masculine' qualities.

In Adolphe Basler's 1929 monograph on Suzanne Valadon, he described her harsh childhood and pointed out that she had learned her skill in a hard school. Not for her the artificialities of genre painting. According to Basler, Valadon's forms were executed with a 'masculine brutality' and her 'corrosive colour' was 'the sincere expression of intense feeling and of a vehement lyricism'. 'Her paintings', he wrote, 'sing with a harsh voice, but they do sing.'[7] The writer Francis Carco detected a sexual ambiguity in Valadon's work: 'striking a balance between the severity of a masculine vision and that quality which through a faintly defensive instinct is deliberately left to the feminine touch . . . The line becomes human and here it is clear that Madame Suzanne Valadon is a woman.'[8] The critics seemed to be awarding her points for femininity as much as judging her work as a painter.

For the first two months of 1929 a major retrospective exhibition of about a hundred of Valadon's drawings and engravings, the work which Degas had admired so much, was held at the new Galerie Bernier in Paris. The critic of the *Beaux-Arts* was guarded in his praise, acknowledging that by constantly working at the gifts that Degas had first discovered in her Valadon knew how to develop. But he also censured her for being out of step with the movements of the day: 'One senses that Suzanne Valadon is closer to the Impressionists than to the present generation. Hers is an absolutely sincere art which owes all its qualities to an unceasing contact with nature.' In July the same year the Galerie Bernier held a second exhibition of her work, this time of recent paintings. With the new work on show, the critic of the *Beaux-Arts*, uninhibited by Degas's authority, felt able to express his true feelings about the artist:

It is not a question of evaluating the technique of these works . . . [Suzanne Valadon's] talent is indisputable. Praise of the artist has been expressed too often . . . If Suzanne Valadon has painted hideous shrews in tones of great vulgarity, it is because she wants to. That is the most disturbing thing. Apart from two or three works, the most recent, like the large bathers which are normal and healthy if not graceful, her female nude studies are treated as caricatures . . . As for her flower paintings, the charm of their colour, their fragility, is always spoilt by a detail, a basket or ladder, placed there to look unpleasant. Does it spring from her poverty or her spite?[9]

The critic was affronted, it is clear, by Valadon's gritty resolve to look beyond the world of fashionable boutiques and pretty girls. 'A painting can never be too ugly, violent or crude in colour,' she told the critic Florent Fels. To Maximilian Ilyin, a writer who wanted her to paint his portrait at the time, she replied: 'I can't flatter a subject.'[10]

But the establishment wanted women artists to soothe and please. The *Beaux-Arts* reviewer found Valadon's show of paintings in the summer of 1929 displeasing and her attitude mean-spirited: 'A beautiful nude is as real and as well able to provide the subject of a canvas as a hideous matron; only the choice of the painter intervenes . . . Perhaps Suzanne Valadon is a mystic who wants to make the human race divine by portraying the weakness of the flesh as disgusting.'[11] In this extraordinary outburst the critic reveals more about himself than about Valadon. When she was a beautiful young woman, the art critics had applauded, somewhat reluctantly, the willpower and independence that had enabled her to become an artist. But the middle-aged aesthetes who ruled the Paris art scene in the 1920s found Valadon's lack of education and defiance of etiquette distasteful, and the emotional whirlpool in which she floundered an embarrassment.

In her sixties Suzanne still flirted, still drank, still refused to defer to any man or woman, and lived and worked as a bohemian, turning night into day. In the house in the Avenue Junot where she and Maurice were now installed, Utter, had become a semi-detached member of the family, coming in and out as he pleased. Most of Picasso's cronies were contemporaries and friends of Utter, and when they spoke of the couple they invariably took his part, while Utter himself knew how to manipulate the situation. He talked up the prices of his two 'impossible children' by telling colleagues amusing stories about Suzanne's lavish tips

to taxi drivers, waiters and other menials (she even tipped an engine driver on a train journey to Lyon) and by exaggerating Utrillo's escapades when he slipped away from his mother or his nurse. Utter needed high prices, he boasted, to keep his four mistresses in fur and diamonds.[12] It all made good copy and led to ridicule and mockery in private and in print.

The critics were mainly men of André's generation, only too ready to soak up stories about his extravagant and eccentric wife. Valadon was unpopular with them in any case, seen as high-handed and distant. For André Salmon – the creator of the Modigliani myth and a man who thrived on gossip – the rumours about the 'unholy trio' had a particular relish. In the early years of the century, when he was a young poet, he had fallen in with Picasso's gang and become friendly with Utter. Salmon soon established himself as a progressive, if not very discriminating, art critic; he wrote for journals in Paris and London about the art scene and whenever he could he introduced malicious tales about the Valadon family.

In an exhibition catalogue late in 1919 the critic Adolphe Basler had described André Utter as 'le Saint Joseph' (Joseph was Utter's second name). The quip delighted Salmon and he elaborated on it in the influential *Revue de France* of January 1930, pointing out that Utter had become the head of the family. 'Maurice Utrillo is the ancient miraculous child,' he said. 'Utter lives in the light of Utrillo's explosion of genius and in the tyrannical sweetness of the long-suffering Suzanne Valadon, queen and mentor of the artists of her sex in France.'[13] In a few lines Salmon had managed to relegate Valadon to third place in the family and to dismiss her as a female artist, albeit the queen of female artists. The amount of damage articles of that kind inflicted on Valadon's sales and reputation is incalculable.

About that time a good-looking young Cypriot living in Paris, Paul Pétridès, a man with a love of art and an eye for business, entered their lives. The twenty-eight-year-old Pétridès was already beginning to dabble in art dealing, although he earned his living as a tailor. One afternoon in 1928 an English silk merchant, a Mr Roussel, visited Pétridès's shop and noticed two Utrillos hanging on the wall. The Englishman mentioned casually that he was due to meet André Utter shortly and offered to effect an introduction. Roussel warned the tailor gravely not to speak of Valadon or Utrillo, since that made Utter so furious that it sometimes even led to a fight.

A lunch with Utter was arranged in Montmartre; Paul Pétridès was careful to avoid the subject of Utrillo or Valadon during the meal, which proved convivial. When he heard that Pétridès was a tailor, Utter suggested a deal: 'Look here, old man,' he said, 'you make me a suit and I'll paint your portrait.'[14] Pétridès agreed happily to the arrangement, hoping it might lead to a meeting with Utrillo or Valadon. Then, as they left the restaurant together, Utter, in jovial mood, asked Pétridès if he would like to meet his wife, who lived close by.

For the tailor the afternoon passed like a dream. Valadon took a liking to the goodlooking young man and offered to introduce him to Utrillo, who was in Paris at the time. 'I find you sympathetic,' she said, as she showed him upstairs into a shabby room. Pétridès was appalled by what he saw. Utrillo, sad-faced, was wearing baggy trousers and a soiled shirt. Although he put on a jacket, to the elegant tailor the artist's clothes were a disgrace. Valadon, who had slipped into the room, understood Pétridès's discomfort immediately. 'If you make Maurice a suit, we'll give you a painting,' she suggested. Utrillo muttered 'blue' – whereupon Pétridès arranged to come back one afternoon to take Utrillo's measurements and show him samples of blue cloth. Then Suzanne asked the tailor to make her a beige coat; she presented him with a magnificent flower painting in exchange.[15]

In the old studio in the Rue Cortot, Utter painted Pétridès's portrait, and although he went out of his way to be friendly to his sitter Pétridès soon saw signs of Utter's irritability. As he had been warned, it was directed at anyone who angled for introductions to Valadon and Utrillo. 'They won't get at me like that,' he growled. In a corner of the room Pétridès noticed a partly destroyed canvas from Utrillo's famous white period, but when he asked Utter what had happened to the painting the reply was non-committal. Later the tailor heard from Suzanne that when her husband bowled home in a drunken rage he lashed out and wrecked everything he could find. She showed him the debris of several broken chairs crammed under the stairs leading to Maurice's room. Over the years a number of her drawings and paintings were damaged or destroyed by Utrillo and Utter.

Through swapping tailor-made clothes for paintings, Pétridès came to know the trio well. In the 1930s he gave up tailoring to open his own art gallery, though he still kept his shop with the sign 'English tailor'. Eventually Paul Pétridès became the principal dealer to both Valadon

and Utrillo, and today the Pétridès Gallery, now in the Rue du Faubourg Saint-Honoré, still handles their work.

During the times he lived with his mother in the Avenue Junot, Utrillo would often interrupt her when she was working in her studio, bursting in on a whim. Utter's daily visits too were disruptive; Suzanne never knew when to expect him. Yet she longed to see him, leaving her door always open, and Utter himself confessed to a friend that the sight of his wife, even in old age, never failed to fill him with a sense of excitement.[16] After he had gone, Valadon felt totally exhausted.

The few hours she spent at her easel, giving shape to the harsh vibrant rhythms in her head, represented the only peace and satisfaction she knew. In her flowers – her 'friends', she called them – she now expressed her feeling for voluptuous form, rich texture and glowing colour. Of the over 120 flower paintings she produced, all are completely individual. In 1931 she painted a rose on a palette, but even the roses she loved were too alive to be purely decorative. Although her themes were now restricted, Valadon was still developing as a painter, but André Salmon could never write about her without a patronising nod towards her past, as in January 1930:

> There are painters of fortune just as there were soldiers of fortune. Suzanne Valadon did not come to painting straightaway. But the most beautiful periods of painting are reflected in her bright eyes . . . Suzanne Valadon's art deserves the respect which *no-one grudges her any longer*. It is an art always at the service (if I may say so) of a very pure spontaneity . . . [Her] colour is deep. The air moves with a rare fluidity around her beautiful nudes, rich in humanity, as about the simple bouquets she composes with a few choice tones.[17]

That year Valadon took part in an Exhibition of Living Arts at the Pigalle Theatre in Montmartre.

By 1930 Valadon was sixty-five, conscious of her age and impatient of an increasing tendency to tiredness which she tried to ignore. In Montmartre she was often alone, separated from the two men she loved. Her pets remained her most faithful companions and she paid tribute to them on canvas. In 1920 she had painted Raminou as a handsome, tigerish kitten with blazing eyes; in a painting of 1932 Raminou, still alert, has put on weight and lies slackly on a table beside a vase of carnations, his eyes misted over. As her animals had free run of the household, she painted them on her bed, on sofas, cushions and tables.

Utrillo, who realised their importance to his mother, never failed to enquire about their welfare.

André Utter had grown to treat the family's property both at the Rue Cortot and in Saint-Bernard as his own. (The house in the Avenue Junot had been bought, wisely, in Utrillo's name.) At the time Utter had a mistress known as 'Yvette', a former secretary to all three artists. Suzanne knew of the liaison and hated it, but when she heard that Utter was taking his mistress to Saint-Bernard she flew into a frenzy of jealousy and pursued the lovers to her château. Once when they were in bed in Utter's room, Valadon tiptoed to the door and locked them in. Despite their screams and shouts, she refused to let them out for a week, sending them up only boiled cabbage to eat, in a basket they lowered from a window.[18]

Occasionally when Valadon and her husband were alone together, they found the peace and contentment in the countryside that they had hoped for when they bought the château eight years earlier. Suzanne only had to open a window to gain a view of the trees, the church, the mellow sun-drenched walls. André, swaggering about their estate in plum plus-fours, enjoyed shooting a hare or partridge or catching a pike from the river for their meal. When he was feeling at peace with himself he would sometimes settle down to paint. For the two of them life in the country was both a joy and a torment. By now they could not live without each other, yet as a couple they were mutually destructive. Old passions, old jealousies, old resentments drew them together; they were also bound by complicated financial and legal arrangements concerning both Valadon's and Utrillo's work. André Utter, now in his forties, had turned into a weak, manipulative, grasping man. Yet Valadon still haunted his imagination and when he was away from her he dreamt of a harmonious reunion. He felt remorseful whenever her frayed nerves or her ill health prevented her from painting.

'Ma You-You [a pet name], Ma Suzanne aimée,' he wrote to her from Saint-Bernard on 2 April 1930: 'In beautiful spring weather I want to reconsecrate my love for you, to tell you that I love and embrace you with all my heart. In the hope that you will be strong and well, and courageously take up your brushes, because you are so admirably made for painting.'[19] One could remark cynically that her husband wanted money from her, receipts from Utrillo's paintings or her own, and he probably did; that he was drunk, and that was possible too. But a

genuine admiration for her art and a lingering love for her person seem also to inform his note.

Whatever his weaknesses, Utter knew that Valadon was unique. Her art was reaching a wider public than ever. In Brussels in 1931 the Galerie le Centaure held a major retrospective exhibition of her paintings and drawings; in Prague she participated in a show of the 'School of Paris'. This increased recognition was due in part to the influence and loyalty of her friend, the politician Édouard Herriot. A large, burly man with a bushy moustache, Herriot had become a close ally of Valadon, appearing at her exhibitions and celebrations. In 1931 he wrote a foreword to the catalogue of a show in May of her recent work at the Galerie le Portique in Paris.

The son of an army officer, Herriot had won a high reputation as a scholar and teacher at the lycée in Lyon before he entered the political arena. His stature as a man of letters was later enhanced by literary criticism and a well-received biography of Beethoven. He was of Valadon's generation, just five years younger, and the kind of man who had always attracted her – cultured, liberal, but a man of the people, and in his case inspired by a vision of international co-operation. Had the circumstances been different, they would no doubt have been lovers. For although Valadon came from humbler origins her stories of Montmartre and of the heroic political struggles of the past intrigued him. Above all, he appreciated her talent.

In June 1932 Herriot was again elected Prime Minister and took over the Ministry of Foreign Affairs. That did not prevent him from attending the opening in October of Valadon's most important retrospective exhibition at the Galerie Georges Petit in Paris, and keeping the diplomatic train to London waiting for an hour while he strode around the gallery admiring her work. In his preface to the catalogue, Prime Minister Herriot wrote of Suzanne Valadon with a warm lyricism:

> I think of the words of Théophile Gautier, 'Summer is a colourist, winter a draftsman.' To those of us who admire and love her art, Suzanne Valadon is springtime; the fountains of life, the spontaneity of everyday living flow from the objects and forms she describes, naturally and without artifice. And in front of the works of this very great and dedicated artist, the heir of those masters of the nineteenth century we now revere, I marvel that so scrupulous a respect for the truth of form is able to achieve such a feast of colour and movement.

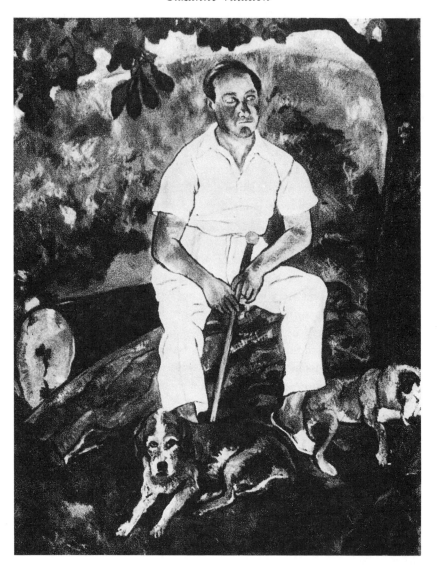

André Utter and his Dogs, 1932.
Valadon painted this autumnal portrait of her husband as the couple were on the point of breaking up.

Herriot also described Saint-Bernard: 'The courtyard of the dwelling where the three painters work – a trinity inspired by the cult of art – is surrounded by old, crumbling walls.'[20]

It is impossible to know whether Herriot was privy to the storms and scandals that buffeted the trio when they lived together at Saint-Bernard. Their temple of art was in hock to their creditor, who was placated from time to time with paintings from Valadon and Utrillo. The white and lavender lilac might be blooming on the terrace but Utrillo would escape for days, selling a painting and roaming the local inns until he wandered home, exhausted and ill. Utter would ignore Suzanne's pleading, leave the château night after night, smartly dressed and reeking of eau-de-Cologne, to meet one of his mistresses. According to a servant, Valadon stormed and pleaded and even offered bribes to persuade her husband to stay at home, but he would not listen. After his assignations, however, he always came back to the château to sleep, no matter how late it was. Valadon herself, unable to sleep, unable to work, would drink or wander in the grounds in despair.

Despite the bitterness between them, Valadon decided to make a portrait of her husband, the first for years. She painted a head and shoulders in oils; then she painted a full-length portrait of Utter posed in the countryside at Saint-Bernard. He sat for her perched on two logs, under a horse-chestnut tree, his two large dogs sleeping at his feet. Twenty years earlier she had seen André as an upstanding Adonis in a sketch for her masterpiece, *The Casting of the Net*. In 1932 Utter, running to a paunch, looks all of his forty-six years, his hair receding, his mouth thin and tight-lipped, his eyes thoughtful and sad. There is no bitterness in the painting, only a sense of melancholy, and the colours, green, tan and gold, seem to herald the approach of autumn. Earlier, in the spring, the trio, with their friend, the sculptor Georges Salendre, attended the opening of an exhibition of their work at the Galerie Moos in Geneva. Valadon showed over a hundred paintings; predictably, her work was well received by the critics but there were few sales. The journey, with Utrillo, Utter and the two dogs, proved a strain for them all.

The retrospective exhibition held that October at the Galerie Georges Petit was Valadon's most important ever. Again the press greeted the show with enthusiasm, but again very few people bought her work. Hopes had been high for this exhibition. Not only had Herriot

contributed to the catalogue; Claude Roger-Marx, a distinguished art historian, had published a volume of eighteen of her engravings bound in a handsome limited edition at his own expense. Roger-Marx had taken great pains to discover the plates, some of which were lost or scratched, and the engraver Daragnès had printed the edition, yet sales of the book were disappointingly small. Claude Roger-Marx may have explained the reason in his essay. He praised Valadon's imperative tone, her passion, her 'harsh and sometimes sullen charm', the way in which she portrayed women deformed by age or servitude stoically, without seeking a facile, pitying response. Above all he admired the uncompromising nature of her character and her inspiration, her total refusal to be influenced by current trends. At a time, he remarked, when the painting scene was 'invaded by so many jugglers and acrobats', the former trapeze artist – virtually alone among her coquettish sisters, tyrannised by fashion – knew how to remain true to herself, 'austere and sturdy as her engravings . . . [her qualities] would last.'[21] In the 1930s, with the financial markets depressed, the art-buying public looked for a sure return on their investment, and commercially Valadon's paintings failed to please; in any case fewer people could afford to buy art at all.

By 1933 friends noticed that Valadon's extraordinary vitality had begun to flag; when tired, she was given to moods of total despair relieved by sudden outbursts of optimism. In all probability she was suffering from the gradual onset of the diabetes that was only diagnosed later. While Suzanne had always been temperamental, it seems likely that the illness, untreated, was exacerbating her mood swings. Her overwhelming fatigue in itself depressed her deeply, sapping her energy and preventing her from painting. That year she produced only three or four of her flower pieces. She no longer had the consolation of the château that she loved: after her last visit to Saint-Bernard she had decided that she would never stay there again. Utter, she said, 'has poisoned the well.'[22]

As for her son, she cared for him deeply but he was no companion for her, whether he was in Paris or Saint-Bernard. From the château, where he was virtually a prisoner, Utrillo wrote her touching little notes reporting on the state of his health. One day in the castle grounds he came across a child's catechism that belonged to one of the servants. The simple text fascinated him and he tried to plumb the significance of the dogma as he read and reread each page. Maurice began to attend mass

each Sunday, searching for consolation in religion; in the end he became convinced that in order to escape eternal damnation he must be baptised. As a young woman Suzanne had given no thought to providing her son with a religious education: she had disliked her convent and had lapsed happily into indifference. But by now she was ready to agree to any desire of Maurice's that would comfort him and divert his attention from the craving for drink. In Lyon on 8 June 1933 Maurice Utrillo was baptised at the age of forty-nine. Valadon was nearly sixty-eight; after a punishing life she had begun to recognise her own vulnerability and to fear for Maurice's future, suspecting that André Utter was more likely to exploit her son than protect him. Maurice himself, in middle age, was still obsessed and tormented by his passion for his mother.

As Suzanne aged and worried, a woman in her fifties was waiting in the wings. Lucie Pauwels had visited Valadon and Utrillo when she and her late husband, a Belgian banker, had bought their paintings soon after the First Word War. In February 1933 Lucie had been widowed and while she grieved for her husband, who had suffered business reverses before his death, she soon discovered that she could no longer afford the luxurious life of the past. Lucie was both vain and energetic. In widowhood her life was empty and she sought a new purpose, a new direction. She had been an actress in her youth, and with artistic licence she often elaborated on the story of how she found her final role.[23]

Not long after she was widowed, she invited a well-known clairvoyant to her home in Paris, hoping for guidance. After reading Lucie's hand and the tarot cards, the clairvoyant told the eager widow that in two years she would be married to the greatest man in France. His first name was Maurice. To make certain, Lucie consulted another clairvoyant, who repeated the prophecy. Lucie then decided to act. Over the years she had kept up a friendship with the Valadon family, referring to Suzanne as her 'dearest friend, the great artist'. Valadon was amused by Lucie, but almost certainly detected the egotism and pretension beneath her unctuous manner. In 1933 Lucie Pauwels and her nephew went to Saint-Bernard to see Maurice, who was delighted to receive a visit from a lady who flattered him and seemed so interested in his welfare. Naturally he told his mother of Lucie's visit.

In Paris Valadon was again short of money. Although Utrillo's paintings fetched vast sums and she had made sales of her own in the

1920s, his medical treatment and his nurse, the upkeep of the dilapidated castle and the rent for two apartments in Paris, Utter's playboy habits and her own extravagance had all eaten into the family budget. The fact was that by 1933 Valadon was finding it difficult to meet her expenses.

Perhaps that is what finally persuaded her to agree to exhibit at the Salon des Femmes Artistes Modernes in 1933. Up until then she had disliked the concept of women exhibiting separately and refused to consider herself to be a 'woman painter'. In her own description of her artistic development she had confessed to a 'hint of misogyny' in her art, derived from Degas.[24] Throughout her career Valadon had been only remotely aware of the struggle of women artists for professional advancement. She was already working as an artist's model in 1881, when the Union of Women Painters and Sculptors was founded in Paris. The Union had promoted annual exhibitions of women's art for fifty years. By 1897, when their campaign had compelled the authorities to open the state-funded École des Beaux-Arts to women students, she had already exhibited five of her drawings at the Salon de la Société Nationale des Beaux-Arts without any formal art education. As an artist who had made her own way she had little interest in artistic groupings and she was known in Montmartre circles as a man's woman. In 1931 Marie-Anne Camax-Zoegger had founded the Salon of Modern Women Artists and was eager to enlist Valadon in their ranks. Suzanne resisted at first, telling Madame Camax-Zoegger, the energetic president, that the women painters would detest her work. That was, of course, her way of expressing her dislike for theirs. When Madame Camax-Zoegger reassured Valadon that her own work was hung beside Suzanne Valadon's at the Musée du Luxembourg, she agreed to exhibit within the group.[25]

Once she was drawn into meeting people Suzanne became animated and curious. She took most of her meals in Montmartre cafés, enjoyed the company and would call across the tables to friends and strangers. Valadon had begun to give tuition to a handful of recommended students, both men and women, who all adored her. The young sensed that she was an ally, unselfconsciously bohemian, understanding and impossible to shock. Her past fascinated them and an air of glamour, albeit somewhat raddled, clung to her.

In 1934 the arrival of a new man in her life sparked off all the gossips of the Butte. A Russian painter half her age, Gazi Igna Ghirei – a

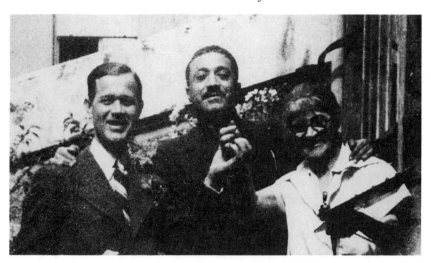

Valadon with her dealer, Paul Pétridès (left) and a young painter friend, Gazi.
Even in later life Suzanne remained a vivacious and fascinating woman.
Gazi Igna Ghirei, who claimed to be the descendant of a Tartar prince,
adored her and adopted her as his 'spiritual mother'.

dashing young man, with dark hair, blazing eyes and a swarthy
moustache – had become her close companion. At the age of seventy, it
was rumoured, Suzanne Valadon had found another young lover. The
truth was even more surprising: Gazi, a Tartar prince, adored Suzanne
almost as an idol, and adopted her as his 'little mother'. Consumed by a
mystical sense of religion, Gazi tried without success to enthuse Suzanne
with his Christian devotion. In more mundane matters, however, he
helped her with household chores, shopped and cooked for her, played
the guitar to her and wrote her letters. He was a townscape artist, and
Suzanne helped him with his paintings. For hours they sat together in
the kitchen of her house, talking.

Although she painted so little that year, Valadon did invite Paul
Pétridès, now a professional gallery owner, to sit for a portrait.
Goodlooking young men always cheered her. A date was arranged and
Valadon sternly warned her model to arrive on time. Pétridès arrived
promptly at nine in the morning and Valadon asked him to sit down.
While Pétridès sat waiting, she cleaned her brushes thoroughly, then fed
and groomed her dogs and cats. About eleven o'clock Valadon appeared
to become aware of her sitter. She told him how to pose, put a few

strokes on canvas and at noon laid down her brushes, reminding Pétridès to be punctual the next day. The following morning, Pétridès again turned up promptly on time and Valadon repeated the performance.

On the fourth day the young dealer had had enough. He arrived at eleven o'clock to find Valadon fuming.

'So this is your punctuality?' she yelled.

Pétridès explained that he had wanted to give her time to prepare and look after her animals.

'I've had no time to do anything!' Valadon snapped. 'I've been waiting for you. Come back tomorrow punctually at nine.'[26]

To Pétridès, the sessions seemed interminable, although he was delighted with the finished portrait. As he was leaving, Pétridès realised that the artist was waiting for payment. To his embarrassment he had to explain to her that he had paid the fee of 1,500 francs to Utter. Pétridès noted in his memoirs that Valadon was much more interested in hearing his sincere compliments on her work than in the 'premature cashing of the cheque by her own husband'.[27]

The year was overshadowed by ill-health and in January 1935 Valadon was rushed to the American Hospital in Neuilly suffering from diabetes and uraemia, a condition caused by the kidneys' failure to evacuate urine from the blood. Lucie Pauwels was soon on the scene. According to her account, Valadon had sent for her. Gravely ill, the artist had murmured, 'What will become of Utrillo? He needs a great soul.'[28] Then Lucie's revelation struck. Realising the fortune-teller's prophecy had come true, she asked Valadon if she could visit Maurice, who was languishing in the house in Montmartre, too overcome by his mother's illness to visit her in hospital. The story was told and retold by Lucie.

When Valadon came home, her convalescence was anything but peaceful. If in a moment of weakness she had wanted Lucie to look after Maurice, she now recognised the sacrifice she would have to make. The other girls that she had proposed as wives for her son were malleable and young, and the couple would have lived in her orbit. Lucie, in her fifties, was a formidable rival. For years Valadon had looked upon the care of her son as a kind of martyrdom. He had remained immature, a latent alcoholic, both a cause of terrible anxiety and a reason for living. The idea of parting with him was unbearable. However, she was anxious about his long-term future: she did not oppose the marriage but prevaricated.

Utter, on the other hand, tried actively to prevent the union. Utrillo's prices had dropped but he still provided a useful income. So Utter telephoned Lucie and went to visit her, to warn her what impossible people mother and son were, what a burden she would be taking on. They lunched together in Montmartre; Utter accused Lucie of wanting to marry Maurice to make a profit out of him. 'You have been doing that for years,' she countered. At the end of their lunch, Lucie remained adamant in her determination to marry Utrillo. Utter turned to the company with a dramatic shrug and announced: 'The firm of Utrillo has changed hands.'[29]

In a last attempt to stop the marriage, Utter physically barred Lucie's path when she and her nephew Robert came to fetch Utrillo, telling her he was going to take Maurice to Lyon for a month, where he would be looked after by friends. Lucie burst into tears, Valadon turned on Utter furiously, and Utrillo, sober and the centre of family attention for the first time in years, cried pathetically: 'They want to take me away from you, Lucie, but don't worry. I will be your husband.'[30]

Maurice needed his military card to obtain a marriage licence; Suzanne had lost it. His clothes were a disgrace, so Lucie cleaned and mended them and bought her future husband two new suits. A welter of stories was leaked out to useful scandalmongers and eventually to the press, all the tales detrimental to Valadon. Enjoying his new status as Lucie's fiancé, Maurice had become obstreperous with his mother. A few days before the wedding Suzanne confronted Lucie, Robert and Maurice, wearing his bedroom slippers, and threw them out of the house. Convinced that his favourite saint, Joan of Arc, had sent Lucie to him, Utrillo embraced his mother and left, crying, 'Vive la liberté!'

One interesting fact can be salvaged from the debris of gossip. On the front page of the popular evening paper, *Paris Soir* on 12 April 1935, a banner headline announced that Maurice Utrillo, the hermit painter, had visited the cathedral of Chartres with his fiancée to pray for their future happiness, taking a reporter from the newspaper with him. He was to be married shortly. On the way to Chartres the reporter, René Barotte, had witnessed a miracle. Maurice sat down and in half an hour had produced a marvellous landscape: 'working in front of our eyes, Utrillo proved again that the rumours which allege that the artist has given up his vocation and allows copyists to do his work are lies.'[31]

On 18 April, six days after the visit to Chartres, the couple were married at the town hall of the sixteenth arrondissement, the public well

LEFT *Portrait of Lucie
Valore* (Madame Maurice
Utrillo), 1937.
Despite her daughter-in-
law's attempts to curry
favour, Suzanne painted
Lucie with her usual
candour.

BELOW Maurice and
Lucie Utrillo outside the
church, 1935. Maurice was
fifty-two when he left his
mother to marry Lucie.
Valadon was absent from
the religious service held
in Angoulême.

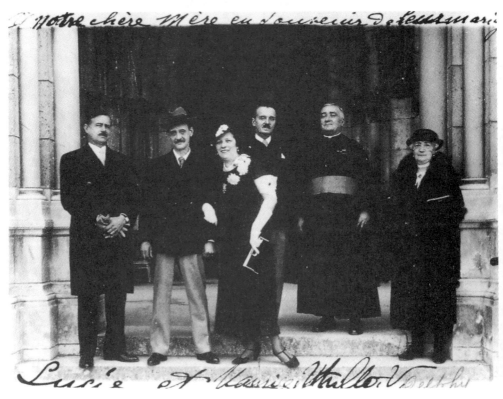

alerted. Maurice signed the marriage contract with his usual, 'Maurice Utrillo V.' Valadon and Utter attended the wedding in Paris but absented themselves from the religious ceremony, which was held at the bride's home in Angoulême. The bride, aged fifty-seven, wore a clinging black dress which reached to her ankles, open sandals with small heels, long white gloves, white cuffs, corsage and a white feather in her hat. The groom, aged fifty-one, looked mildly uncomfortable in his new flannel trousers, jacket and soft hat. Next to him, ironically, stood the district prefect of police, a plump priest, a local sculptor and Lucie's elderly mother, all eminently respectable. Suzanne received the photographs, including one of the bride's bouquet, as a filial souvenir of their marriage.

Even before they were married Lucie had set about publicising and reforming Maurice, urging him to pray and to give up drink, with pious exhortations and many professions of affection. In the years to come Lucie was to prove a more efficient guardian of Utrillo than Valadon could ever have been. She was more single-minded, more consistent and more interested in exploiting Utrillo's talent. She prided herself on being a model wife and many letters expressing her devotion were to be published in the future.

An undated note among Valadon's papers suggests that Utrillo's dream of liberty when he married may have been an illusion: '*Maurice.* I want to see you shaved on Wednesday and Saturday. Lucie.'[32]

10

La Grande Valadon

Alone in her house in the Avenue Junot, Suzanne felt physically and emotionally drained. For years she had longed to see her son safely married, but she had been unprepared for the circus of the courtship and the blatant takeover by the bride. The strain of it all brought on a relapse in her health and she became too weak to work.

Three hundred miles from Paris, Maurice was installed in his wife's house in Angoulême. Lucie Utrillo lacked the imagination to comprehend that in removing a son who had been dependent for forty years she was not only relieving her mother-in-law of a burden but depriving her of her closest tie. Utrillo, as always, was agitated about his mother, anxious that she might be short of money without the profits from his painting. As for Utter, he told his cronies that Suzanne had allowed the marriage to take place in order to punish him for his infidelities by cutting off his, and incidentally her own, money supply.[1]

Lucie was anxious to patch up the split in the family. She held such a high opinion of herself that she could not bear anyone to differ from her. In a gesture of appeasement, soon after her marriage Lucie sent her mother-in-law a painting by Utrillo. The offering riled Valadon; despite her frailty she had not lost her fire: 'Madame Valadon', she replied on 2 June 1935, 'est toujours souffrante.' She pointed out that her dog was very ill, due to have an operation, and she asked the couple frostily not to send any more paintings as they would be returned. 'She merely requests to be informed of your addresses,' she added. In conclusion she wished them good health, sent her love and signed herself 'Madame S. Valadon'.[2]

That winter Suzanne had her frames and stretchers, her easels and brushes moved from her garden studio into the house. No paintings dated 1935 exist. She was too weak to stand for hours at an easel. For the first time for years she focused on her etching. After making a preliminary drawing, she would work directly on to the copper plate. In *Three Nudes under the Trees* she developed a theme she had explored thirty years earlier.[3] The couple next door, the Poulbots, old-timers from Montmartre, proved extraordinarily kind to her in her illness. Poulbot, the illustrator of the urchins of Montmartre, had fought side by side with Suzanne against the 'unscrupulous landlords' who put up skyscrapers. His wife visited Suzanne regularly, bought flowers and helped with household chores. How much Valadon valued her friendship can be discerned in the dedication of another etching she gave to her neighbour that year. On the surround of the print she wrote: 'For Madame Poulbot, for her spontaneous, courageous good nature, with all my heart, which will never forget'.[4]

By 1936 Valadon felt well enough to paint again, confident and in command of herself now that she could produce her work. 'She was like an angel when she painted,' Paul Pétridès said.[5] Her moods and worries faded at the easel as she concentrated completely. She did small oils of flowers, either cut from her garden or bought by friends. As models flowers were convenient, no expense and no trouble, and she could observe them settling in a vase for days. In 1936 and 1937 she painted what looks like her lunch – herrings on a plate with a lemon beside them. Valadon loved roses and painted them in a glass vase for weeks on end – one rose; two roses; four roses. In one bold oil of 1936 she wrote the inscription 'Vive la Jeunesse' on a ceramic jar bearing her beloved roses. Her friend Francis Carco bought that picture. At seventy-one, after serious and debilitating illness and with a devastated family life, Valadon was painting with skill and spirit.

Meanwhile André Utter, living nearby in the Rue Cortot, was drinking heavily and playing a curious game. Now that Lucie was firmly in charge of Utrillo's affairs, Utter was anxious to ingratiate himself with her and to widen the gulf between Suzanne and her son and daughter-in-law. In the autumn of 1936 Utter had arranged for Valadon to exhibit a painting at the Indépendants of Bordeaux, but when the packers arrived at the house she had backed down and refused to show the work. Utter told Lucie all about it in a letter:

Dear daughter-in-law and friend,

Suzanne becomes more and more incomprehensible. She is going through a crisis of disproportionate pride and pretentiousness. Modesty becomes her so well, but I believe that this modesty is merely superficial and that pathological timidity conceals a crazy pride. *Tant pis.*

Utter added spitefully that Suzanne had sneered at a letter her daughter-in-law had sent her with a few words from Maurice. He warned Lucie against an idea she had harboured of returning to Montmartre to share the house in the Avenue Junot with Suzanne:

If you three did live together, there would certainly be a victim – You! . . . Suzanne or Maurice, perhaps all three, but victim there would surely be, whether morally, artistically or financially . . . If, after some time, you have found satisfaction in Maurice's life, it is because of the isolation in which you keep him and the regular and organised life he leads.

There André was probably right, but it was his next remark, exaggerated and malicious, which seemed designed to blacken Valadon:

With Suzanne there would be anarchy – she is used to living by night, to inviting 20 people by day, and given her age and her personality you would not be able to prevent her.[6]

Utter slipped in a request at the end of his letter for two gouaches and two oils by Utrillo. If Lucie could send them to him at the lowest possible price, he was sure he could sell them for her quickly.

Suzanne was undeniably eccentric and unpredictable but Utter's comments gave the impression that she was half crazed, rather than peculiarly individual, as she had always been.

Utter had asked his neighbour, Robert Naly, a Swiss painter, to keep an eye on Suzanne when he was away. 'My role was to stop her from collecting the *clochards* of Montmartre,' Naly said. Naly had understood that Valadon picked up the odd down-and-out artist, took him to her bed when she felt the urge and sent him away the next morning with a Degas drawing as a souvenir. Naly's own experience came as a surprise to him. Sometimes he would sleep in the house for months. 'Sleep is a manner of speaking,' he observed. 'She would keep me awake all night talking heatedly about art. She would, for example, pick up a book on Venetian art and analyse the technique of Titian and Tintoretto with extraordinary insight and lucidity. She taught me everything I know.' Naly recalled that whenever he and Utter found a painter with her they

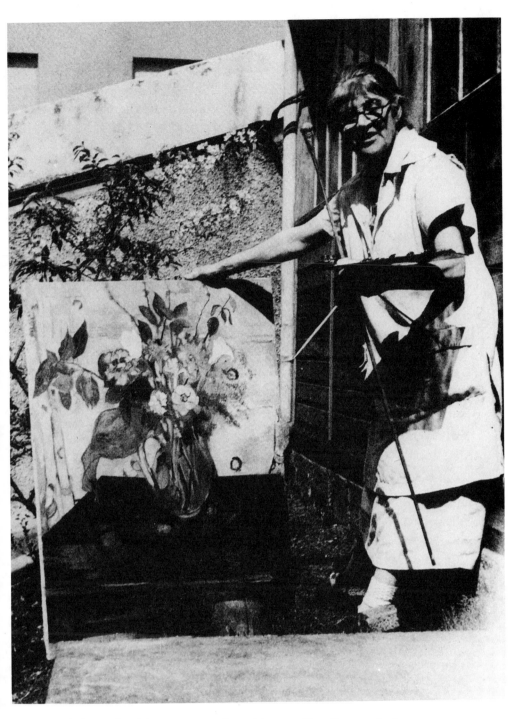

Valadon in her Montmartre garden with one of her flower paintings.

threw him out. 'But Gazi was entirely honest, entirely devoted to Suzanne Valadon, so much so that even Utter accepted his presence.'[7]

Whether or not Suzanne was as sexually active as Utter made out is impossible to tell; but the intensity of her feelings towards both men and women had not diminished with age: her passion was part of her personality. Fortunately another, very different account of Valadon in her seventies is on record. Years of exploring human nature through the portraits she painted had deepened the artist's understanding of people and she could be delicate as well as earthy when required. In 1936 she was painting a portrait of Geneviève Camax-Zoegger, a young student of both history of art and fine art and the daughter of the president of the Fédération des Artistes Modernes. Innocent and pretty, Geneviève had heard whispers of Suzanne's wild youth. But years later, Geneviève, now Madame Barrez, recalled that Valadon, who named her model 'Angélique', was careful not to use bad language or to tell stories that would shock a well-brought-up young girl. 'She had class,' she noted.[8]

Madame Barrez had the impression that Valadon was short of money. When she asked her young model to buy her some liver, Valadon added, 'Not calves' liver; it's for the cats.' But Geneviève thought it might well be for Valadon herself. One morning an official from the gas corporation turned up and threatened to cut the gas off if Valadon did not pay her bill. The artist was indignant: 'To do that to me, a customer for forty-five years!'[9] The one event in Valadon's day that she longed for, Madame Barrez remembered, was Utter's visit: that always brightened her.

Geneviève sat for three sessions of three hours and her experience of modelling for Valadon echoed that of Paul Pétridès. When she arrived the painter would be absorbed in feeding her animals and cleaning her brushes, and the sitter had to wait for an hour or two until the morning routine was over. Geneviève was hugely impressed and fascinated by Valadon. She later made the painter the subject of her doctoral dissertation. Today she retains a clear-eyed defence of her heroine.

Goodlooking young men were still calling to see Valadon in her seventies, provoking gossip and perhaps envy. Pierre Noyelle, her student, was a frequent and popular visitor – and, of course, Gazi was nearly always about the house. But it was her doctor friend, Robert Le Masle, with whom she had the closest friendship; she sketched him, emphasising his high forehead and generous mouth. A distinguished man of letters and a translator, as well as a medical man, Le Masle, who

was half her age, had been close to the family for years; occasionally he corresponded with Utrillo. Le Masle moved in artistic circles; he knew Ravel and Cocteau, and had translated the letters of Valadon's former lover, Erik Satie. As a connoisseur he admired Valadon greatly and collected her work.

To Robert's mother, Madame Jeanne Bernard Le Masle, Valadon sent an undated note:

> Madame,
>
> I am grateful that you allow Dr Robert Le Masle, your son, to be near me in the anxious and uncertain moments of illness. I have need of his presence and his care . . .
>
> Yours ever,
>
> *Suzanne Valadon*

On 3 March 1936, she wrote to Le Masle impatiently: 'My dear Robert, I am very surprised not to have received the little note you ought to have sent me on Sunday morning. Was it lost in the post or intercepted?'[11] Suzanne hated writing letters, but on 15 July 1937 she wrote again to Le Masle, distant but distinctly emotional:

> Madame Valadon, without word of you and waiting to hear from you, has not started the painting of the white roses, because she needs 100 francs for the flowers.
>
> Could you bring her [the flowers] and she will paint the picture for Madame with pleasure?[12]

Suzanne also asked Robert to return a book of engravings that he had borrowed, stressing that for her it was never a question of money: the idea of mixing art with money disgusted her. She preferred, she said, to starve alone in a corner, saddened by the poverty of those for whom love never triumphed over money. She closed her letter with a flourish: 'As for me, in embracing you affectionately I cry "Vive l'Amour!"'[13]

Le Masle's own little notes suggest a close and loving relationship but there was no question of physical love between them; Le Masle was homosexual. On 2 September 1937 he wrote:

> Dear Suzanne,
>
> I will come to the Avenue Junot this evening, a little after midnight.
>
> Must I tell you again that you have pride of place in the corner of my heart?[14]

On 31 December he wrote to wish her a happy New Year and sent tender greetings.

Valadon and her husband never divorced. After receiving word from Utter, now fifty and crippled with gout, that he was desperately short of cash, Suzanne sent him small sums of money whenever she could. In return he wrote her plaintive, nostalgic letters: 'I'm thinking about you,' he assured her in September 1937. 'It was in November that we first got to know each other. What a long time ago, and you are always intensely present in my heart. But you have an obstinate nature, don't you, terrible Maria!'[15] In a letter tinged with bitterness, jealousy and regret, Utter complained that he was unhappy with her 'disastrous circle', mentioning in particular Pierre Noyelle, her student, and Robert Le Masle. Her intimates now included Germaine Eisenmann and Odette Desmarets, both students, and the painter Georges Kars and his wife Norah; Utter thought her friends were unworthy of her. At Christmas 1937 he wrote of his 'indestructible love and his deep and respectful affection for her'.[16] She had not understood, he said, that she belonged entirely to him. But it was all too late.

After Utrillo's marriage in 1935 the trio had separated and scattered. For a year and a half Utrillo lived three hundred miles from Paris in the city of Angoulême in western France not far from Limoges. Lucie's home, La Doulce France, an imposing mansion by the river Charente with a large garden, was well staffed and managed with iron efficiency. At first Maurice enjoyed an outward and exaggerated deference that he had never been shown before. Nothing was permitted to interfere with the master's work: his wife, almost a governess, saw to that. The couple sent out Christmas cards bearing the message: 'The Painter and Madame Utrillo send their best wishes.' After fifty years of chaos, he now lived according to a rigorous timetable, the hours for church attendance, painting, walking and mealtimes carefully measured out. If he was permitted a glass of wine with his meal, it was well watered.

Soon after they were married Lucie had taken over the management of Utrillo's business affairs, scrutinising the accounts and supervising every detail of his professional work. Payments to Utter stopped altogether and Valadon was dependent on Lucie's goodwill. Utrillo worried about his mother's finances and asked his wife to visit her and help her; but Valadon was furious when Lucie told her that she could stay on in 'her' house, the house bought in Utrillo's name, in the Avenue

Junot, until she died. When Paul Pétridès visited Utrillo at Angoulême to ask him to authenticate a painting, Utrillo enquired when the two were alone whether the dealer had seen Valadon; Pétridès was able to reassure him that he had not only visited Valadon but had bought several of her paintings and drawings. Subtly and without an explicit admission, however, Valadon's works were seen to be a part of the Utrillo circus and relegated to second place.

In the autumn of 1936 Lucie took Maurice to Paris. She had decided to move nearer to the capital so that she could play a more active part in promoting her husband's career. In Le Vésinet, a wealthy, fashionable suburb of Paris, Lucie found the ideal situation; the district was a safe distance from Montmartre and had no local inn. Lucie chose a substantial villa, made extensive structural alterations and by Christmas 1936 named her new home La Bonne Lucie. Then she invited Paul Pétridès and his wife Odette to spend the holiday there.

For a son of Valadon the house seemed an unlikely setting. Ornately furnished with sumptuous tapestries and carvings, it was cluttered with expensive furniture. Utrillo's large murals of Montmartre and a three-foot statue of Joan of Arc dominated the main sitting-room and Utrillo was given a private chapel. The garden in front of the house was immaculate, with neat rectangular lawns, potted plants and small trees; lifelike figures of frogs and turtles adorned the stone walks. A dog-run for Lucie's prize Pekinese occupied one side of the garden; a large aviary for fifty parakeets the second. Valadon told her daughter-in-law that art would be stifled at La Bonne Lucie, but Lucie did not understand.

What she did understand very well was how to promote Utrillo. She severed links with his old dealer and negotiated an agreement with Pétridès. In 1928, when Utrillo was under contract to Bernheim-Jeune, a large painting of his would fetch about 40,000 francs at auction. By the 1930s his prices had slumped to 2,000 francs. Pétridès, however, knew that in a depressed market a painter needed a shrewd dealer to ensure that his work maintained its value. A contract was duly signed with Utrillo on 1 January 1937. Then Pétridès created a shortage. He visited dealers all over Paris, asking them if they had any Utrillos to sell. The artist, he confided, was painting less and less. News spread quickly among the art dealers, and those who had Utrillos held on to them, so that it became rare to see his work and his prices soared. Pétridès himself took a calculated gamble. Of every six Utrillos he received from the

painter he held back four, building up a large personal collection. He had lent Lucie 60,000 francs, interest free, and agreed that she could pay him back with sixty of Utrillo's gouaches.[17]

The Pétridèses and Utrillos grew very friendly, their interests linked. Utrillo became enmeshed in the world of golf-courses and fashionable seaside resorts, a world remote to Valadon. She disliked visiting La Bonne Lucie and instead often met the two couples for lunch on her own territory at the Moulin Joyeux in Montmartre where she felt at home. The former tailor wrote in his memoirs that Valadon must have been pleased to see her son so well dressed and comfortable. In fact, she told a journalist, she was horrified to discover that her son had become obedient.[18] After a lifelong battle against bourgeois values it was ironic for her to see him completely dominated by the most pretentious of women.

Lucie always referred to Valadon's art with breathless reverence: 'I kneel before Valadon,' she would say. In 1937 she even commissioned a painting of herself from Valadon, and perhaps she hoped that her praise would encourage her mother-in-law to immortalise her with a flattering portrait. She must have been disappointed when she saw the result. Valadon's work was truthful as always: she painted a plump, heavy-jowled matron with hard, glinting eyes.

That year the state recognised Suzanne Valadon's importance as a painter. The Musée du Luxembourg, then the Museum of Modern Art in Paris, bought three of her best works, *The Casting of the Net* (1914), *Grandmother and Grandson* (1910) and *Adam and Eve* (1909), as well as several drawings. Valadon always said that it was recognition as an artist that she wanted, not personal fame.

In 1937 she visited the Exhibition of European Women Painters at the Musée du Jeu de Paume which included work by Berthe Morisot and Marie Laurencin and a small selection of her own. That evening she turned to the friend who had accompanied her and said: 'You know, *chérie*, I often boasted about my art because I thought that was what people expected – for an artist to boast. After what we have seen this afternoon I am very humble. The women of France can paint too, *hein*? . . . But do you know, *chérie*, I think perhaps God has made me France's greatest woman painter.'[19]

At seventy-one, on good days, she was defiantly vigorous. She told a visiting journalist that she had been trained as an acrobat and could still

jump as high as the table. Her garden was a joy to her and she liked to hoe the soil and tend the flowers which she subsequently painted. Valadon said she did not mind housework, although she often neglected it: she had been used to looking after herself since she was a child; she continued to sew and mend; and she found pleasure in washing up and seeing the water glistening.[20]

By the late 1930s, however, Valadon's world had begun to change in a different way. Almost every day the French newspapers carried news of Nazi Germany and the threat it posed to France. All her life Suzanne had been too preoccupied with her art to be deeply involved in politics, yet as an old Montmartre fighter and a member of the Anti-Skyscraper Party she had always leaned instinctively to the left. In her lifetime she had also been close to at least two Jewish friends, Modigliani and Berthe Weill. With anti-Semitism rampant in France, she said publicly in an interview that she loved Jews and hated those who were their enemies.[21]

In May 1937 in Paris, the Galerie Lucie Krogh put on an exhibition entitled 'Suzanne Valadon and her Pupils, Odette Desmarets, Germaine Eisenmann and Pierre Noyelle'. These students adored her and bought her work. 'Valadon, *ma chère* Valadon, whose name opens all doors,' Germaine Eisenmann wrote to her in March 1938.

> What pride is greater than to be able to say, 'I love you and I venerate you . . .'? You are famous and yet you are much more feminine than the rest, passionate, loving, extremely understanding and so goodnatured.
>
> I don't owe you my life, Valadon, but I owe you the other, more important birth which enables me to love painting and to understand it a little. I don't mind being accused (as a painter) of being too much like Valadon. What greater example . . . and I do not presume that anyone other than you can create a Valadon.
>
> My love to you, dear Valadon, with all my strength and affectionate gratitude.[22]

Like all those close to Valadon, Germaine Eisenmann had been painted by her, in a portrait of 1924.

During 1937 Valadon had produced at least nine works – two portraits, a still life and six flower paintings. But the years were beginning to tell. Francis Carco went to visit her after a long absence and was shocked by the change in his friend.

She had taken refuge in the downstairs room in the Avenue Junot, where she had installed a divan among the stretchers and frames. My first impression was so intense that I was unable to disguise it. It was almost a year since I had seen Valadon and I had difficulty in recognising her. One sensed that she had exhausted her strength. Her worn shoes, her grubby dressing-gown, the strands of white hair that fell over her forehead and the signs of deterioration in her shiny, wrinkled face made her look like an old woman whose body appeared to have shrunk.

For the first time Carco felt that Valadon was giving up. 'Why should I struggle?' she asked him. 'As long as I had Maurice to look after my life had some meaning . . . My work? That is finished and the only satisfaction I gain from it is that I have never surrendered. I have never betrayed anything that I believed in. You will see the truth of that one day, if anyone takes the trouble to do me justice.'[23]

According to Geneviève Barrez, towards the end of her life the old fighter of Montmartre seemed to turn to religion. Gazi, the Russian painter who had adopted her as his 'mother', often steered the conversation in that direction and they discussed the subject endlessly. On one occasion Valadon recalled that as a small girl she had noticed a pebble in a glass case at a friend's home. When she asked what it was the old lady of the house had replied: 'It is a souvenir of Notre-Dame de Montmartre. When the revolutionaries destroyed the sanctuary, my father salvaged a fragment of stone and we have always kept it.'[24] Gazi assured her that she was mistaken, that there never had been a cult of Notre-Dame de Montmartre. But Suzanne was so certain that she convinced him. After assiduous apostolic researches, Gazi discovered that an ancient sanctuary under the patronage of Notre-Dame de Montmartre had existed before the Revolution. Madame Barrez maintained that Suzanne was so stirred by the confirmation of the story she had heard as a child that she became a convinced Christian.[25]

One can well imagine Valadon moved by religious sentiment, and eager to please such devoted friends as Gazi and Madame Barrez, but she had lived outside the church all her adult life and married twice in register offices. According to another writer she would answer every question on theology by saying: 'I am an atheist; I never go to church. However, nobody who knocks on my door for help goes away empty-handed.'[26] That sounds more like the authentic Valadon and indeed a

booklet of the ancient church of Saint Pierre confirms that Gazi was led to discover the statue of the Virgin of Montmartre 'by the go-between Suzanne Valadon, a non-believer, [which] was a miracle'.[27]

Early in 1938, an observer from her own world, the critic Jacques Guenne of *L'Art Vivant*, visited the Galerie Bernier in the Rue Jacques-Callot, expressly to see Valadon, who was participating in a group exhibition. André Utter had promised Guenne that he would try to persuade her to be present.

> She was ensconced in an armchair with a knitted hat on her head and bands of wool wrapped round her legs. Suzanne Valadon seemed tinier than usual but bent this time and quiet. When she caught a glimpse of me she called out: 'Well, are you working?' Trying hard to conceal my emotion I muttered, 'Like you, alas, with less joy!' 'Be quiet,' Valadon replied. 'Work's the only thing that matters.'[28]

In the spring she produced two paintings on the same subject: *Nude standing by a fig tree.* Images of youth and grace still stirred her: she had not given up. Early in the morning of 7 April 1938 she was at her best, painting at her easel. When her friend Madame Poulbot walked past the studio she heard a sudden cry and called anxiously to her friend Madame Kvapil. Together the two painters' wives broke into Suzanne's house to find her crumpled on the studio floor. She had suffered a stroke and was rushed by ambulance to the Clinique Piccini. Lucie was summoned. Suzanne Valadon died at the *clinique* at eleven o'clock. She was seventy-two years old.

Valadon's funeral took place two days after her death, marked by little public notice. *Le Figaro* merely reported that 'the funeral of Suzanne Valadon, *wife of the painter André Utter and mother of Maurice Utrillo*, will take place today, Saturday 9 April, at the Church of Saint Pierre in Montmartre at 3.30.'[29] In *Paris-Soir* Valadon's death rated far less prominence than had the announcement of her son's engagement. The notice of the demise of the 'great artist' was buried halfway down the page. Maurice, who had been frantic and almost insane with grief at the Clinique Piccini, was kept away from the funeral on Lucie's orders.

A large wreath of lilacs covered her coffin; the mourners included Picasso, Derain, Georges Huysman, then director of the Fine Art Museum, and other painters and critics as well as models, waiters and shopkeepers. André Utter was there looking haggard; so was Gilberte, her great-niece, and Lucie, directing operations. To an audience which

the critic Jacques Guenne found 'appallingly small', Édouard Herriot spoke simply of the friends gathered together, of old Montmartre which her son had made into a country and of Valadon herself, 'the greatest light among the artists of this century'.[30]

Suzanne Valadon was buried in the family tomb in the cemetery of Saint-Ouen, beside her mother. Despite Édouard Herriot's presence and the tribute paid to her in all the art journals, none of the daily press reported the event. Gossip about Suzanne Valadon remained the general public's chief source of information.

Only six months after her death members of the art world were incensed by the announcement of the publication of a book purporting to be 'Utrillo's Love Story'. Valadon had been one of their own, and a group of artists and critics led by Picasso and Derain protested publicly in a letter to Utrillo published in the journal *Beaux-Arts* on 18 November 1938. They described the book as 'a tissue of lies which would give a false image of Valadon and Utrillo'. However, the day their letter appeared, Utrillo's reply, under Lucie's direction, rejected their misgivings.[31] The author, R. J. Boulan, had consulted Lucie Utrillo and her husband extensively, although he had not contacted Utter. For his part, Utrillo saw the publication as an opportunity to hit back at those critics and fellow artists who had disparaged him in the 1920s as a drunk, fit only for the gutter or the hospital. The serialised episodes were maudlin as well as one-sided and inaccurate as the protesters had feared. Lucie emerged as the heroine – 'the good fairies were present at her birth' – Valadon as the 'gifted mother of a genius *whose name would become as well-known as her son's*'. Valadon had never been a model, the author asserted: she had sat once for a portrait by Toulouse-Lautrec. The rows and scandal of Utrillo leaving home were repeated, and six months after Valadon's death Utrillo, it was said, recovered from his grief with the constant repetition of the phrase 'Thank God I am married'.[32] For Utrillo the serialised story was brilliant publicity and had its effect: for years Valadon's name was never mentioned without Utrillo's.

The *catalogue raisonné* of her work lists 478 paintings, 273 drawings and 31 etchings as her legacy. Through her irregular life, some of the work escaped classifcation. A number of drawings and paintings were damaged or destroyed by Utter, Utrillo or her dogs, a number given away and some simply lost.

The state took nine years fully to recognise Valadon's achievement. In 1947 and again in 1967 two major Valadon retrospective exhibitions

Nude Standing by Fig Tree, 1938.
Valadon's last known work, painted in the year of her death. Can she be recalling her early days as a model in this fresh image of youth?

were held at the National Museum of Modern Art in Paris, an honour accorded neither to her son nor to her husband. André Utter had associated himself with the protest against the publication of the 'love story'. However tormented their personal lives had been, he remained an ardent admirer of her work. He had intended to write a book about her and in his unpublished papers Utter paid a moving tribute to the artist after her death:

Utter's popularity annoyed me and I despised it. I considered that it was too *Paris-Soir* [i.e. vulgar] and that that vulgarity encroached on the dignity of my – of our – family aspirations. I have always hated Boutique Art . . . it is not what is shown that one must look at, it is what is hidden that one must look for. Don't be misled by appearances. Valadon's art is linked to her character as a human being and to the early figures that are seen on the ancient monuments of Limoges. It is her profound human qualities and the spirit of her form that I wish to emphasise. She is complete because her painting is based on her drawing, her design, such a mistress of her art that she unites with the most human traditions, free of all artistry.

Yet she is not a *case* in the manner of El Greco, van Gogh or Douanier Rousseau. The Valadon 'drama' is physical, it exists everywhere in her art without rules, yet she remains traditional and classical. How it came about she does not know – it is a sort of divine magic that governs her will – a myth comparable to Androgenes fulfilled in her . . . with a certain psychological imbalance which makes this painter, who is after all unique.[33]

André Utter was right. Valadon was unique, both as a woman and as an artist. She was no intellectual, she had not attended life classes or studied anatomy, but she turned her handicap into an asset and taught herself to understand human beings through the flesh. She found the expression of the body more revealing than the composure of the face, and in particular drew and painted the backs of her models with extraordinary power.

'One must always be aware of the importance of volume,' she said.[34] Her drawings, in particular, have a deceptive solidity about them. You can feel the muscles in the arm of a plump girl lying on her bed; the strain on the spine as a scrawny adolescent climbs into the bath; the tension in the shoulders of an old servant as she fills a washbasin.

Degas hung her drawings and engravings alongside works by Ingres, Delacroix, Daumier, Hokusai, Manet, Gauguin, Cézanne, Pissarro and Whistler. It was no empty gesture; her best work stands comparison with the finest. She was clearly influenced by the outstanding artists of her day: her subjects and poses are close to those of Degas himself; her earthy realism to Courbet; her stylised use of flat, emotive areas of colour to Gauguin; her delight in richly patterned backgrounds to Bonnard and Matisse; and she herself wrote of the influence of the

psychology of Toulouse-Lautrec.[35] One can trace the influence of other artists too in Valadon's work; yet she remained independent, ignoring the rules of tradition and standing aloof from the schools of painting.

Valadon drew from her own experience and from the life around her. That is her strength. She was incapable of flattery and nothing was too ugly for her. Yet, despite her imperious line, her drawings of women, young and old, engaged in the most menial tasks, convey a sense of dignity and a stern love. Her drawings remain the most immediate and compelling examples of her work, and it is her strong flowing line that lends distinction to her paintings. In her body of work Valadon affirms life in all its curious forms. That is why she is important and enduring as an artist.

André Utter prided himself on introducing Valadon to painting and he tried to gain wider recognition of the boldness and audacity of her realism. His life had been taken over by Valadon; even in his infidelities she was his reference point. After her death, he continued to live off the memory of her greatness, writing articles and giving talks about Valadon, while continuing to paint himself. When Utter died in February 1948, aged sixty-two, Utrillo wrote privately: 'I would only reproach him for having molested my mother in word and deed.'[36] That was generous, because he had also teased and tormented his stepson.

In the years after Valadon's death, Lucie looked after Maurice with care and diligence – a secretary, chaurffeur and manservant always in his wake. The Bonne Lucie villa began to be filled with Lucie's crude paintings too. She convinced herself that she was an artist and sometimes persuaded Maurice to endorse her talent. Even their friend Pétridès was forced to admit that Lucie lacked any critical sense. 'Valadon was much greater than I am,' she would say; but in Mons in her native Belgium in 1959 she managed to arrange an exhibition of Utrillo, Valadon and Lucie Valore (her maiden name). As Utrillo's prices soared, Lucie acquired outsize diamond-encrusted rings and clothes from Paris's leading couturiers because, she reasoned, 'I must dress in keeping with the position of the wife of the greatest painter in France.'[37] The Utrillos met Prince Aly Khan and Rita Hayworth while holidaying on the Riviera and were invited to their wedding. Meanwhile Utrillo – ageing, emaciated and frail – continued to paint landscapes of Montmartre, now little more than hollow images, and to pray in his chapel.

Maurice Utrillo retained a loyal and loving memory of his mother.

Suzanne Valadon

During the war in 1942 the Pétridès Gallery held an exhibition of her paintings. Utrillo wrote the preface to the catalogue:

> To my dear mother Suzanne Valadon.
>
> From what I remember of my early childhood that admirable woman seemed always of the Élite.
>
> She cherished me with her loving heart and assured me of happiness even after her death.
>
> I was, from the first, attracted, fascinated by her sublime art which is equal to and even surpasses the greatest names in French art. Her drawings are incisive in line and perfect, her values in painting were sure and harmonious . . . I thank God I followed her pictorial gifts.
>
> *Maurice Utrillo V.*[38]

Vive la jeunesse, 1936.
The artist's spirit remained unquenchable, despite the encroachments of age and illness. She celebrated youth and beauty until the end.

When Francis Carco visited Maurice shortly before he died, aged seventy-one, in 1955, he noticed a life-sized photograph of Valadon in a white smock with a palette. The old man rubbed his hands and looked up: 'It is splendid to have her with me always,' he muttered.[39]

Recognition for Valadon came slowly in the years after her death but the tributes continue. With the increasing interest in the history of women's art in the past twenty years, Valadon has been hailed by feminists as a strong artist and a pioneer. In her time she was regarded as an outsider, never aligning herself with the schools of painting that developed during her lifetime, but her vivid realism speaks to us more directly today, as the many new forms of figurative art vie for attention.

At the Pierre Gianadda Foundation in Switzerland in 1996 a major retrospective exhibition of seventy-eight of her paintings and sixty drawings attracted crowds of over 66,000 to this small town near Mont Blanc. A part of this exhibition was put on display in the northern city of Cambrai in France later in 1996.

In Montmartre, the mellow old house in the Rue Cortot, now the Museum of Montmartre, is redolent with memories of Valadon and the unholy trio. And you cannot go up to Montmartre today without remembering her. A square opposite the funicular that climbs up to the Sacré-Cœur was named in her honour 'Place Suzanne Valadon'. She would have loved the recognition and laughed raucously.

Chronology

DATE	EVENTS	MAIN WORKS OF ARTISTIC AND BIOGRAPHICAL INTEREST
1865	23 September: Marie-Clémentine born, in Bessines-sur-Gartempe, to Madeleine Valadon, sewing maid, and father unknown.	
1869/70	Taken to Paris by mother, who works as a cleaning woman.	
1870?	Sent to Nantes to stay with half-sister, Marie-Alix. Returns to Paris and attends convent school until c. 1876.	
1876–9	Apprenticed as seamstress, then works in casual jobs.	
1880–3	Works briefly in circus. After bad fall turns to modelling, posing for Puvis de Chavannes, Renoir and many others.	
1883	26 December: Gives birth to Maurice Valadon, father unknown. Family move to 7 Rue Tourlaque. Returns to modelling; her mother cares for Maurice. Valadon sits for Toulouse-Lautrec and adopts professional name, Suzanne Valadon.	First known works: *Self-Portrait* (pastel) and *The Grandmother* (drawing)
1886	Draws prolifically – portraits, scenes, nude children.	*Maurice Utrillo, Aged Two*
1890?	Beginning of important friendship with Degas, who encourages her, buys her work and helps to launch her career.	*Miguel Utrillo*
1891	Miguel Utrillo, Spanish journalist, formally 'acknowledges' Maurice Utrillo as his son	
1892–3	First known oil paintings. Brief, intense affair with Erik Satie, eclipsed by determined pursuit of Valadon by wealthy stockbroker, Paul Mousis.	

1894	Continues to draw and, encouraged by Degas, exhibits five drawings at prestigious Salon de la Société Nationale des Beaux-Arts in Paris, only woman exhibitor.	*The Foot Bath* *Grandmother and* *Grandson* *Paul Mousis with his Dog*
1895	Degas instructs Valadon in technique of soft-ground etching, using his own press.	
1896	5 August: marries Paul Mousis. Couple divide their time between Montmartre studio, 12 Rue Cortot, and country house north of Paris, where Maurice and his grandmother live.	
1897–1900	Valadon's life transformed by material wellbeing. Drawings and etchings sold, prints sold but little new work recorded.	*Nursing Mother*
1900–04	Valadon's comfortable existence disturbed by her son's precocious alcoholism. Teaches Maurice to paint as therapy. In 1904 Utrillo's violent drunkeness leads to first of many incarcerations.	
1909	Landmark year for Valadon. Love affair with her son's friend, André Utter, brings sense of renewal to artist. Spurred on by Utter, she concentrates on painting with fresh power. Leaves husband and moves to Montmartre with her lover and son.	*Summer* *Adam and Eve* *Nude with Mirror* *After the Bath* *André Utter* (drawing)
1910	Mousis files for divorce.	*Maurice Utrillo, his* *Grandmother and his Dog*
1911	Moves back to Rue Cortot. First solo exhibition at the Galerie du Vingtieme Sièclè. Exhibits at Salon d'Automne. Shows at Indépendants from 1911 until outbreak of First World War.	*The Joy of Living*
1912	Utter, Valadon and Utrillo take holiday in Britanny.	*The Future Unveiled* *Portrait of the Family*
1913	Exhibits in Berthe Weill's group show. On holiday in Corsica with Utter and Utrillo.	*Marie Coca and her* *Daugher Gilberte* *Nude Having her Hair* *Brushed*
1914	Best of her large canvases, *The Casting of the Net*, shown at Salon des Indépendants. Valadon and Utter marry before Utter joins army at outbreak of war.	*The Casting of the Net*
1915	Berthe Weill gives Valadon and Utter show at her gallery: Valadon's mother, Madeleine, dies.	*Portrait of Madame* *Coquiot*

1916	Paints series of beautiful nudes after model Gaby; also flowers and landscapes.	*Harlequin*
1917	In June visits Utter recovering from bullet wound in hospital near Lyon.	*Rest*
1918	Utter returns from war and urges Valadon to paint more.	*Self-Portrait*
1919	Many works. Black Venus shown at Salon d'Automne with three others. Her drawings exhibited at Berthe Weill's gallery. Utrillo's prices soar.	*Black Venus* *Maurice Utrillo, Painting*
1920	Elected member of Salon d'Automne. Elected representative of Anti-Skyscraper Party in 'free town' of Montmartre.	
1921	Work on show at the Salon d'Automne and the Indépendants. Group show at Berthe Weill's gallery with Utter and Utrillo. Solo exhibition at John Levy. Excellent reviews from Robert Rey, André Warnod, Adolphe Tabarant and Florent Fels. Exhibits two portraits at the International Exhibition of Modern Art, Geneva.	*The Abandoned Doll* *The Utter Family*
1922	Portraits, nudes and Montmartre landscapes. Shows at Salon d'Automne and at the Indépendants. In group show with Utrillo and Utter at Berthe Weill's gallery and with Utrillo at Dalpayrat Gallery. Robert Rey publishes monograph on Valadon. The artist wins great critical acclaim but it is her son's work that makes the family fortune.	*Portrait of Lily Walton* *Germaine Utter*
1923	Exhibits at Salon d'Automne, Indépendants, Bernheim-Jeune, and Tuileries. Buys château at Saint-Bernard.	*The Blue Room* *Catherine on a Leopard Skin* *Still Life with Violin* *Still Life with Hare and Partridge*
1924	Valadon-Utrillo show and contract with Bernheim-Jeune, celebrated at banquet at Montmartre's Maison Rose.	*Woman in White Stockings*
1925	Valadon-Utrillo-Utter show at Galerie Bernheim-Jeune. Exhibits two paintings at the Indépendants.	*Resting*
1926	Moves with Utrillo to modern house in Avenue Junot. Utter remains at Rue Cortot.	
1927	Acclaimed retrospective exhibition at Berthe Weill's gallery.	*Self-Portrait*

1928	Solo shows at Gallerie des Archers, Lyon, and at Berthe Weill's. Illustrated article in *Deutsche Kunst und Dekoration* confirms Valadon's growing international reputation. Group exhibitions in Amsterdam and New York.	
1929	Galerie Bernier hold major retrospective of drawings and prints with catalogue foreword by Robert Rey; also a show of her recent works. Meets Paul Pétridès, who becomes her dealer.	
1931	Relationship with Utter deteriorates. Takes part in School of Paris exhibition in Prague. Recent works shown at Galerie Le Portique with catalogue foreword by Édouard Herriot. Large retrospective at Galerie Le Centaure, Brussels.	*Self-Portrait with Bare Breasts* *Woman Putting Shoes on Little Girl*
1932	Last visit to Saint-Bernard. Important and well-received retrospective at Galerie Georges Petit but poor sales. Drawings and prints exhibited at Le Portique and large show with Utter and Utrillo at Moos Gallery, Geneva. Daragnès luxurious edition of her complete engraved works sells few copies.	*André Utter and his Dogs* *Basket of Eggs*
1933	Paints less and suffers fatigue in onset of illness. Joins Groupe des Femmes Artistes Modernes, with whom she shows until her death. Utrillo's fame increases. He becomes a devout Roman Catholic and is baptised.	
1934	Beginning of friendship with young Russian painter, Gazi.	*Paul Pétridès*
1935	Treated at American Hospital in Neuilly for diabetes and uraemia. Maurice marries Lucie Pauwels. Too weak to paint, she makes several etchings.	
1936	Paints mainly flower pieces and a few still lifes.	*Vive la Jeunesse* *Still Life with Fish*
1937	Musée du Luxembourg buys *Adam and Eve, The Casting of the Net, Maurice Utrillo, his Grandmother and his Dog* and several drawings.	*Lucie Utrillo*
1938	Suffers a stroke while at her easel. Dies at the Clinique Piccine on 7 April.	*Nude Standing by Fig Tree*

Notes

Throughout these notes the following abbreviation has been used:
MNAM Archives of the Musée National d'Art Moderne,
Centre Georges Pompidou, Paris

In Search of Suzanne Valadon

My own research into the life and work of Suzanne Valadon is the main source for this introductory chapter. I also cite Philippe Jullian's *Montmartre*, published in Oxford in 1977, and the first book written about her, Robert Rey's *Suzanne Valadon*, published in 1922 during the artist's lifetime. Another source is an unpublished, undated postcard from Suzanne Valadon to her son Maurice Utrillo, kindly lent to the author by Madame Jeannette Anderfuhren of the Pétridès Gallery, Paris. I also draw on an unpublished PhD thesis by Madame Geneviève Barrez (Camax-Zoegger) from the École du Louvre in Paris.

1 Mysteries

1 Thérèse Diamand-Rosinsky, 'Les Multiples Identités de Suzanne Valadon: Marie-Clémentine, "Biqui" ou "Terrible Maria"?', and Suzanne Courdesses-Betout, 'Le Panthéon de Bessines – les origines de Suzanne Valadon', in the catalogue of the exhibition at the Fondation Pierre Gianadda, Martigny, Switzerland, *Suzanne Valadon 1865–1938*, ed. Daniel Marchesseau (Martigny, 1996).

2 Cited in Courdesses-Betout, in ibid.

3 Passport no. 58632, issued in Paris on 26 October 1931, Suzanne Valadon Archives, MNAM. In fact the date of birth appears as 6 June 1867; the change in the day and month has not been accounted for.

4 Suzanne Courdesses-Betout, 'Le Panthéon'.

5 Ibid.

6 Ibid.

7 André Utter, MNAM; Jean Fabris, *Maurice Utrillo – folie?* (Paris, 1992).

8 Courdesses-Betout, 'Le
Panthéon'.
9 John Storm, *The Valadon Story*
(London, 1959).
10 Ibid.
11 Marie Coca, Suzanne Valadon's
niece, in answer to an
unpublished questionnaire sent
to her by André Utter in 1938,
after Valadon's death, MNAM.
12 Courdesses-Betout, 'Le
Panthéon'.
13 Ibid.
14 Alistair Horne, *The Fall of Paris*
(London, 1965).
15 L. P. G. Hamerton, 'The Salon
of 1863', *Fine Arts Quarterly
Review* (London, October 1863).
16 Count Émilien Nieuwerkerke,
cited in John Rewald, *The
History of Impressionism*, 4th rev.
edn (New York, 1973).
17 Cited in Storm, *The Valadon
Story.*
18 Edmond and Jules de
Goncourt, *Pages from the
Goncourt Journals*, ed. Robert
Baldick (London, 1962).
19 Robert Rey, *Suzanne Valadon*
(Paris, 1922).
20 Marie Coca, answer to
unpublished questionnaire from
André Utter, 1938, MNAM.
21 Suzanne Valadon, 'Suzanne
Valadon ou l'absolu',
n.d., MNAM.
22 Storm, *The Valadon Story.*
23 Valadon, 'Suzanne Valadon ou
l'absolu'.
24 Horne, *The Fall of Paris.*
25 Berthe Morisot to
her sister Edma, 27
February 1871, cited in

Roy McMullen, *Degas*
(London, 1985).
26 Louise Michel, *Mémoires*
(Paris, 1886).
27 Article in Suzanne Prou's
Suzanne Valadon, catalogue
of exhibition at the Franska
Institutet (Stockholm, 1978).
28 Cited in John and Maria
Blunden, *Impressionists and
Impressionism* (London, 1980).
29 Ibid.
30 'The Salon of 1874', unsigned
letter from Paris, 25 May 1874,
cited in Rewald, *History of
Impressionism.*
31 J. Clarétie, *Le Salon de 1874*,
cited in Rewald, *History of
Impressionism.*
32 Louis Leroy, 'L'Exposition
des Impressionistes', *Charivari*
(Paris, 1874).
33 Valadon, 'Suzanne Valadon ou
l'absolu'.
34 Storm, *The Valadon Story.*
35 Ibid.
36 Valadon, 'Suzanne Valadon ou
l'absolu'.
37 Paul Pétridès (ed.), *L'Œuvre
complet de Suzanne Valadon*
(Paris, 1971).
38 Storm, *The Valadon Story.*

2 Street Life

1 Suzanne Valadon, 'Suzanne
Valadon ou l'absolu',
n.d., MNAM.
2 'Montmartre', *Paris Magazine*
(June 1896).
3 Jules Simon, cited in Bernard
Denvir, *Toulouse-Lautrec*
(London, 1991).

4 John Storm, *The Valadon Story* (London, 1959).

5 André Utter, MNAM; Jean Fabris, *Utrillo, sa vie, son œuvre* (Paris, 1982).

6 André Utter, MNAM.

7 Storm, *The Valadon Story*.

8 Ibid.

9 Valadon, 'Suzanne Valadon ou l'absolu'.

10 George Moore, *Impressions and Opinions* (London, 1891).

11 Ernest Molier, *L'Équitation et le cheval* (Paris, 1911).

12 André Utter, MNAM.

13 François Gauzi, *Lautrec et son temps* (Paris, 1954).

14 Valadon, 'Suzanne Valadon ou l'absolu'.

15 Robert Rey, *Suzanne Valadon* (Paris, 1922).

16 Gustave Coquiot, *Renoir* (Paris, 1925).

17 Valadon, 'Suzanne Valadon ou l'absolu'.

18 Marie Bashkirtseff, diary entry, January 1879, cited in Kathleen Adler and Tamar Garb, *Berthe Morisot* (Oxford, 1987).

19 Valadon, 'Suzanne Valadon ou l'absolu'.

20 André Utter, MNAM

21 Henri Perruchot, *La Vie de Toulouse-Lautrec* (Paris, 1958).

22 Storm, *The Valadon Story*.

23 Suzanne Valadon in interview, Adolphe Tabarant, 'Suzanne Valadon et ses souvenirs de modèle', *Le Bulletin de la Vie Artistique* (Paris), 15 December 1921.

24 William Rothenstein, *Men and Memories* (London, 1978).

25 Arsène Alexandre, *Puvis de Chavannes: His Life and Work* (London, 1905).

26 Ibid.

27 Ibid.

28 Valadon, cited in Tabarant, 'Suzanne Valadon et ses souvenirs de modèle'.

29 Ibid.

30 'Degas et ses modèles', *Mercure de France* (Paris, 1919).

31 Suzanne Valadon, MNAM.

32 Valadon, cited in Tabarant, 'Suzanne Valadon et ses souvenirs de modèle'.

33 Ibid.

34 Louise Marie Richter, 'The Life and Work of Jean-Jacques Henner', *The Connoisseur* (London, February 1930).

35 Jean-Émile Bayard, *Montmartre Past and Present* (London, 1926); Philippe Jullian, *Montmartre* (Oxford, 1977).

36 Bayard, *Montmartre*.

37 'Suzanne Valadon par elle-même', *Prométhée* (Paris, March 1939).

38 Cited in Catherine Banlin-Lacroix, *Miguel Utrillo i Morlius*, cited in Fabris, *Utrillo, sa vie, son œuvre*.

39 Ibid.

40 Paul Gauguin to Camille Pissarro, summer 1881, cited in John Rewald, *The History of Impressionism* 4th rev. edn (New York, 1973).

41 George Moore, *Confessions of a Young Man* (London, 1888).

42 Enrico Piceni, *Zandomeneghi* (Milan, 1967).

43 Federico Zandomeneghi

to Suzanne Valadon,
MNAM.

3 Transformation

1 Auguste Renoir, *Renoir Retrospective*, ed. Nicholas Wadley (New York, 1987).
2 Jeanine Warnod, *Suzanne Valadon* (London, 1981).
3 Suzanne Valadon, cited in Gustave Coquiot, *Renoir* (Paris, 1925).
4 Georges Rivière, *Renoir et ses amis* (Paris, 1921).
5 Valadon, cited in Coquiot, *Renoir*.
6 Adolphe Tabarant, 'Suzanne Valadon et ses souvenirs de modèle', *Le Bulletin de la Vie Artistique* (Paris), 15 December 1921.
7 Jean-Paul Crespelle, *Montmartre vivant* (Paris, 1964); John Storm, *The Valadon Story* (London, 1959); Philippe Jullian, *Montmartre* (Oxford, 1977).
8 Auguste Renoir to Philippe Burty, Paris, 8 May 1888, in Renoir, *Renoir Retrospective*.
9 Auguste Renoir to Jean Renoir, in ibid.
10 Crespelle, *Montmartre vivant*.
11 Valadon, cited in Coquiot, *Renoir*.
12 André Utter Archives, MNAM.
13 Storm, *The Valadon Story*.
14 Ibid.
15 Adolphe Tabarant, *Utrillo* (Paris, 1926).
16 Storm, *The Valadon Story*.
17 Edmond Heuzé, *The Complete Work of Maurice Utrillo* (Paris, 1959); Jean Fabris, *Utrillo, sa vie, son œuvre* (Paris, 1982).
18 Renoir, *Renoir Retrospective*.
19 Odilon Redon, cited in John Rewald, *Post-Impressionism* (New York, 1956).
20 Henri de Toulouse-Lautrec, cited in P. Huisman and M. G. Dortu, *Lautrec by Lautrec*, ed. and trans. Corinne Bellow (London, 1964).
21 Gustave Coquiot, *Toulouse-Lautrec* (Paris, 1914).
22 Cited in Patrick O'Connor, *Toulouse-Lautrec: Paris Night Life* (London, 1991).
23 Madame Geneviève Barrez in interview with author, Paris, 1995.
24 Huisman and Dortu, *Lautrec by Lautrec*.
25 François Gauzi, *Lautrec et son temps* (Paris, 1954).
26 Bernard Denvir, *Toulouse-Lautrec* (London, 1991).
27 Henri de Toulouse-Lautrec to the Comtesse Adèle de Toulouse-Lautrec, Paris, spring 1888, *The Letters of Henri de Toulouse-Lautrec*, ed. Herbert D. Schimmel (Oxford, 1991).
28 *Le Gin Cocktail*, in *Courier Français* (Paris), 6 September 1886.
29 Jean Lorrain, cited in Philippe Jullian, *Montmartre* (Oxford, 1977).
30 Henri de Toulouse-Lautrec to the Comtesse Adèle de Toulouse-Lautrec, Paris, July 1886, *Letters*, ed. Schimmel.
31 Suzanne Valadon, cited in Nino

Frank, *Montmartre ou les enfants de la folie* (Paris, 1956).

32 Huisman and Dortu, *Lautrec by Lautrec.*

33 Tabarant, *Utrillo.*

34 Suzanne Valadon, cited in Tabarant, 'Suzanne Valadon et ses souvenirs de modèle'.

35 André Utter, MNAM.

4 The Joy of an Artist

1 Suzanne Valadon, cited in Adolphe Tabarant, 'Suzanne Valadon et ses souvenirs de modèle', *Le Bulletin de la Vie Artistique* (Paris), 15 December 1921.

2 Edgar Degas to E. de Valernes, October 1890, cited in Roy McMullen, *Degas* (London, 1985).

3 Valadon, cited in Tabarant, 'Suzanne Valadon et ses souvenirs de modèle'.

4 Jean-Paul Crespelle, *Le Monde de Degas* (Paris, 1974).

5 Henri Perruchot, *La Vie de Toulouse-Lautrec* (Paris, 1958).

6 P. Huisman and M. G. Dortu, *Lautrec by Lautrec*, ed. and trans. Corinne Bellow (London, 1964).

7 Ibid.

8 Interview with Angela Snell, great-great-niece of Suzanne Valadon, London, August 1996.

9 Cited in Florent Fels, *L'Art vivant de 1900 à nos jours*, vol. 2 (Geneva, 1950).

10 Paul Gauguin, cited in John Rewald, *The History of Impressionism* 4th rev. edn (New York, 1973).

11 'Suzanne Valadon par elle-même', *Prométhée* (Paris, March 1939).

12 Cited in Fels, *L'Art Vivant.*

13 C. B. Cochran, cited in Patrick O'Connor, *Toulouse-Lautrec: Paris Night Life* (London, 1991).

14 William Rothenstein, *Men and Memories* (London, 1978).

15 *Le Décadent* (Paris, 1886).

16 Maurice Denis, cited in Norbert Lynton, *The Modern World* (London, 1965).

17 Suzanne Valadon, cited in Paul Pétridès (ed.), *L'Œuvre complet de Suzanne Valadon* (Paris, 1971).

18 Paul Bartholomé to Suzanne Valadon, May 1891, MNAM.

19 John Storm, *The Valadon Story* (London, 1959).

20 Ibid.

21 Ibid.

22 Claude Roger-Marx, *Les Dessins de Suzanne Valadon* (Paris, 1932).

23 Fels, *L'Art vivant*, vol. 2.

24 See Rewald, *The History of Impressionism.*

25 Suzanne Valadon, 'Suzanne Valadon ou l'absolu', n.d., MNAM

26 Suzay Leudet, 'Suzanne Valadon chez les Pompiers', *Beaux-Arts* (Paris), 279 (1938).

27 Francis Jourdain, *Utrillo* (Paris, 1930).

28 Belinda Thomson, *The Post-Impressionists* (Oxford and New York, 1983).

29 Jourdain, *Utrillo.*

30 Ornella Volta, *Satie Seen Through his Letters* (London, 1989).
31 Ibid.
32 Ibid.
33 Ibid.
34 Storm, *The Valadon Story*.
35 Valadon, 'Suzanne Valadon ou l'absolu'.
36 Erik Satie to Suzanne Valadon, MNAM.
37 Rollo Myers, *Erik Satie* (London, 1948).
38 Suzanne Valadon to Marie-Alix, Collection Madame Jeannette Anderfuhren, Pétridès Gallery, Paris.
39 Ibid.

5 The Country Wife

1 Roger Shattuck, *The Banquet Years: Arts in France 1885–1918* (London, 1959).
2 Erik Satie to Conrad Satie, cited in Ornella Volta, *Satie Seen Through his Letters* (London, 1989).
3 Erik Satie to Conrad Satie, in ibid.
4 Rollo Myers, *Erik Satie* (London, 1948).
5 Suzanne Valadon to Conrad Satie, in Volta, *Satie Seen Through his Letters*.
6 Adolphe Tabarant, *Utrillo* (Paris, 1926).
7 Cited in Jeanine Warnod, *Suzanne Valadon* (London, 1981).
8 Paul Bartholomé to Paul Helleu, in ibid.
9 Suzanne Waller, *Women Artists in the Modern Era* (New Jersey and London, 1991).
10 Edgar Degas to Suzanne Valadon, in *H.-G.-E. Degas: Letters*, ed. Marcel Guerin (Oxford, 1947).
11 Ibid.
12 Claude Roger-Marx, *Les Dessins de Suzanne Valadon* (Paris, 1932).
13 Maurice Utrillo, cited in Jean Fabris, *Maurice Utrillo – folie?* (Paris, 1992).
14 Maurice Utrillo to Michel Utrillo, 1 January 1896, cited in Jeanine Warnod, *Maurice Utrillo V.* (London, 1984).
15 Tabarant, *Utrillo*.
16 Edgar Degas to Suzanne Valadon, in *Degas: Letters*.
17 Ibid.
18 Ibid.
19 Octave Mirbeau, cited in Arthur Gold and Robert Fizdale, *Misia* (London, 1982).
20 Camille Pissarro to Lucien Pissarro, 3 July 1896, cited in *Correspondance de Pissarro*, vol. 4, ed. Jean Bailly (Paris, 1989).
21 Edgar Degas to Paul Durand-Ruel, 1898, in *Degas: Letters*.
22 Edgar Degas to Suzanne Valadon, 1 January 1898, in ibid.
23 Edgar Degas to Suzanne Valadon, in ibid.
24 English critical opinion of the Impressionists at the Exhibition was not much more encouraging. 'We ourselves are not inclined to think that the craze for the Impressionists will

last,' wrote *The Times* art critic on 5 June, 1900.

25 Edgar Degas to Suzanne Valadon, in *Degas: Letters*.

26 Thérèse Diamand-Rosinsky, 'Les Multiples Identités de Suzanne Valadon: Marie-Clémentine, "Biqui" ou "Terrible Maria"?', in the catalogue of the exhibition at the Fondation Pierre Gianadda, Martigny, Switzerland, *Suzanne Valadon 1865–1938*, ed. Daniel Marchesseau (Martigny, 1996).

27 Maurice Utrillo, cited in Warnod, *Maurice Utrillo V.*

28 Ibid.

29 André Utter to André Warnod, cited in Warnod, *Suzanne Valadon*.

30 Jean-Paul Crespelle, *Montmartre vivant* (Paris, 1964).

31 Ibid.

32 André Utter Archives, MNAM.

33 'Suzanne Valadon par elle-même', *Prométhée* (Paris, March 1939).

34 Suzanne Valadon to André Utter, MNAM.

35 Bernard Dorival, *The School of Paris in the Musée d'Art Moderne* (New York, 1962).

36 Jean Fabris, *Utrillo, sa vie, son œuvre* (Paris, 1982).

6 Fulfilment

1 'Suzanne Valadon par elle-même', *Prométhée* (Paris, March 1939).

2 Fernande Olivier, *Picasso et ses amis* (Paris, 1933).

3 'Acte de divorce entre Suzanne Valadon et Paul Mousis, Paris, 1910', in catalogue of the exhibition at the Fondation Pierre Gianadda, Martigny, Switzerland, *Suzanne Valadon 1865–1938*, ed. Daniel Marchesseau (Martigny, 1996).

4 Paul Pétridès (ed.), *L'Œuvre complet de Suzanne Valadon* (Paris, 1971).

5 'Suzanne Valadon par elle-même'.

6 Suzanne Valadon, 'Suzanne Valadon ou l'absolu', n.d., MNAM.

7 Maurice Utrillo, unpublished autobiography, cited in Paul Pétridès, *Ma chance et ma réussite* (Paris, 1978).

8 Adolphe Tabarant, *Utrillo* (Paris, 1926).

9 Robert Coughlan, *The Wine of Genius* (London, 1952).

10 Francis Carco, *De Montmartre au Quartier Latin* (Paris, 1927).

11 'Manifesto of Futurist Painters', *Le Figaro* (Paris), 11 February 1910.

12 John Richardson, *A Life of Picasso*, vol. 1 (London, 1991).

13 Roland Dorgelès *Bouquet de bohème* (Paris, 1927).

14 Pétridès (ed.), *L'Œuvre complet de Suzanne Valadon*.

15 Maurice Utrillo cited in Alfred Werner, *Maurice Utrillo* (New York, 1952).

16 Tabarant, *Utrillo*.

17 Ibid.

18 Pétridès (ed.) *L'Œuvre complet de Suzanne Valadon*.

19 André Utter, MNAM.

20 Yves Deneberger in interview with author, August 1996.
21 Michelle Deroyer, *Quelques souvenirs autour de Suzanne Valadon* (Paris, 1947).
22 Pétridès (ed.), *L'Œuvre complet de Suzanne Valadon.*
23 Jean-Émile Bayard, *Montmartre Past and Present* (London, 1926).

7 Separation and Success

1 Maurice Utrillo, unpublished autobiography, cited in Paul Pétridès, *Ma chance et ma réussite* (Paris, 1978).
2 Beatrice Hastings writing as Alice Morning, *The New Age* (London), 27 August 1914.
3 Paul Pétridès (ed.), *L'Œuvre complet de Suzanne Valadon* (Paris, 1971).
4 Utrillo, unpublished autobiography, cited in Pétridès, *Ma chance.*
5 Berthe Weill, *Pan! Dans l'œil* (Paris, 1933).
6 'Suzanne Valadon par elle-même', *Prométhée* (Paris, March 1939).
7 Gustave Coquiot, *Cubistes, Futuristes et Passéistes* (Paris, 1914).
8 Gustave Coquiot, *Des peintres maudits* (Paris, 1924).
9 Weill, *Pan!*
10 Marevna, *Life in Two Worlds* (London, 1962).
11 John Storm, *The Valadon Story* (London, 1959).
12 General Douglas Haig, diary, quoted in John Terraine, *The Road to Passchendaele* (London, 1977).
13 Suzanne Valadon to Adolphe Tabarant, 16 February 1917, Collection Madame Jeannette Anderfuhren, Pétridès Gallery, Paris.
14 Suzanne Valadon to Adolphe Tabarant, 10 March 1917, Collection Madame Jeannette Anderfuhren, Pétridès Gallery, Paris.
15 Suzanne Valadon to Adolphe Tabarant, 23 March 1917, Collection Madame Jeannette Anderfuhren, Pétridès Gallery, Paris.
16 Tim Newman and Quentin Newark, *Brassey's Book of Camouflage* (London, 1996).
17 General Henri-Philippe Pétain, *A Crisis of Morale in the French Nation at War, 16 April–23 October 1917* (1926), in Sir Edward Spears, *Two Men Who Saved France* (London, 1966).
18 Ibid.
19 Dr Raymond Latarjet in interview with author, 1996.
20 Suzanne Valadon to Maurice Utrillo, cited in Pétridès, *Ma chance.*
21 Ibid.
22 Berthe Weill, unpublished diary, property of Bouche family, seen by courtesy of Gill Perry.
23 Ibid.
24 Suzanne Valadon to Maurice Utrillo, cited in Pétridès, *Ma chance.*
25 Maurice Utrillo to Suzanne Valadon, cited in ibid.

26 Maurice Utrillo to Henri
 Delloue, cited in Adolphe
 Tabarant, *Utrillo* (Paris, 1926).

27 Suzanne Valadon to Henri
 Delloue, cited in Paul Pétridès
 (ed.), *L'Œuvre complet d'Utrillo*
 (Paris, 1959).

28 Coquiot, *Des peintres maudits*.

29 Storm, *The Valadon Story*.

30 Ibid.

31 Maximilian Ilyin, *Utrillo*
 (London and Paris, 1953).

32 Weill, *Pan!*

33 Robert Rey, *Suzanne Valadon*
 (Paris, 1922).

34 Weill, *Pan!*

35 André Warnod, cited in
 Jeanine Warnod, *Utrillo*
 (London, 1984).

36 Osbert Sitwell, *Left Hand, Right
 Hand* (London, 1945).

37 Greville MacDonald,
 The Nation (London,
 August 1919).

38 Storm, *The Valadon Story.*

39 Jean-Émile Bayard,
 Montmartre Past and Present
 (London, 1926).

40 Suzanne Valadon to police
 commissioners, Collection
 Jean Fabris, Utrillo
 Association, Paris.

41 Maurice Utrillo to Berthe
 Weill, cited in Tabarant,
 Utrillo.

42 Robert Rey, *L'Opinion* (Paris,
 December 1921).

43 Adolphe Tabarant, *L'Œuvre*
 (Paris), 15 December 1921.

44 André Warnod, *L'Avenir* (Paris),
 19 December 1921.

45 Florent Fels, *L'Information*
 (Paris), 25 June 1921.

46 Suzanne Valadon, *Le Bulletin
 de la Vie Artistique* (Paris),
 15 February 1922.

47 Lucie Pauwels, cited in Robert
 Caughlan, *Wine of Genius*
 (London, 1952).

48 Rey, *Suzanne Valadon.*

8 La Châtelaine

1 Cited in Paul Pétridès (ed.),
 *L'Œuvre complet de Suzanne
 Valadon* (Paris, 1971).

2 Robert Rey, *Suzanne Valadon*
 (Paris, 1922).

3 Denise Hooker, *Nina Hamnett*
 (London, 1986).

4 Adolphe Tabarant, *Utrillo*
 (Paris, 1926).

5 John Storm, *The Valadon Story*
 (London, 1959).

6 Tabarant, *Utrillo.*

7 Gérard Druet in interview with
 author, 1995.

8 Cited in Marius Mermillon,
 'Le Trio de Saint-Bernard',
 Les Lettres Françaises (Paris,
 July 1948).

9 Robert Coughlan, *The Wine of
 Genius* (London, 1952).

10 Storm, *The Valadon Story.*

11 Ibid.

12 Mermillon, 'Le Trio de
 Saint-Bernard'.

13 Cartoon reproduced in the
 catalogue of the exhibition at
 the Fondation Pierre Gianadda,
 Martigny, Switzerland, *Suzanne
 Valadon 1865–1938*, ed. Daniel
 Marchesseau (Martigny, 1996).

14 Jean Cocteau, cited in
 Francis Steegmuller, *Cocteau*
 (London, 1986).

15 André Utter, MNAM

16 Florent Fels, *L'Art vivant de 1900 à nos jours*, vol. 2 (Geneva, 1950).

17 Jean-Émile Bayard, *Montmartre Past and Present* (London, 1926).

18 Louis Vauxcelles, *L'Histoire générale de l'art français de la Révolution à nos jours* (Paris, 1922–5).

19 Edmond Jaloux, *L'Art Vivant* (Paris), 1 March 1925.

20 Storm, *The Valadon Story*.

21 André Utter to Suzanne Valadon, MNAM.

22 Dr Raymond Latarjet in interview with author, 1996.

23 André Utter to Suzanne Valadon, MNAM.

24 Geneviève Camax-Zoegger, unpublished PhD thesis, École du Louvre, Paris, 1947.

25 Cited in Maximilian Ilyin, *Utrillo* (London and Paris, 1953).

26 Jean Guillermet, *Adadémie de Villefranche en Beaujolais: Bulletin de l'année 1978*.

27 Jean Fabris, *Utrillo, sa vie, son œuvre* (Paris, 1982).

28 André Utter to Suzanne Valadon, MNAM

29 Storm, *The Valadon Story*.

9 A Male Brutality?

1 Suzanne Valadon, cited in Florent Fels, *Utrillo* (Paris, 1930).

2 Jeanine Warnod, *Suzanne Valadon* (London, 1981).

3 Daniel Marchesseau, *Marie Laurencin*, exhibition catalogue (Martigny, 1994).

4 Marie Laurencin, cited in René Gimpel, *Diary of an Art Dealer* (London, 1986).

5 Marie Laurencin, cited in Karen Petersen and J. J. Wilson, *Women Artists* (London, 1978).

6 Octave Uzanne, 'Parisiennes de ce temps', *Mercure de France* (Paris, 1910); Gill Perry, *Women Artists and the Parisian Avant-Garde* (Manchester and New York, 1995).

7 Adolphe Basler, *Suzanne Valadon* (Paris, 1929).

8 Francis Carco, *Le Nu dans la Peinture Moderne* (Paris, 1947).

9 *Beaux-Arts* (Paris, January and July 1929).

10 Suzanne Valadon, cited in Fels, *Utrillo*; Valadon, cited in Maximilian Ilyin, *Utrillo* (London and Paris, 1953).

11 *Beaux-Arts* (Paris, July 1929).

12 Ilyin, *Utrillo*.

13 André Salmon, *Revue de France* (Paris, January 1930).

14 Paul Pétridès, *Ma chance et ma réussite* (Paris, 1978).

15 Ibid.

16 André Utter, cited in Storm, *The Valadon Story*.

17 André Salmon, *Apollo* (London, January 1930).

18 Peter de Polnay, *The World of Maurice Utrillo* (London, 1967).

19 André Utter to Suzanne Valadon, MNAM.

20 Édouard Herriot, preface to exhibition catalogue, Galerie Georges Petit (Paris, 1932).

21 Claude Roger-Marx,

'L'Œuvre gravé de Suzanne Valadon', *L'Art Vivant* (Paris, September 1932).

22 Suzanne Valadon, cited in Robert Beachboard, *La Trinité maudite* (Paris, 1952).

23 See, for example, Lucie Valore, *Maurice Utrillo, mon mari* (Paris, 1956).

24 'Suzanne Valadon par elle-même', *Prométhée* (Paris, March 1939).

25 Geneviève Camax-Zoegger, unpublished PhD thesis, École du Louvre, Paris, 1947.

26 Pétridès, *Ma chance.*

27 Ibid.

28 Lucie Valore, *Maurice Utrillo, mon mari.*

29 De Polnay, *The World of Maurice Utrillo.*

30 Valore, *Maurice Utrillo, mon mari.*

31 René Barotte, in *Paris-Soir*, 12 April 1935.

32 Lucie Utrillo to Maurice Utrillo, MNAM.

10 La Grande Valadon

1 André Utter, according to the painter Edmond Heuzé, cited in Jean-Jacques Crespelle, *Montmartre vivant* (Paris, 1964).

2 Suzanne Valadon, cited in Jean Fabris, *Utrillo, sa vie, son œuvre* (Paris, 1982).

3 Suzanne Valadon, *Nudes under the Trees*, etching (1904), in Paul Pétridès (ed.), *L'Œuvre complet de Suzanne Valadon* (Paris, 1971).

4 *Adèle préparant le tub et Kitty aux bras levés*, etching, in ibid.

5 Madame Jeannette Anderfuhren in interview with author, 1996.

6 André Utter to Lucie Valore, cited in Fabris, *Utrillo, sa vie, son œuvre.*

7 Robert Naly, cited in Crespelle, *Montmartre vivant.*

8 Madame Geneviève Barrez in interview with author, 1995.

9 Ibid.

10 Suzanne Valadon to Madame Le Masle, MNAM.

11 Suzanne Valadon to Robert Le Masle, 3 March 1936, MNAM.

12 Suzanne Valadon to Robert Le Masle, 15 July 1937, MNAM.

13 Ibid.

14 Robert Le Masle to Suzanne Valadon, 2 September 1937, MNAM.

15 André Utter to Suzanne Valadon, September 1937, MNAM

16 André Utter to Suzanne Valadon, Christmas 1937, MNAM.

17 Paul Pétridès, *Ma chance et ma réussite* (Paris, 1978).

18 Suzanne Valadon, cited in Michelle Deroyer, *Quelques souvenirs autour de Suzanne Valadon* (Paris, 1947).

19 John Storm, *The Valadon Story* (London, 1959).

20 Valadon, cited in Deroyer, *Quelques souvenirs autour de Suzanne Valadon.*

21 Ibid.

22 Germaine Eisenmann to Suzanne Valadon, MNAM.

23 Francis Carco, *L'Ami des peintres* (Paris, 1953).
24 Storm, *The Valadon Story*.
25 Madame Geneviève Barrez in interview with author, 1995.
26 Suzanne Valadon, cited in Robert Beachboard, *La Trinité maudite* (Paris, 1952).
27 Plaquette no. 1, *Notre-Dame de Montmartre*, cited in Robert Bleachboard, *La Trinité maudite* (Paris, 1952).
28 Jacques Guenne, 'Homage à Suzanne Valadon', *L'Art Vivant* (Paris, May 1938).
29 *Le Figaro*, 9 April 1938.
30 Édouard Herriot, cited in Alfred Werner, *Utrillo* (London, 1981).
31 *Beaux-Arts* 18 November 1938.
32 R. J. Boulan, 'Le Roman d'amour d'Utrillo', *Paris-Soir* (November 1938); my italics.
33 André Utter, MNAM.
34 Suzanne Valadon, cited in Guenne, 'Hommage à Suzanne Valadon'.
35 'Suzanne Valadon par elle-même', *Prométhée* (Paris, March 1939).
36 Maurice Utrillo Archives, MNAM.
37 Cited in Robert Coughlan, *The Wine of Genius* (London, 1952). (London, 1948).
38 Maurice Utrillo, preface to exhibition catalogue, *Suzanne Valadon, Peintures*, Galerie Pétridès (Paris, 1962).
39 Maurice Utrillo, cited in Jeanine Warnod, *Maurice Utrillo V.* (London, 1984).

Select Bibliography

Books

Barrez, Geneviève. *Suzanne Valadon.* Unpublished thesis. Paris, 1947.

Bayard, Jean-Émile. *Montmartre Past and Present.* London, 1926.

Beachboard, Robert. *La Trinité maudite,* Paris, 1952.

Carco, Francis. *La Légende et la vie d'Utrillo.* Paris, 1928.

Carco, Francis. *L'Ami des peintres.* Paris, 1953.

Catalogue de l'Exposition: Hommage à Suzanne Valadon. Musée National d'Art Moderne, Paris, 1948.

Catalogue de l'Exposition: Suzanne Valadon. Musée National d'Art Moderne, Paris, 1967.

Catalogue de l'Exposition: Suzanne Valadon. Fondation Pierre Gianadda, Martigny, 1996.

Crespelle, Jean-Paul. *Montmartre vivant.* Paris, 1964.

Degas, Edgar-Germain-Hilaire. *Letters.* Ed. Marcel Guerin. Oxford, 1947.

Diamand-Rosinsky, Thérèse. *Suzanne Valadon,* New York, 1994.

Fabris, Jean. *Maurice Utrillo, sa vie, son œuvre.* Paris, 1982.

Fabris, Jean. *Maurice Utrillo, – folie?* Paris, 1992.

Gauzi, François. *Toulouse-Lautrec et son temps.* Paris, 1954.

McMullen, Roy. *Degas.* London, 1985.

Pétridès, Paul. *Catalogue raisonnée de l'œuvre de Suzanne Valadon.* Paris, 1971.

Rewald, John. *The History of Impressionism.* New York, 1973.

Rey, Robert. *Suzanne Valadon.* Paris, 1922.

Storm, John. *The Valadon Story.* London, 1959.

Volta, Ornella. *Satie Seen Through his Letters.* London, 1989.

Warnod, Jeanine. *Suzanne Valadon.* London, 1981.

Warnod, Jeanine. *Maurice Utrillo.* London, 1984.

Weill, Berthe. *Pan! dans l'œil.* Paris, 1933.

Articles

Leudet, Suzay. 'Suzanne Valadon chez les Pompiers', *Beaux-Arts*, Paris, May 1938.

Tabarant, Adolphe. 'Suzanne Valadon et ses souvenirs de modèle', *Bulletin de la Vie Artistique*, Paris, December 1921.

Valadon, Suzanne. 'Suzanne Valadon par elle-même, *Promethée*, Paris, March 1939.

Special issue on Suzanne Valadon. *Beaux-Arts*, Paris, April 1938.

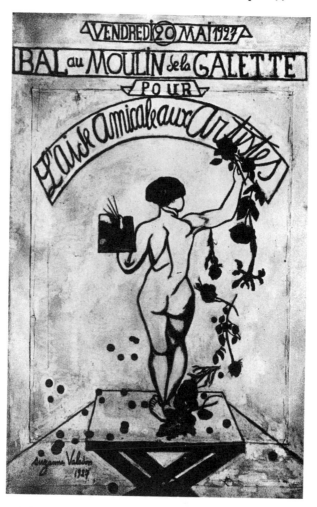

Valadon's poster for a dance in aid of young artists, 1927.

Index

Page numbers in italics refer to illustrations